D1514558

C015692324

England's Motoring Heritage from the Air

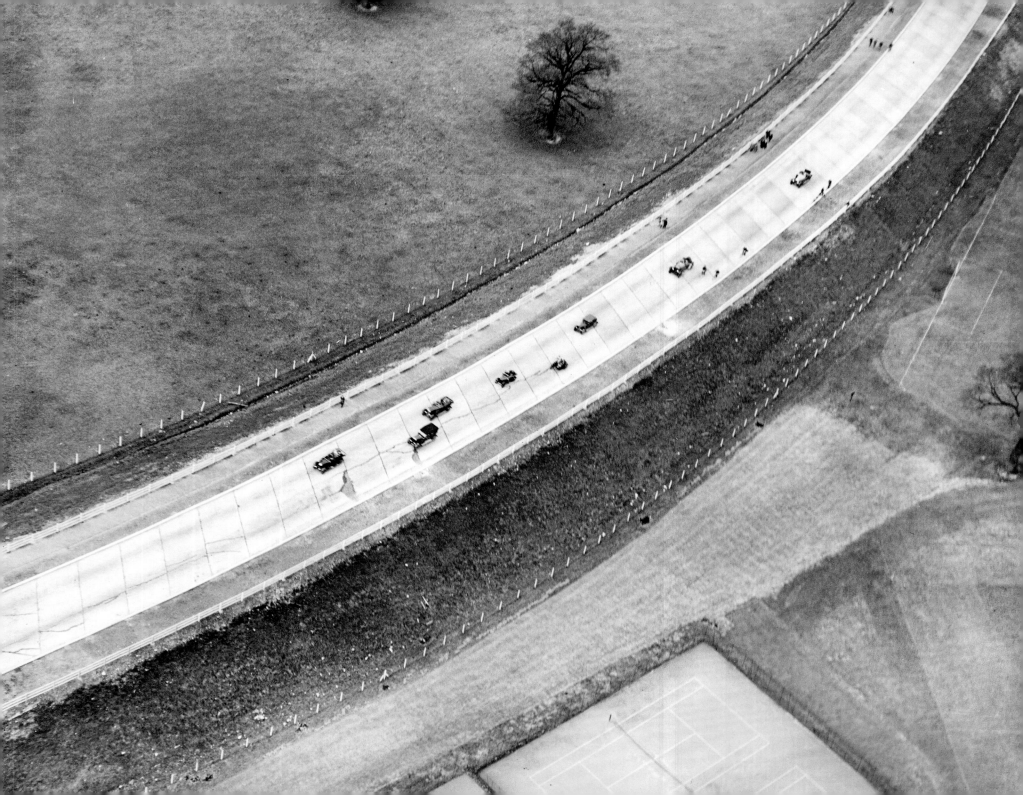

England's Motoring Heritage from the Air

John Minnis

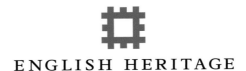

ENGLISH HERITAGE

Published by English Heritage, The Engine House, Fire Fly Avenue,
Swindon SN2 2EH
www.english-heritage.org.uk
English Heritage is the Government's lead body for the historic environment.

© English Heritage 2014

Images (except as otherwise shown) ©English Heritage. Aerofilms Collection.

First published 2014

ISBN 978-1-84802-087-0

Product code 51616

British Library Cataloguing in Publication data
A CIP catalogue record for this book is available from the British Library.

For more information about images from the English Heritage Archive, contact Archives Services Team,
The Engine House, Fire Fly Avenue, Swindon SN2 2EH; telephone (01793) 414600.

Brought to publication by Robin Taylor, Publishing, English Heritage.

Typeset in Gill Sans, 11pt on 13pt

Edited by Wendy Toole
Page layout by Andrea Rollinson, Ledgard Jepson Ltd.

Printed in the UK by Butler Tanner and Dennis Ltd.

Frontispiece:

Kingston Bypass, 1928

The open road. Traffic at Raynes Park on the
Kingston bypass in 1928. The newly opened
road served as a symbol of modernity although
the concrete surface is already showing signs
of damage. The complete absence of road
markings is striking, as is the narrow width of the
carriageway, emphasised by the fact that the cars
are engaged in overtaking each other. Although
much was made at the time of the fact that these
new arterial roads were intended to speed motor
traffic on its way, the road is not exclusively used
by motor vehicles: there are several cyclists and a
number of pedestrians strolling along the edge of
the bypass. The camera angle from the aeroplane
lends a slightly surreal quality to the photograph.

EPW020675

Contents

Preface

This book has its origins in the Car Project, undertaken by Kathryn Morrison and myself between 2008 and 2012. In the course of our research, it became clear that there were some splendid images of motoring in the Aerofilms Collection, recently acquired by English Heritage Archives. Although we used some in *Carscapes: The Motor Car, Architecture and Landscape in England*, there were many more that deserved publication and I conceived the idea of *England's Motoring Heritage from the Air*.

While *Carscapes* covered only the car, the aerial photographs I have chosen depict the whole field of road transport from trams to motor racing. As always, the choice of photographs was governed by what was available. I would have liked to include views of road haulage and lorry depots but they just seemed to have escaped Aerofilms' photographers. Almost all of the commercial and industrial work by Aerofilms was commissioned rather than taken speculatively, and if companies in a particular industry did not commission photography then it was not carried out at all.

The overall history of what is depicted in these photographs is narrated in *Carscapes*, which contains an extensive bibliography, to which those seeking further information about any of the topics raised here are directed. The present book could be seen as a pictorial supplement to *Carscapes*, although it is a stand-alone work.

It starts in 1920, the year after Aerofilms was established, and ends in the early 1970s when the firm began to move from black-and-white to colour photography. It covers a period of some 50 years, the first 30 of which saw road transport make a relatively limited impact on the historic environment, the next 10 rather more, and the final 10 almost incalculable change. This degree of change continues to the present day, but that is another story.

In *Carscapes*, we were careful to maintain an objective tone throughout and I have tried to do the same here. However, the contrast between the England revealed in the photographs of the early 1920s and that of the early 1970s is marked. It is possible to make a strong argument (and many have) that what happened to England's towns and cities in the 1960s was a disaster. Some will consider that the photographs reproduced here reinforce that argument and I would not dissent from that judgement, as may be clear from some of the captions. But we should be careful not to condemn everything that was done in the 1960s. Yes, much of it was, frankly, awful but not all of it. Some of the schemes shown here, such as those in Sheffield, including Castle Square and Norfolk Park, were a genuine attempt to deal with the conundrum of how people and traffic could co-exist and offered a brave and visionary glimpse of a new accommodation between man and motor. The new landscapes created by the car – the motorways, the bridges and flyovers and, indeed, a few of the buildings – could be things of grandeur and beauty, and it is becoming clear that there are elements in this heritage that people are beginning to cherish in the same way that 19th-century industrial and transport monuments are now treasured.

It is always a pleasure to thank those who have helped with a book, and I would especially like to thank Kathryn Morrison for reading and commenting on the draft of the book and colleagues past and present for help and encouragement in writing it: Katie Carmichael, John Cattell, Wayne Cocroft, Olivia Horsfall-Turner, Pete Smith and Matthew Whitfield. At English Heritage Archives, Keith Austin was always enthusiastic in coming up with more of the Aerofilms file prints for me to look at on my visits and the Enquiry and Research Team dealt promptly with my orders for photographs, while Katy Whittaker and Verity Hancock were helpful in providing information at a time when they were heavily involved with the launch of the *Britain from Above* website. Ian Leith gave great encouragement during my time at Swindon and without his foresight in acquiring the collection for English Heritage the book could not have been written. To John Hudson and Robin Taylor, for having the faith to publish it, my thanks.

John Minnis

Introduction

Views taken from the air go back much further than we think. The earliest such photographs were taken from balloons and were used to produce engravings in journals such as the *Illustrated London News* in the 1880s. Photography from aeroplanes started almost as soon as the first machines started flying and was developed into a vital weapon of war for reconnaissance purposes during the 1914–18 conflict. Aerial photography on a commercial basis began shortly after the armistice and the principal company involved, Aerofilms Ltd, commenced operations in 1919. This selection of photographs makes use of its collection, acquired by English Heritage in 2007 and subsequently digitised and made available on the *Britain from Above* website, www.britainfromabove.org.uk.

The arrival of aerial photography happened at a particularly significant moment, visually, for England. When Aerofilms fliers first went up in the skies in 1919, they captured a country that, with the obvious exception of some large-scale structures such as aircraft hangars and munitions factories, had more or less been set in aspic in 1914. What we are looking at in many of the earliest photographs in this book is essentially Edwardian England, with towns and villages generally quite compact, with fields reaching almost up to the high streets in many cases, and with little sign of the sprawl that was to engulf them in the 1920s and 1930s. The streets of many towns, especially the seaside resorts that provided the aerial photographers with many of their earliest subjects,

have an orderly, almost pristine appearance to them, with the Victorian and Edwardian houses undisturbed by any out-of-place redevelopment.

The phrase 'Lost Elysium' was famously used by John Betjeman in his poem 'Middlesex' to express his sorrow for the way in which the field and villages of Middlesex gave way to serried ranks of semi-detached houses. The destruction of Betjeman's Middlesex was due not to the motor car, but to the electric underground trains of the Metropolitan Railway. The impact of this rail-induced development was limited, however, to London; in provincial towns and cities other than Manchester, Liverpool, Birmingham and Newcastle, which had extensive suburban rail networks, suburban development had initially more to do with the tram and the motor bus and then, from the 1930s, with the car.

But the most striking thing about these early aerial photographs, certainly those covering the years between 1919 and around 1922, is that there are hardly any cars to be seen in the streets, and almost none parked by the kerb. While ground-level photographs of the period show the same thing, the view from the air makes the point so much more graphically. The streets have an uncluttered look to them, with nothing to divert attention from the buildings and gardens, and this extends to the whole town. Townscape has a clarity that shines out from many of these photographs, with streets leading logically out from the town centre. Even by the early 1930s

there had been little change in that respect and many towns still looked much as they had done a century earlier, with high street shops backed by gardens instead of service yards, and market gardens and allotments instead of surface car parking.

The purpose of this book is to show just how radically that position changed over the ensuing half-century. We trace the outward expansion of places brought about by the availability of the car: the new suburbs and ribbon development. We see how new arterial roads came into being to meet the needs of motor transport (pp 214–29) and how the centres of cities started to be rebuilt to accommodate it. We witness the growth of sprawl around road junctions on the edges of built-up areas (pp 212–13) and the arrival of new types of building there to service both cars and people: the filling station (pp 120–25, 132–33), the roadhouse (pp 168–73). We see how the car encouraged more people to go further afield for sport and pleasure: to the seaside (pp 184–201), the races (pp 156–63) or to new forms of attraction such as the amusement park in the country (p 174). And we see how public transport changed over the period from trams to buses, with the advent of new facilities such as bus stations (pp 38–51). The scale of traffic congestion becomes apparent by the late 1930s (pp 222–3, 240–1). In addition, the impact on the landscape of large motor factories (pp 64–117) and provision for motor sport (pp 176–83) is made clear. With Kathryn Morrison, I have already

Tandridge Court
1968

Although in many country houses provision for the motor car took the form of converted stables and carriage houses, in some instances entirely new structures were built. This circular combined stable and motor house court was built in 1904 (architects F S Brereton & Sons) at Tandridge Court, Tandridge, Surrey. The building was little altered when the photograph was taken in 1968. It was entered through an arch in the clock tower, and the motor house with its six garages was on the left-hand side with workshops behind. An extensive glazed canopy runs around this part of the building and was used to shelter cars while they were being washed. The dormer windows mark the chauffeurs' accommodation above the garages. The stables were on the right-hand side. This is one of the most ambitious structures of its kind and survives externally little altered although the garages are now in residential use.

Afl 03_A185616

explored in some detail the impact of the motor car on England in our book *Carscapes: The Motor Car, Architecture and Landscape in England* (Yale University Press, 2012). Here, I am looking visually at these changes, associated not just with motor cars but with public transport and other aspects of motoring such as motor sport.

Some early attempts at altering towns to suit the motor car were evident by the mid-1930s. But this sort of large-scale reconstruction remained rare until well after the Second World War. Plenty of plans were produced, all of which envisaged large-scale property demolition to create new roads. Perhaps fortunately, however, few of them, with some exceptions such as Corporation Street, Coventry, actually came to fruition – aspiration rather than actuality.

It was not until the 1960s that our cities and towns saw major redevelopment. A process of gentle attrition had already been going on for some time. More and more land close to town centres was being given a hard surface and used for car parking, a process accelerated by the availability of many bomb sites. The urban fabric began to fall apart as more gaps appeared to accommodate car parks or buildings were set back in the course of street widening. A sense of enclosure, engendered by continuous building along a street, vanished as spaces were made for new roads, parking or sight lines. Much larger buildings had to be accommodated, and this led to an increase in scale that made existing buildings look curiously diminished. Again, the motor vehicle cannot take all the blame – much of it was the Zeitgeist, the belief in new ways of doing things in which the car was seen as an agent of change and modernity. Any difficulties that arose from its widespread use would be solved by separating it from pedestrians. This was the great mantra of post-war town planning, a doctrine given wide

propagation by the Metropolitan Police Assistant Commissioner, distinguished watercolour artist and traffic guru, Sir Herbert Alker Tripp, and the status of biblical writ in the Buchanan report of 1963.

From this spread what has been described as the assault on towns and cities – the introduction of ring roads, doing away with street patterns that had evolved over a millennium and sweeping through existing communities, cutting off town centres from their hinterlands; the transformation of back streets and gardens into car parks and service yards; the increasing take-up of land for roundabouts and other forms of road junction; and the general disintegration of townscape into carscape. People no longer walked into town along familiar and well-travelled routes but were shepherded by barriers and signs through subways and up and down steps, penned in traffic islands and led along convoluted paths.

These are the changes we see depicted in the aerial photographs. Since then, things have moved on again. By the 1980s, as it became more difficult to drive and park in the centre, development moved to the edge with out-of-town supermarkets (first seen in substantial numbers in the 1970s), followed by the ubiquitous retail parks that provide a ring of sheds around almost every town of any size in the country. Closely coupled with them are the leisure parks providing multi-screen cinemas, bowling alleys and restaurants. Towns have expanded to fill the land between their existing built-up area and the ring road with facilities catering for such uses and with swathes of housing. We have what is a new and constantly evolving landscape, based around motor transport, overlaying townscape with its origins in medieval times and expanding beyond it to occupy what was until recently agricultural land. Throughout the history of the English landscape

over many millennia, the process of change is a constant: the railways made considerable changes in the 19th century but on nothing like the same scale or at the same rate as the motor vehicle has done, especially in the last 40 years. The pace of change is such that even newly constructed structures seen in photographs of 40 years ago are rapidly disappearing.

This degree of change is evident in these photographs, in particular in so far as it has affected manufacturing industry. The sites of so many of the great names of the British motor industry are now supermarkets or business parks. At the time of writing, the industry has been experiencing a boom, with production rising steadily – but it is an industry very different from that of 40 years ago. The volume producers are mainly foreign owned, producing cars on new sites far away from the traditional heart of the British motor industry in the West Midlands. Even where a traditional site remains, it is often used for an entirely different purpose: Ford make engines at Dagenham rather than assembling cars there today; Vauxhall build only vans, not cars, at Luton.

The location of Aerofilms at Hendon is fortunate for the student of transport. It was an area that was to see fundamental change in the inter-war years as the farmland became built over, and some of England's earliest arterial roads criss-crossed the district. It was also near to Wembley, the site of the Empire Exhibition of 1925. North-west London was one of the major centres for car, component and coachbuilding factories in the capital, and new building for these industries was widespread. However, it should be borne in mind that Aerofilms Ltd was a commercial company and generally photographed those sites that it was commissioned to photograph. Thus, there is often good coverage of one company's premises with a variety of photographs from different angles,

and none at all for others. The practical problems of aerial photography are another restricting influence. Views above central London and some other large cities tend to be disappointing as the aeroplane had to fly at quite a high altitude and there was little opportunity to record the type of intimate detail found especially in seaside resorts where opportunities for low flying over the water abounded. Atmospheric pollution from domestic and factory chimneys is another factor limiting photography, to which the northern industrial cites were particularly susceptible. Hence there is a relatively poor showing of central London and Manchester in this selection.

There is coverage of all aspects of road transport in these pages. The arrival of aerial photography as a practical commercial proposition coincided with a great boom in road transport of all types. The production of large numbers of standardised lorries for the army during the First World War led to vast numbers of surplus vehicles being sold off from dumps such as that at Slough. These were reconditioned and formed the basis of many haulage fleets, charabancs and rural bus services, which were often started up by ex-servicemen. In addition to this increase in commercial and passenger vehicle operation, the advent of small, reliable and cheap cars such as the bullnose

Morris and the Austin 7 a few years later brought in its wake motoring for those of more limited means, with the number of cars on the road in Great Britain going up from 187,000 in 1920 to 1,042,258 in 1930.

While all these changes were taking place, some aspects of road transport survived largely unchanged from the pre-war days. Electric trams continued to run in many English towns and cities, although by the 1930s they were rapidly being replaced by motor buses or trolleybuses. One network of horse trams, that at Morecambe, remained long enough to be photographed from the air (pp 2–3). Although large numbers of lorries came on to the roads, horses were still widely used for local delivery work well into the 1930s and indeed survived with the railways, in limited numbers, post-1945 and with dairies into the 1960s.

All these various forms of transport required appropriate buildings to house them, and many are visible in these photographs. The factories used to produce them, like the bus and tram depots and bus stations, are in many cases best seen from the air where a clear idea of their layout can be gained. Although *Carscapes* deals with buildings connected to the motor car, motorway service

areas are covered in various works by David Lawrence and car factories are described in detail by Paul Collins and Michael Stratton in *British Car Factories from 1896* (1993), bus and tram depots and bus stations await their historians. No overarching studies of them have been published to date, only monographs on specific aspects. The photographs here are divided into a number of themes, each often has a wealth of information relating to other themes within the book and so they are best approached as a starting point for study.

In conclusion, the photographs in this book depict the impact on England of what is, visually at least, the most significant force for change in the 20th century. Whatever one's views may be as to whether its effect has been positive or negative, the car (along with its fellow road vehicles) is an intrinsic part of the history of the last century and of the present one. It exists and cannot be un-invented. And cars do not exist in isolation: they do not, much as we might anthropomorphise them, have a life of their own. They are designed, built and driven by people, and in talking about their impact we are actually talking about ourselves, humankind. If we complain about what the car has done to our world, we have nobody to blame but ourselves.

Kensal Green
March 1921

Not a single car is to be seen on the streets of
Kensal Green, the only form of transport visible
on Purves Road and Ashburnham Road being
horse-drawn delivery vehicles. Such streets of
villas for the lower middle classes, in this case built
about 1900 as part of the development of the
United Land Company estate, constitute precisely
the type of area which is now choked with parked
cars, having been built with very little spare land
left available for parking them. It is seen here
exactly in the form in which it was built and has an
uncluttered appearance. Harking back to an earlier
age, a goods train passes along the North London
Railway line just outside Kensal Rise station, hauled
by a tank locomotive dating back to the 1870s.

EPW005601

Morecambe

July 1920

Morecambe shows barely a trace of the motor age. Visitors arrive at the Midland Railway's station, opened in 1907 (on the right), where an immense line of horse-drawn landaus are waiting to take them to their hotels. A horse-drawn tram makes its way along the sea front; Morecambe was the last place to retain them on the British mainland (one survives to this day at Douglas, Isle of Man), and this glimpse of what was once such a familiar sight in many English cities is a fortuitous capture by the cameraman, as they were replaced by buses in 1926. Bathing machines and a Punch and Judy show on the beach complete a scene that could date from the 1880s, if it were not for the group of parked motor charabancs just visible to the left of the tram and the warship and the destroyer stationed somewhat ominously on the left.

EPW004079

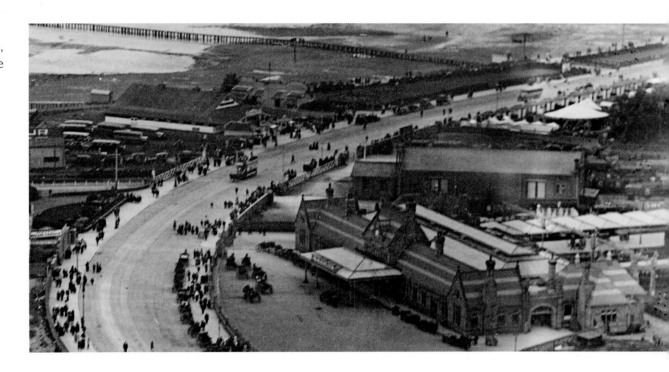

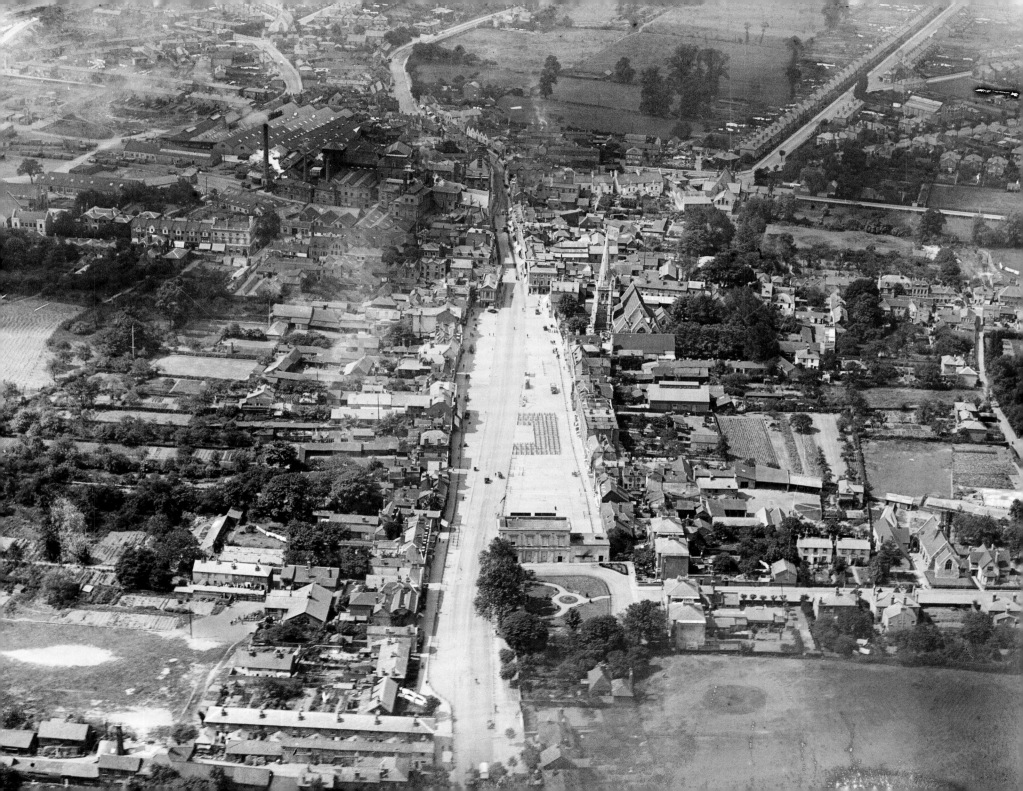

Romford

7 June 1920

Although the ancient market town expanded
greatly in the 19th century following the arrival
of the railway, as can be seen by the enormous
Ind Coope brewery and the terraces of workers
cottages in the distance, the core of Romford
around its broad market place remained largely
untouched. What is striking is the way in which the
medieval burgage plots are still so distinct and that
behind the buildings on the market place in almost
every case are gardens leading on to fields and
market gardens. This close relationship between
the built-up areas and a hinterland of gardens,
fields and allotments was at the heart of towns,
and its destruction is one of the most significant
changes wrought by the motor vehicle. Today,
Romford is barely recognisable; the brewery was
demolished following closure in 1993 and its site
subsequently redeveloped as a shopping centre.

EPW001394

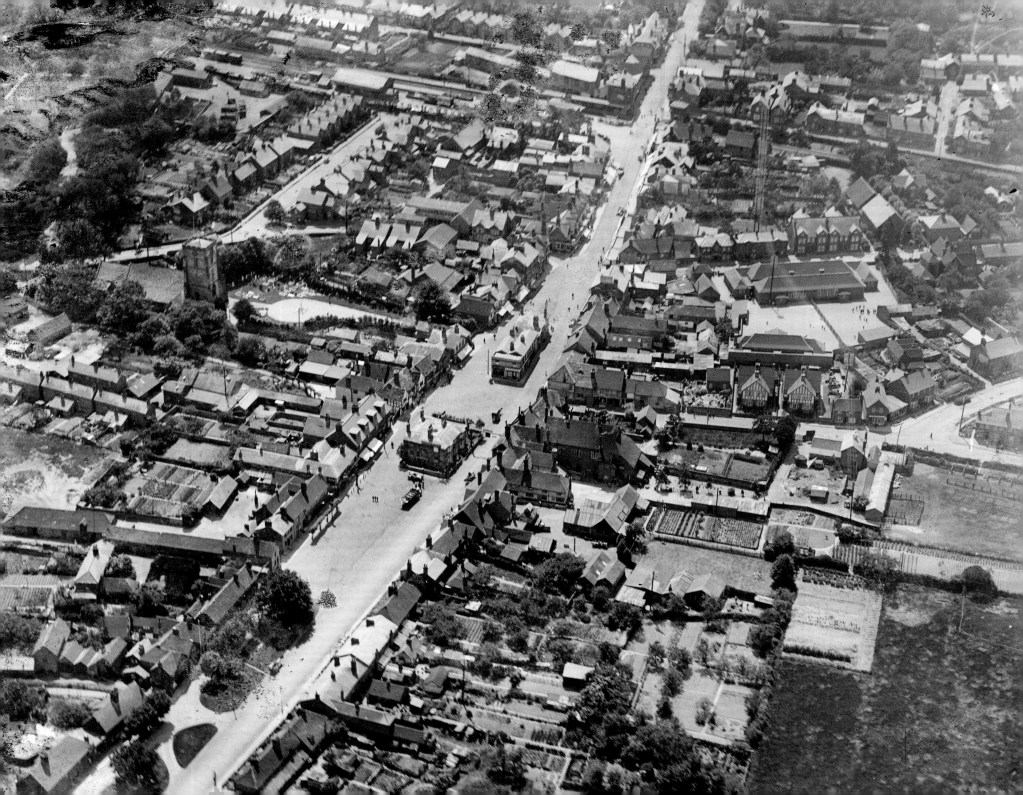

Crawley, Sussex

June 1920

Crawley, when photographed in 1920, still had the traffic of the main London to Brighton road running through its centre. The broad market place, known as The Square, is seen in this view looking south. Gardens and vegetable-growing form the predominant use of land behind the buildings fronting the high street. Today these areas are occupied entirely by service yards and roads and car parking, while many of the small-scale buildings have been replaced by much larger retail units as part of Crawley's transformation into a New Town in the 1950s. Hardly any cars are visible, but Crawley acquired a reputation as one of the major obstructions on the Brighton Road because of its level crossing (just visible near the top of the photograph) which could lead to long lines of waiting traffic at weekends. Railway level crossings on main roads were a constant trial for motorists in the inter-war years, even the main A1 London–Edinburgh road being beset with many of them. Crawley town centre was bypassed as early as the 1930s.

EPW001483

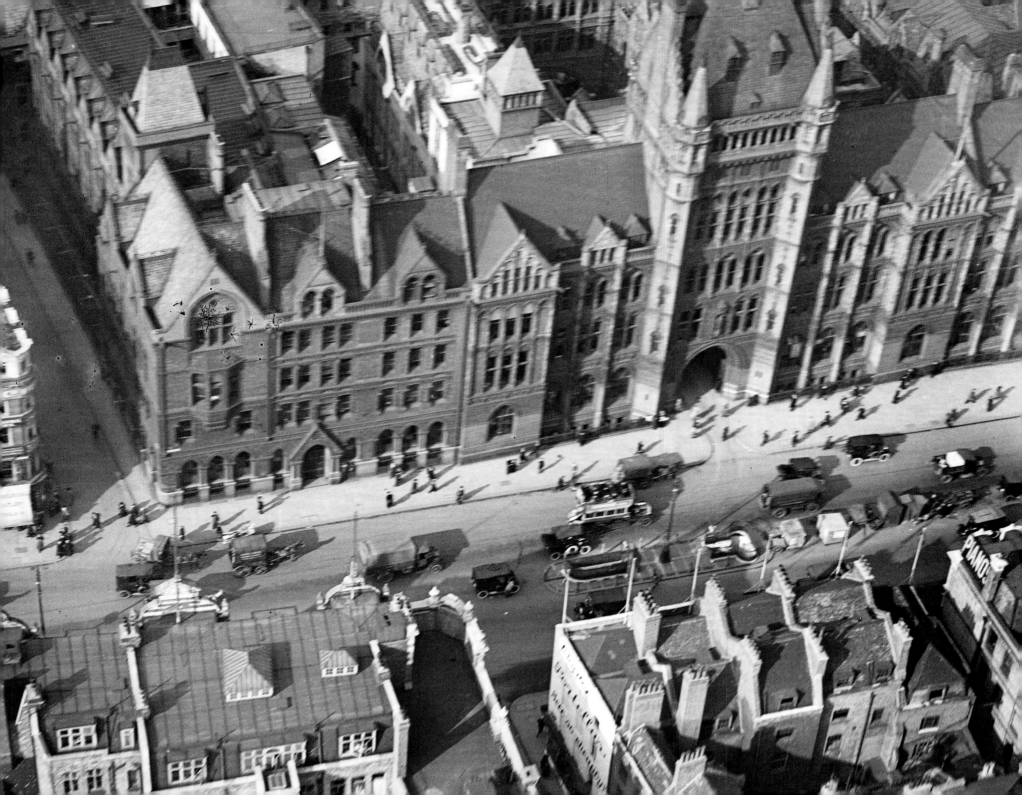

Holborn

March 1921

The one place where substantial numbers of motor vehicles could be found were city streets and in particular those of London. Here, Holborn is seen with, in the background, the offices of the Prudential Assurance, designed by Alfred Waterhouse and built in a number of phases from 1876 onwards, and now, as Waterhouse Square, housing the London office of English Heritage. But even here there are hardly any private cars visible. There is a motor bus, and some motor lorries and horse-drawn delivery vans – but the photograph is deceptive in that what appear to be cars are in fact taxi cabs, which made up a substantial proportion of London traffic.

EPW005923

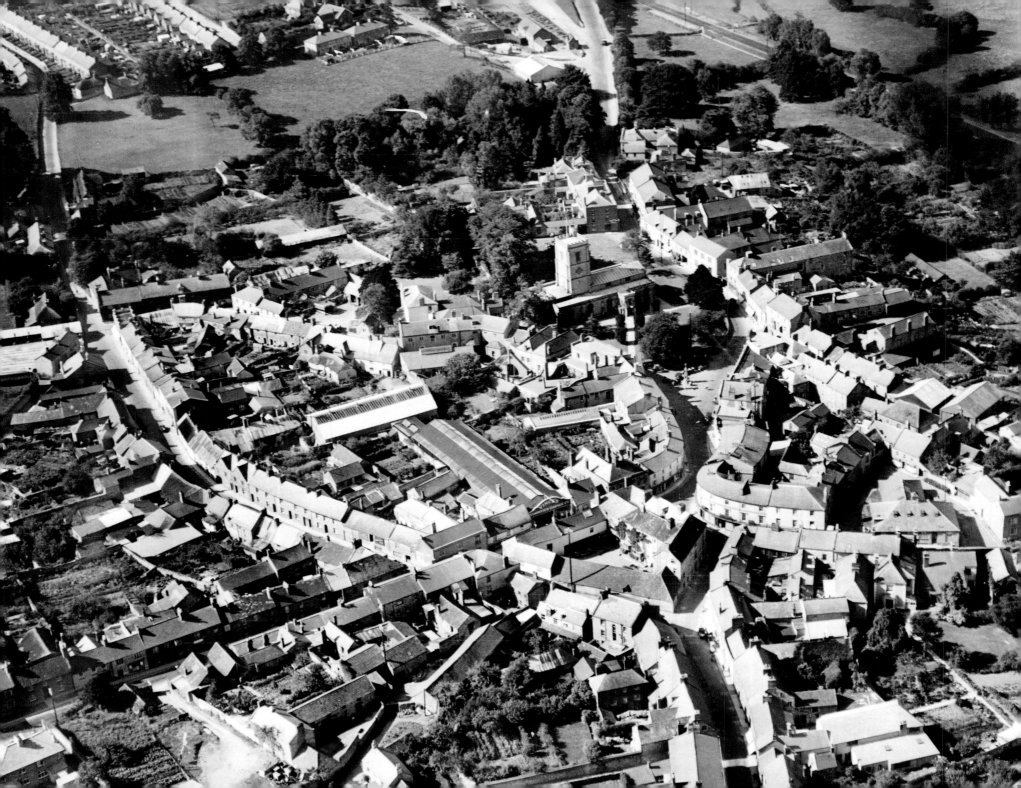

Axminster, Devon

1928

Even by the late 1920s, many towns showed no sign of the motor car's impact. Axminster, Devon, displays an ancient street layout that has changed barely at all since the 19th century. Hardly any cars are visible in the streets; there are no obvious parking places – where are they all? The answer is to be found in the large building in the centre of the town with a narrow frontage to Lyme Street but extending a considerable distance back. This is Vince's Axminster Garage Co. Garages fulfilled the function of public car parks then and would frequently house 50 to 100 cars while their owners were in town. It was the recognised practice to leave a car at such a garage rather than by the side of the road, if one were stopping for more than a short while.

EPW023973

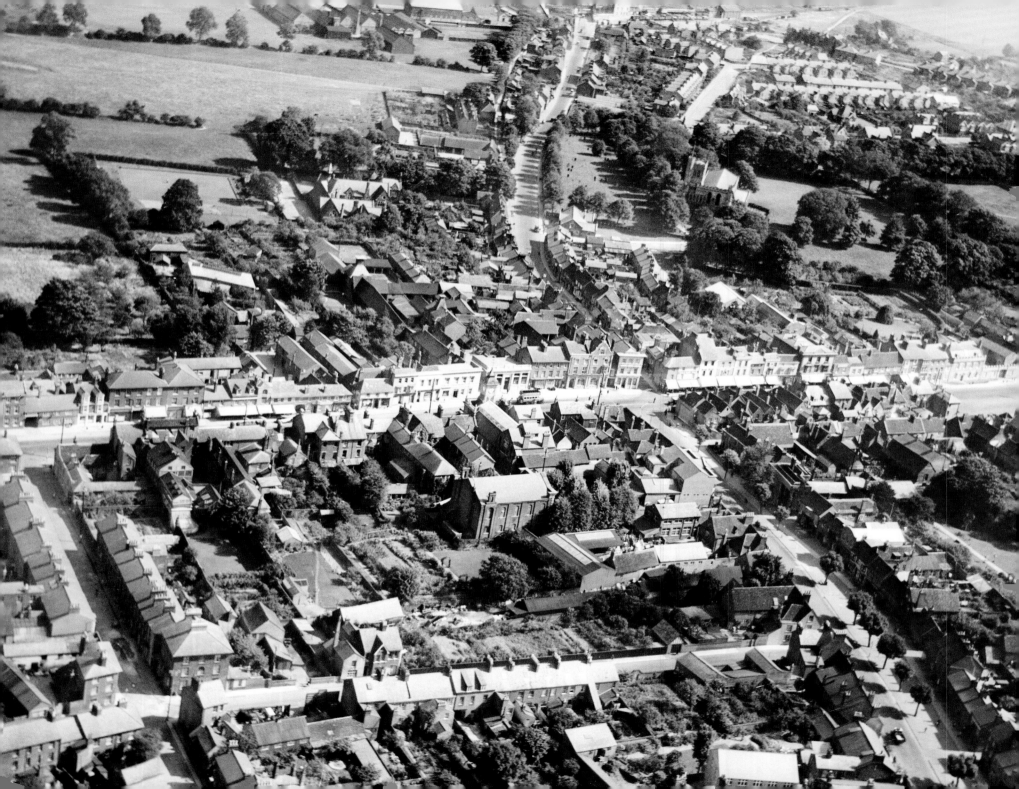

Dunstable, Bedfordshire

September 1928

Dunstable displayed the close relationship between the town and surrounding country, with fields coming close to the town centre. Looking east towards Luton, the backland behind the high street is barely developed apart from some streets of terraced houses and villas south of the Luton road. Gardens proliferate behind the shops; there is no visible provision for the car. Everything is still much as it had been in 1900. But by the end of the 1930s Dunstable would be joined, by a continuous ribbon of housing, with Luton, and today the fields on the left behind the high street are filled with the Quadrant Shopping Centre, a superstore and acres of surface car parking with more housing beyond it.

EPW023859

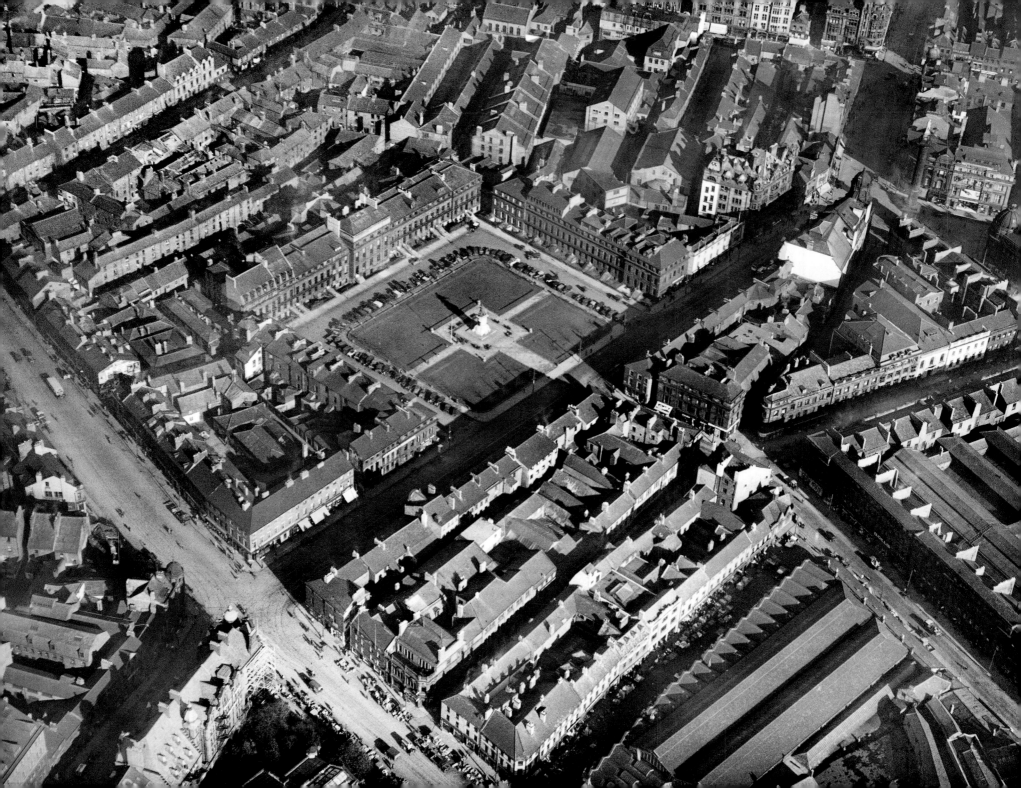

Eldon Square, Newcastle upon Tyne

1927

Street car parking in cities was subject to severe restrictions, certainly up to the late 1930s. Motorists faced the risk that a policeman might book them for obstruction unless they parked either in a parking garage – private garages offered parking facilities at a price – or in an official parking place. These were designated areas where one could park without risk of a fine. Formal urban squares were greatly favoured for the purpose. This is Eldon Square, with cars parked in the way that was usual for such locations, backing on to the square with bonnets facing the houses. The north and west sides of Eldon Square (1825–31, by Thomas Oliver and John Dobson) were demolished in the 1960s, one of the greatest losses resulting from Newcastle's post-war redevelopment.

EPW019819

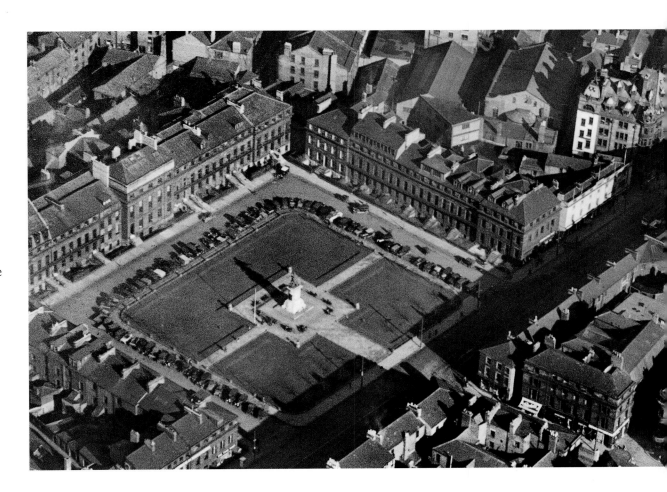

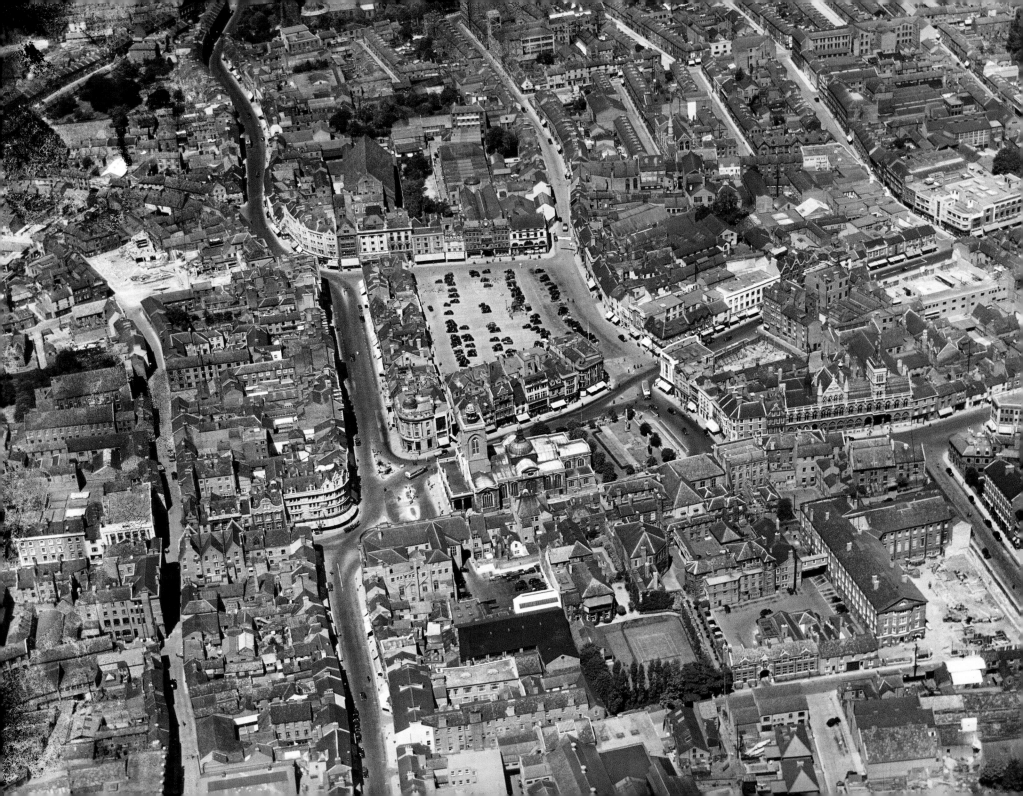

Northampton

1938

As late as the end of the 1930s, even some larger
towns showed little sign of change. The centre
of Northampton retains its 19th-century street
pattern and, despite some new building, maintains
its scale and the vast majority of its earlier fabric.
The market place is used as a car park, and a few
cars can be seen parked on the roadside, but they
barely make their presence felt.

EPW057745

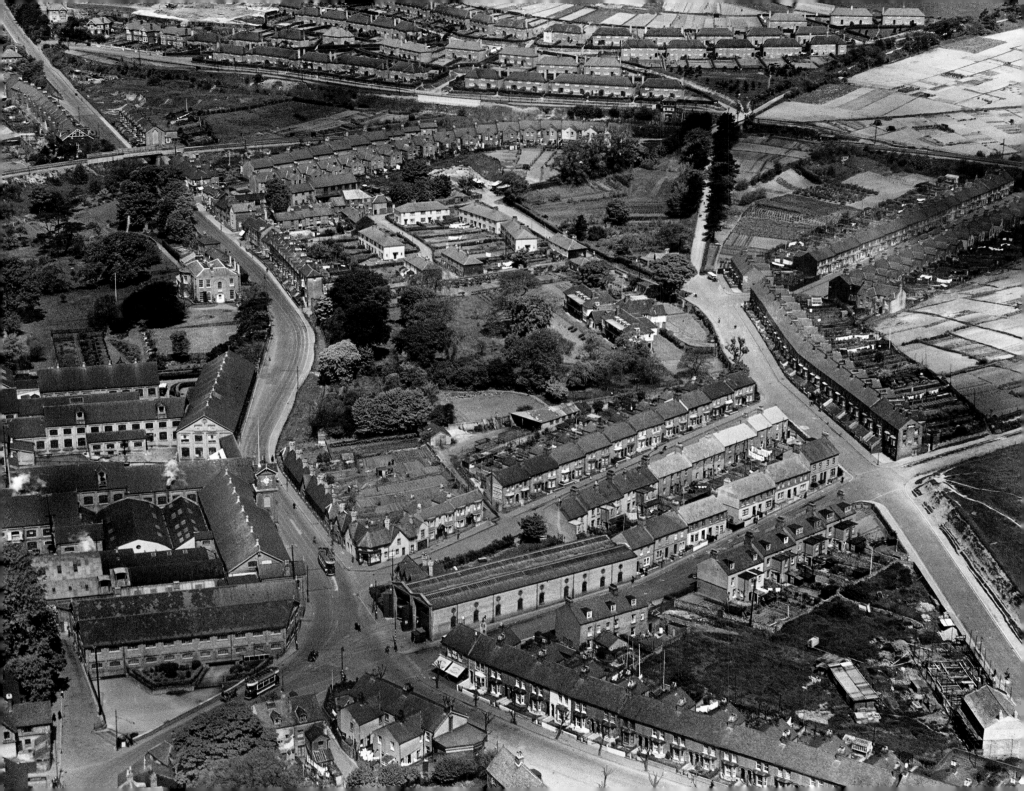

Buckland tram depot, Dover, Kent

31 May 1932

Dover Corporation was an early user of electric trams, with the first part of the system from the outlying suburb of Buckland to the harbour opening in September 1897. The depot, which had four tracks, was located at London Road, Buckland, built in the midst of terraces of houses and opposite a paper mill. It was the principal depot for the system throughout its life, although there was a second depot at Maxton. In this view, a tram can be seen north of the depot on the extension to the village of River, opened in 1905. Although the system was closed on 31 December 1936, the depot still exists in retail use.

EPW038166

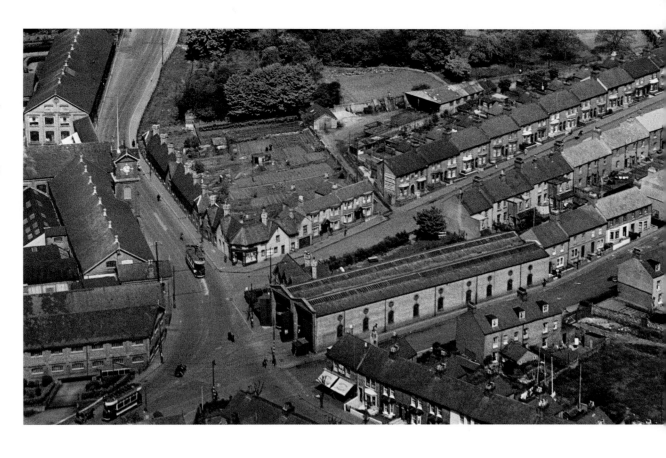

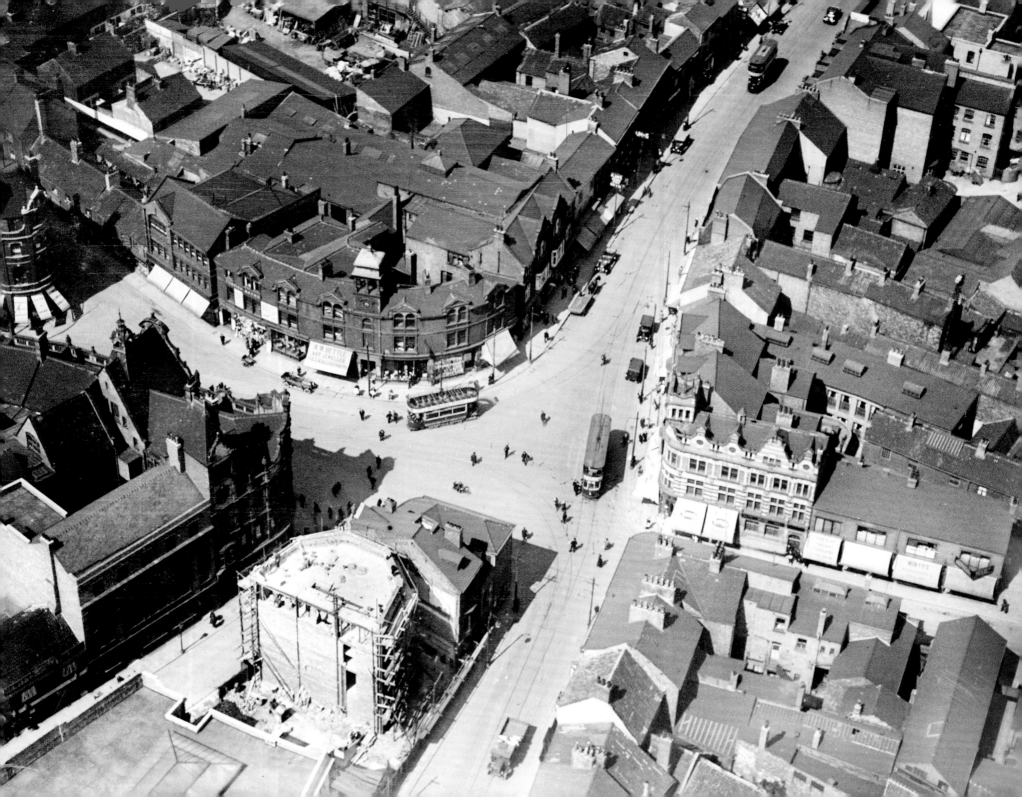

Doncaster

15 May 1925

The junction of St Sepulchre Gate and West Laithe Gate, Doncaster, with two Doncaster Corporation trams visible in the centre. The open-top car is one of the first 25 tram cars supplied to Doncaster Corporation in 1902–3. It was of the 'Preston' type, one of the most common of all British tram car designs, so named because it was built by the Electric Railway and Tramway Carriage Works, a subsidiary of Dick, Kerr & Co Ltd of Preston. The car visible to its right is one of the last 10 trams built for Doncaster by English Electric in 1920, with enclosed ends to the lower decks. Doncaster's trams were replaced in 1935 by trolleybuses, a fate that befell many British tramway systems at this time. There is a handful of motor cars parked outside shops, but their owners would not have been able to leave them there for any length of time otherwise the police would book them for obstruction. The most striking thing about this view is the way in which people were able to walk at will across the road or indeed stand in the middle of it. There is no attempt to encourage crossing at designated places, something that first appeared in London from the mid-1920s but only became widespread as cars became more numerous in the 1930s.

EPW012777

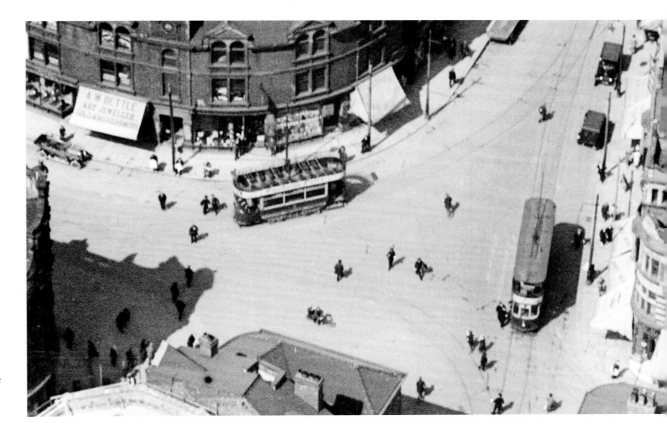

Barras Bridge, Newcastle upon Tyne

10 June 1924

Two of the Corporation's trams stand in the foreground. Newcastle gained its first electric trams in 1901, and of the two trams in this photograph, the furthest from the camera is of the Class A supplied by Hurst, Nelson & Co for the opening. It was subsequently rebuilt with a covered top deck, but its short length contrasts with the nearer vehicle, a Class B design, one of many built by Newcastle Corporation Transport between 1917 and 1926 with a completely enclosed vestibule and top deck. The latter cars lasted until the system was closed in 1950. This area became a public transport hub, with Haymarket bus station located just beyond the war memorial on the left. At the back of Haymarket, a long building at right angles to the road is just visible; this was the Haymarket tram depot and is typical of how some of these buildings were fitted into tight city locations with access through a narrow gap in the adjoining buildings. There is some roadside parking but many of the cars are probably waiting rather than parked for any length of time. John Dobson's St Thomas's (1827–30) still dominates the area today and the Grand Hotel opposite is now in retail use, but the area behind, including the tram depot, has been subsumed within the University, whose Student Union building is under construction on the right.

EPW010593

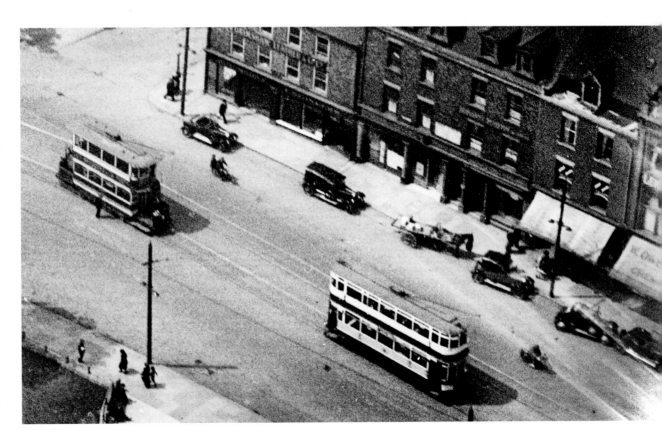

Mersey Square, Stockport

1927

Whereas today transport depots tend to be located on cheaper land on the edge of urban areas, at the beginning of the 20th century they were often located at the hearts of the communities they served. At Stockport, the tram depot was built in the centre of town at Mersey Square. It was erected for the opening of the town's electric tram service in 1901 and formed part of what almost amounted to a civic centre, with the fire station, opened in 1902, and the offices of the Tramways department in a 'Wrenaissance' style to its right. The car shed is seen here prior to its extension in 1929, when an imposing frontage was added. The depot was subsequently used as a bus garage, following the closure of the Stockport tramway system in 1951. It was replaced by a new maintenance depot and headquarters of the transport department in 1968, just a year before it was subsumed into the SELNEC (South East Lancashire North East Cheshire) passenger transport authority. The site is now Heaton Lane car park. The two buses in the square belong to the North Western Road Car Co: the single-decker is a Tilling-Stevens B9A delivered that year, with a Tilling body incorporating an opening canvas roof in the rear portion, and the double-decker is also a Tilling-Stevens, a TS6 model of 1925 with a Brush body. The trams are all four-wheel cars of Stockport Corporation apart from the car just below the *Daily Mail* advertisement. This is a Manchester Corporation standard bogie car – one of hundreds put into service in the

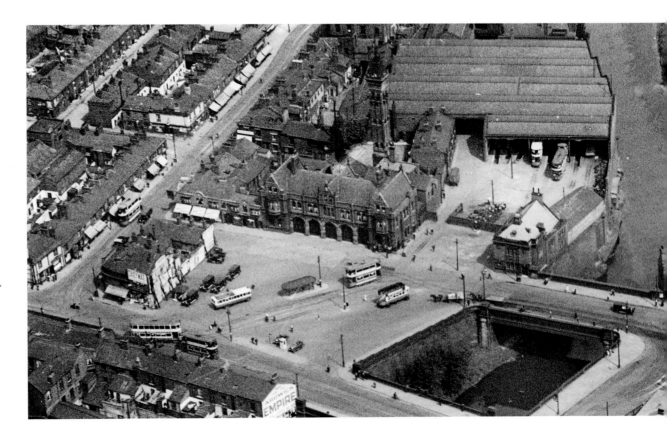

1920s – and is running on the joint service to its home city. Just below the bridge to the right are the premises of Talbot Motors Ltd, which held an agency for Sunbeam, Talbot and Darracq cars, as advertised on its roof, but which took its name not from the car but from nearby Talbot Street.

EPW019110

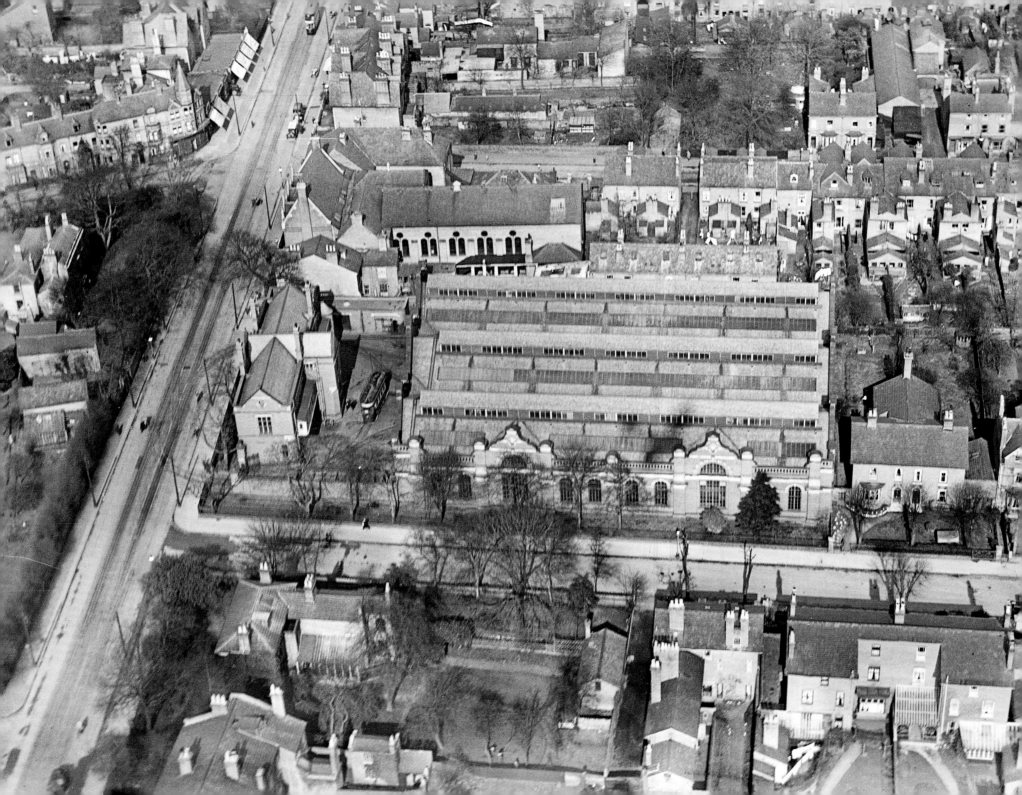

Moseley Road tram depot, Birmingham

March 1921

Tram depots could be an expression of municipal pride, and one of the most elaborate was the Moseley Road depot of Birmingham Corporation. It was opened on 1 January 1907, the day when services commenced on nine new tramway routes, and was seen as the showpiece of the Birmingham tram network being much more ornate than the Corporation's other depots. It had a total capacity of 75 trams when it opened and was built at a cost of £22,220. The office building, in neo-Tudor style, facing Moseley Road was designed by F B Osborn and it is probable that he designed the depot as well. Following the demise of Birmingham's trams, it was taken over for buses from 2 October 1949. Final closure came in 1975, but the building has survived and is now listed Grade II.

EPW005405

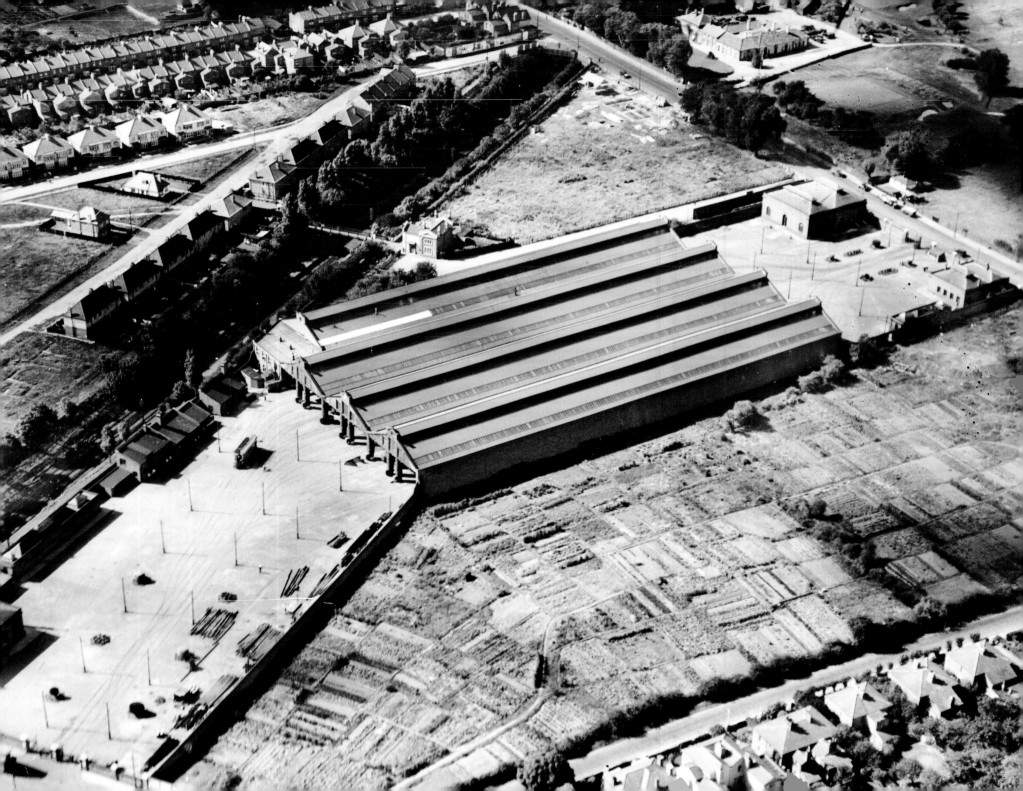

Fulwell tram depot and Works, Middlesex

September 1928

Fulwell, just to the north of Hampton Hill, Middlesex, was much more than a tram depot as it housed the works of the London United Tramways Company. Built on a five-and-a-half-acre site in 1902, the scale of the works can be appreciated in this photograph. The plan of the depot was innovative, making full use of available space by having frontages and access to both Stanley Road and Wellington Road. The depot was one of the largest in London, with 18 tracks holding 165 tram cars. The building just above the works is Fulwell station on the London & South Western Railway's Shepperton branch. The first trolleybuses to enter service in London ran from Fulwell depot in 1931, and with the ending of tram services in the area in 1935 Fulwell became used for trolleybuses until they too were phased out in 1962. The garage was converted for buses, and today Fulwell is still an operational bus garage.

EPW023243

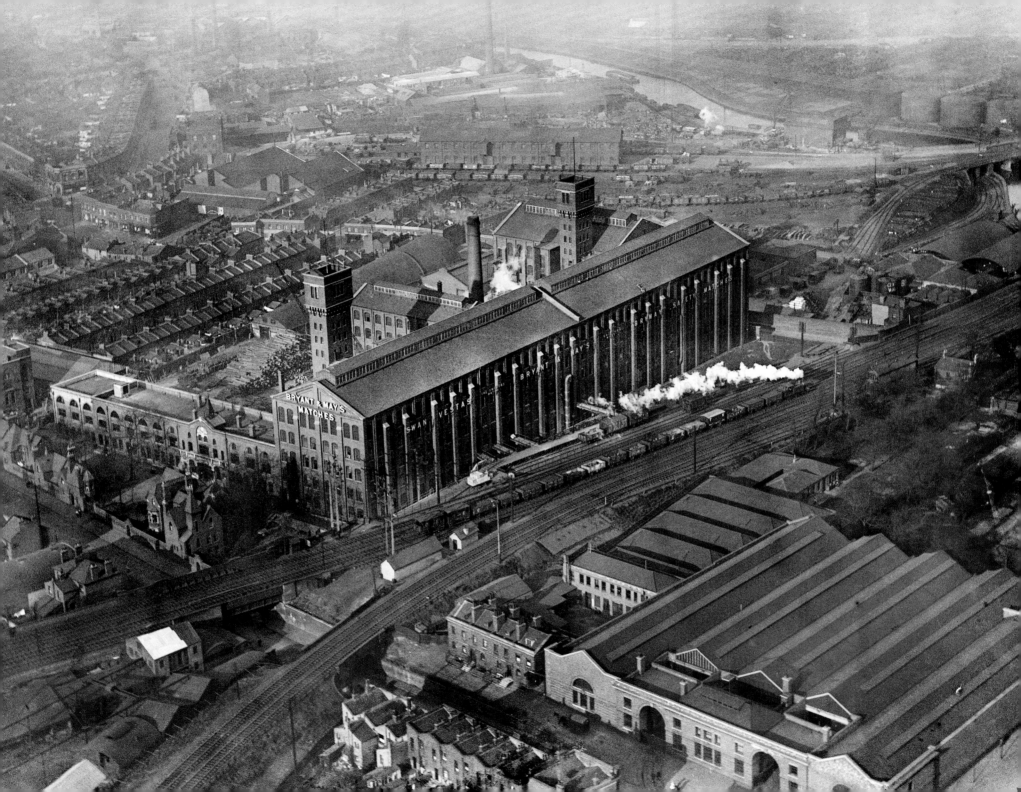

Fairfield Road tram depot, Bow

January 1921

The London County Council built an imposing tram depot in Fairfield Road, Bow. It was opened in 1908, with a second phase for tram car body maintenance, involving extensions on either side of the original depot, opening two years later. It was built on land once forming the grounds of the largest mansion in Bow, the late 17th-century Grove Hall which was demolished in 1909. The architect is likely to be E Vincent Harris, who commenced his architectural career with the LCC, and the design shows his adept handling of neoclassical forms for which he would later become famous. It was reconstructed for trolleybuses and reopened in November 1939, housing 100 vehicles. In turn, the trolleybuses were replaced by buses in August 1959. The building survives today, still in use as a bus garage, and is listed Grade II. The massive principal building of the Bryant & May factory dates from 1909–11. Like the tram depot, it still exists today but it has been converted into flats. Between the two buildings is the main line of the Great Eastern Railway, running into Liverpool Street, while the line diverging to the south at Bow Junction joins the line to Fenchurch Street. In the background is the Midland Railway's Bow goods yard with the River Lea flowing beyond it.

EPW005224

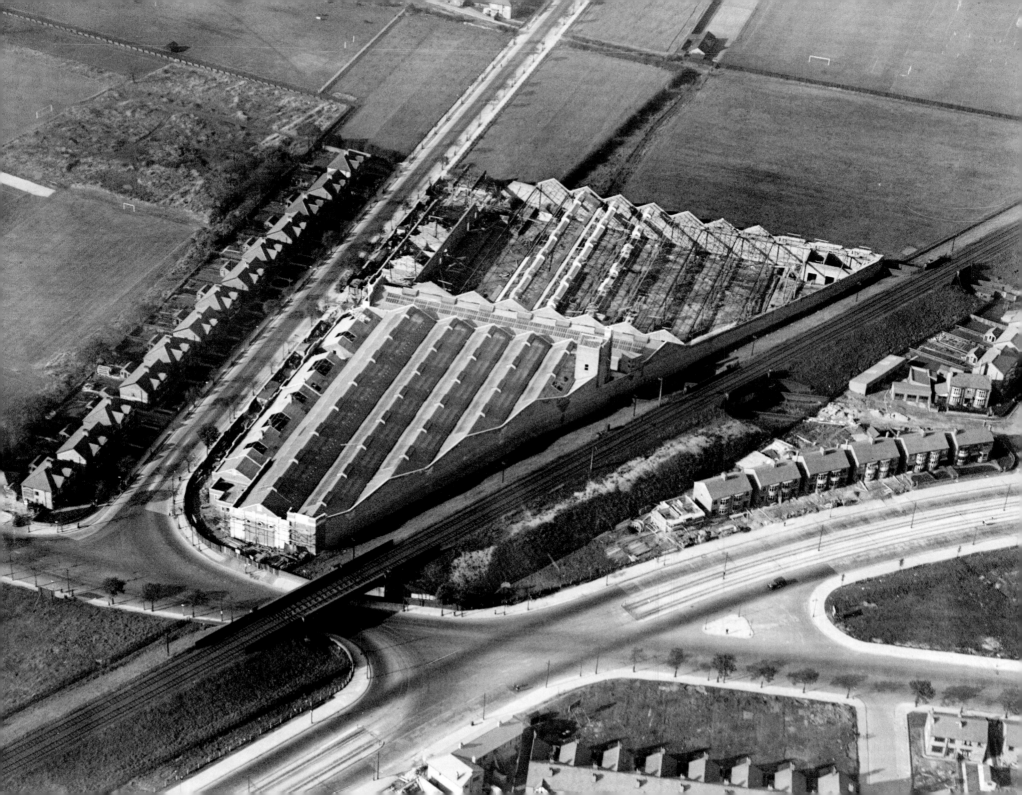

Birchfields Road tram depot, Manchester

8 October 1927

Tramway development continued in several northern cities throughout the inter-war years. This is the new Birchfields Road, Manchester, tram depot taking shape. The depot opened in July 1928 and housed a maximum of 230 tram cars. Much of the interior of the depot consisted of inspection pits, with the rails and flooring of the depot carried on iron pillars across the lower level of the pits. The interior may be glimpsed through the steel trusses of the roof of the far part of the building, which has not yet received its cladding. The trams exited in the centre of the building onto Birchfields Road. In the foreground can be seen tracks laid in the centre of Kingsway, one of the broad boulevards with trams running in a central reservation (see pp 202–3). The site of the depot is now Fallowfields Shopping Centre.

EPW019641

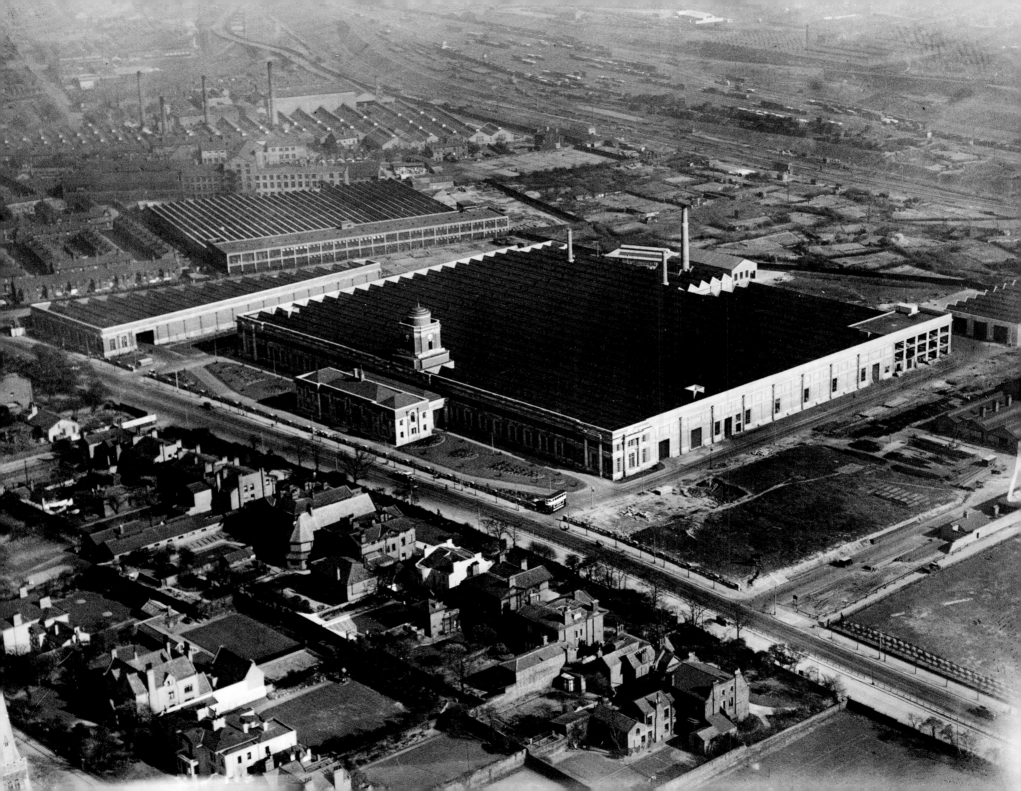

Edge Lane Works, Liverpool

18 April 1929

Perhaps the most impressive of all municipal facilities built to maintain and build trams was the Edge Lane Works of Liverpool Corporation. The works were evidently regarded as a great civic undertaking as the foundation stone was laid by the Lord Mayor of Liverpool on 17 May 1926. Formal opening by the Minister of Transport, Sir Wilfrid Ashley, took place on 17 October 1928. The works were built on the site of the Tournament Hall, which had plenty of space for further expansion. A separate office building was erected as a frontispiece to the main works building. It was a neoclassical design of brick, faced with Portland stone, as was the Edge Lane façade of the works building itself, while the remainder of the works were of reinforced concrete built around a steel roof structure. A real attempt was made to give the works some civic grandeur, with a clock tower and gardens adjoining Edge Lane. The wedge-shaped building on the left is the tram car shed and the small building to the right of the main works is the bus repair shop. The statistics for Edge Lane were impressive: the works building was about 600ft long on each façade; it contained some two miles of track within the building; employment there reached a peak of 1,091 in 1937 and about 463 trams were built within its walls. Yet the works were never fully exploited. They were built to service a fleet of 1,000 tram cars and this was never achieved.

EPW026153

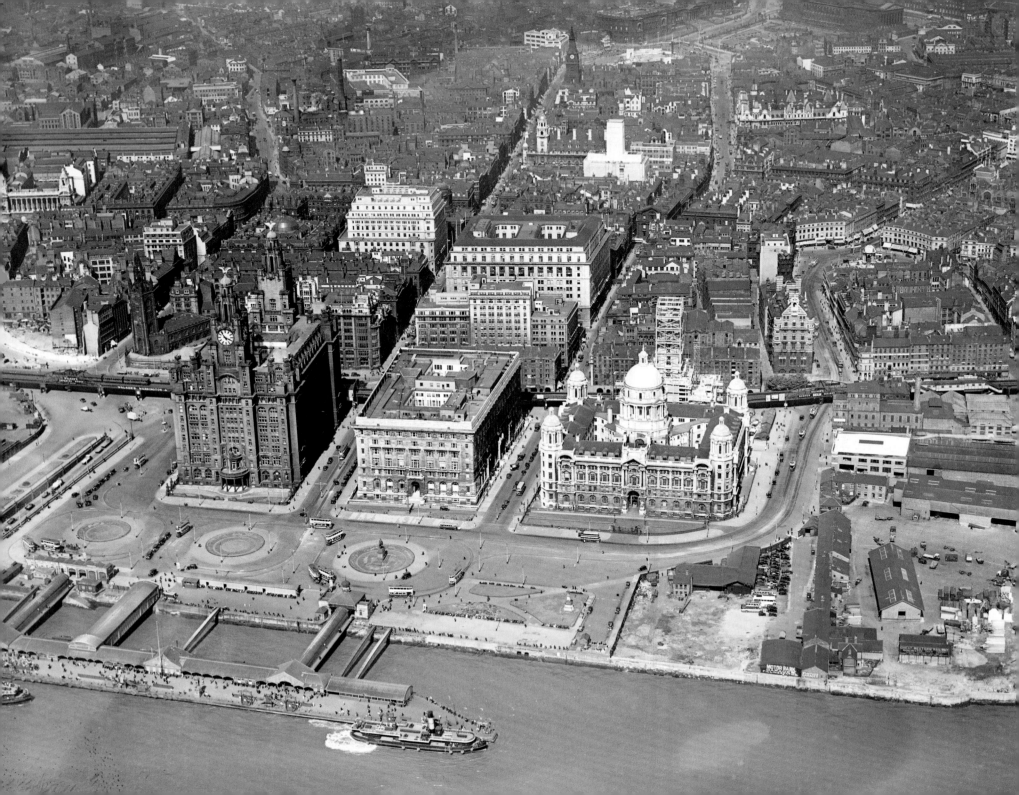

Pier Head, Liverpool

June 1934

Certain places became indelibly associated with public transport. This is Pier Head, the terminus for many of Liverpool's trams and, later, buses. Two of the circles of track for the trams to turn round were originally installed and a third added in 1921. Such terminal arrangements were rare, most trams simply reversing along the track on which they arrived. The arrangements made transfer to and from the Mersey ferries easy for those who used them to go to work each day. Behind them stand the 'Three Graces' and, nearing completion, the ventilation tower for the Mersey road tunnel, opened the following month. The line of the Liverpool Overhead Railway runs across the view, with its station visible on the right. A Leyland Titan, probably belonging to the Crosville company, is almost dead centre. To the right is a car park and garage where cars were closely parked by attendants, typical of the rather rudimentary premises found in many cities at this time. Further to the right is the Great Western Railway's Liverpool Goods Depot, and a couple of its distinctive chocolate-and-cream-painted delivery lorries are in the yard together with a number of horse-drawn drays – horses still outnumbered powered vehicles for railway work at this time.

EPW045194

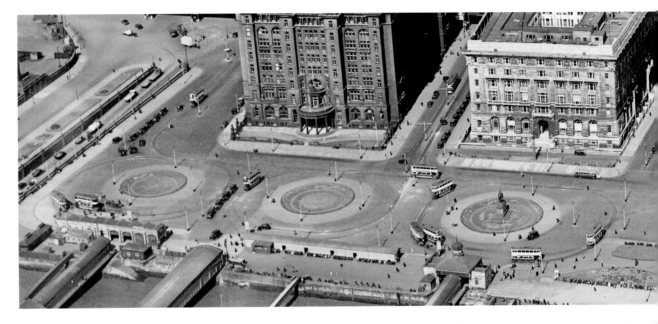

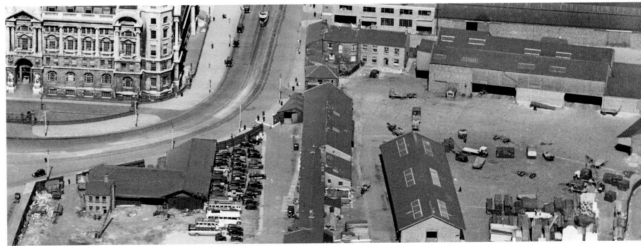

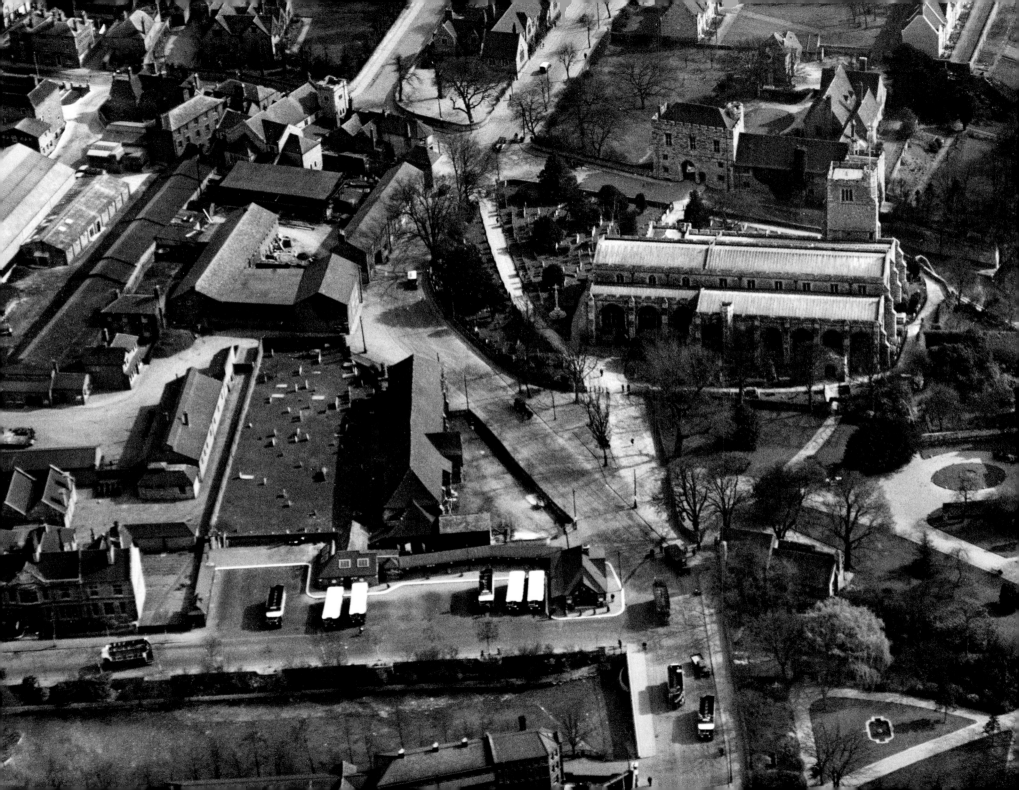

Maidstone & District Bus Station, Maidstone, Kent

18 April 1929

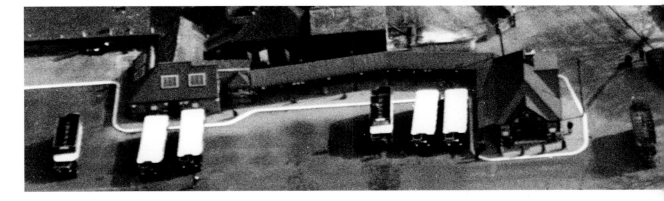

Not long after Blackpool claimed the first coach station in England in 1921, the country's first bus station opened in Maidstone in 1922, built for Maidstone & District Motor Services Ltd off Mill Street. Just to the south of the station were the late medieval stables of the Archbishop's Palace and the parish church. Accordingly, the offices were designed to harmonise by the use of half-timbering infilled with stucco and red-brick nogging and a tiled, gabled roof. Alongside the offices was a glazed verandah, providing shelter for waiting passengers. It, too, was supported on timber posts with rustic-looking curved wind braces and can be seen behind the light-painted roofs of the waiting buses. Maidstone was soon followed by other towns and cities. A bus station at Albert Street and Exchange Street, Derby, by the local architect T H Thorpe for the Trent Motor Traction Co, was opened a few weeks later. The Maidstone bus station was expanded in later years and closed in 1976, the buildings themselves mainly being demolished in the 1980s although the booking office was removed to the Kent & East Sussex Railway – initially to Rolvenden and then, in 1988, to Tenterden.

EPW026065

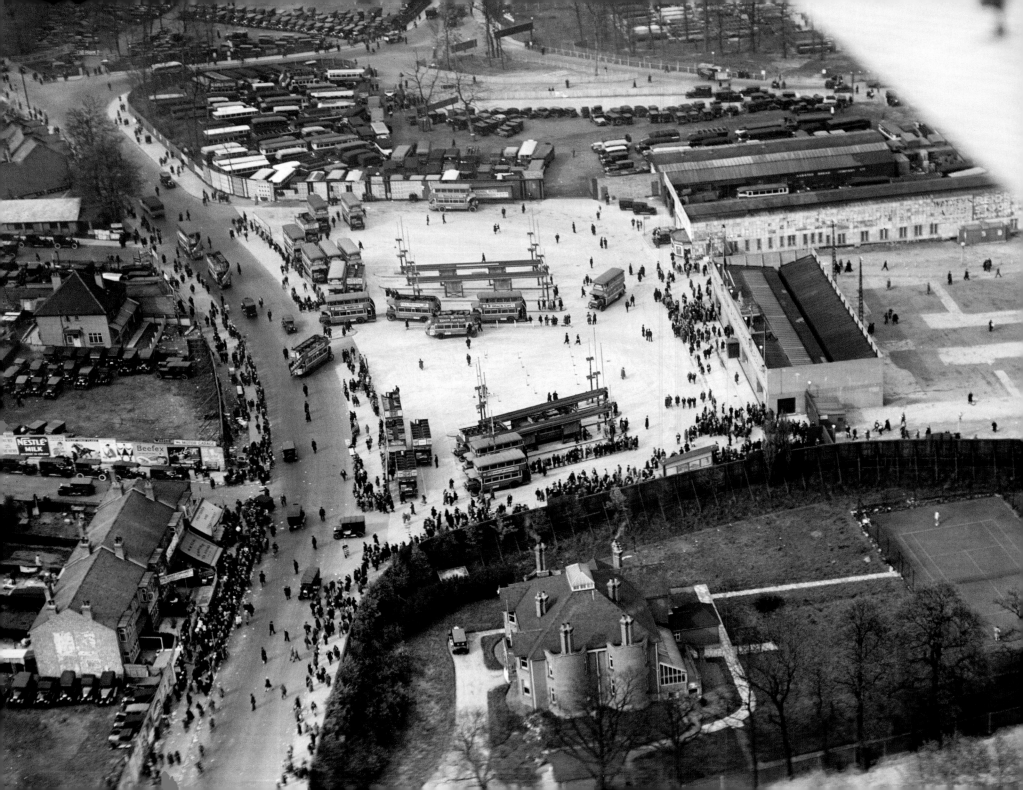

London General Omnibus Co bus station, Wembley

21 April 1928

The opening of the Wembley Empire Exhibition in 1924 brought about the need for facilities capable of handling 200,000 bus passengers per day. The London General Omnibus Co built a bus station occupying nearly two acres off Wembley Hill Road. It was described at the time as the first of its kind in the world. This was an exaggeration (see the Maidstone bus station, pp 38–9), but the Wembley station, designed by Charles Holden, was perhaps the first to feature rows of parallel platforms, a form that became widely used in Britain. Each platform had a roof over it, decorated with a jazzy zig-zag pattern, and masts were placed at each end of the platforms bearing details of services from them. After the exhibition closed the bus station was retained to serve Wembley Stadium and it is seen here, looking north with the stadium entrance to the right, on Cup Final day, with mainly London General Omnibus Co vehicles present. The majority of the buses are of the NS type, introduced in 1923, with both open-top and covered varieties present. Fourteen have covered tops: a high proportion considering that they only began to be fitted in 1926, following years of opposition from the Metropolitan Police on the grounds that they would make the vehicles unstable. The site today is occupied by the car park for an office block. On the left side of Wembley Hill Road numerous pieces of waste land and yards have been pressed into service as rather makeshift car parks, while the road lined with posters for Nestlé's Milk and Beefex has become a taxi rank.

EPW020870

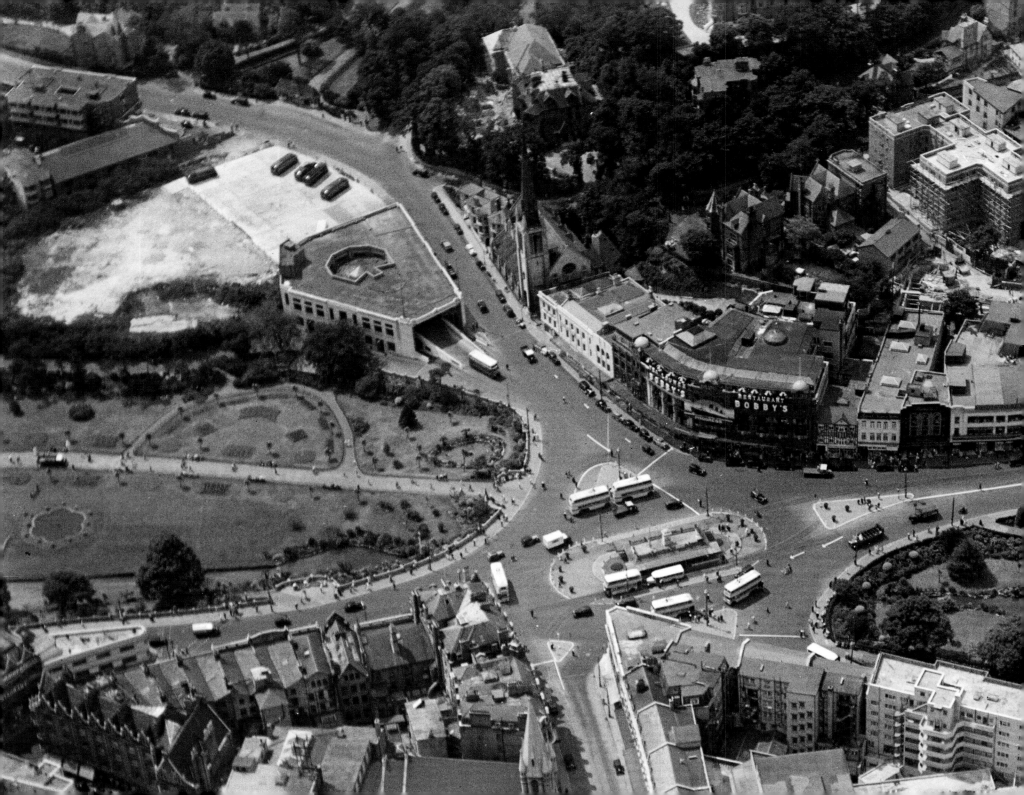

Bournemouth bus station

23 June 1936

One of the most elaborate bus stations to be constructed was that at Bournemouth for Hants & Dorset Motor Services and Elliott Brothers (Bournemouth) Ltd, who operated the once famous Royal Blue coaches. Opened on 8 March 1931, it adjoined the pleasure gardens by The Square and was designed by Jackson & Greenen, a local firm of architects. What was special about it was that it was built on two levels, with Hants & Dorset buses occupying the ground-floor level while the Royal Blue coach station was at basement level. Both entry and exit points for vehicles were contained within one façade, with a broad central two-way ramp for the buses that was flanked by ramps down to the basement for the coaches: one for incoming vehicles, one for outgoing. In the centre of the building was a domed waiting hall for Hants & Dorset passengers and below it a waiting room and booking office for Royal Blue. Built of steel and concrete, the bus station cost almost £100,000. It was rebuilt between 1957 and 1959 to the design of the Tilling Group architect A A Briggs, still retaining the two-level arrangement, but it was damaged beyond repair by fire in 1976 and demolished. In the centre of the photograph is the trolleybus stand in the Square with its shelter (still extant) paid for by Captain and Mrs Harry Norton in 1923, a rare instance of private funding for such facilities. Six-axle Bournemouth Corporation Sunbeam trolleybuses are visible nearby.

Afl 03_ r1697

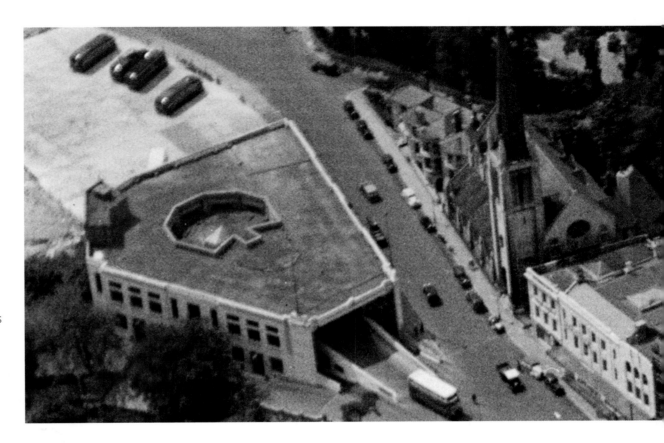

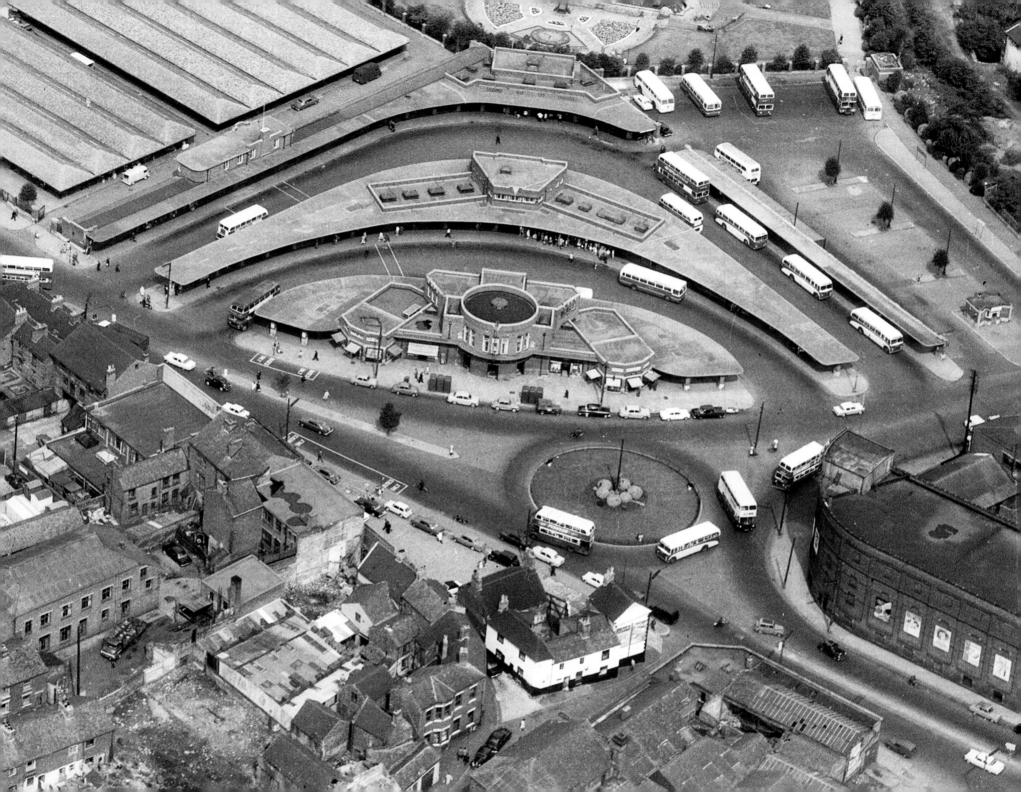

Derby bus station
10 August 1961

England's bus stations, on the whole, lacked architectural ambition. A notable exception was that at Derby, where a design by C H Aslin, the Borough architect, made use of sweeping curves and curved platforms for the buses. The bus station was opened in 1933 and formed part of a general scheme for improving the centre of Derby with broad new roads. It was built by Derby Corporation, not for its own buses but to accommodate those of other operators entering the city; the Corporation's buses only began to use it many years later. There were three sets of platforms, each with groups of buildings located on it. The first set included a circular enquiry office with a restaurant above; the central block provided facilities for the Trent Motor Traction Co, which was the principal user of the bus station, and the third, offices for the Council's supervisor of the station and a mess room. Incorporating a car park, bus park and filling station, it cost £31,000. It closed in 2005 and, despite attempts to save it, the bus station was demolished the following year and replaced by the Riverlights development, a multi-use facility incorporating a bus station.

Afl 03_a94450

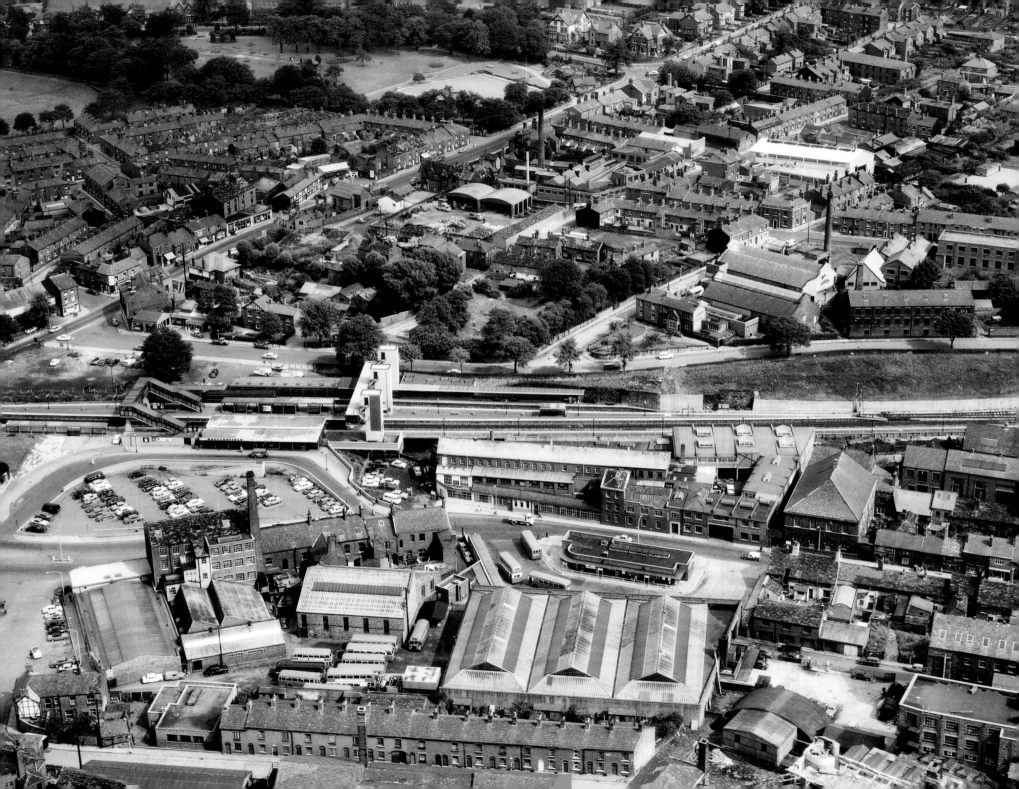

Macclesfield bus station, Cheshire

20 August 1963

The North Western Road Car Co built a new depot and bus station at Macclesfield in Sunderland Street to replace premises in King Edward Street just prior to the outbreak of war in September 1939. The garage is on a cramped site at the bottom of the photograph, with the brick-built modernist bus station immediately above it. This view sums up the piecemeal, small-scale nature of many such developments. The bus station was located here, where it was convenient for passengers transferring from rail to bus or vice versa – Macclesfield railway station, rebuilt in modular form in 1960, is just to its left – but was moved to a new location in 2004. Also worth noting is the small station car park and, on the other side of the station, the use of waste ground for parking – something once very common in towns and cities until vehicle security and personal safety became important concerns.

Afl 03_a119145

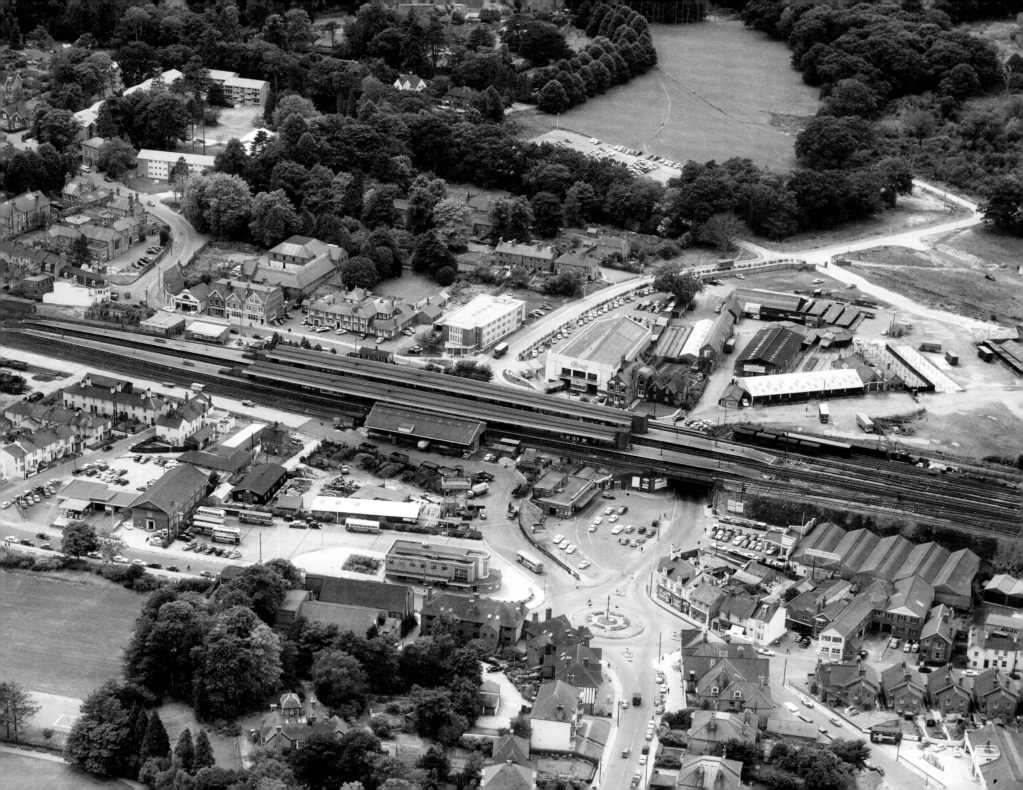

Southdown bus station, Haywards Heath, West Sussex

28 July 1961

Southdown Motor Services Ltd was responsible
for a number of impressive bus stations. This
one at Haywards Heath dates from 1952. In its
position adjacent to the booking office of the
railway station (rebuilt 1932), it is a reminder of a
time when the integration of road and rail traffic,
often vaunted, seemed closer to achievement
than it does in the deregulated competitive world
of today. The bus station was in appearance a
throwback to the 1930s, with an Odeonesque
north elevation greeting the prospective
passenger. It closed in the 1980s and has now
been let as offices. Garages, too, congregate
around the station. Besides that immediately
opposite the station building, there is the white
façade of Caffyns garage just under the railway
bridge. One of the firm's many excursions in
the moderne style, it was opened in 1936 and
is still a branch of Caffyns today though only the
façade remains, the workshops having been rebuilt
behind it.

AfI 03_a94356

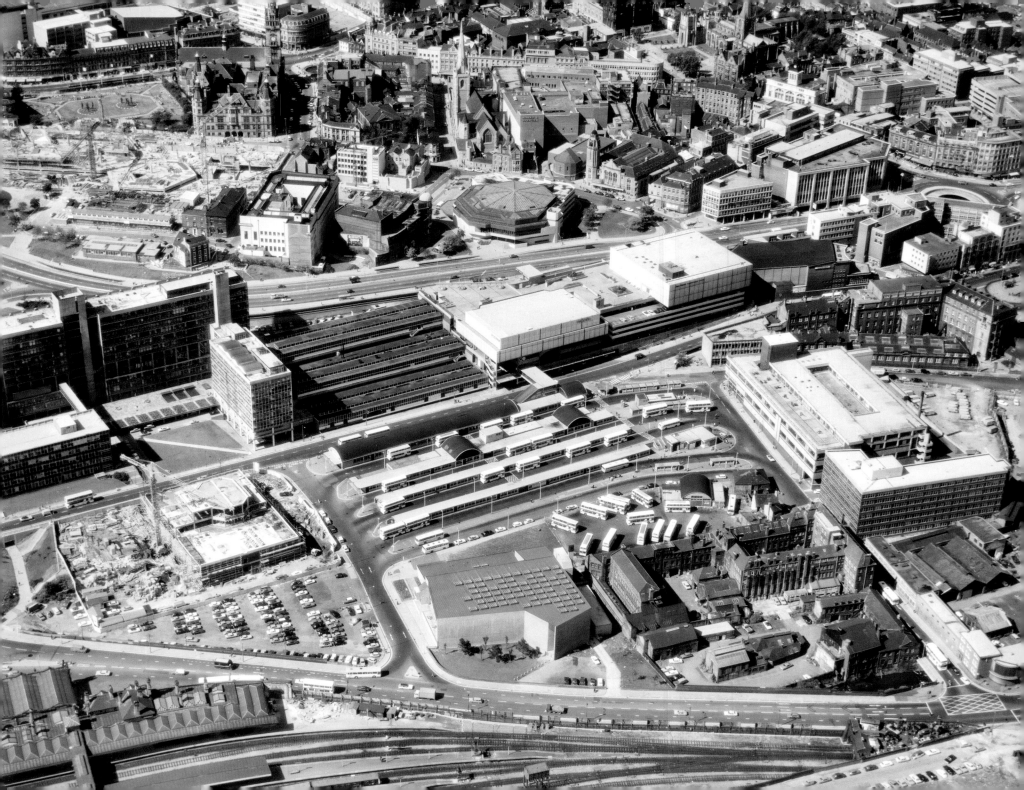

Pond Street bus station, Sheffield

August 1974

The Corporation built a bus station that was convenient for passengers using Sheffield Midland railway station. It was substantial, with four long island platforms and a café. Opened in the mid-1950s, it replaced stops on Pond Street itself, immediately to the north of the bus station. It was efficiently set out, with buses entering at the west end and leaving at the east and space for buses to park on the south side. In this view it is possible to see how the bus station was integrated into the late 1960s redevelopment of Sheffield city centre, which sought to separate traffic and pedestrians. An escalator led up from the bus station to a covered bridge over Pond Street, which in turn led to a pedestrian walkway at first-floor level of the Epic development of 1968–9. These walkways were very much part of Sheffield's planning at the time, inspired by the Buchanan report *Traffic in Towns* of 1963. The Epic development, which housed a dancehall and nightclub, was itself built above a multi-storey car park, and the pedestrian heading for the city centre had to negotiate further escalators, passages and subways to emerge beyond the dual-carriageway inner ring road by the City Library. The bus station was completely rebuilt in 1990, and while the Epic development remains, the convoluted route to town has long since disappeared.

AFl 03_284053

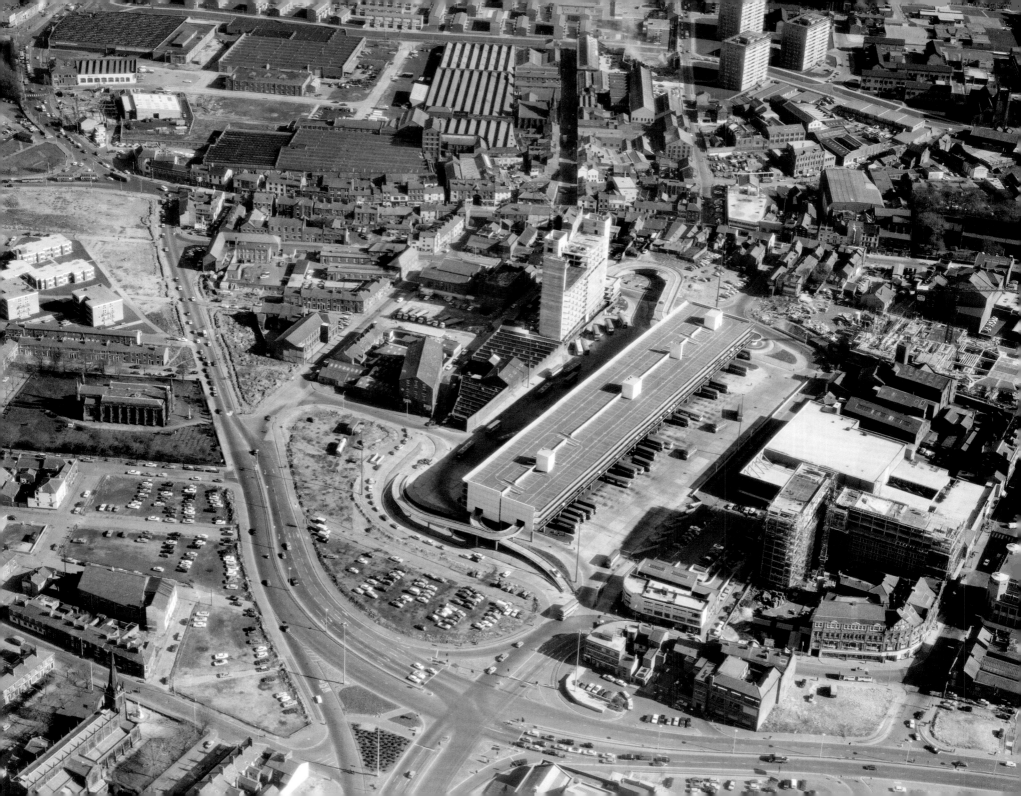

Preston bus station

16 April 1971

The Preston bus station is perhaps the most celebrated example of its kind in England. The work of the locally based Building Design Partnership (project architect: Keith Ingham), it was opened in 1969 and described in the Pevsner volume for North Lancashire as 'marvellously Brutal'. It is both bus station and car park. The buses occupy the ground level, and above are decks of car parking. It is usually seen from below, where the curved concrete edging of the decks provides powerful photographic images, but the way in which it fits into the city can be seen much more clearly from above. The sheer scale of the structure impresses, as do the sinuous curves of the ramps linking upper floors with the road network. After facing an uncertain future for many years, it was listed in 2013.

Afl 03_a211995

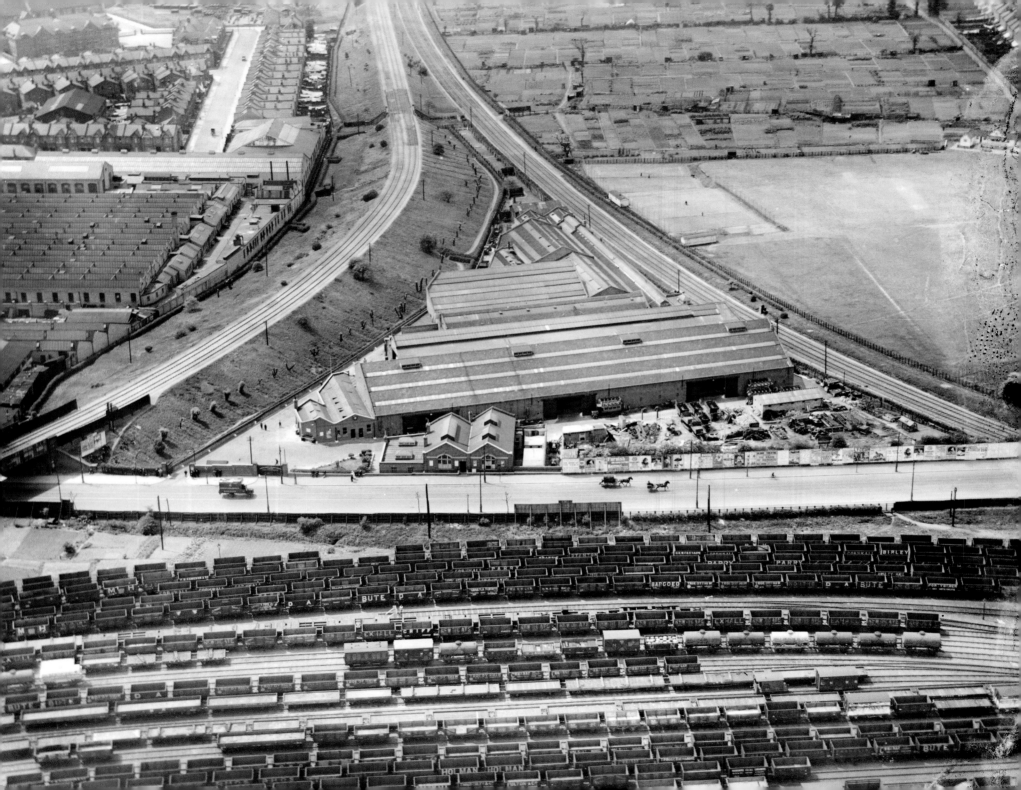

Cricklewood bus garage

April 1921

Cricklewood bus garage occupied a very compact triangular site bounded by the Cricklewood sidings of the Midland Railway and the lines to Dudding Hill and Acton, with the Edgware Road squeezed in between it and the railway. The depot was the first motor bus garage for the London General Omnibus Co, opening in May 1905, and became the company's largest garage, with 200 buses. It also served as the first central engineering depot for the LGOC motor buses until 1908. Hidden behind hoardings is a dump for surplus material, including the bodies of several buses. A complete vehicle stands alongside the garage, probably one of the celebrated B-type buses of the LGOC, introduced in 1910. This was the first standardised bus built for London in quantity: over 2,500 were built, many of which were conscripted to carry troops to the battlefields in France during the First World War. The garage is still in use today.

EPW006173

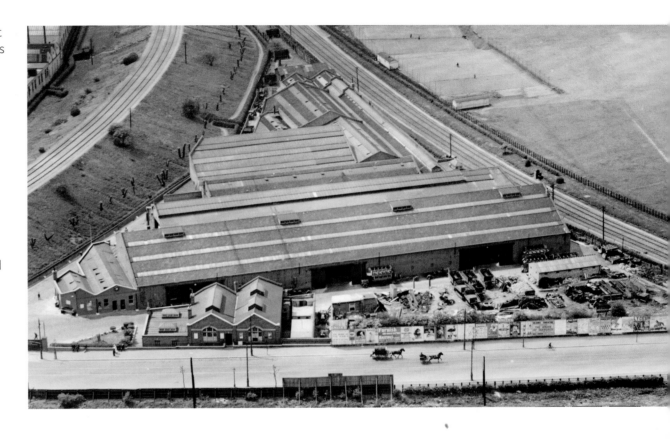

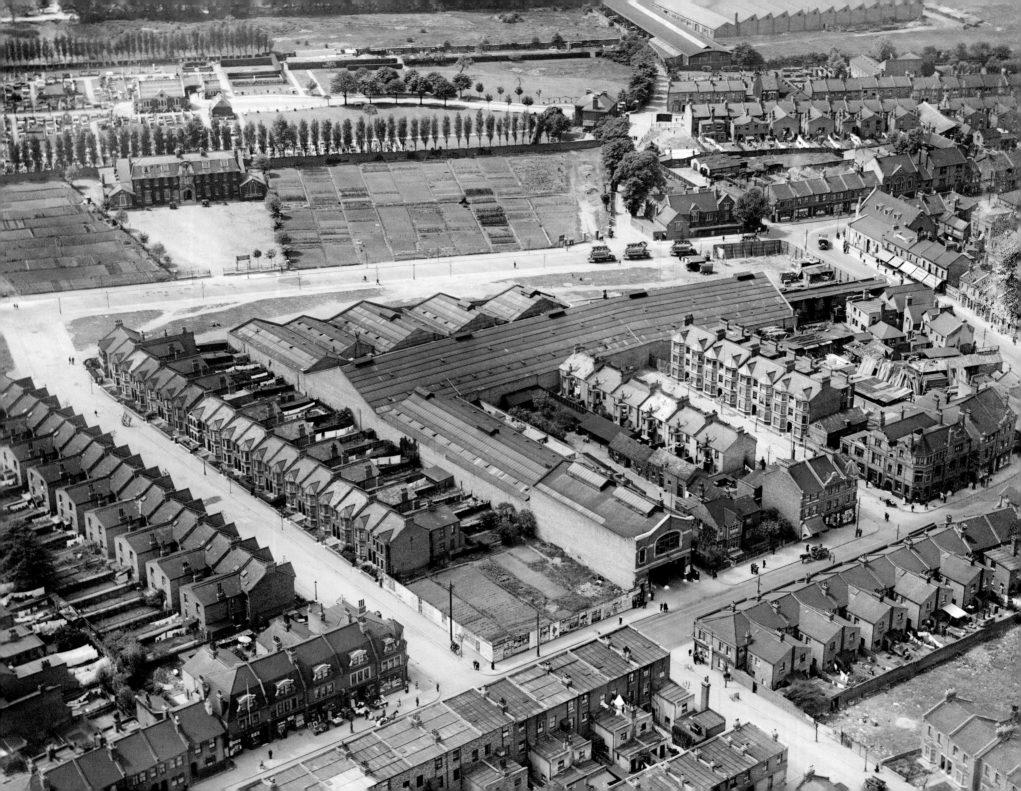

Willesden bus garage

May 1921

At Willesden the garage was tucked into an awkward site filling up the land between terraced housing, the exits being through narrow passages. It was opened in 1902 for horse buses and enlarged for motor buses in 1912. In the background can be seen three examples of B-type buses. Following modernisation in the late 1970s that resulted in change mainly to the rear of the building, it is still in use today – one of the oldest of London's bus garages.

EPW006174

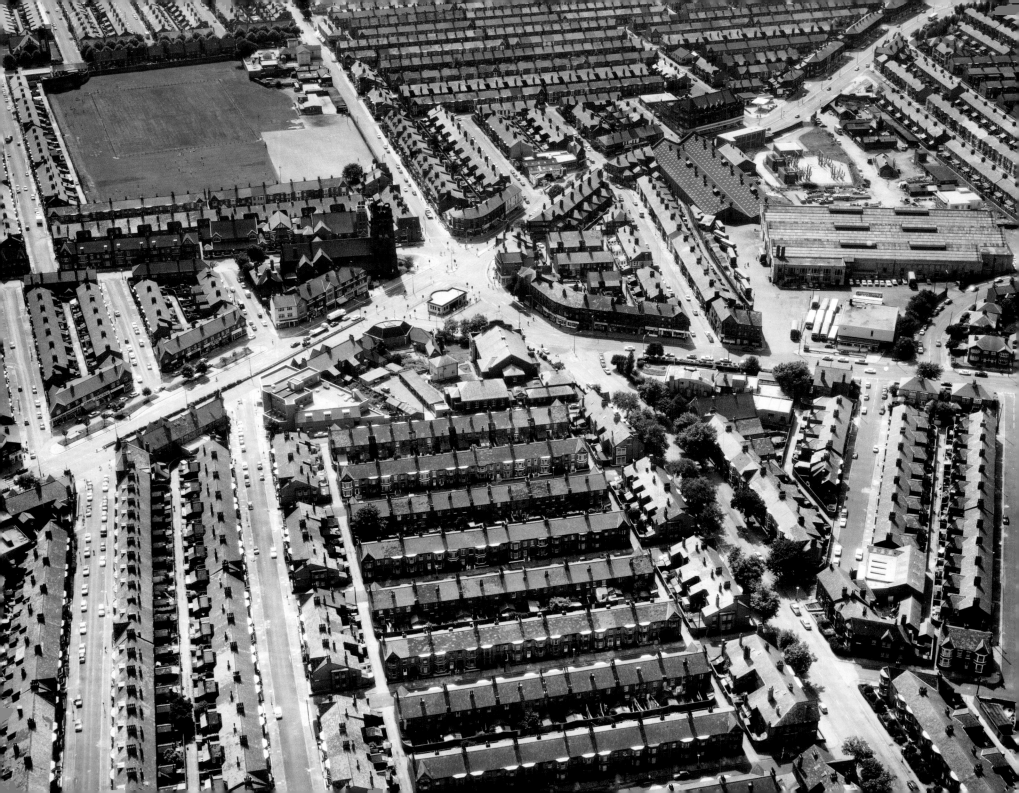

Penny Lane bus terminus, Liverpool

17 July 1972

Penny Lane, besides being the title of one of the Beatles' most famous songs, is a familiar destination for Liverpool buses. It is the suburban terminal, near Wavertree, of a number of routes. A substantial shelter stands at the point where several roads meet, among them Penny Lane itself, which heads south-west past Grove Mount playing fields. Before Penny Lane became a bus terminus it was used as a tram terminus, and the flat-roofed shelter dates from that period: probably when the terminus's layout was altered in 1931. On the right, just off Church Road, is Prince Alfred Road bus depot. The further part of it, with prominent roof ventilators, which faces onto Smithdown Road was built as a tram depot in 1899 and extended on the south side in 1902. It was designed by John Brodie, Liverpool's long-serving City Engineer. This depot, originally known as Smithdown Road depot, was closed to trams by 1930 and used as a bus garage, its place as a tram depot being taken by the large building to its right, opened in 1928. Both buildings have now been replaced by a retail park.

Afl 03_a234704

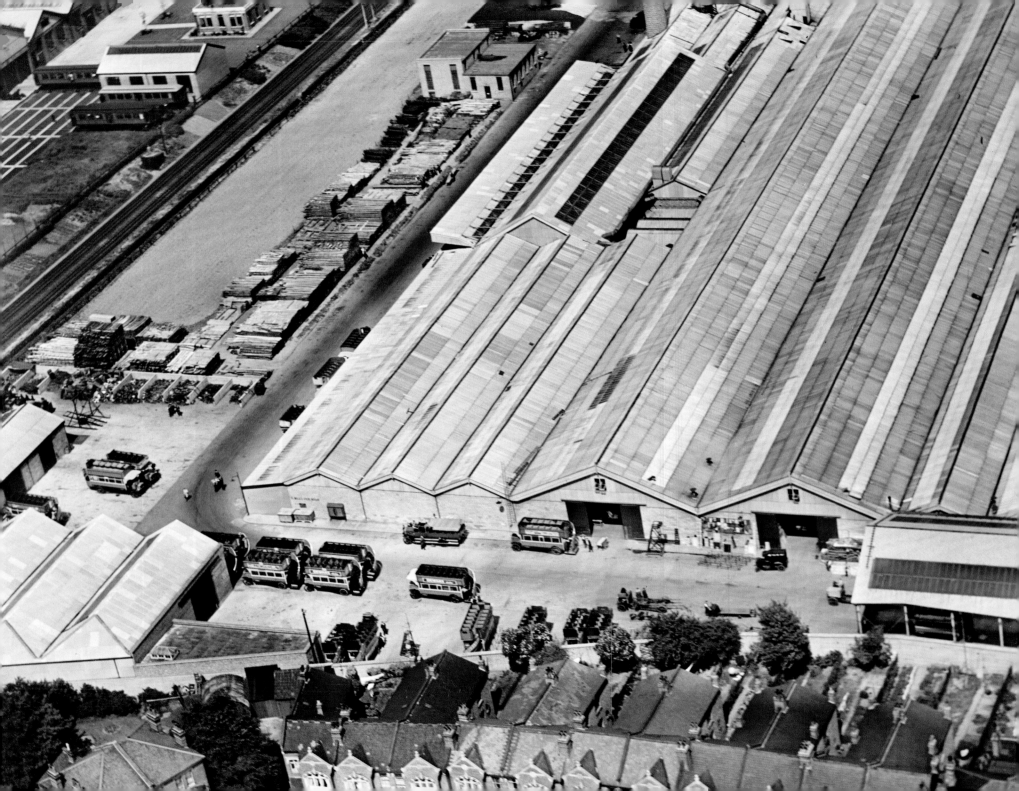

London General Omnibus Co Chiswick Works

21 June 1924

The London General Omnibus Company established a Central Overhaul Works at Chiswick, which opened in 1921. Repair, overhaul and the construction of buses (especially of bodywork) was undertaken there on a 32-acre site. This work had previously been undertaken at 30 depots, and centralising it reduced overhaul times from 16 days to 4 days. Besides the extensive ranges of single-storey sheds, there was a test track, a skid patch, a sports ground with a bowling green and a canteen capable of housing 1,000 staff at a single sitting. Visible in this view are K- and S-type LGOC buses and stores of timber for bodybuilding. After the Second World War, a new works was developed at Aldenham (see pp 62–3) and Chiswick took on more specialist roles of engine overhaul and bus development. The Routemaster was developed in the Experimental department housed at Chiswick. Aldenham itself closed in 1986, with more repair work being put out to the individual bus garages – a move that turned the wheel full circle – and Chiswick was closed in 1990. The site is now occupied by a supermarket.

EPW010681

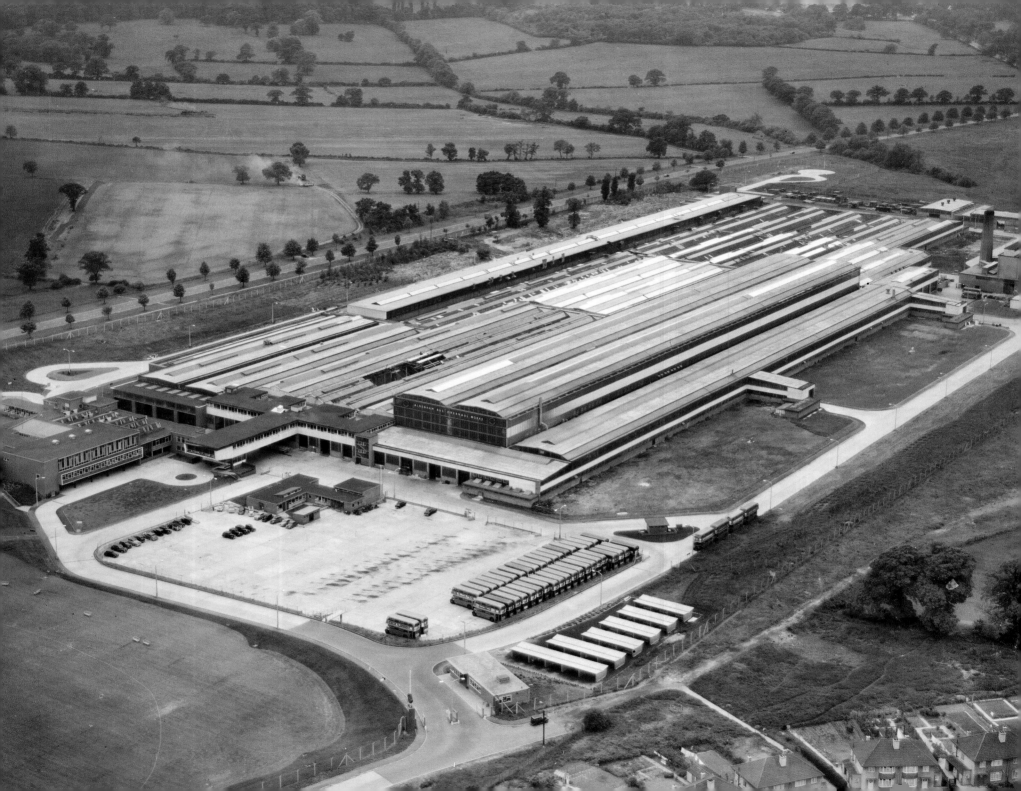

London Transport Aldenham Works, Hertfordshire
9 June 1958

On 30 October 1956, London Transport opened what was claimed to be the largest bus overhaul operation in the world, in a semi-rural setting at Aldenham, Hertfordshire. At its peak, some 50 buses were overhauled there each week. Its 53-acre site was acquired by LT before the war as the depot for the Northern line extension to Bushey Heath. The project was started but abandoned and the site was used for an aircraft factory. The factory buildings were converted and extended for use in bus overhaul. Only bodies and chassis were dealt with at Aldenham, engines and transmissions continuing to be handled at Chiswick (see pp 60–1). The overhaul of buses was treated as an industrial process and led to the extremely long service lives of London buses. Aldenham featured in the 1963 film *Summer Holiday*, starring Cliff Richard. The buses visible in the photograph of 9 June 1958 are all from the RT family, the standardised range of buses that were the precursors of the Routemaster and were the type of buses that Aldenham was specifically designed to handle. Although a staff of 1,800 was employed at the time of opening, the works were never at full capacity and complete overhauls ceased in the 1980s. The works finally closed in 1990 and were demolished in 1996, to be replaced by a business park.

Afl 03_a71296

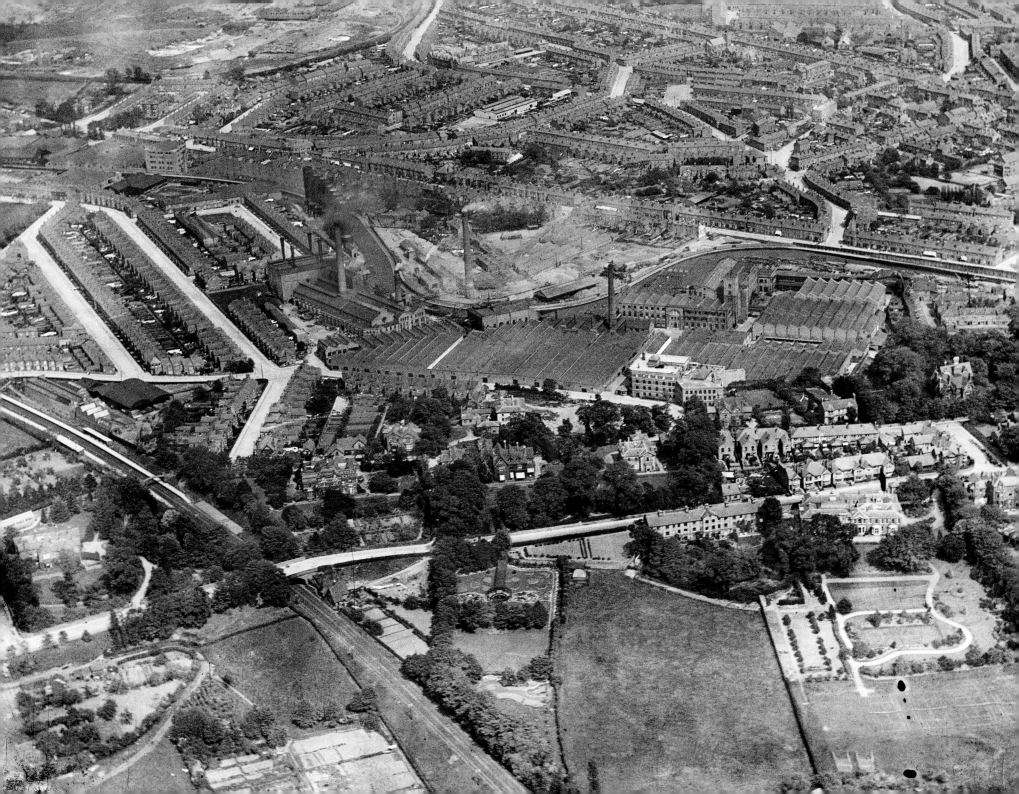

Daimler, the Motor Mills, Coventry
1920

The cradle of the British motor industry, the Daimler plant in Coventry was the first factory in England to manufacture motor vehicles on a commercial basis. In 1896, Daimler acquired a former cotton mill in Sandy Lane. It was a typical multi-storey mill and Daimler occupied the ground floor, the Horseless Carriage Co the second storey and the Beeston Tyre Co the third. Production began at the Motor Mills – as the factory was renamed – within months. After a few years the factory had considerably expanded, with a number of single-storey northlit sheds surrounding the mill which had itself been extended considerably to the east. The tall buildings to the west of the site are the Daimler Co's offices, built in 1907–8, with the extended original Motor Mills being the tall structure in the centre, just to the right of the chimney. To the east of this is the long sawmill building. Today, bombing and subsequent redevelopment have left only the office building and a power house on the left, adjacent to the Coventry Canal.

EPW001182

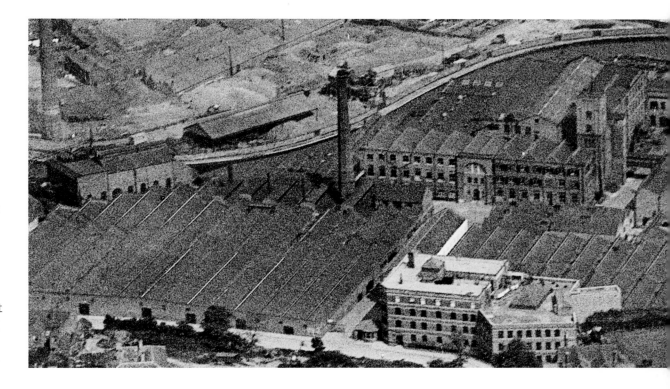

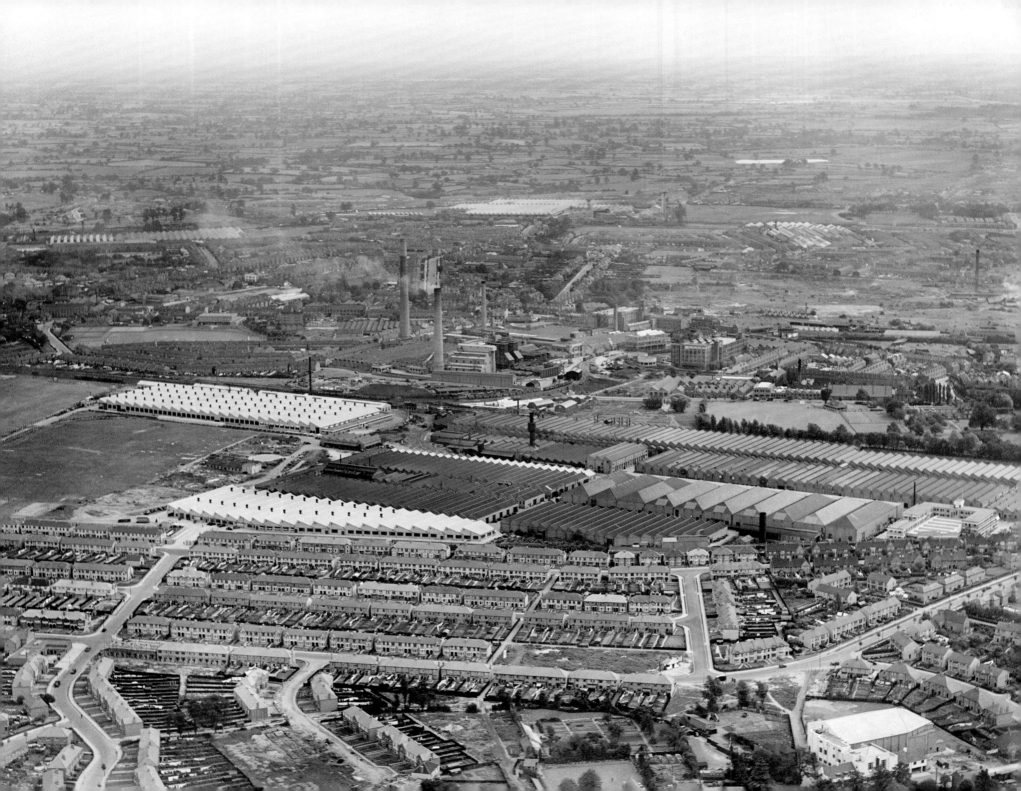

Daimler, Radford, Coventry

26 July 1938

Daimler opened a new factory in 1912 on a site at Radford slightly to the north of the Motor Mills. The premises were on a large scale and saw subsequent expansion following the First World War at the north end of the factory. Still further expansion took place in the 1930s when a shadow factory for the construction of aero engines was completed on the open land on the left. Following the takeover of Daimler by Jaguar in 1960, the site became an axle and engine plant for Jaguar before its closure in the 1990s. It has subsequently been completely demolished and replaced by housing, the only evidence of its existence being the name Daimler Road and the former company fire station, the detached building just visible on the extreme right of the factory site. The photograph, like that of the Standard works at Canley (pp 88–9), shows how, as the industry expanded after 1910, the car factories of Coventry were built on greenfield sites on the edge of the city and were quickly surrounded by new suburban housing. Again, the northlit shops so characteristic of car factories are prominently shown.

EPW058229

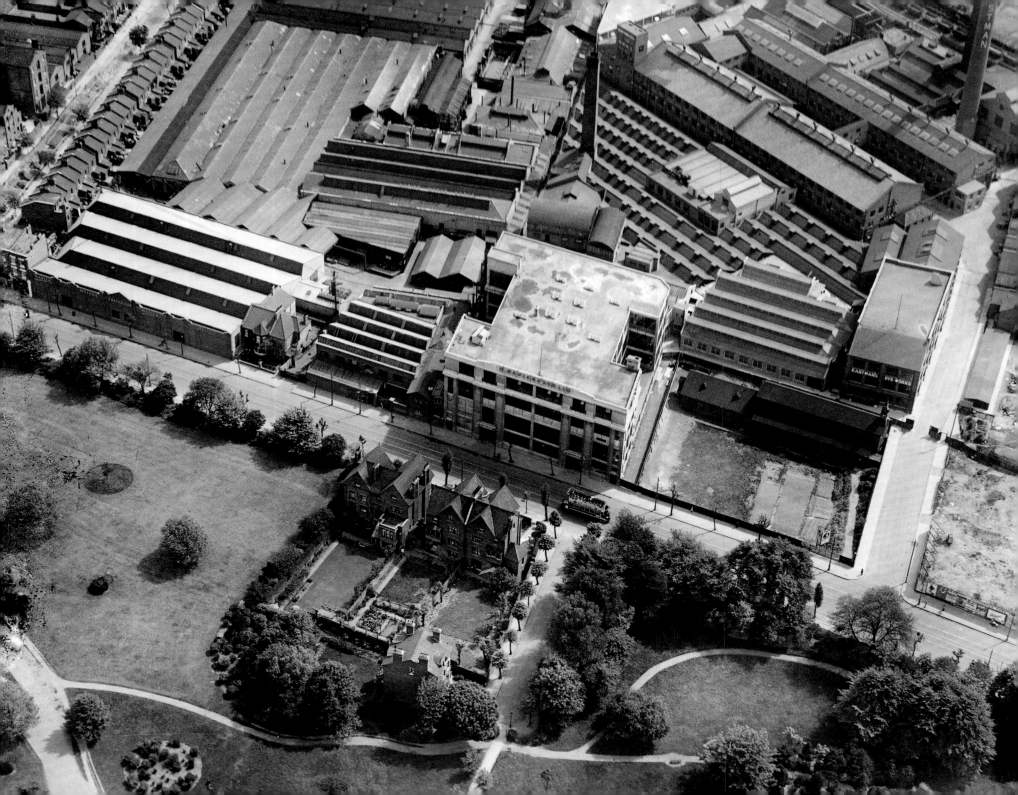

Napier, Acton, West London

April 1921

Napier was one of the most distinguished of the early British car manufacturers, and also one of the best-known, thanks to the efforts of its publicist S F Edge, who never missed an opportunity to promote the cars. The company was founded in 1808 in Soho and moved to Lambeth in the 1830s, where it commenced car production in 1900. It acquired four acres at Acton and moved its production there in 1903. Napier acquired a reputation in motor sport, but it was with its luxury cars that it achieved its greatest success. The works were considerably expanded over the next few years, and by 1907 the factory employed 1,200 people. Napier gave up motor vehicle manufacture in 1924, having become a major producer of aero engines in the First World War. The premises consisted mainly of the usual northlit sheds, but a large 'daylight' factory building was built on Uxbridge Road and this survives, reclad, as does one of the other frontage buildings. The remainder of the site has been redeveloped.

EPW006184

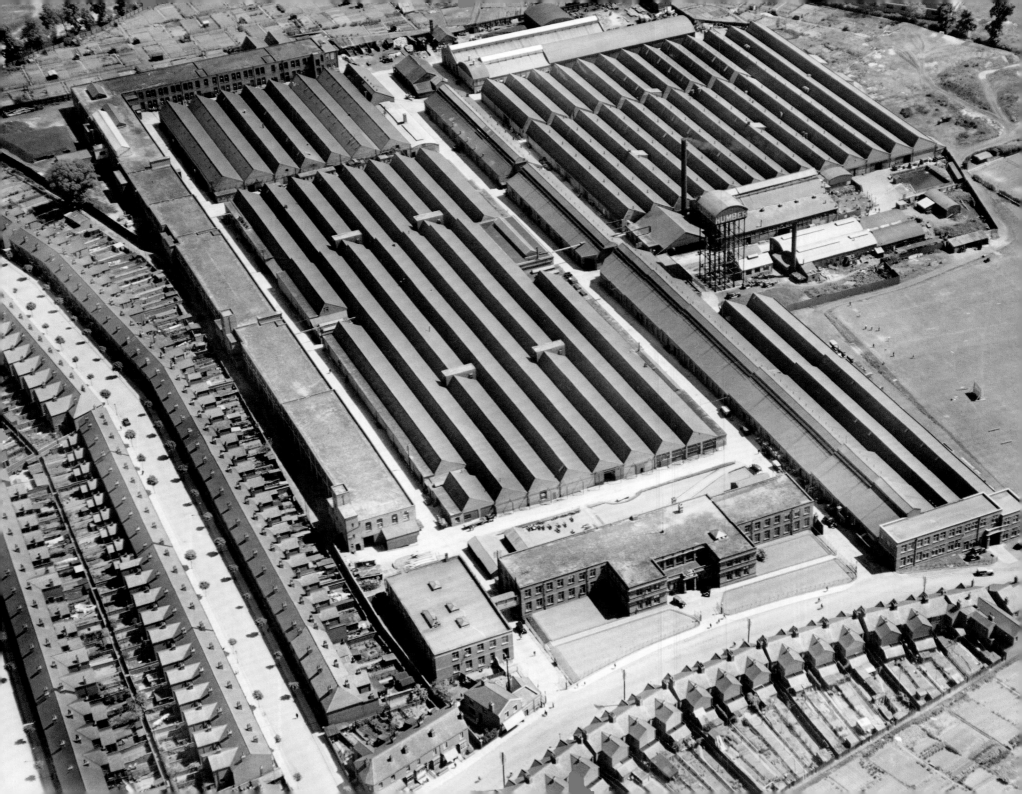

Humber, Stoke, Coventry

25 May 1929

One of the most imposing of the early motor factories was that of Humber, located on the edge of Coventry at Stoke. In 1908 the company consolidated its manufacturing facilities, which had been scattered in a number of factories and workshops in Coventry, into a single greenfield site. There, it built a factory laid out in the form of large single-storey northlit sheds – an arrangement that became the norm for car manufacture. Everything in this photograph dates from 1908, other than the ranges, fronted by an office building on the right between what became known as Humber Road and the prominent water tower bearing the company's name. The factory was designed by the architects Harrison & Hattrell. The company's offices, fronted by gardens, faced Humber Road and behind them is the massive machine shop. Beyond this to the right, behind the water tower, are the power station and the body shop. Humber took over its neighbour, Hillman (pp 104–5), in 1928 and the two works were integrated with much building in the land between the two factories. Car production at the Humber works ceased in 1976 but the plant remained an important components factory, latterly for the Peugeot group. The office buildings, some of the best to survive from the early days of the British motor industry, were demolished in the late 1980s and the remainder of the works went in 2009 as part of the redevelopment of the whole former Hillman-Humber site as offices and housing.

EPW027056

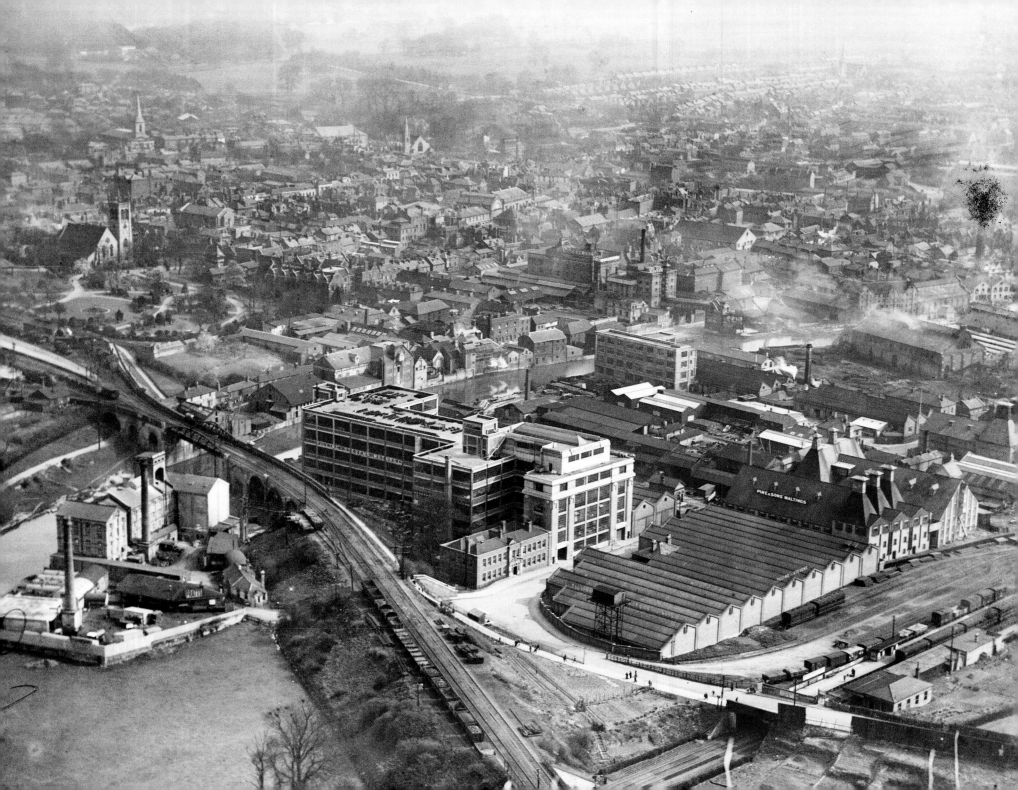

Tilling-Stevens, Maidstone, Kent
March 1921

An ultra-modern 'daylight' factory was built for Tilling-Stevens at Maidstone, Kent, in 1917 – an early work of Wallis, Gilbert & Partners. Located on the west bank of the River Medway, alongside the former London, Chatham & Dover Railway main line through Maidstone East, it was built of reinforced concrete using the Truscon Kahn trussed bar system, a construction method becoming increasingly popular for large factory buildings at the period. Its design was entirely rational, with no added decoration save on the façade to St Peter's Road. All production took place under one roof and there was a downward flow line, aided by large electric lifts, the vehicles being assembled and tested on the ground floor. The firm also occupied more conventional premises on the opposite side of the road adjacent to the yard of Maidstone Barracks station, which is to be seen in the foreground. Both banks of the Medway were heavily industrialised with the breweries of Fremlins (visible in the background)

and Style & Winch, together with numerous maltings, including that of Pine & Sons. Tilling-Stevens were renowned for their petrol-electric buses which used a petrol engine to power an electric generator driving a traction motor to the rear wheels. They were used extensively in London by Thomas Tilling (for which company they were originally built) and also by other bus companies in the south-east such as Southdown, Maidstone & District and East Kent. They led long lives, often extended by showmen who found their generators especially useful for powering fairground rides. The petrol-electrics fell out of favour by the 1930s and Tilling-Stevens built more conventional vehicles. In 1950 the firm was taken over by the Rootes group and the factory was employed making the TS3 two-stroke diesel engine. Final closure came in 1975. The building has recently been listed.

EPW005619

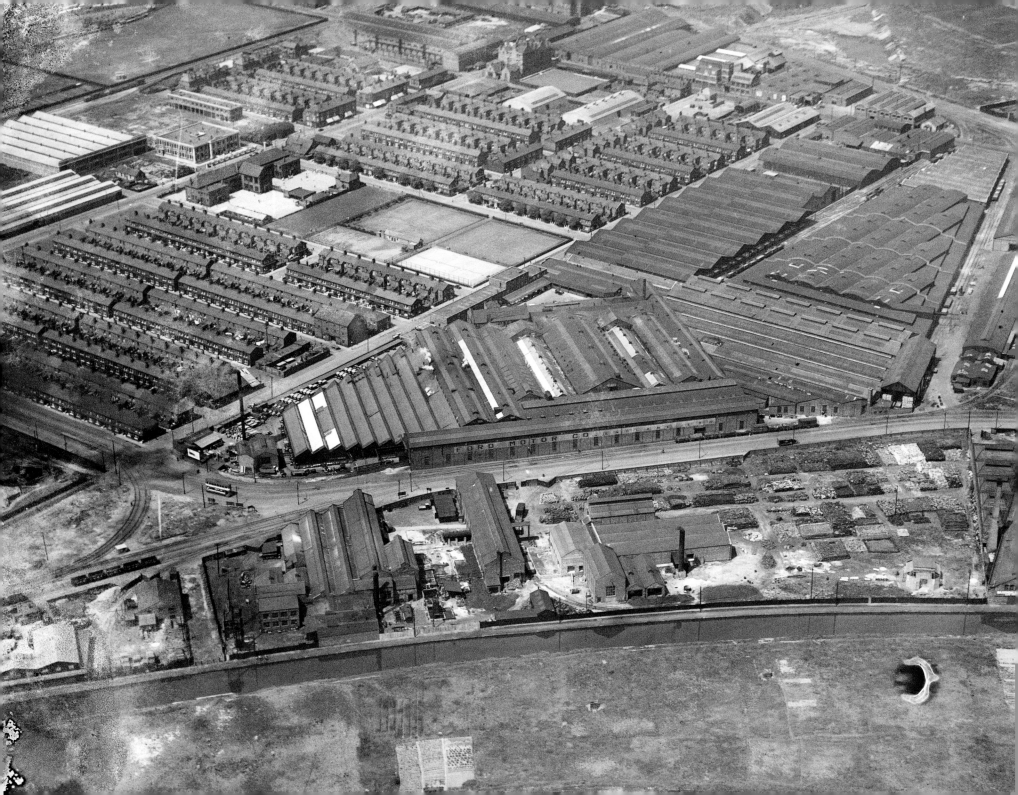

Ford, Trafford Park, Manchester

1 July 1926

Ford opened their British factory at Trafford Park, Manchester, in 1911. It was converted from the factory of the British Electric Car Co Ltd, which built tram cars here between 1902 and 1904. The factory is of great significance in the history of British motor manufacturing as it was here that Ford introduced powered production tracks. These were located in the building behind the Ford lettering on the façade. The works was extended considerably between 1915 and 1918 for war work, these additions being on the right-hand side of the photograph and including several bays with Belfast roofs. Ford moved their production to Dagenham in 1931 but the Trafford Park works remained unsold for a number of years. Only one part of the factory now remains, that immediately to the right of the building housing the production lines. All the houses and other buildings in the photograph have gone, too, to be replaced with modern industrial units.

EPW016097

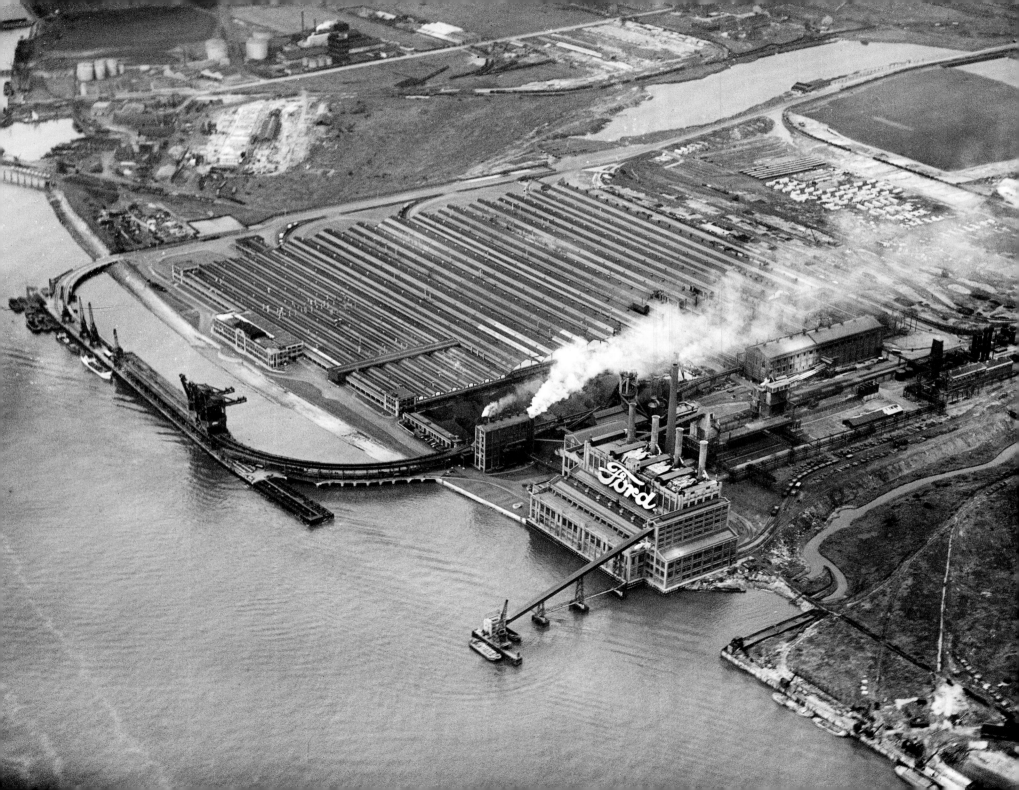

Ford, Dagenham, Essex

20 May 1939

The new Ford factory on the banks of the Thames at Dagenham was one of the largest and most spectacular industrial plants in the south of England. The land had been purchased in 1924; the first sod for the plant was cut by Edsel Ford on 16 May 1929 and it was opened in 1931. The nearest building in this photograph is the power station with the blast furnaces (which were first used in 1934) behind, then the assembly shed with the double-deck jetty for unloading raw materials from ships in front of it. The Ford logo on the power station was 140ft long and 60ft high and was added in 1936. Designed by Charles Heathcote & Sons, who carried out much other work for Ford including their Regent Street showrooms, their Hammersmith service depot and additions to their Trafford Park factory. Dagenham was the largest car factory in Europe at the time of opening. By the 1950s the plant had greatly expanded, occupying at its height 473 acres. By this time, the assembly plant seen here had become the engine plant. Major changes at Dagenham began in the last 30 years, starting with the closure of the foundry in 1984 and culminating with the ending of car production in 2002. However, the Dagenham factory, albeit operating on a much reduced scale, is now Ford's principal diesel engine plant.

EPW060996

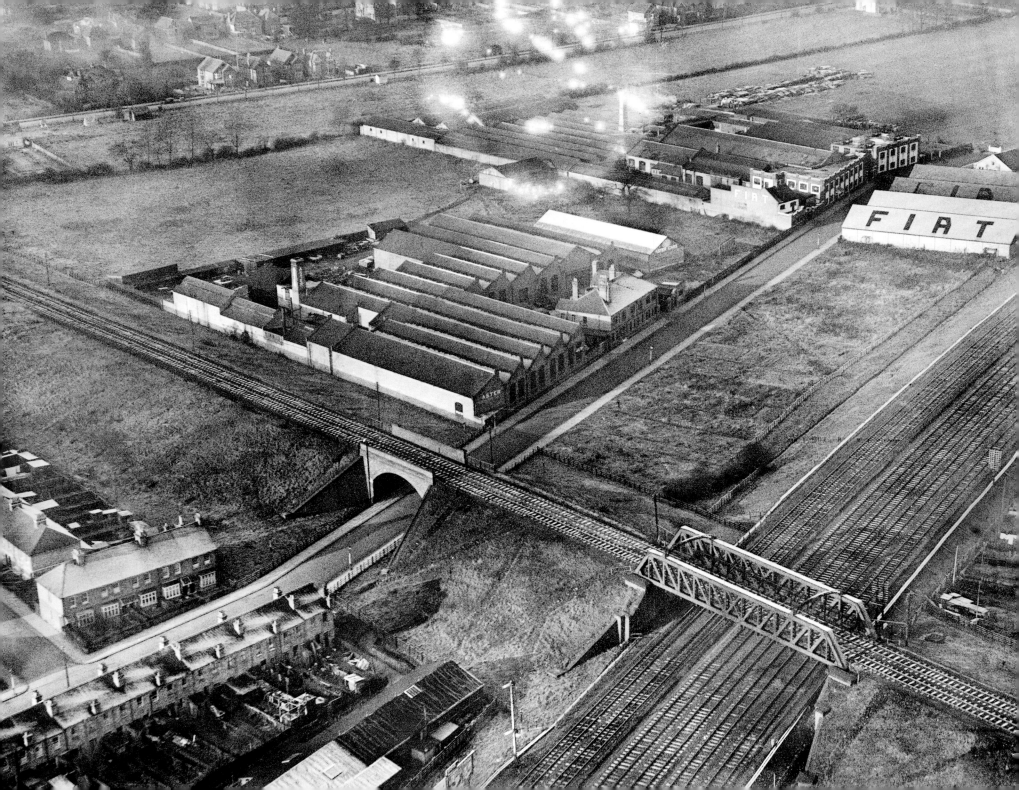

Aster factory and Fiat works, Wembley

6 December 1927

One of many companies that produced cars briefly in the 1920s was Aster. Their factory in Wembley was typical of many built at this period in north-west London along main line railways in what was largely open country. In 1899 Begbie Engineering became the British licensees of the French Aster company. The factory in this view was opened in 1907; the company changed its name to Aster Engineering Co (1913) Ltd and produced stationary engines and cars built to the designs of the French Aster company. In 1922 it made its first British-designed car. The cars were of very high quality but, with small-scale production runs, the company was unable to compete with larger manufacturers and merged with the Scottish Arrol-Johnston company in 1927. The cars produced by the combined company were known as Arrol-Asters and production was moved to the Dumfries Arrol-Johnston factory, the Aster premises being retained as a service depot. Although Arrol-Aster produced a fine range of cars, commercial success eluded them. A receiver was appointed in 1929 and the last car was produced in 1931 from existing parts. The factory later became a London depot for Singer of Coventry. To the north-west can be seen the Fiat repair works, opened in 1907–8. Designed by Stafford Charles, it was largely green and white in colour and much was made at the time of its fireproof brick walls and hollow-tiled roof. All the Italian-made vehicles were tested there before sale: the works manager lived in a house on site. Fiat later moved to a large site on Western Avenue, Acton. Both works have subsequently been demolished.

EPW020190

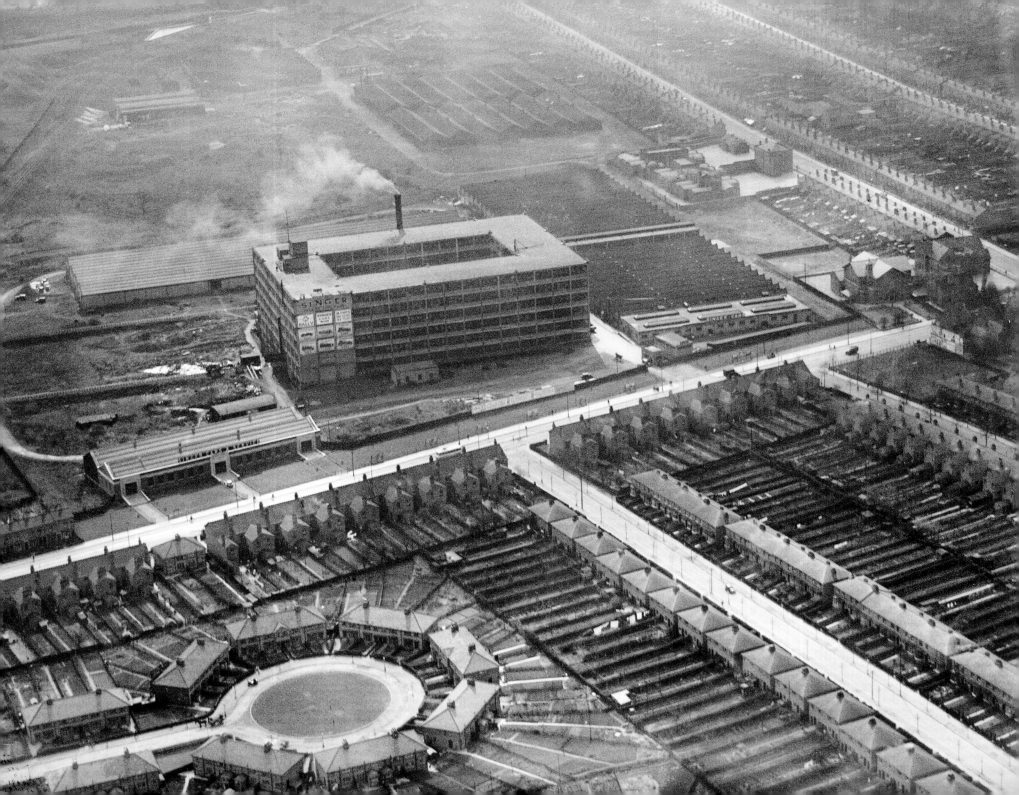

Singer, Small Heath, Birmingham

April 1934

Singer acquired a daylight factory, built for BSA in 1920, when they needed additional production space for their new small car, the Singer Junior, in 1927. The factory, in Coventry Road, Small Heath, Birmingham, was concrete framed and a notable example of rationalist design. When this photograph was taken, part of the blank wall of the façade was being used to advertise the latest Singer models and their rally successes. The factory was used for final assembly of the cars, while engines and gearboxes together with chassis frames and bodywork parts were still being produced at the firm's works in Coventry. A vertical assembly line was established, with assembly starting on the top floor and moving down the building; 16-ton lifts were employed to transport the components. Bodies were united with chassis in a large single-storey building, adjoining the main six-storey factory, on the right of the photograph. The building survived in the ownership of Peugeot into the 1980s before being demolished. The site is now occupied by a supermarket.

EPW044053

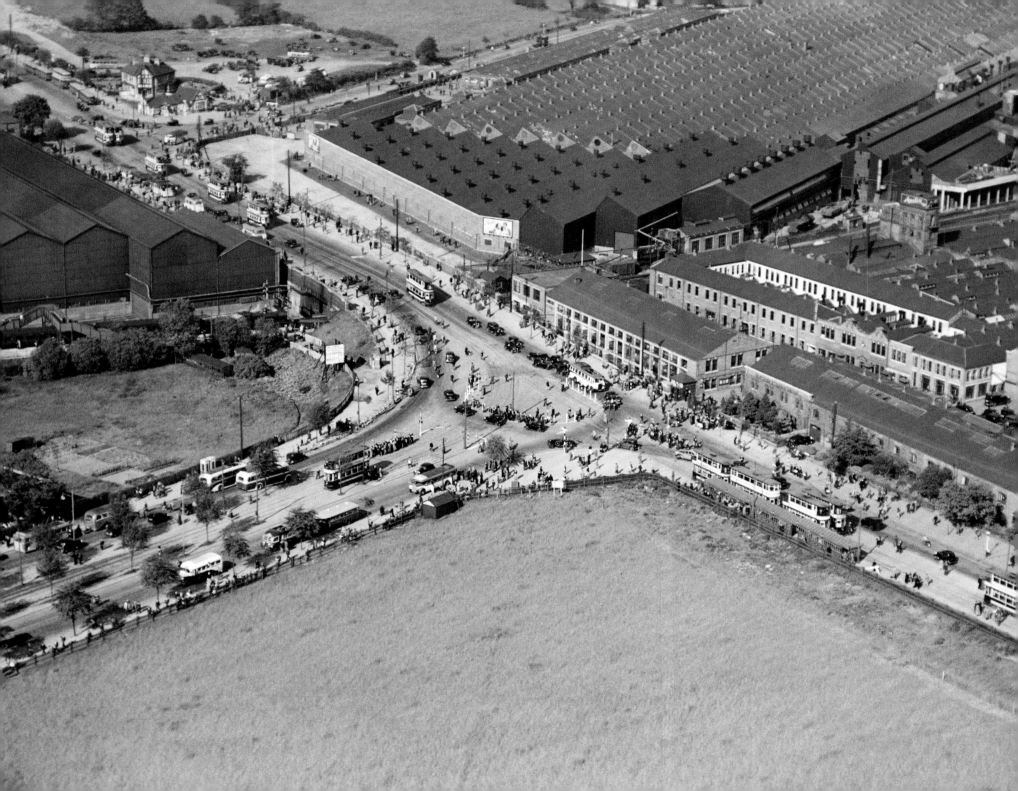

Austin, Longbridge, Birmingham
14 June 1938

A shift change at 'The Austin' gives an idea of the public transport requirements for a factory of this size, located on the edge of a city with relatively few workers living locally and as yet few having cars themselves. A line of trams wait on the Lickey Road, a large number of coaches wait to transport workers to a variety of destinations not easily reached by conventional public transport and Longbridge railway station sees considerable traffic. The part of the works to the south of the railway was known as the South Works and incorporated the original Austin factory, which had been built in 1894 for White & Pike Ltd, tin printers and box manufacturers. This is the single-storey part just to the west of the water tower. Austin acquired the premises in 1906 and soon expanded the works, with all the visible buildings of the South Works dating from before 1914. The North Works beyond the railway and the West Works on the opposite side of Bristol Road (on the left of the photograph) were built in 1916, on Government initiative and cost, for armaments and aircraft engine production. At the time of the photograph, the South Works was the location for the production lines where bodies were mounted on chassis, the West Works was the body shop and the North Works was used for engine production. Following the demise of Rover in 2005, the part of the site occupied by the buildings in the photograph was completely cleared for redevelopment.

Afl 03_ r4232

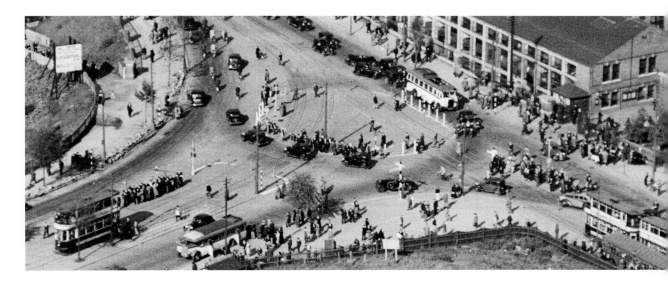

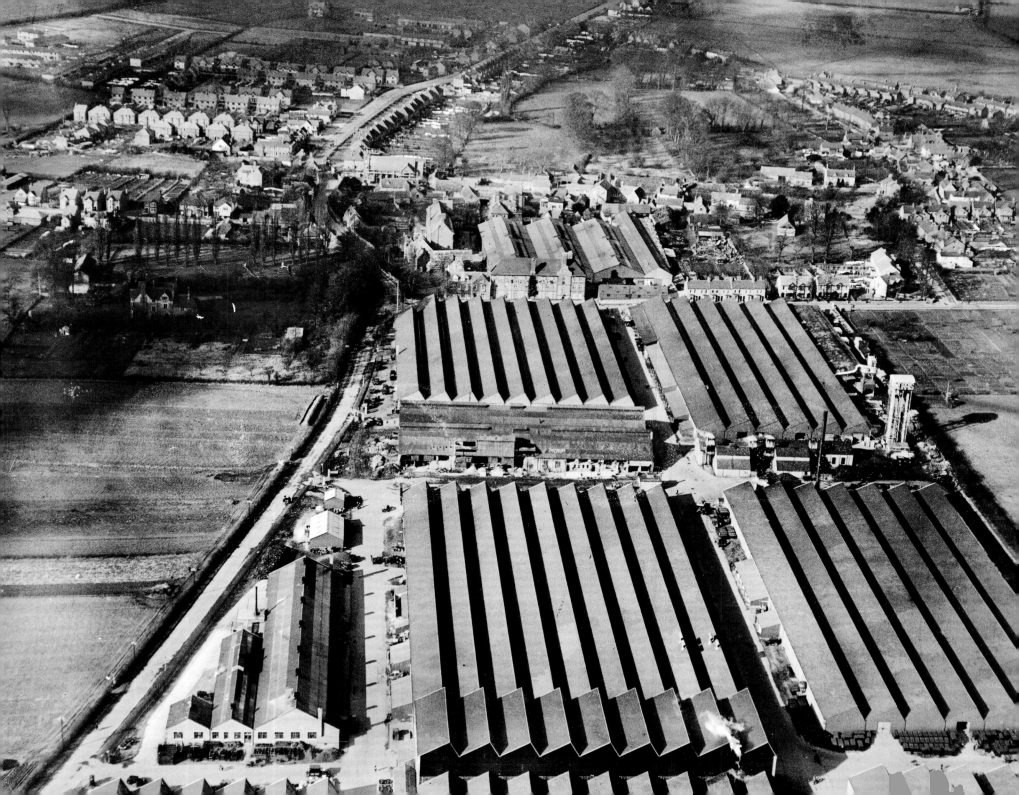

Morris, Cowley, Oxfordshire

February 1930

William Morris began car production in 1914 in the three-storey building bearing the inscription 'Morris Oxford Cars'. The site had an unusual history, with the adjacent stone building on the corner of Hollow Way and Garsington Road erected in 1852 for the Oxford Diocesan College and later incorporated into the Oxford Military College, established here in 1876. This was intended to occupy four sides of a quadrangle, and the noted architect, T G Jackson, who carried out some of his finest work for Oxford University, prepared plans. Only part of the west wing and the southern dormitory wing were constructed, and it was the latter that was used for car assembly. Parts came in and machining took place on the ground floor, assembly took place on the first floor and bodies were fitted on the second floor. Morris used the stone corner building as his office until he retired in the1950s. The first expansion prior to the First World War was to build steel-framed workshops on the quadrangle site. These were demolished in the 1990s and replaced by housing. The Morris factory expanded rapidly following the end of the war, and ranges of northlit sheds were built on the site of allotments east of Hollow Way between 1921 and 1926 – shown here in the lower part of the photograph – when the North Works, as it became known, was

largely complete. Car production moved to these new blocks and the original works buildings were occupied by the Nuffield Press, the Morris in-house printing business. Only the military college buildings survive today, with everything east of Hollow Way demolished, and the area now forms part of the Oxford Business Park. Production of the BMW Mini takes place at the former Pressed Steel works, some distance away.

EPW031331

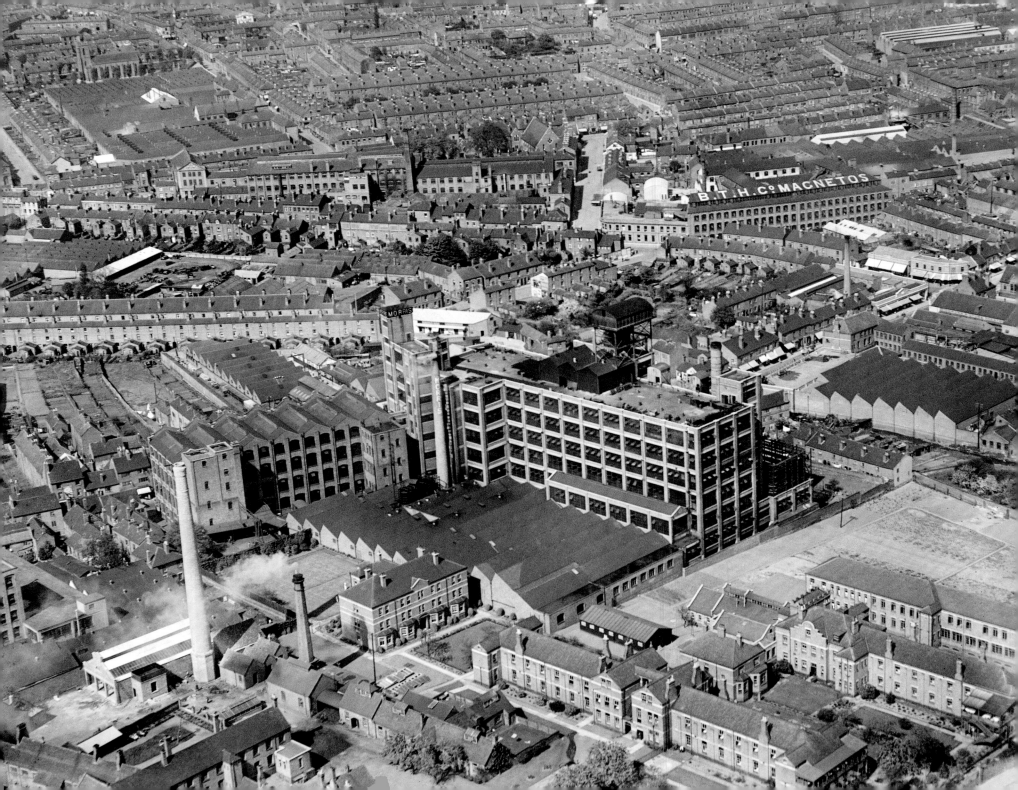

Morris engine plant, Coventry

8 May 1928

Although Morris is indelibly associated with Oxford, the firm had extensive premises in Coventry as well. The engines for its cars were initially bought in from the White & Poppe company, but during the First World War the French armaments company Hotchkiss established a factory in Coventry. It started to supply Morris with engines in 1919. Morris bought the British Hotchkiss subsidiary in 1923, and from this point on built its own engines. The four-storey block of the engine plant facing Gosford Street survives today as part of Coventry University, albeit much altered, but the six-storey 'daylight' factory addition to its right, put up by Morris from 1923 onwards, and the single-storey northlit factory buildings have been demolished. Beyond it is more evidence of Coventry's motor industry: the XL works of Calcott Bros Ltd in far Gosford Street, with its range of northlit sheds where the Calcott light car was built from 1913 to 1926. The works, which had been built as a bicycle factory in 1896, were taken over by Singer in 1926 and the elaborate office building that provided the road frontage still exists, although most of the remainder of the factory was demolished in 2008. A reminder of the many component factories that once thrived in Coventry are the BTH Magneto premises above Calcott, while the principal Singer factory on Canterbury Street is visible at top left.

EPW021002

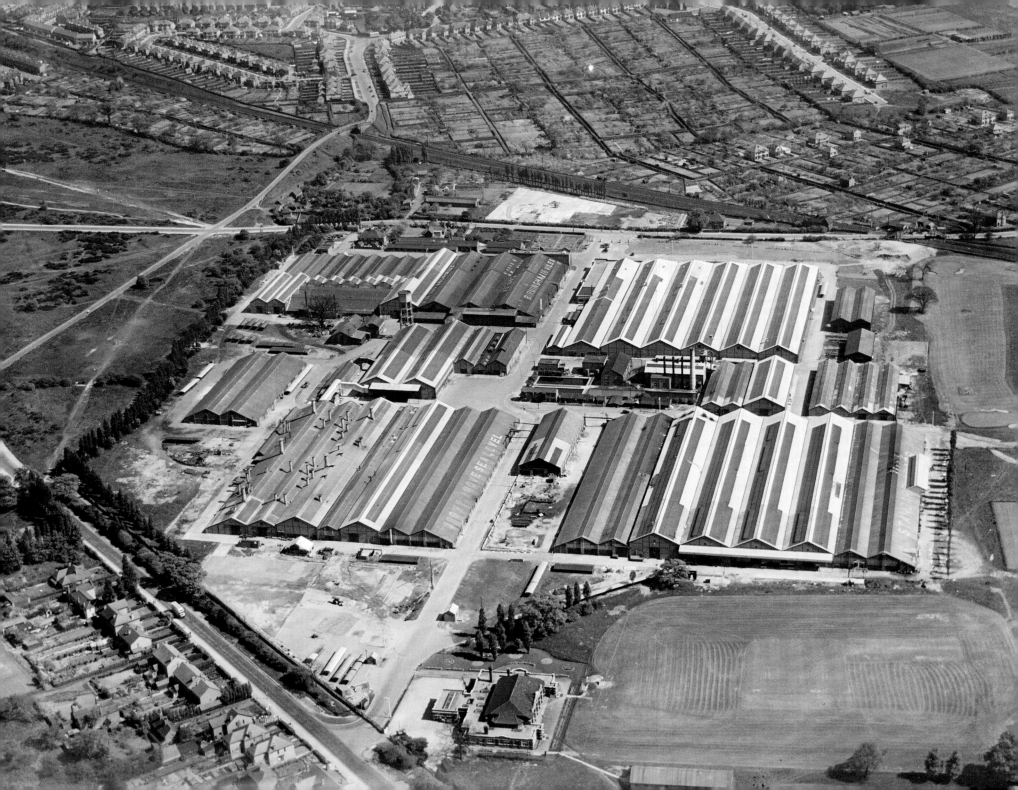

Standard, Canley, Coventry

18 May 1937

The Standard plant at Canley was another car factory constructed on open land, in this case just to the west of Hearsall Common, visible on the left. The main Coventry–Birmingham railway line crosses the view at the top of the picture. Outgrowing its premises closer to the city centre, Standard acquired 30 acres of what was then farmland and moved to this site in 1916. The signs to Birmingham, painted on the roof of the factory, are there to guide aviators: such signs were quite common in the pioneering days of civil aviation. They mark the earliest buildings on the site, which were fronted by an administration block known as Ivy Cottage, facing Canley Road. The factory expanded greatly to cover the entire area up to the railway line in later years and, occupying 300 acres, became one of the largest of the Coventry car plants. From early days, as in the case of many of the other Coventry firms, extensive social provision was made and the building at the bottom of the photograph, taken on 18 May 1937, was the clubhouse. After the Second World War, the production of Triumph cars was switched to Canley and such famous models as the Herald, the TR2-7 sports cars and the Spitfire were built here. The factory ceased making cars in 1980, some of the buildings on the site being retained for design work, but it has now been entirely demolished and replaced by a business park and a supermarket. All that is left is the clubhouse, today the Standard Triumph Club, now considerably extended in size. The roads of the business park are named after models of Triumph cars.

EPW053113

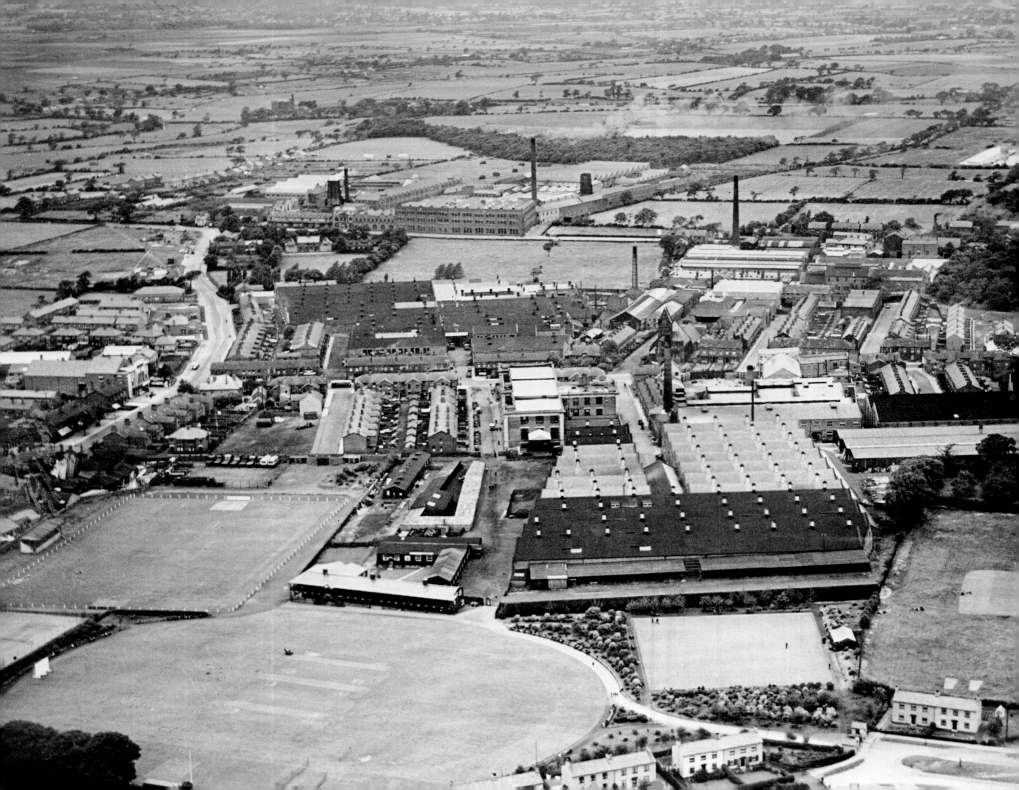

Leyland Motors, Leyland, Lancashire

1932

Leyland was perhaps the greatest name of all in the field of British commercial vehicles. The company was formed in 1896 to build steam vehicles and took its name from the place where they were constructed. By the date of this photograph the company had expanded to become the largest British manufacturer of heavy goods vehicles and buses. This is the factory looking to the north, separated into two complexes by Hough Lane. Production was later concentrated in a factory on a new site at Farington and there is now no trace of the premises seen here.

Afl 03_c14550

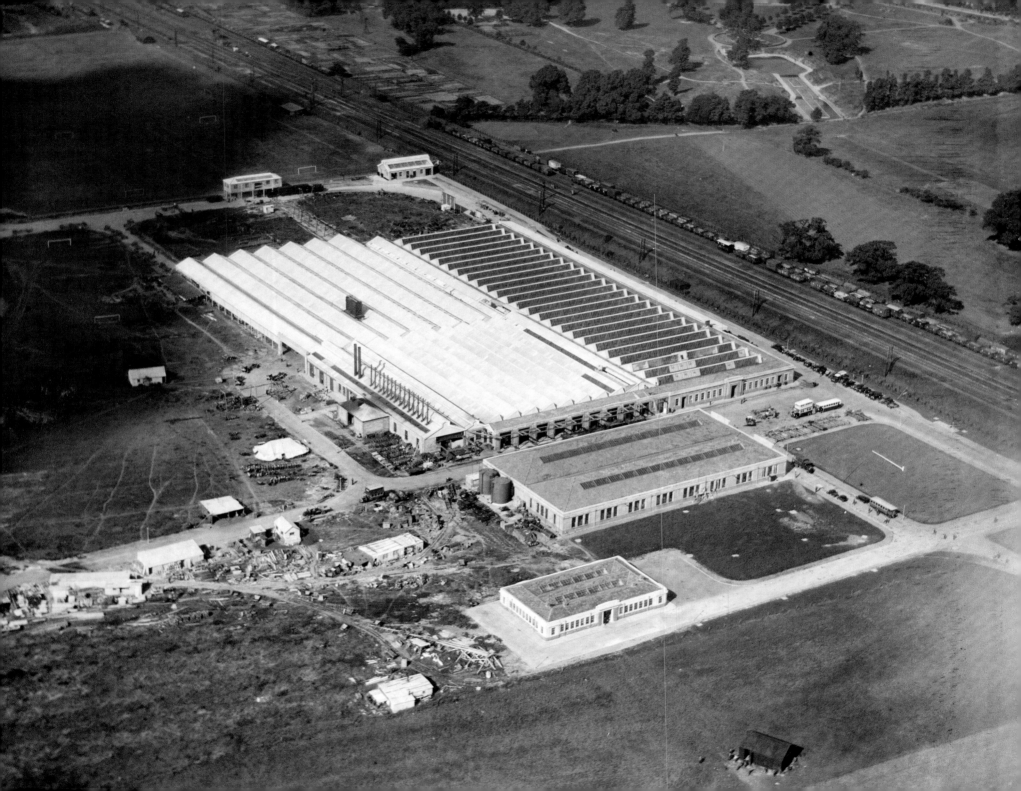

AEC, Southall

12 September 1927

London once played a substantial role in the motor industry, both for the manufacture of complete vehicles and for the components trade. This was concentrated in west and north-west London in the main. One of the largest factories was that of AEC (the Associated Equipment Company) at Southall, which started life as the bus-building arm of the London General Omnibus Co but in the First World War began building lorries for military service. It continued to expand both the passenger and goods vehicle sides of the business and constructed a factory on a greenfield site adjacent to the Great Western Railway main line at Southall which allowed room for expansion. The new factory is seen nearing completion in 1927. To the left of the factory is a former London General Omnibus Co B-type bus, fitted with a rudimentary cover to the top deck, one of a number used by AEC to transport workers from its previous premises in Walthamstow to Southall. To the right is a pair of newly completed buses and a number of chassis. The factory was subsequently extended south along Windmill Lane and became one of the largest commercial vehicle plants in Great Britain. Under British Leyland, it closed in 1978 and the entire site was flattened to be replaced by warehousing.

EPW019283

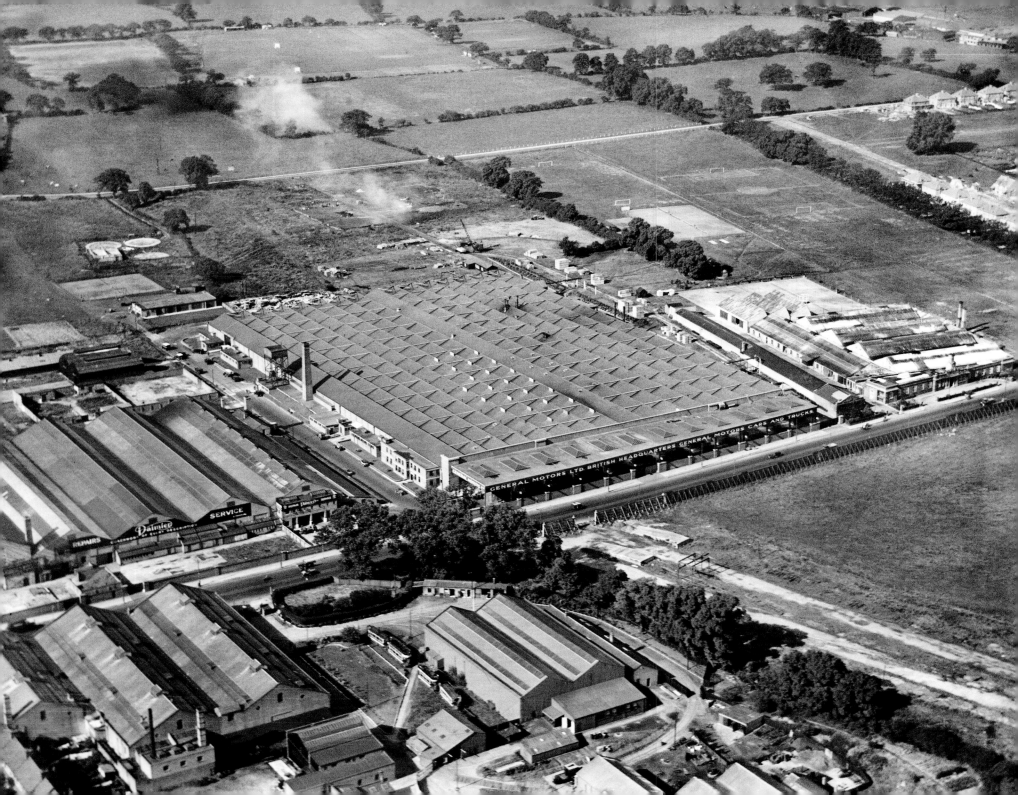

The Hyde, Hendon

10 June 1927

The Hyde, Hendon, spread out along the Edgware Road, became an important transport centre in the inter-war years. Among the largest premises were those of General Motors, which moved there in 1923. They assembled American vehicles, including Buicks, from CKD kits, starting production in 1924. Assembly of the vehicles in England meant that import duties were payable at a lower rate than if vehicles had been imported complete. The emphasis shifted to the production of Chevrolet trucks, which proved popular in Britain, and this continued until GM established a factory at Luton and the Chevrolet became replaced in turn by the celebrated Bedford. The Edgware Road premises were retained by GM as a service depot until 1981. To their left is the Daimler London service depot, also established in the early 1920s. Many of the major motoring manufacturers had large service depots, mostly in west and north London. Daimler's occupied a site of five acres; it could carry out any repairs required and offered regular maintenance programmes at a monthly charge of 15 shillings in 1928. It had 'a tasteful waiting room' for customers and a separate one for chauffeurs.

In the foreground on the opposite side of Edgware Road is the Hendon Tram Depot of Metropolitan Electric Tramways Ltd, opened in 1904, which in September 1909 was where the first British-built trolleybus was demonstrated by the Railless Electric Traction Co. Appropriately, after the ending of tram services in 1936, it became Colindale Trolleybus Depot until closure in 1962. Most of London's trolleybuses were scrapped by the George Cohen 600 group on the patch of spare land behind the depot between 1959 and 1962. To the left of the tram depot is the short-lived bus depot of MET Tramways Omnibus Co Ltd, opened in February 1913 but closed the following year when it was sold to the Aircraft Mfg Co. All four buildings have gone, the site of the tram depot now occupied by an office block, Merit House, and the others replaced by retail sheds. The photograph acts as a reminder of how much of the earlier 20th-century industrial landscape which replaced the fields and hedges still evident here has now itself been replaced.

EPW019298

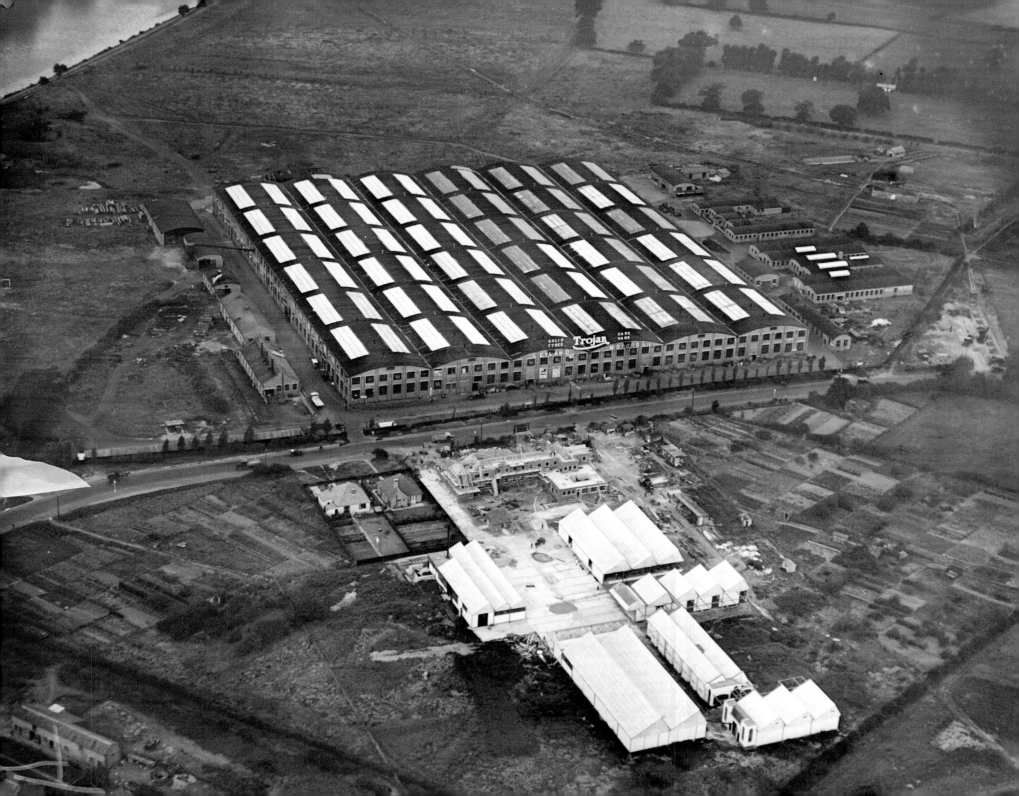

Trojan factory, Kingston upon Thames

15 August 1928

Somewhat out on a limb was the large plant that was used for the manufacture of the Trojan car between 1922 and 1928. This utility car, which ran on solid tyres when almost all other manufacturers used pneumatics, was the brainchild of Leslie Hounsfield and highly unconventional in its design. Hounsfield came to an agreement with Leyland Motors to build the car at its factory at Ham Common, to the north of Kingston upon Thames. The building had been erected in the early years of the First World War as an aircraft factory for Sopwith, and Leyland had acquired it soon after the war to refurbish ex-War Department Leyland lorries for sale. The agreement with Leyland ended in 1928 and production moved to Croydon, where the company continued to build vans until 1960. Leyland used the premises to build its 'Cub' range of light commercial vehicles and buses before disposing of them in 1948. The building survived for many years as a British Aerospace factory but has now been replaced with housing. This photograph shows it just at the end of car production with the six-bay erecting shop clearly visible.

EPW022854

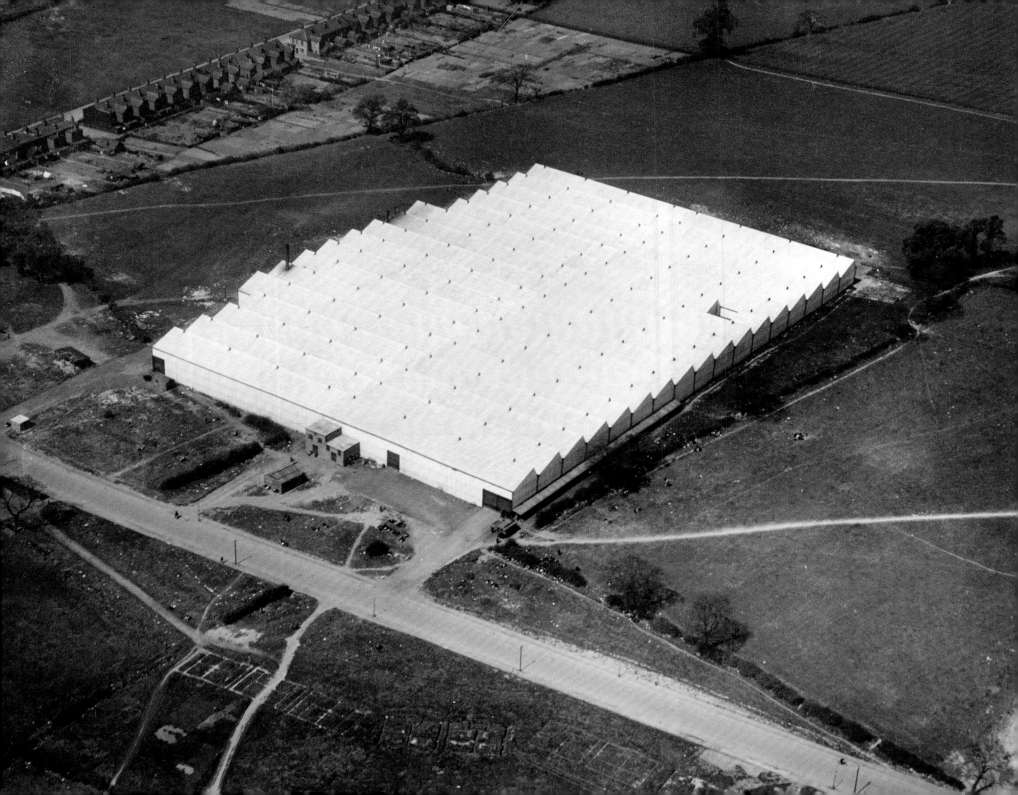

Clyno, Fallings Park, Wolverhampton

28 May 1928

Clyno is a classic case of a car manufacturer that over-reached itself. Briefly, in the mid-1920s it was third behind Morris and Austin in terms of sales. It began as a motorcycle manufacturer before introducing its first car in 1922. By competing on price with Morris, it expanded rapidly and outgrew its existing premises in Pelham Street, Wolverhampton. It built a state-of-the-art factory with a northlit roof and a floor area of over six acres at Fallings Park, a newly developed garden suburb of Wolverhampton. Construction began in 1926, and by the time the factory was completed at the end of 1927 Clyno was suffering in its fight with Morris. Receivers were appointed in February 1929 and the new factory was acquired with the rest of Clyno's assets by Alfred Herbert, the machine tool manufacturer, as the company's largest creditor. The building was sold on by Alfred Herbert and lasted many years before fire destroyed a large part of it in the 1990s, with final demolition in the early 21st century.

EPW021035

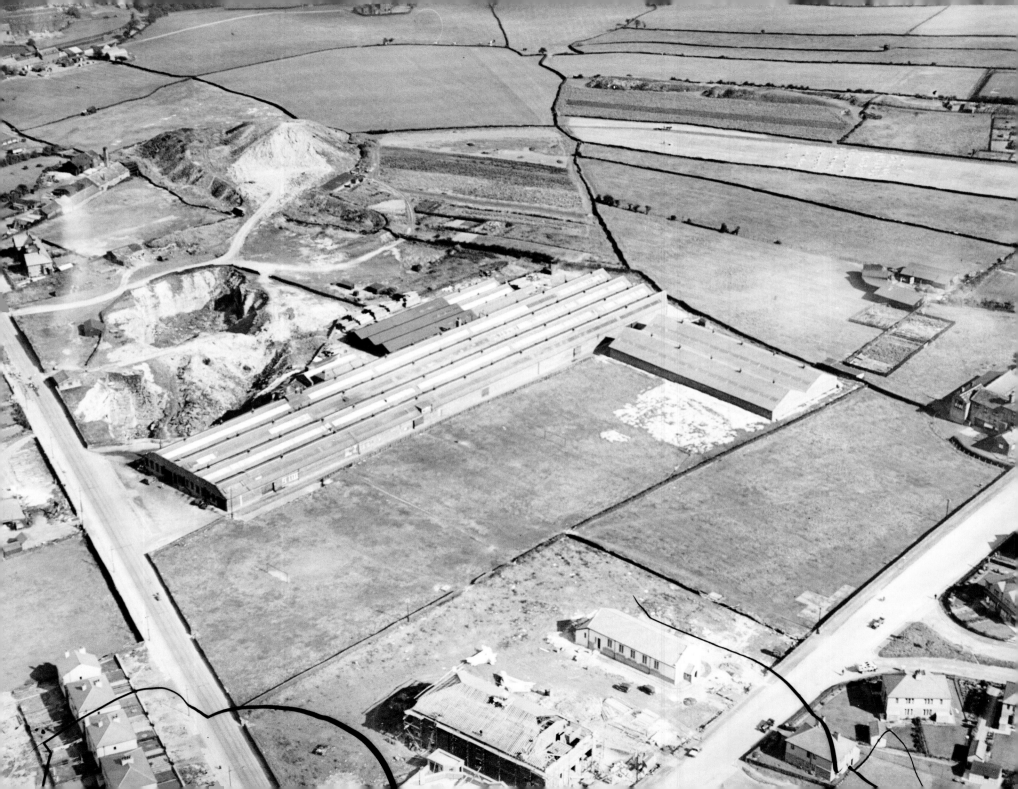

Jowett, Idle, Bradford, Yorkshire

September 1928

Although British motor manufacturing was concentrated in the West Midlands, car producers were found in other parts of the country. The notably independent firm Jowett was based in Bradford and its first car went into production in 1910. It was known for constructing very solid small cars that were ideally suited to the steep hills of the West Riding. A relatively small company, it was profitable and occupied a niche. After the Second World War, a new and radical design, the Javelin, was introduced but the small factory struggled to keep up with demand for the car and, following supply problems with bodies, car production ceased in 1954. Jowett had begun operations in central Bradford but a new factory on Bradford Road, Idle, was built on a greenfield site on the edge of a quarry and opened in 1920. It is seen here three years before it was seriously damaged by fire in 1931. Production resumed after the fire, and following the end of Jowett car production it was sold to the International Harvester Co, which built tractors there until it was demolished in 1983. The site is now the Enterprise Way Industrial Park and a large supermarket, and the rural surroundings in this photograph are completely built up.

EPW024464

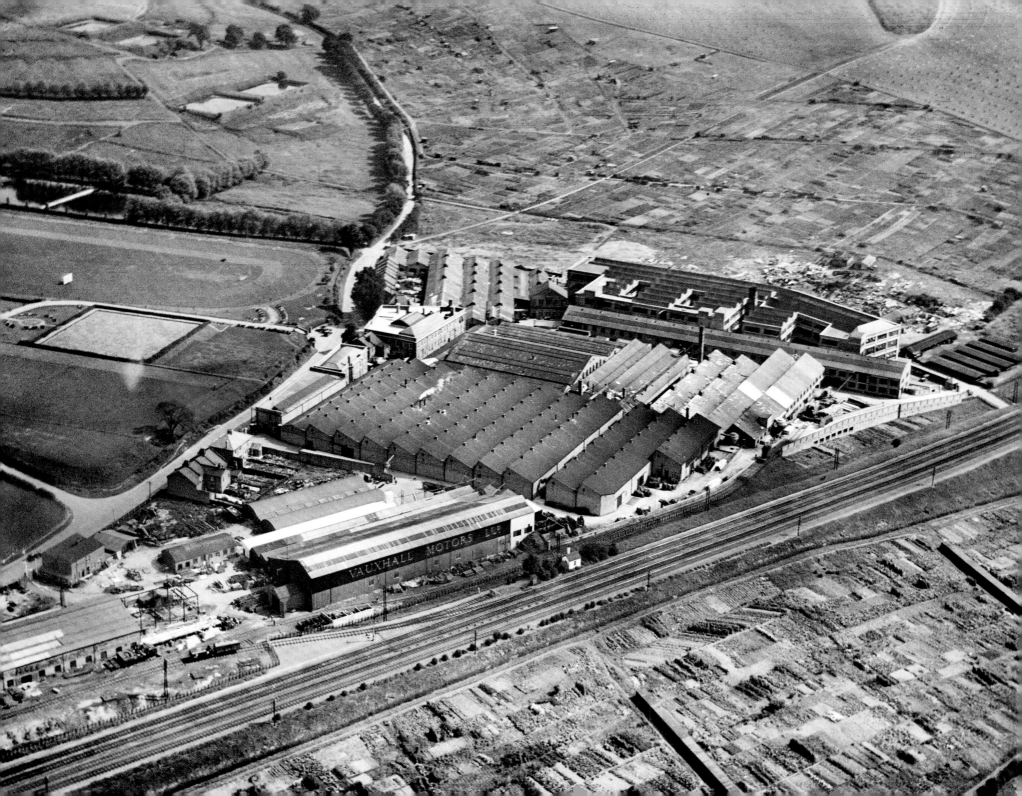

Vauxhall, Luton

29 August 1927

Vauxhall became identified with Luton, but until the 1930s their premises remained quite modest in scale. Seen on 29 August 1927 the factory was still almost out in the country and was confined to the west of Kimpton Road. The only incursion to the east side is the firm's sports ground; later, the major portion of the works would rise up on the hill to the east. The original part of the works opened in 1905, when the firm made the move from Lambeth, and may be seen in the centre of the photograph, with one large bay and one small one, and the neo-Georgian office range of 1907 by H B Cresswell beyond. Surrounding it are numerous later northlit sheds, while in the foreground is the former West Hydraulic Engineering Co building of 1905, by this time incorporated into the Vauxhall works. Although there is still a Vauxhall presence at Luton, the remaining buildings lie further to the east and only the Cresswell office range of 1907 is left today, all the other buildings having been demolished and replaced by three large warehouse sheds.

EPW019223

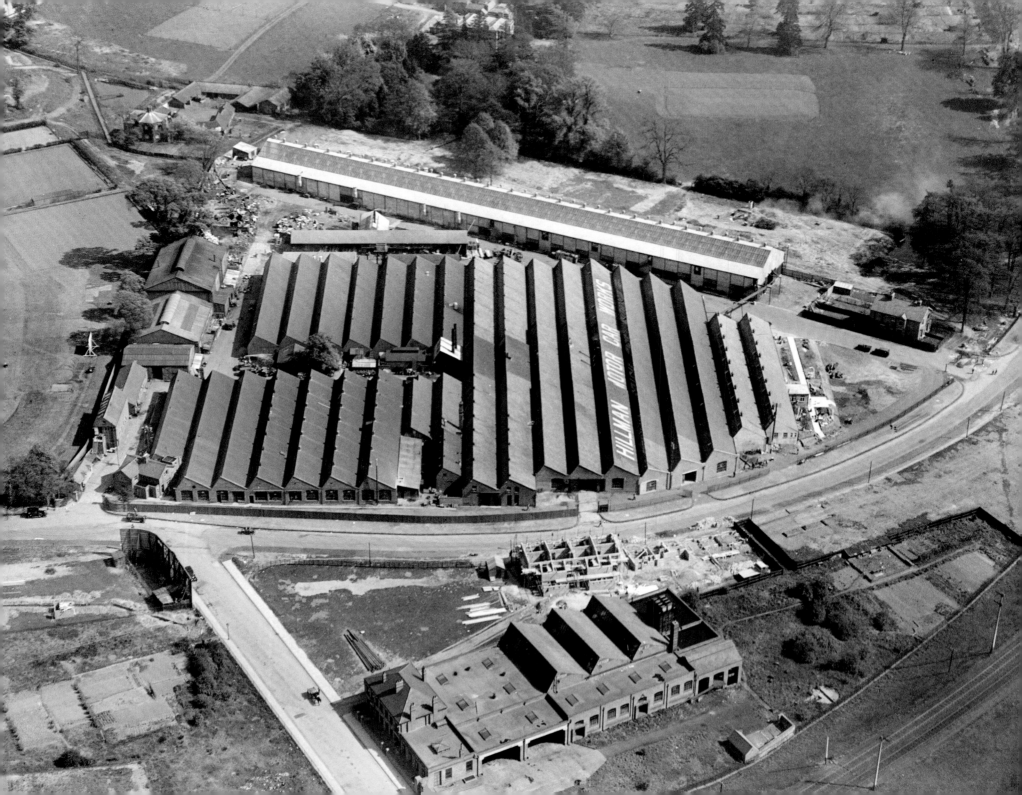

Hillman, Stoke, Coventry
1928

William Hillman embarked on car production in 1907, following many years' involvement in bicycle manufacture. He established his car factory in the grounds of his private residence, Abingdon House, Aldermoor Lane. A lodge to Abingdon House was taken into the factory and is seen here on the left by the principal entrance. The stores were located at this end of the works and production moved from left to right across the premises. By 1929 the works, although modest in size, were capable of producing 200 cars per week. The later history of the works is similar to that of Humber (pp 70–1), with which the Hillman plant was integrated. The lodge lasted until the late 1980s although many of the earliest buildings had gone by then. As with Humber, the entire site was redeveloped in the early 21st century.

EPW021026

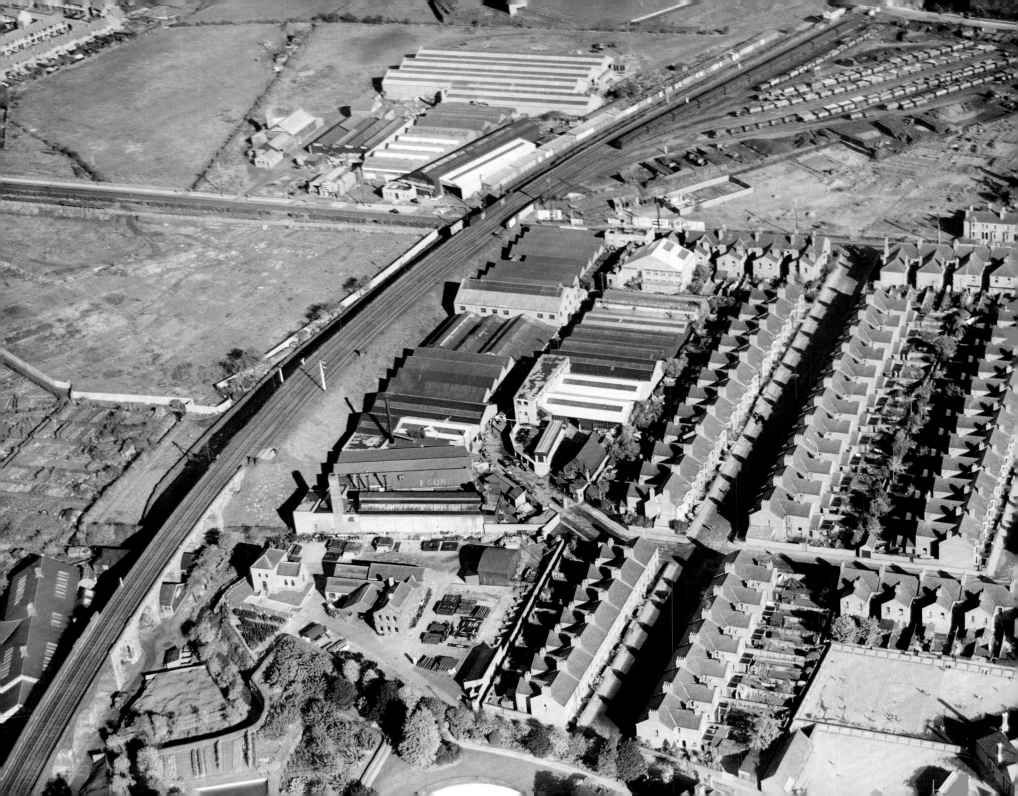

Alvis, Holyhead Road, Coventry

October 1934

A celebrated sporting car made in Coventry was Alvis, and the first part of its Holyhead Road factory was built in 1920. It occupied a cramped site, enclosed by houses, road and railway embankment, and expanded piecemeal with a series of small workshops on either side of a central access road, before a decision was made to construct a completely new factory for aero engine construction on the west side of the Coventry–Nuneaton railway line. To the north of the railway bridge over the Holyhead Road, in later years known popularly as the 'Alvis bridge' on account of the large advertisement for the company that it bore, are the premises of Carbodies Ltd which moved there in 1928. Carbodies was a contract bodybuilder rather than a bespoke coachbuilder, supplying, among others, the nearby Alvis plant. Eventually Carbodies concentrated solely on taxi manufacture and, after several changes of ownership, the London taxi is today still made at Holyhead Road, the last functioning car factory in Coventry.

EPW046379

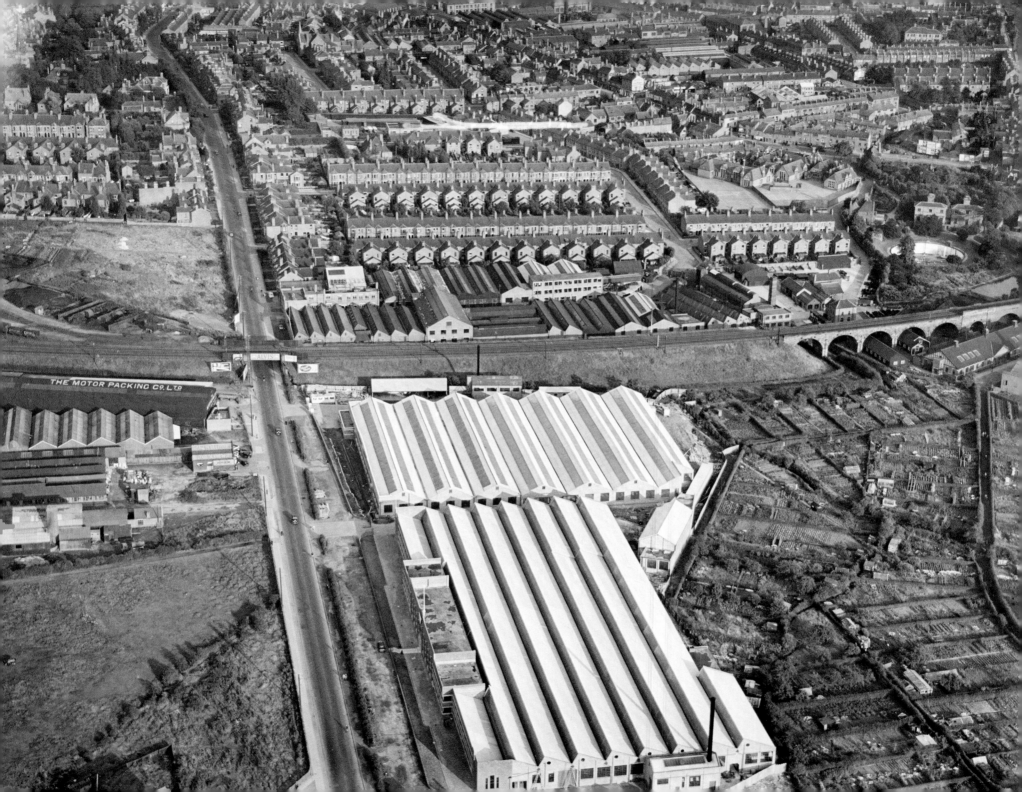

Alvis, Holyhead Road, Coventry

12 August 1936

The new factory gave Alvis the opportunity to plan an ideal layout with two main blocks, one of northlit sheds fronted by a red-brick office block and the other a seven-bay range. The old works is on the east side of the railway line. It was largely destroyed by bombing during the Second World War while the new works were also damaged. Alvis car production was transferred to the new works, until in 1967 the firm ceased to make cars and concentrated on the military vehicles that had provided most of its post-war profits. The company is still a major manufacturer in this field but it vacated Holyhead Road in 1990 for a new factory at Walsgrave, Coventry. The works were demolished in 1991 and replaced by a retail park.

EPW051457

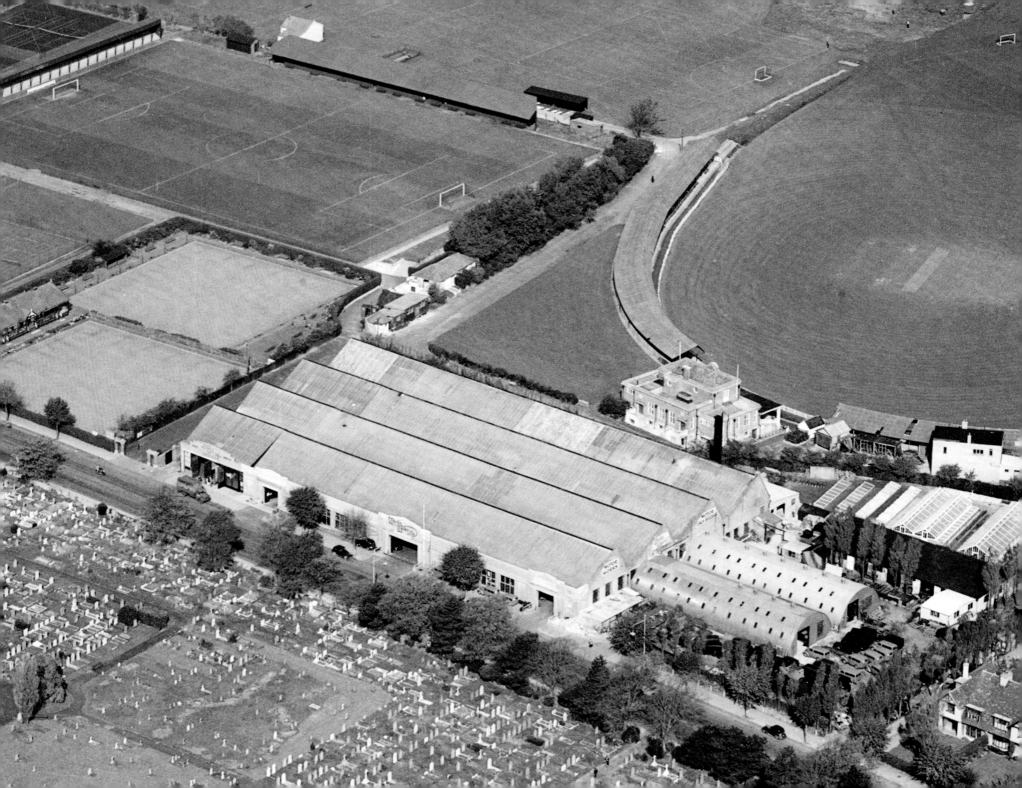

Martin Walter, Folkestone, Kent

1946

Martin Walter Ltd was established in the early
1900s as a saddlery but turned to coachbuilding in
1917 with the acquisition of Norrington's, which,
like Martin Walter, was located in Folkestone, Kent.
Martin Walter specialised in drophead bodies
and built up a niche constructing these on
mass-market chassis. After the Second World
War it produced utility (Utilecon) bodies
based on vans and then, in 1954, launched the
Dormobile motor caravan body, which became
synonymous with this type of vehicle for many
years. The factory, seen in 1946 at the time of
Utilecon production (several may be seen outside
the Nissen hut extensions and another pair at
the front of the building), comprised four bays of
conventional northlit design. Dormobiles ceased
to be manufactured in 1994 and the factory is
now demolished.

Afl 03_a2863

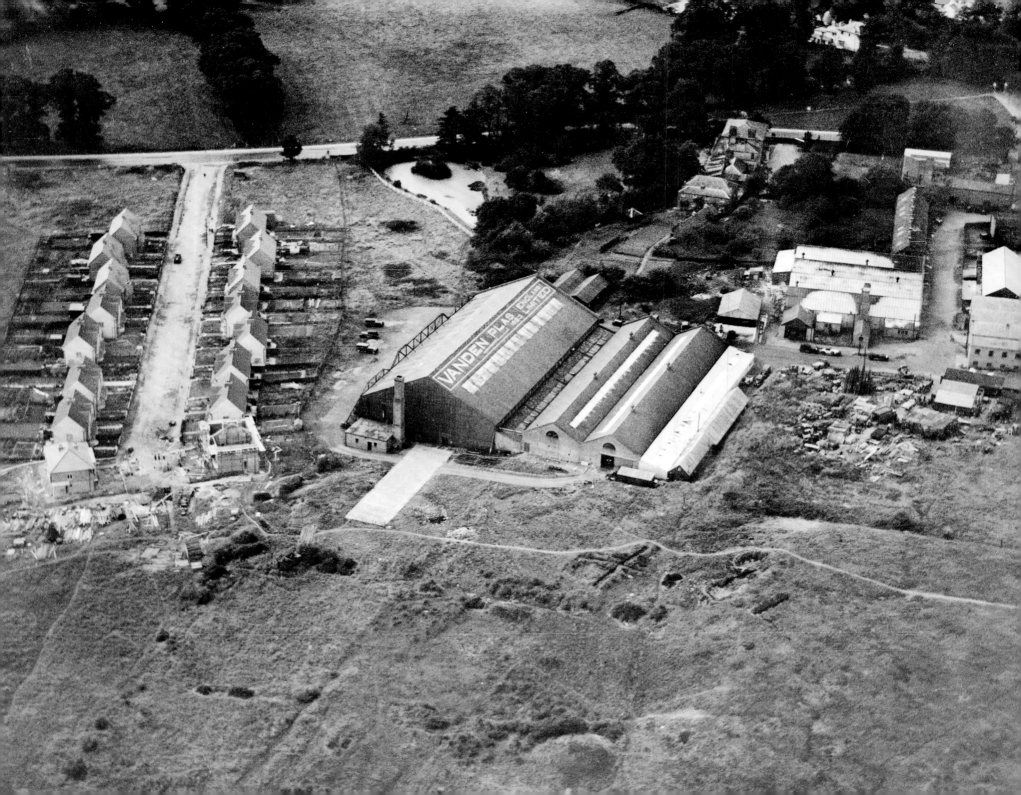

Vanden Plas, Kingsbury, Middlesex

September 1928

Vanden Plas, one of the greatest names in British coachbuilding, had its origins in 19th-century Belgium. Its history was somewhat convoluted, but when this photograph was taken it had been bought by Edwin Fox and his brothers from the receiver and was at the height of its success. It bodied over 700 Bentleys, by far the greatest number by any coachbuilder, and when Bentley itself went into receivership in 1931 it had diversified into building bodies for many others. It was particularly associated with Alvis in the 1930s but carried out work on all the most prestigious makes. Kingsbury Works had been originally constructed for Barningham Ltd, who had acquired the Kingsbury House estate in 1916 and transformed it into Kingsbury Aerodrome. Following a name change to Kingsbury Aviation, the works premises were used to build military aircraft, some 150 DH6s being constructed there. Vanden Plas acquired the premises in 1923 and was able to recruit skilled men with experience of building aircraft – in those days of wooden aircraft, a closely related field. History repeated itself in 1940 when the factory made wings for the Mosquito. Vanden Plas eventually became part of British Leyland and the factory was closed in 1979. It has now been demolished and the hangars that made up Kingsbury Works have been replaced by the Kingsbury Trading Estate.

EPW024254

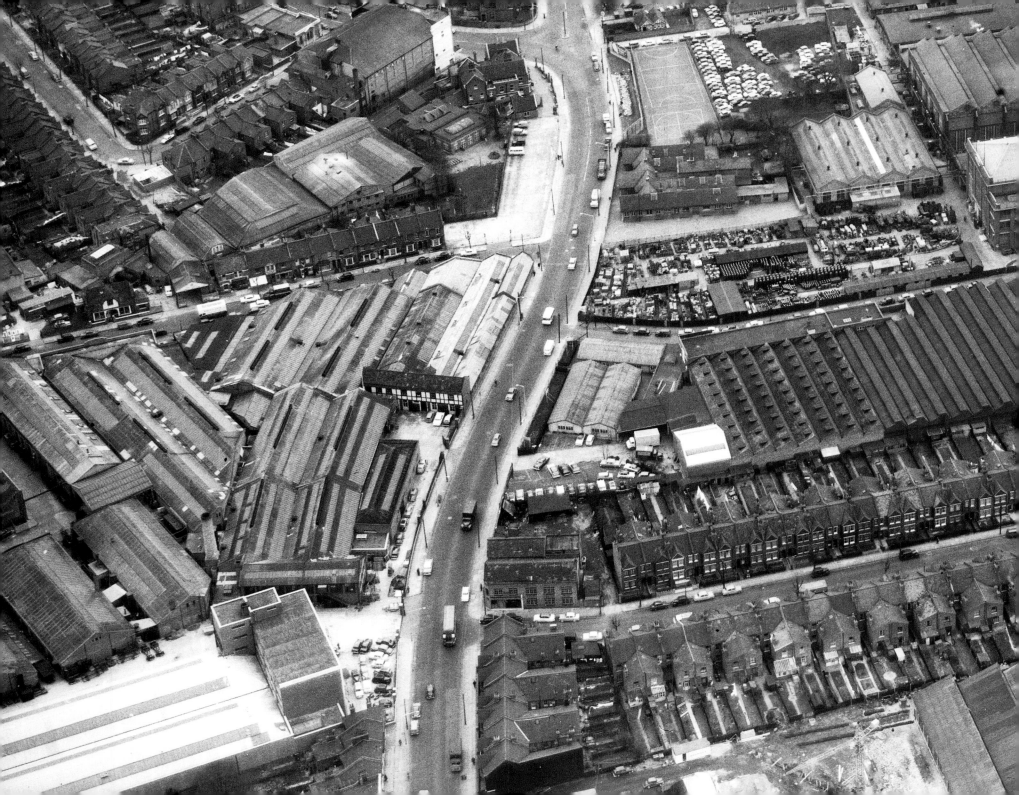

Park Ward, Willesden

20 March 1962

North-west London was a great centre of the coachbuilding trade. Park Ward & Co Ltd was a relatively late entrant, setting up in business at 473 High Road, Willesden, in 1919. The premises had formerly been stables for the London General Omnibus Co. The drawing office and administration occupied what had been the former harness room and hayloft, the wing covered in applied half-timbering in this view. The firm specialised in coachwork on Rolls-Royce and Bentley chassis and rapidly expanded. The works were largely rebuilt in 1927 and extended in 1932–4. The company was a pioneer of all-steel construction at the top end of the market and, following an injection of capital by Rolls-Royce in 1933, became a wholly owned subsidiary in 1939. Park Ward was merged with H J Mulliner in 1961, moved in 1982 to Harlesden and was closed down in 1991. The factory was demolished and replaced by a DIY store.

Afl 03_a98224

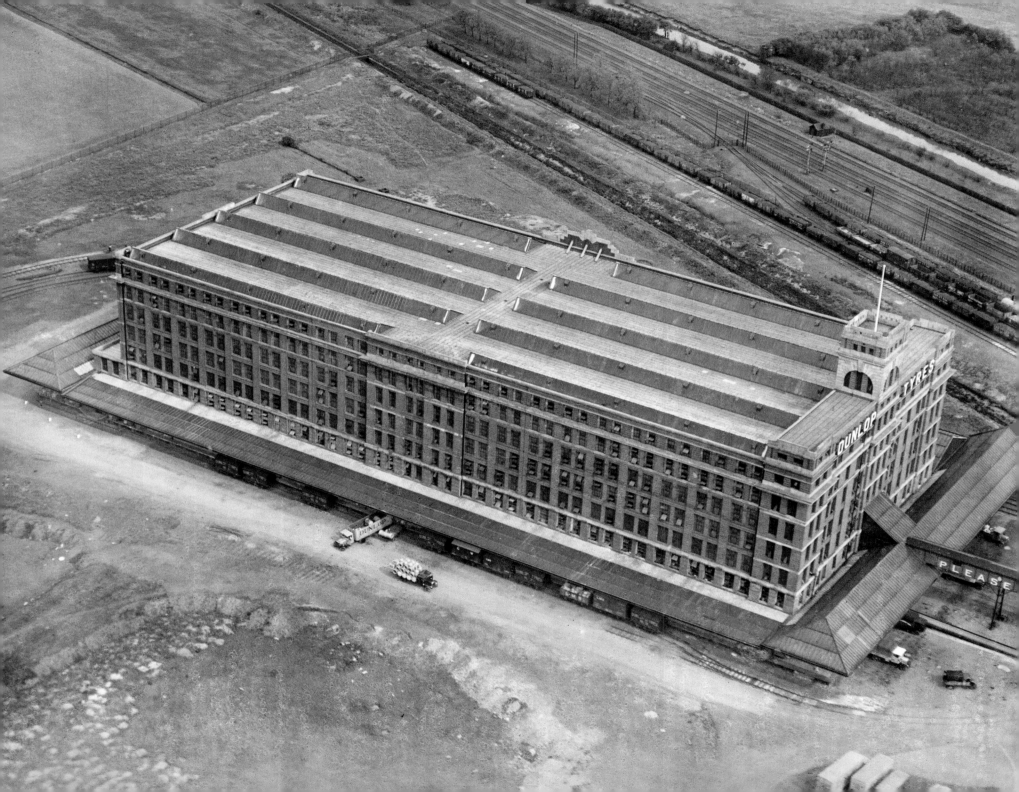

Fort Dunlop, Birmingham

20 May 1929

Fort Dunlop is a tangible reminder of the significance of the British tyre industry. A landmark seen from the M6 motorway, it was transformed by the developers Urban Splash and their architects ShedKM in 2004–6 into offices and a hotel following years of dereliction. A massive steel and concrete structure, it formed part of the largest production facility for motor tyres in the country. It was designed by Sidney Stott and W W Gibbings in the mid-1920s and is locally listed.

EPW026942

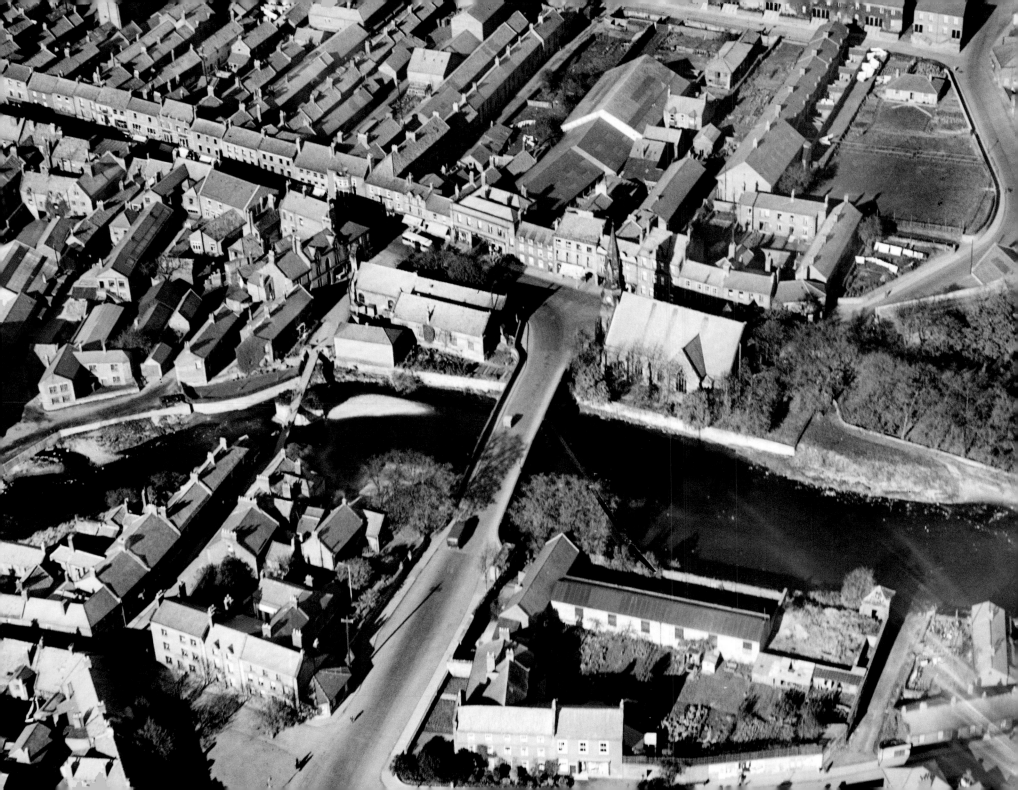

Most early garages were built in the centres of towns, generally occupying an existing building with often a long burgage plot behind it. This is the garage of S Jennings Ltd, in Morpeth, Nothumberland, on 18 October 1927. Septimus Jennings began selling and repairing bicycles in 1903 and moved to No 55 Bridge Street in 1911 by which time he had become a motor agent. By 1927, he was a Ford main dealer, also selling Bean, Buick and Daimler, and the business continues today in a different location. The layout is typical of many garages, with a central entrance flanked by petrol pumps and showrooms leading to a parking garage and workshop, all fitted within the confines of the plot. Both the frontage building and the workshops have now been replaced.

EPW019777

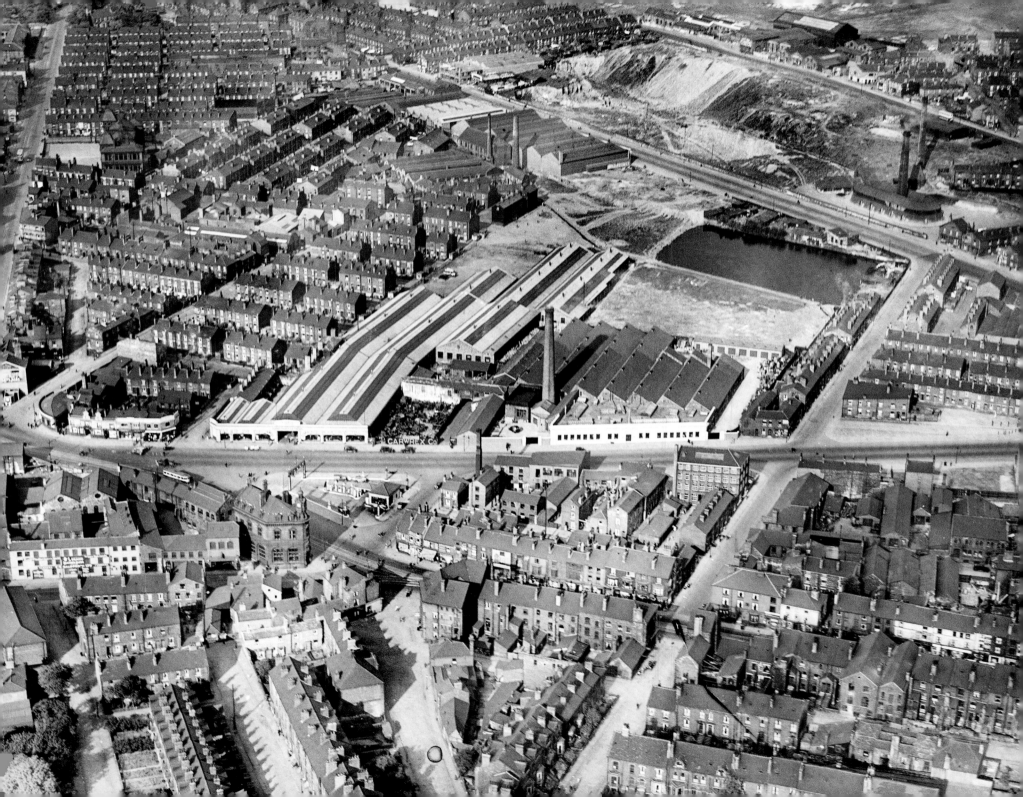

Appleyard of Leeds Ltd, North Street, Sheepscar, Leeds

June 1932

While the earliest garages and car dealerships tended to be located in city centres, by the 1920s there was an emerging trend for them to start moving out to the main roads that led into the city within about a mile of the centre. This gave them more room for expansion but still enabled customers without cars to visit them easily by public transport. An early example was Appleyard's which built new premises in Sheepscar at the junction of several major routes into Leeds in 1927. J E Appleyard, the Managing Director of the firm, founded in 1919, stated that he had personally visited the leading depots of Europe and the USA in developing the design of the premises. The first portion occupied an acre and, by 1929, when Appleyard placed all its sales and service facilities under one roof, this area had been quadrupled. Over 200 staff were employed and the land to the rear of the garage was used for a school of motoring. Opposite the main premises, a filling station was established in the junction of North Road and Sheepscar Street, marked by an illuminated gantry sign over its entrance. Probably less welcome to Appleyard was the presence next door to it of a motor scrapyard, Carwrex Co, an unwelcome reminder of the fate of many cars after what was often then a short life of some seven to eight years. Appleyard's premises have been entirely replaced by industrial units: only the hipped roof kiosk of the filling station survives, completely disguised behind modern cladding.

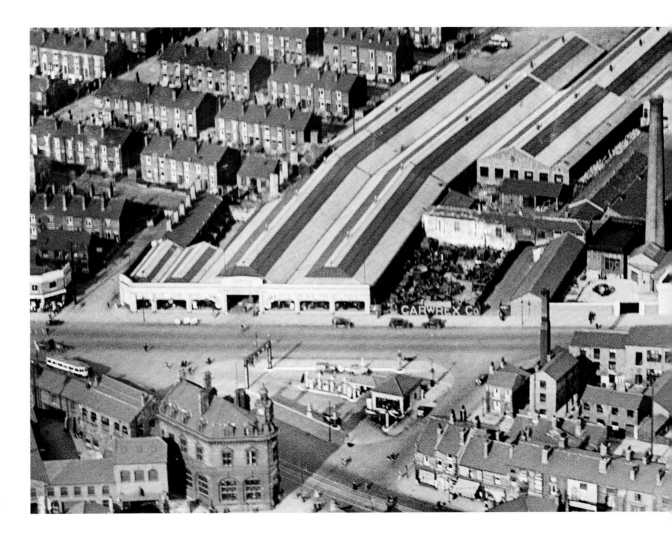

EPW038661

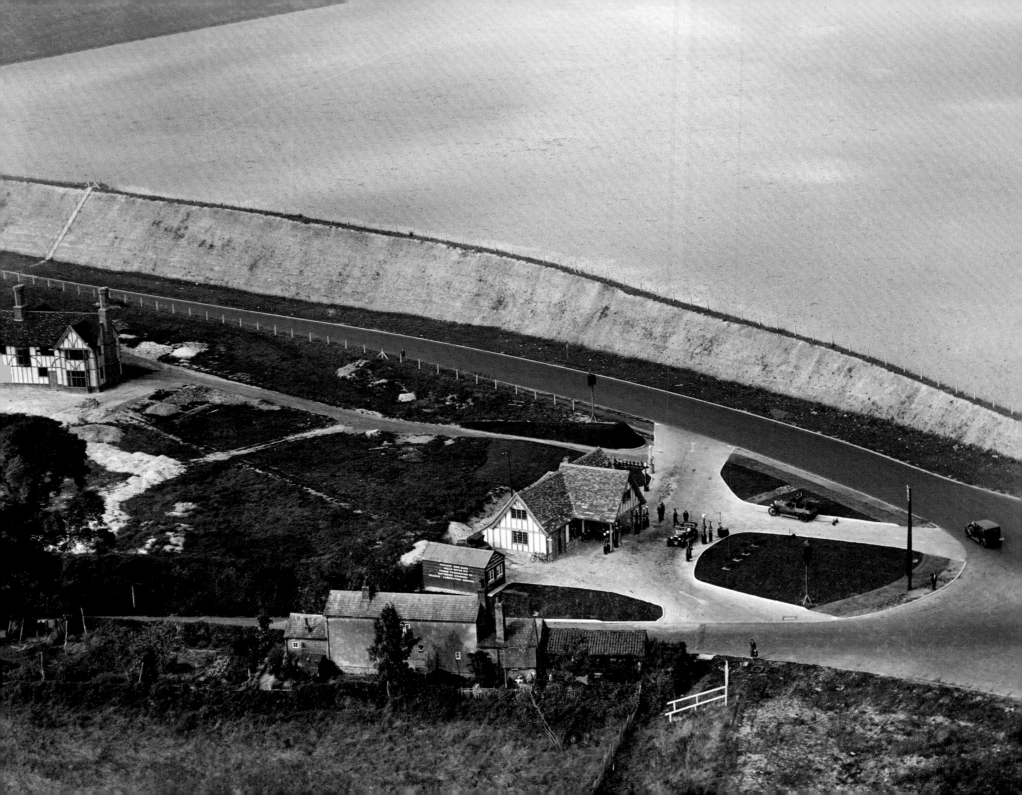

Farningham service station, Kent

1 October 1926

Built in 1926, a time when there was an outcry
against ramshackle filling stations covered in
enamelled signs, Farningham service station was
featured in the motoring journals as an example
of how a filling station could harmonise with rural
surroundings. It was half-timbered, with a tiled
roof and a big gable brought forward to act as a
canopy over the petrol pumps. It had, however,
acquired a small hut which offered Rolls-Royce
hire cars, so the purity of the design was already
compromised a little by the time this photograph
was taken. It was constructed alongside the
new Farningham bypass, and the bare chalk of
the excavation through the North Downs still
shows as a scar. The forecourt of the garage
opens directly off a roundabout. By the entrance,
the parked vehicle is what was then called a
'motor ambulance' – that is, a breakdown truck
– converted, as were most such vehicles then,
from an obsolete touring car (possibly a Crossley)
which has had the rear of the body removed and
a Harvey Frost towing rig substituted. There is still
a garage on the site today but the buildings seen
here have disappeared without trace.

EPW016987

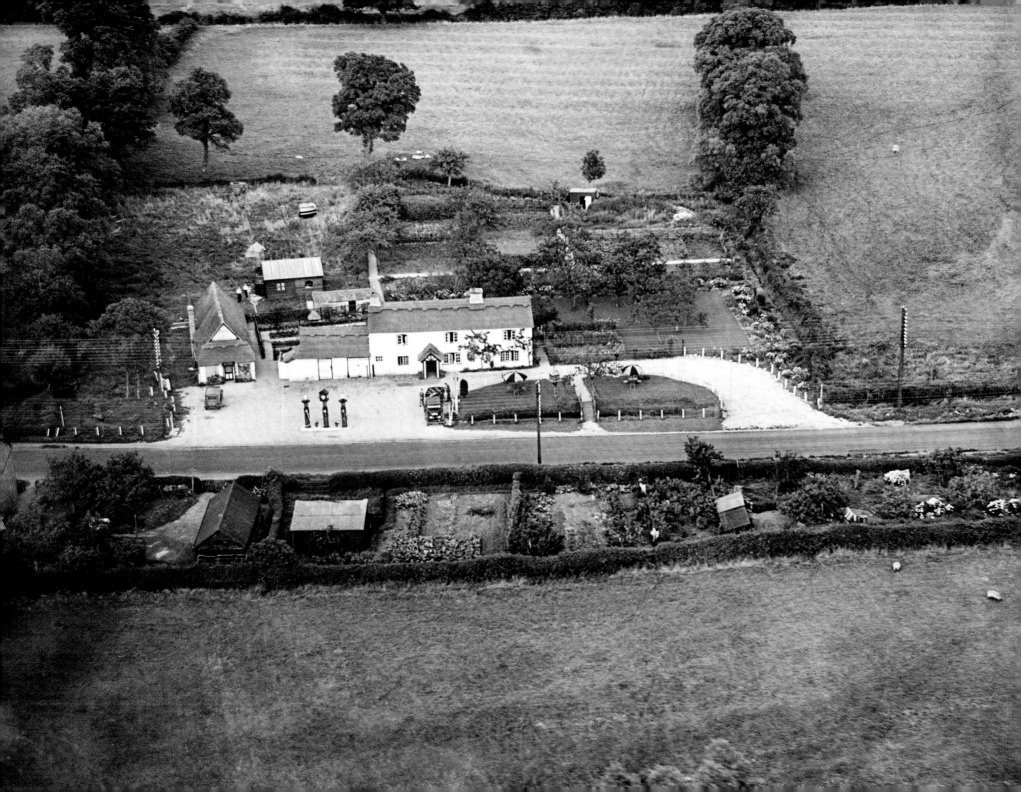

Fountains Hotel, Loughton, Essex

1931

Many wayside inns took the opportunity to sell petrol to passing motorists, initially in the form of two-gallon petrol cans and from the 1920s through having pumps installed in front of their premises. This is the Fountains Hotel, Loughton, Essex, where the proprietor had just installed pumps and commissioned Aerofilms to photograph them. No changes have taken place to the thatched roof inn to equip it for petrol sales — it is clear that it is strictly a filling station and not a garage. The position of the pumps is noteworthy: they are set back from the road sufficiently to be on the inn's land and to enable a vehicle to pull off the road to fill up.

EPW036357

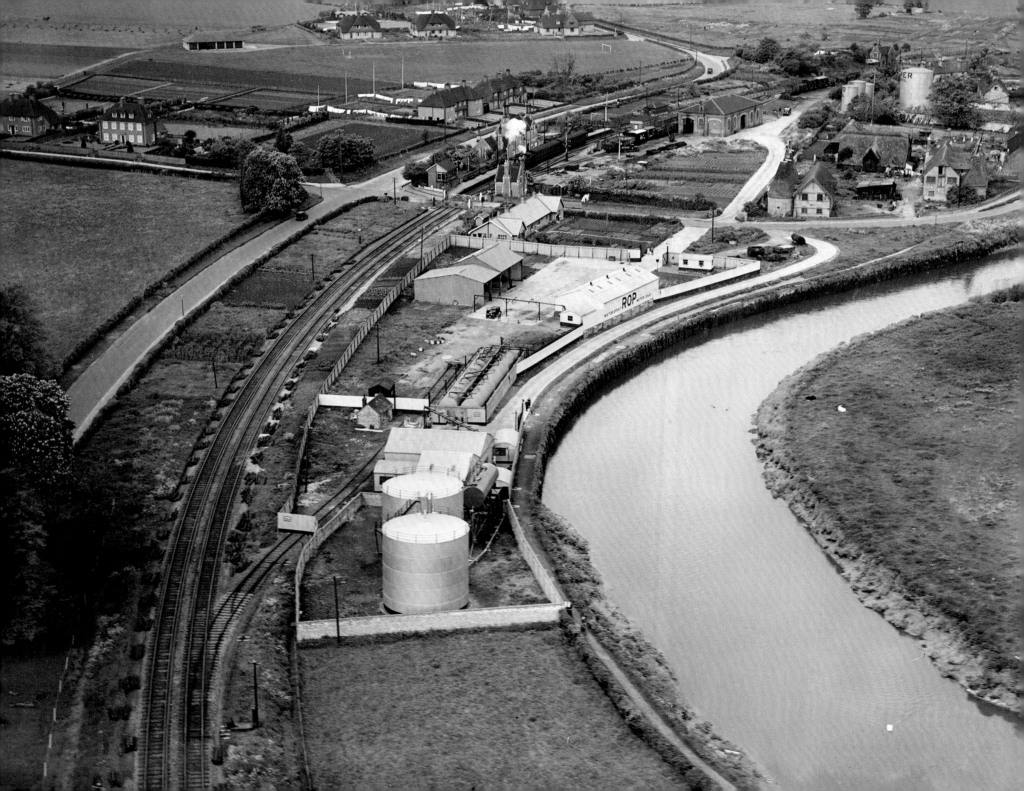

ROP petrol depot, Aylesford, Kent
24 May 1932

Small petrol storage depots were established throughout the country in the 1920s. They were often located alongside railway lines with a private siding allowing deliveries from refineries to be made via rail tank wagons. This is seen clearly in this view of a petrol depot at Aylesford, Kent. The depot was owned by ROP (Russian Oil Products Ltd), a company that had gained a good share of the market in the 1920s despite considerable opposition. Buying ROP petrol was, it was argued, giving support to the Bolsheviks. The site is a tight one, hemmed in between the Strood–Maidstone railway line and the River Medway.

EPW038097

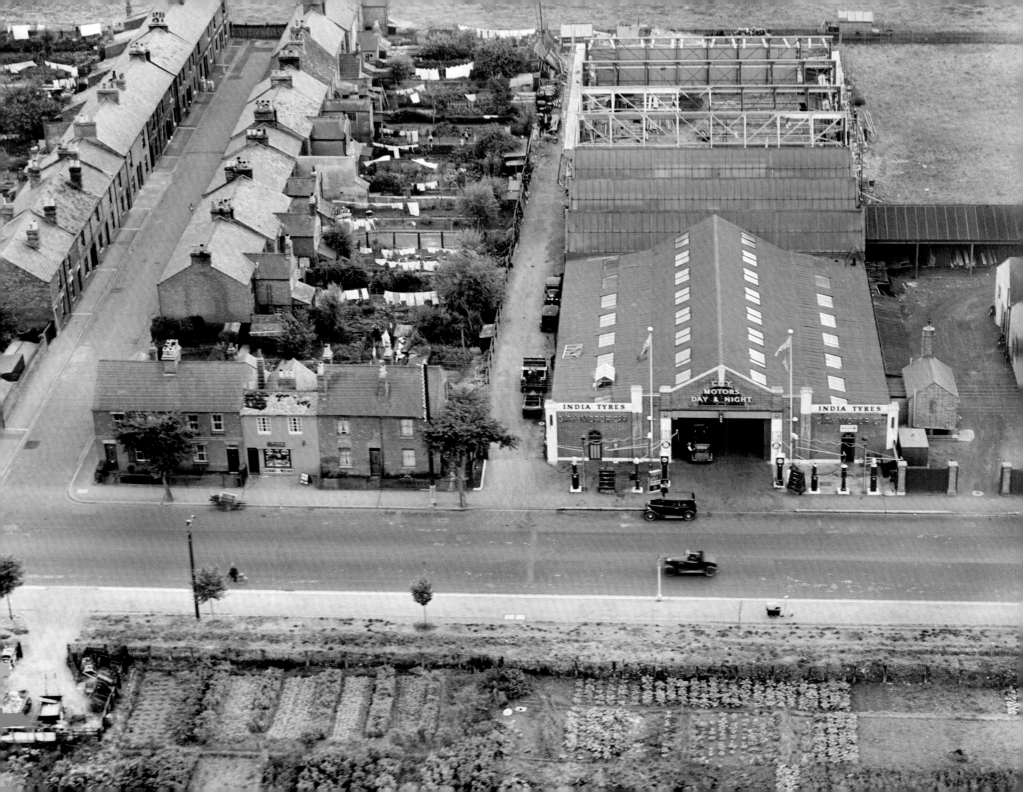

The City Motor Co Ltd, Botley Road, Oxford

August 1935

The service depot of the City Motor Co, located on the main road to the west out of Oxford, is a representative of the most common form of garage building, a large top-lit structure with brick walls and a light steel truss roof, unencumbered by piers or stanchions internally, and with its longest façade at right angles to the road. At the rear, it has been extended by a structure of three northlit bays and a further four bays are in course of construction. The building has few pretensions: decoration is confined to a screen wall hiding the pitched roof and a couple of flag poles either side of the broad entrance. An impressive line of pumps and oil dispensers fill the forecourt. There were no car sales here – they were dealt with elsewhere, either at the company's head office in Gloucester Street or its other branch on the Woodstock Road. Like many of its kind, the building has now gone.

EPW048866

Land Yachts, Egham, Surrey

24 March 1939

Caravanning had become popular by the mid-1930s, and the premises of specialist dealer Land Yachts Ltd, located on The Causeway, which formed the Egham bypass, was photographed on 24 March 1939. By this time, rounded streamlined forms had replaced the 'Tudor cottage on wheels' look prevalent in the 1920s and almost all the vans visible in the photograph are of the streamlined type. Next to Land Yachts is a typical garage of the kind put up on new roads, with a two-storey building fronted by a canopy and a single-storey workshop behind. The location on marginal land with a main road frontage and a sewage works in close proximity is typical of the motor trade.

EPW060720

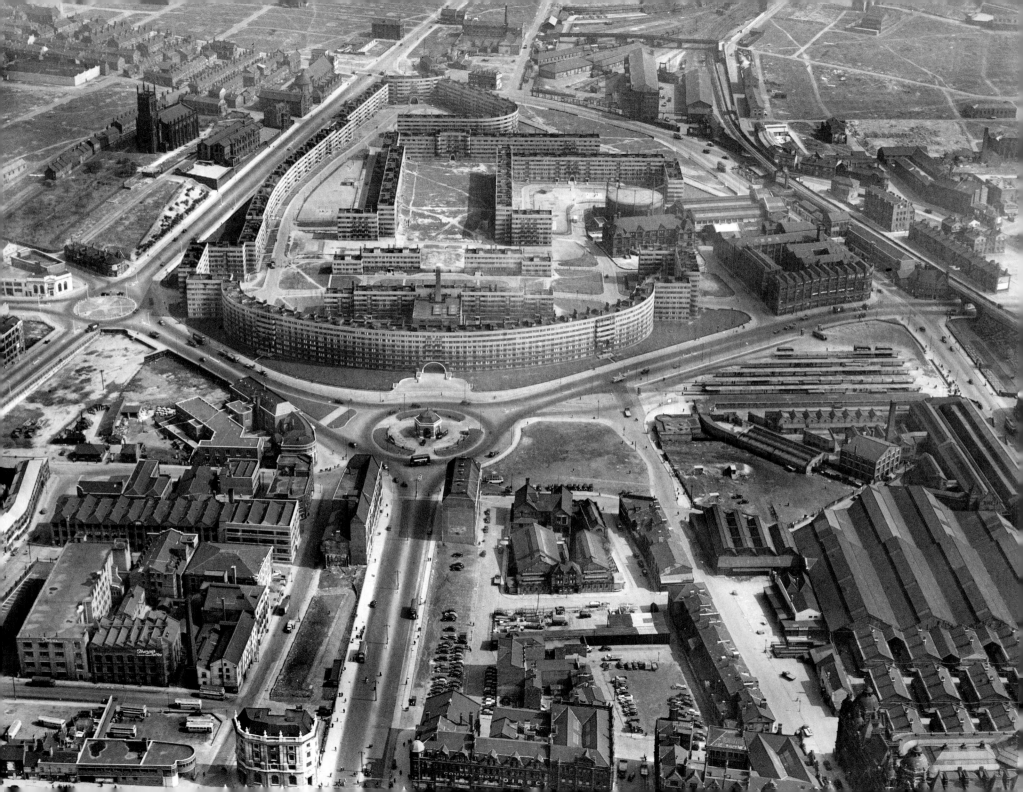

Appleyard's filling station, Leeds

1948

A filling station is seen here as a focal point in a grand axial plan. The small building in the centre of the roundabout is the Appleyard's filling station, designed by Reginald Blomfield in 1932 to close the view from his Headrow scheme. The filling station was built in a neo-Georgian style resembling a market cross. Leeds was in the forefront of reshaping the city to meet the needs of the car, with the New York Road, widened and running straight as a die, at upper left in the photograph. The filling station also acted as a frontispiece to the famous Quarry Hill flats that were erected to the west of it in 1935–41. On the right is the bus station, again carefully designed to fit into this impressive civic scheme which was complete by 1948, the year the photograph was taken. Much of the impact of the planning has been lost today, with the demolition of Quarry Hill flats in 1977 and their replacement by buildings that do not, unlike their predecessors, echo the curve of Eastgate and St Peter's Street. The bus station is still on the same site although it has been completely rebuilt.

EAW014656

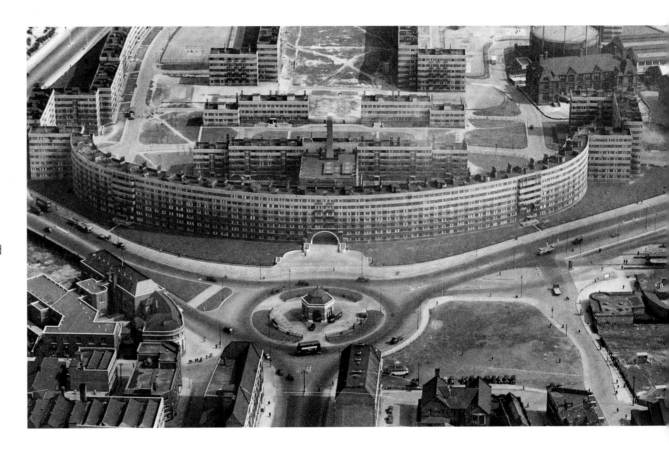

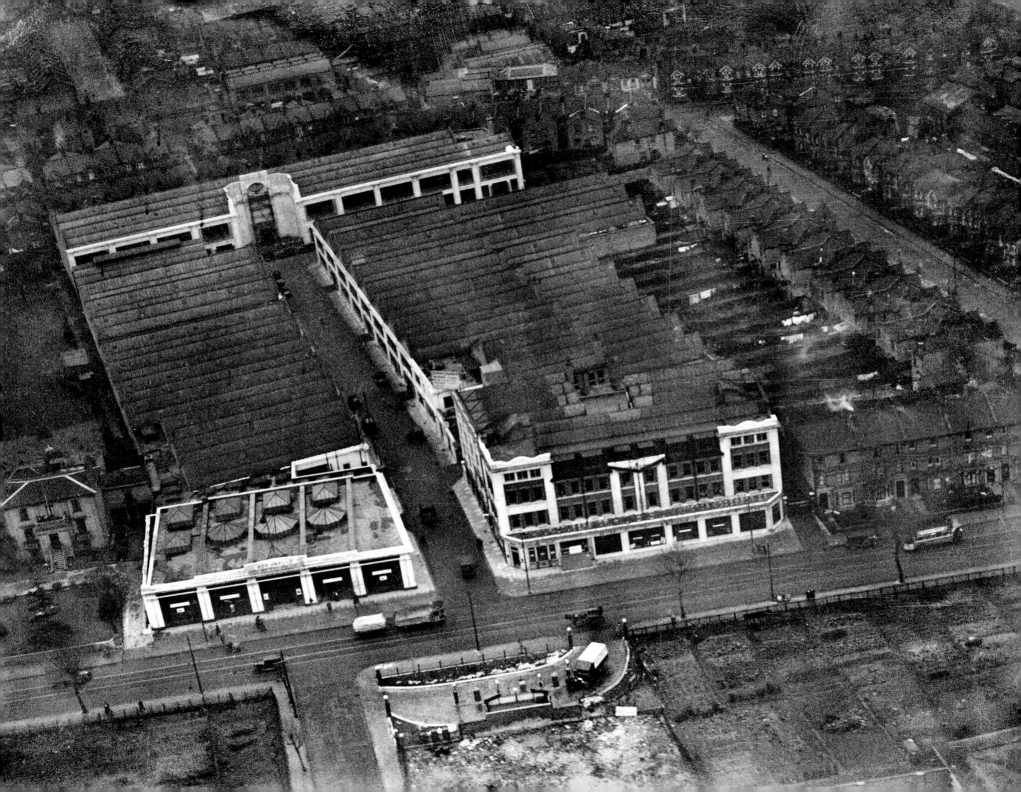

Stewart & Ardern, The Vale, Acton

5 January 1928

Stewart & Ardern Ltd, established in 1912, were the sole Morris agents for London, with showrooms at Morris House, 103 New Bond Street. They built a central service depot in The Vale, Uxbridge Road, Acton, designed by Arthur H Davis & Partners, serving the whole of London. It is seen here when new on 5 January 1928. A showroom block facing Uxbridge Road claimed to be the largest room in London without any central supporting pillars. The firm proclaimed: 'Every model is indeed treated as though it were a valuable jewel to be set out for inspection in luxurious surroundings and brilliantly lighted up with specially arranged illumination.' This 'illumination' took the form of eight lanterns that are clearly seen on the showroom roof. The firm held a stock of some 600 new Morris cars which were stored on site and prepared for sale, together with a large second-hand stock. These departments and workshop accommodation were housed in the northlit sheds lining the side road, the view terminated by a two-storey block with its centre recessed as an eye-catcher from the main road. Stewart & Ardern's policy appears to have changed a few years after the works were constructed as they concentrated on opening large new branches with extensive workshop facilities in suburban centres such as Ilford, Catford and Staines. Only the façade of this block and those on the right-hand side of the central roadway survive today.

EPW020215

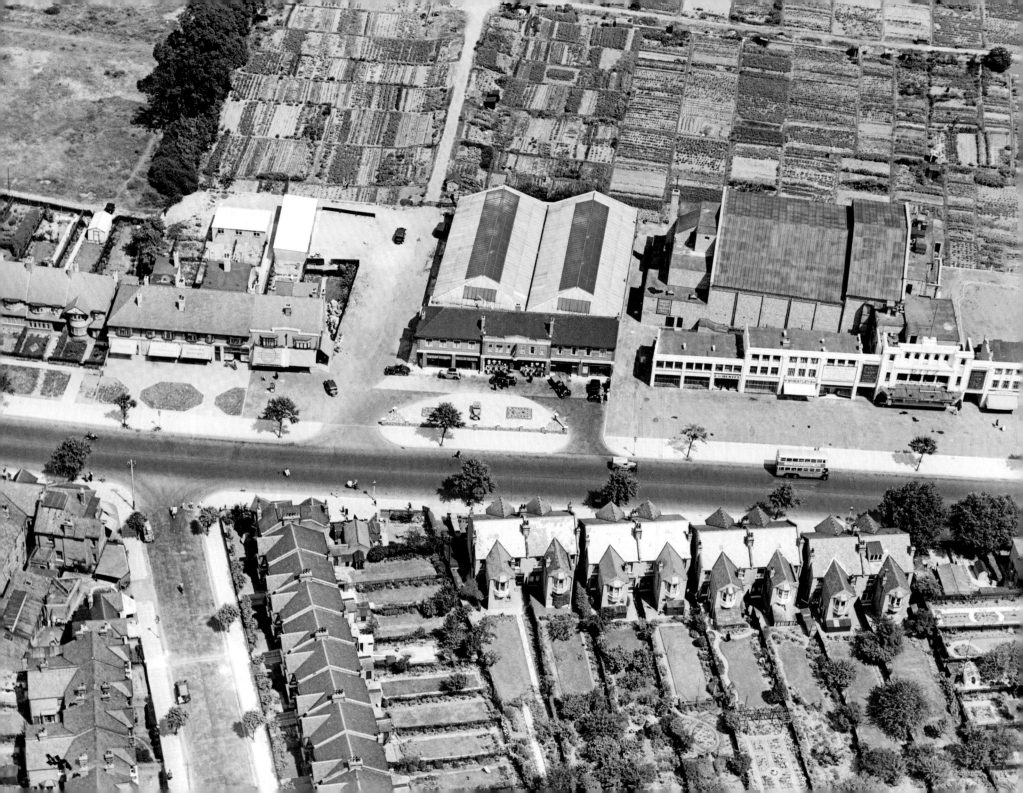

Bowes Road Garage, New Southgate

July 1935

As new suburban shopping parades were built in the 1930s, garages were often included within the neighbourhood shopping centre, sometimes as part of the parade or on occasion, as here, detached from it but built to the same building line so remaining visually part of it. Neo-Georgian styles in red brick were often favoured for the frontages of such garages, enabling them to fit in with their neighbours, although, in this case, the adjacent Ritz cinema and associated shopping parade were rendered. The Bowes Road Garage and Engineering Co Ltd, according to the lettering on its fascia, offers cellulose spraying and high-pressure car washing. The central part of the façade is slightly recessed to accommodate eight closely spaced petrol pumps: a common arrangement in 1930s garages. Behind the façade are two utilitarian workshops, generously lit from above. There is little traffic on the usually busy Bowes Road other than an AEC Renown of London Transport's LT type. Today, although the cinema and the shopping parades either side of the garage remain, the garage itself has been demolished and the site used for parking vans.

EPW048132

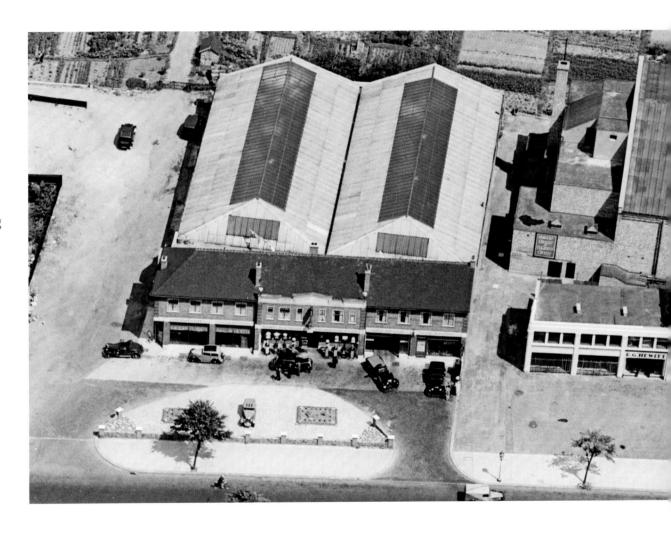

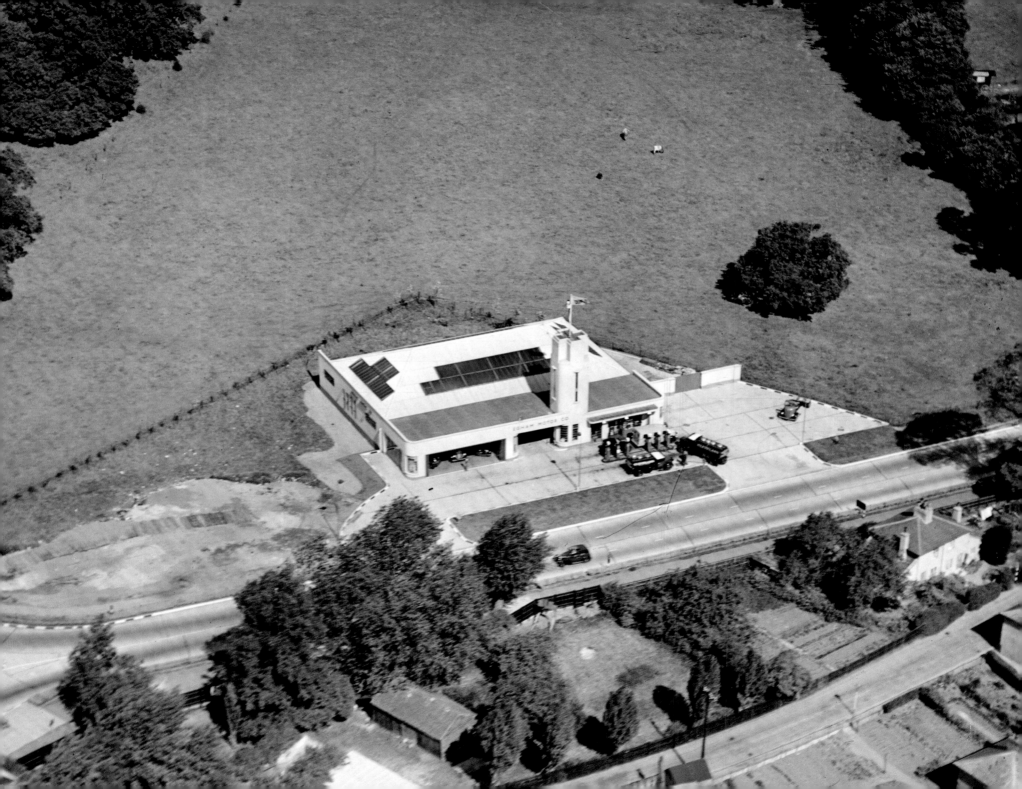

Tower garage, Egham, Surrey

30 July 1938

The 1930s saw a move to garages that reflected developments in car design. As cars became more streamlined, so too did garages, employing unadorned white surfaces, rounded corners and strong vertical features to attract the passing motorist's eye. All these elements are to be seen in the Tower garage, on the Egham bypass, Surrey. Built in 1935 for the Egham Motor Co, Vauxhall dealers, it was designed by the Burnham, Buckinghamshire, practice of Rix & Rix, who were responsible for other moderne garages. This view shows it on 30 July 1938 in its original form. Greatly extended, especially at the eastern end, in a sympathetic style, it still exists today and is listed Grade II. Since 1967 it has been the premises of Maranello Concessionaires, the Ferrari importers, and an attraction to motoring enthusiasts.

Afl 03_ r4266

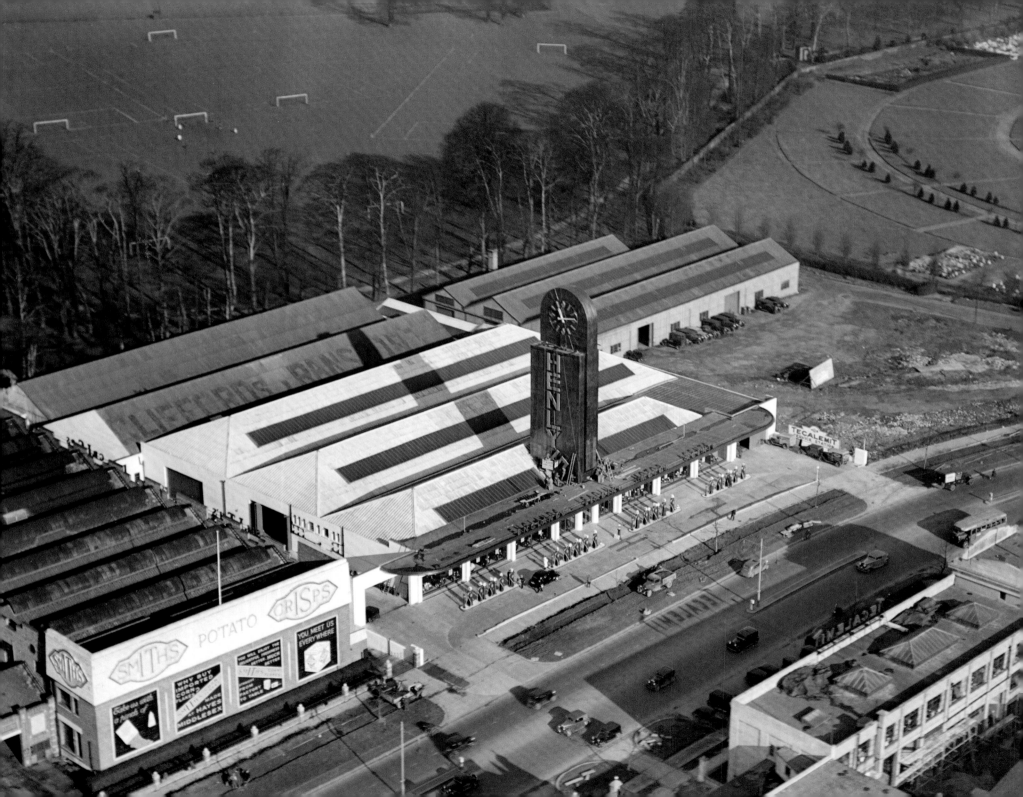

Henly's garage, Great West Road, Brentford
1937

Henly's was a major chain of garages from the 1920s to the 1970s. Its 1937 premises on the Great West Road, Brentford, was seen as a showpiece for the company. It was designed by Wallis, Gilbert & Partners, who were the architects for many of the art deco factories on the Great West Road such as Firestone as well as the striking Hoover factory at Perivale. The line of 22 petrol pumps was covered by a curved concrete canopy running the length of the building while the 130ft high tower, of steel construction and clad in lacquered steel sheeting, stood out as an illuminated neon beacon at night. The final 'S' of the name is being added to the tower. Henly's incorporated two bays of an existing transport depot at the rear. The company's founder and chairman, H G 'Bertie' Henly, felt that the building

was far superior to any of the service stations he had seen in the course of a fact-finding visit to the United States. The building, which had become a warehouse for Martini, was demolished in the 1960s, and only the tower remained until it was largely destroyed by fire in 1989. It was replaced by a replica that retained the basic form of the structure but none of the detailing, incorporated into an office building on the site. Henly's is no more: transformed into a business that undertook commercial vehicle manufacture, the group went into administration and was broken up in 2004–5. Opposite are the premises of Tecalemit, who produced lubrication bays and some of the first car washes.

Afl 03_ r2036

Kenning's, Sheffield

31 July 1959

By the late 1930s the larger garage groups were putting up substantial buildings fulfilling the roles of car sales, repairs and service, and filling stations. Kenning's, a chain that expanded considerably across the north Midlands and beyond during this period, built a very large central garage in Sheffield near the Midland station in 1937–8 (architect: F W Tempest). The filling station was recessed within the ground floor of the building and, like many garages of the time, its flat roof was used for parking and accessed by a vehicle lift, a feature that can be clearly seen in this photograph. Just to the left of the garage is the extensive Shoreham Street depot of Sheffield Corporation Transport. It was built as a tram depot in 1910 and later extended to take motor buses to the rear. Its last tram had departed some months earlier at the end of February, when it was converted to house only buses. On the right, one of the final design of Sheffield trams, a Roberts car of 1952, is seen in Pond Street. Sheffield was the final inland town in England to retain trams – the last ran in 1960. Kenning's is now the Showroom cinema, café and offices but only the octagonal towers of the tram depot remain, retained as a frontispiece to a development of flats.

Afl 03_a77734

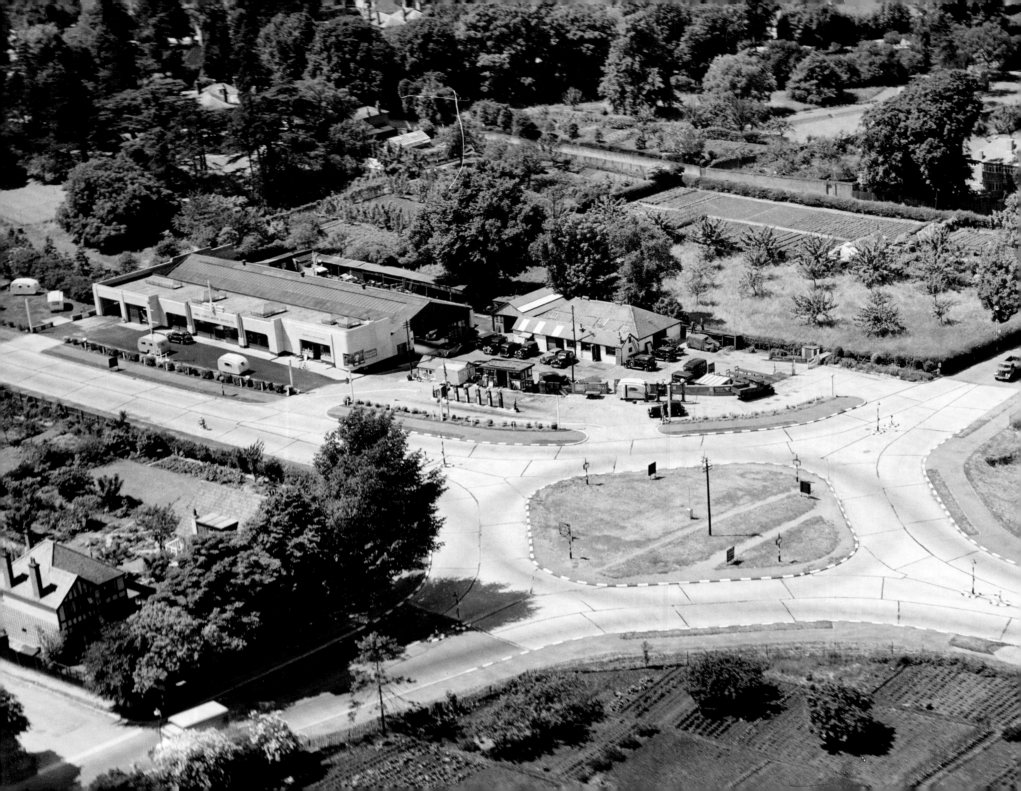

Ewell Downs Motor Services, Ewell, Surrey

11 June 1937

Ewell Downs Motor Services Ltd's garage at the junction of the Ewell bypass and Reigate Road, Ewell, Surrey, shows how a garage could develop over the years. The original buildings are located behind the petrol pumps but, to their left, a large new showroom has been constructed in a moderne style, with top lighting, backed by a large and utilitarian workshop. The firm evidently made a speciality of caravan sales. The garage is typical of many that sprang up at major road junctions on the outskirts of built-up areas where land was relatively cheap. The tarred joints of the concrete road surfaces are very prominent, as is the liberal use of black and white paint on kerbs to warn the motorist of the roundabout, which was not well lit. There is still a filling station at this site today but all the garage buildings seen here have gone.

Afl 03_ r3003

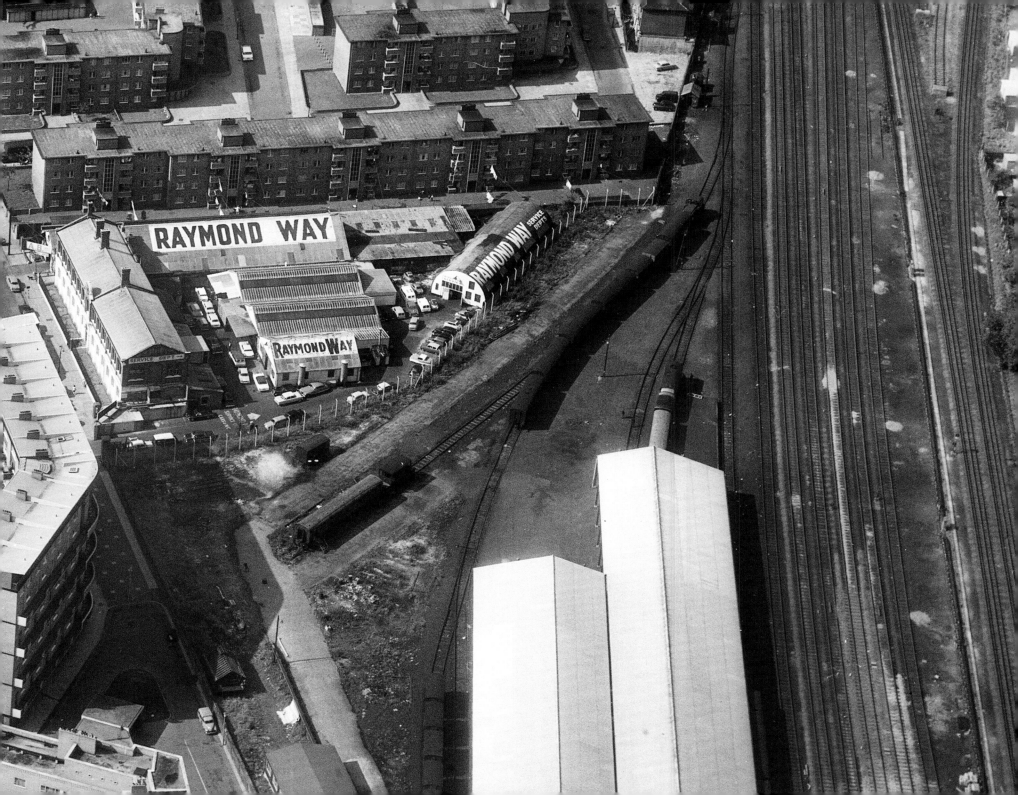

Raymond Way, Kilburn

28 August 1963

Raymond Way was a larger-than-life character who specialised in second-hand cars on hire purchase terms. He was a great believer in publicity, running large advertisements in the weekly motoring journals and, as can be seen in this photograph of 28 August 1963, he ensured that his business stood out from the air. His premises were interesting. The main building on Canterbury Road had been constructed as the offices of the signal works of Messrs Saxby & Farmer in 1863, the largest of its kind in England and probably the world at the time. The company moved to Chippenham, Wiltshire, in 1906 and the site was acquired by the Humber Co in 1910 for their London service depot. Humber erected a workshop building in 1910–11 adjoining the existing office building at its west end, and further workshops to the rear. In turn, it vacated the site which was taken over by Raymond Way. The 1863 building survives today, as does the long Humber workshop of 1911, still used as a garage.

Afl 03_a119667

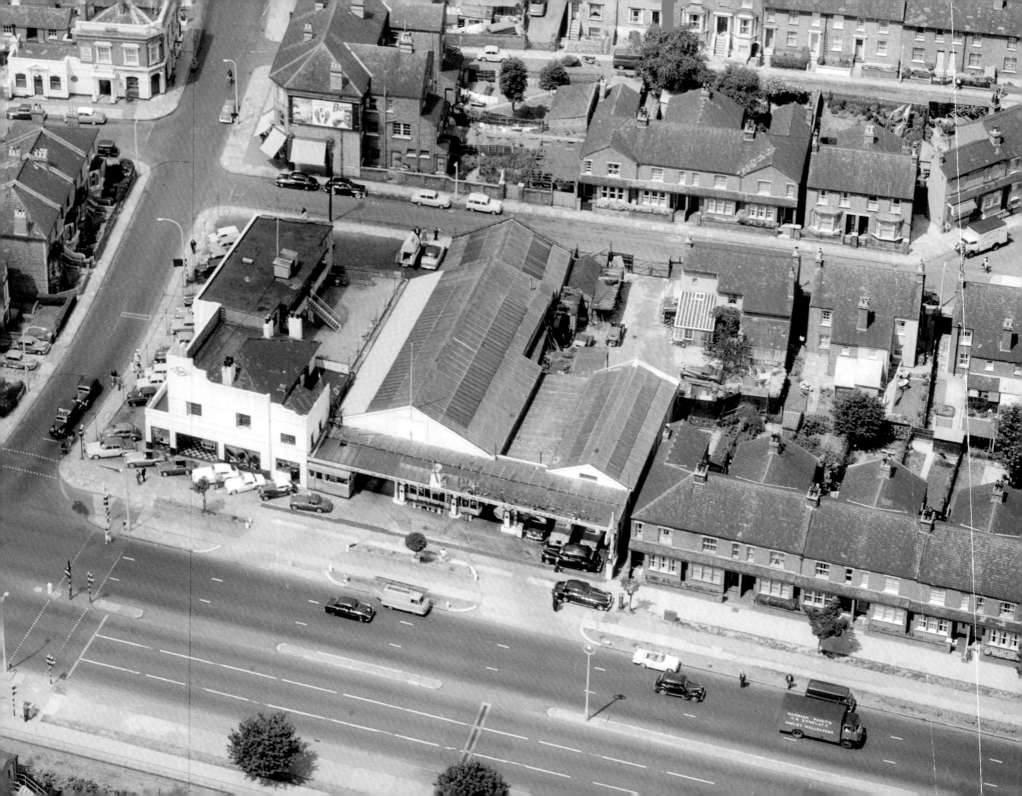

Performance Cars, Brentford

24 June 1961

Certain garages achieved a fame that extended far beyond their locality. One such was Performance Cars, located on the Great West Road at Brentford. Its monthly advertisements in *Motor Sport* throughout the 1950s and 1960s contained an extraordinary selection of vintage and sports cars. In one issue alone, that for August 1953, it had seven vintage Bentleys for sale from £125. The aerial view reveals that the apparently moderne block on the corner of the premises is in fact a Victorian house given a new façade with metal windows, its hipped slated roof hidden behind a high parapet enabling it to harmonise with the new block behind. Such modernisations were a feature of many garages. The workshops adjoining have pumps located under a canopy. But it was the stock of cars that stood out, and these included an Austin Healey, an Aston Martin DB2, a Triumph TR3 and an MG TD Midget when this view was taken. There is also a Rolls-Royce Silver Cloud and an Austin Princess. A Toyota showroom now stands on the site.

Afl 03_a91574

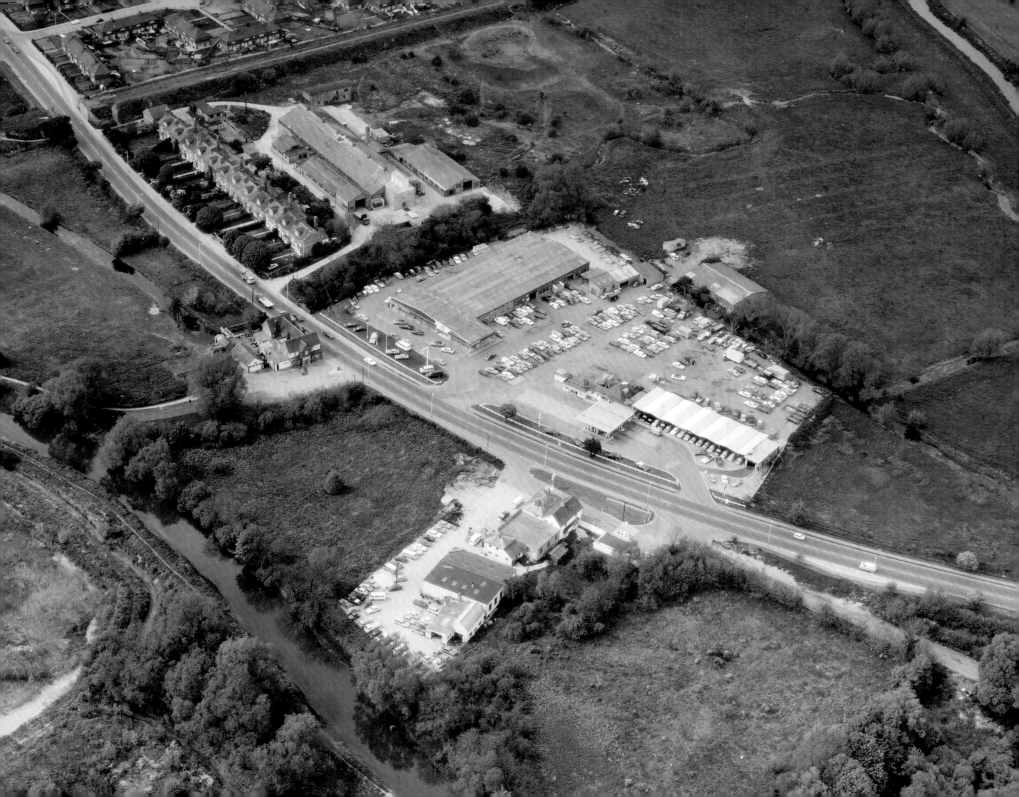

Gowrings, Newbury, Berkshire
17 May 1972

By the end of the 1960s, garages tended to be set back further from the road with an extensive forecourt, used for displaying cars. They also occupied more land, with extensive surface car parking space. Both these characteristics are clearly seen in this view of Gowrings of Newbury, a Ford dealership, of London Road, Newbury. The garage sold petrol, with a large flat canopy over the pumps: something that was to disappear in the next decade as large garages moved out of petrol sales, using the space created for the display of more cars. On the right is a large series of ridge and furrow canopies covering the stock of second-hand cars for sale. There was a vogue for open canopies of this type in the 1960s but today they are rarely to be seen, with most second-hand cars simply displayed in the open. Gowrings are now based at the Newbury Automotive Park and the London Road site is simply a filling station, with all the buildings in the 1972 photograph demolished and much of it sold off for office development. This indicates the extent of change in the motor trade sector: even relatively recent buildings disappear without trace. The semi-rural setting, too, is no more: the filling station is surrounded by the big sheds and car parks of 21st-century commerce, a reminder of how much landscapes change over time.

Afl 03_a230879

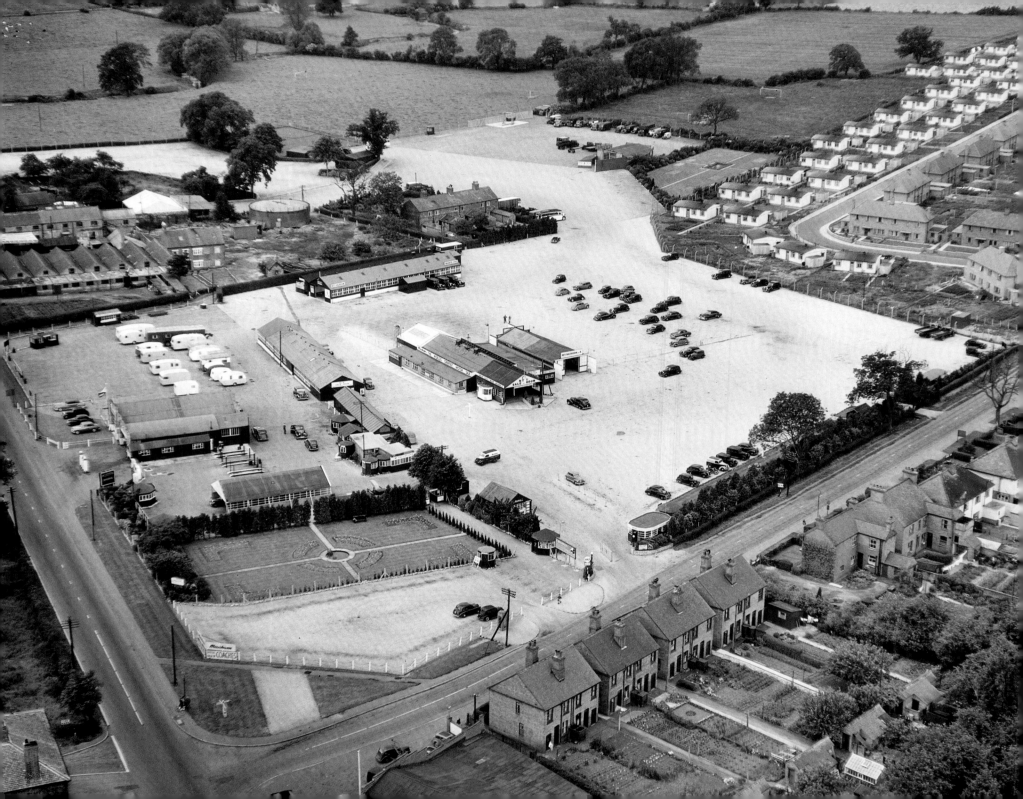

Measham Motor Auctions, Leicestershire

14 July 1954

An essential, if often overlooked, part of the
motor trade is the car auction, through which
much of the wholesale part of the second-hand
car trade is conducted. The largest car auctions
were held at Measham. Various sale rooms are
located around the site, which would normally be
filled with cars in the course of an auction, both
those for sale and the parked cars of the buyers.
To the left of the site is a garage with pumps and
a number of hydraulic ramps to enable buyers to
inspect cars. Most of the cars visible are British
although there are a couple of 1940s American
models. Commercial vehicle sales take place at the
far end of the site. It still functions today as part
of British Car Auctions but far more extensive
covered accommodation has been provided.

Afl 03_r20935

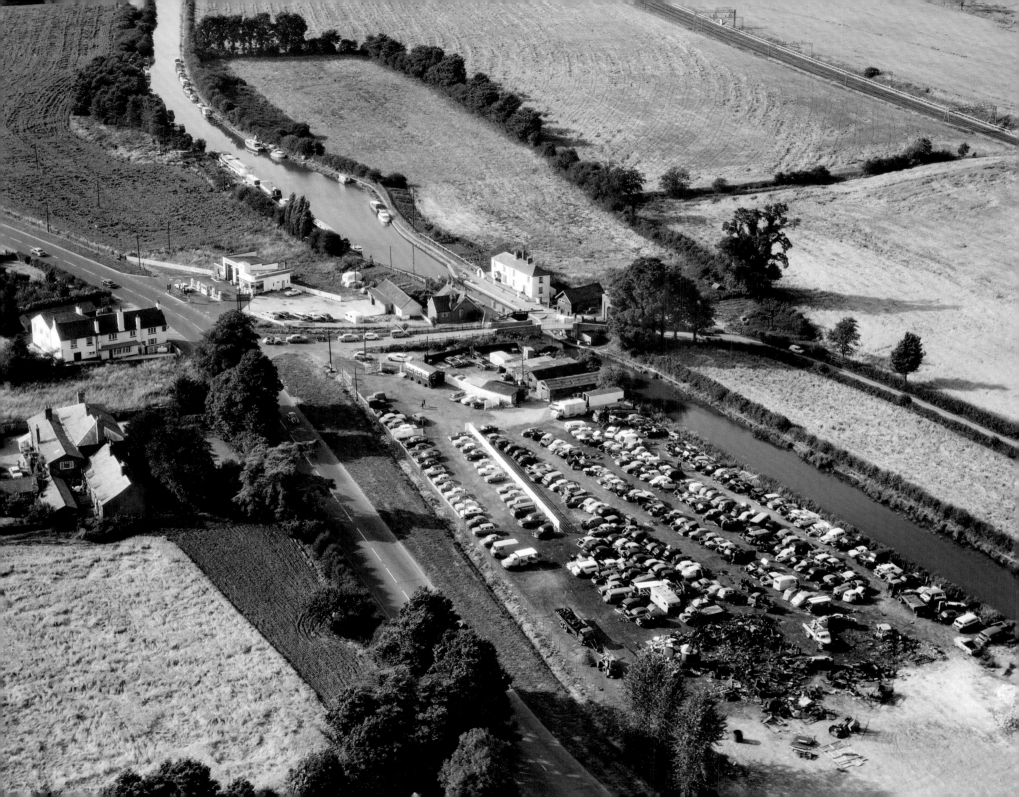

Scrapyard, Tring, Hertfordshire

25 July 1967

At the end of the line is the scrapyard. This is one at Tring, Hertfordshire, near the Cow Roast Inn, alongside the Grand Union Canal and, beyond, the West Coast main line. The yard is a relatively small one and is much more orderly than many of this era. The cars are not stacked up on top of each other and neither is the site overgrown, with cars vanishing into the undergrowth, as was common in this period. Most of the cars are fairly recent, suggesting that the majority are being scrapped because of accident damage rather than through being worn out, although there is a sprinkling of pre-war designs. Among the more interesting vehicles in the foreground is an Armstrong-Siddeley Sapphire. The site is hidden from the road by a display of second-hand cars for sale, all of them British other than a VW and a Renault Dauphine, and including such delights as a Standard Pennant, a Hillman Husky and a relative rarity in the shape of an Austin A70 Hereford with 'woodie' estate car body. At top left is a typical Esso filling station of the 1960s with a small kiosk for the petrol pump attendant and a couple of lubrication bays next to the office.

Afl 03_a174913

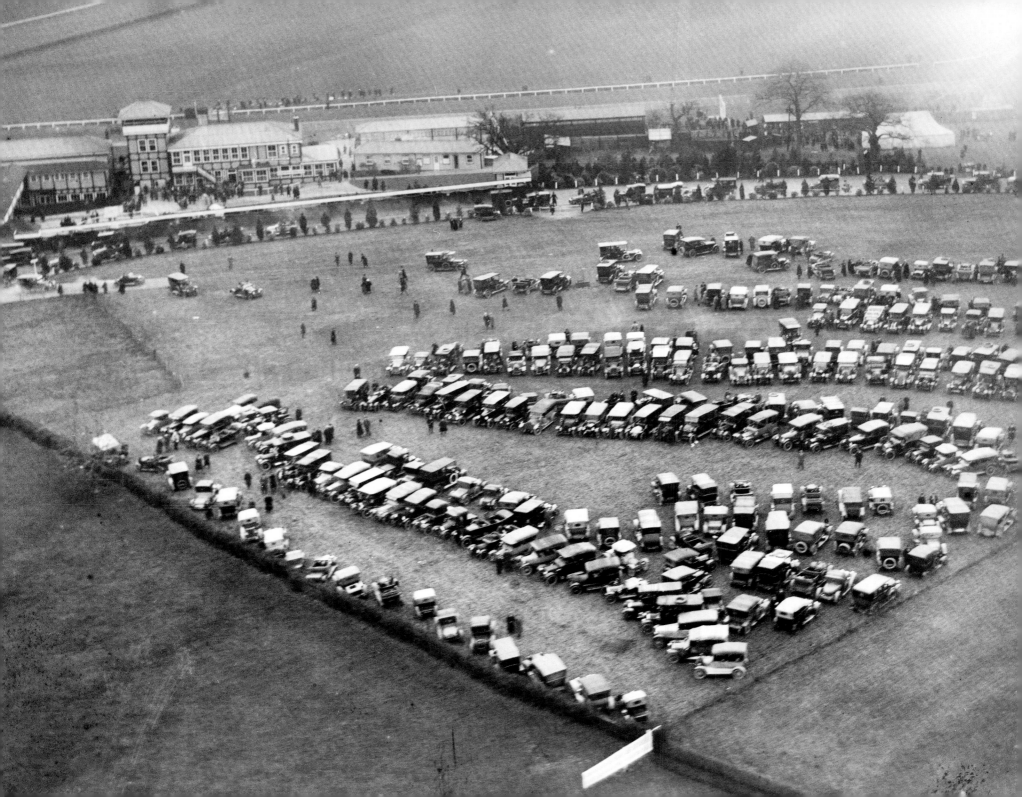

Cheltenham racecourse

March 1920

Horse racing attracted large numbers of motorists
from the earliest days. This is the car park at
Cheltenham racecourse. The cars are parked in
a curious layout that must, with the large turning
circles then usual, have caused some difficulties in
manoeuvring when exiting. Many of the cars date
from just before the First World War and include
some fine limousines, but more modest vehicles
are also present including several light cars and at
least one Model T Ford.

EPW000194

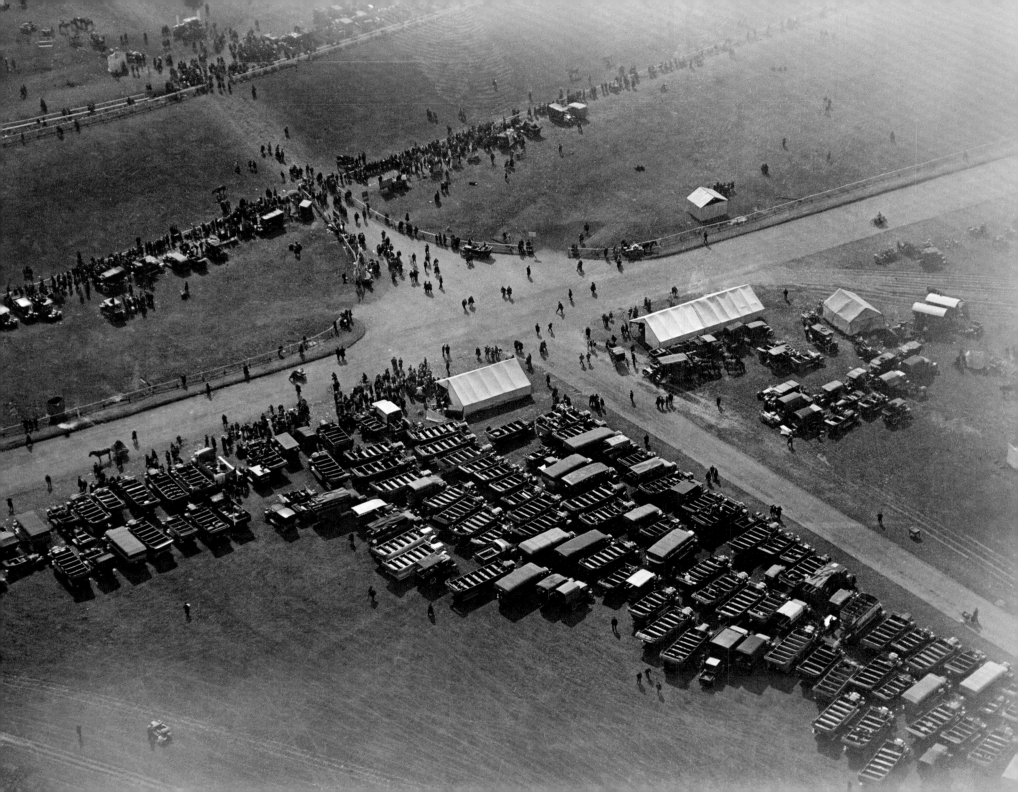

Derby Day, Epsom

1922

The early 1920s were the heyday of the charabanc. These vehicles were open, with the seats running across the coach, each row of seats being served by individual doors. Many were built on ex-War Department chassis that became available after the First World War and a sizeable number had detachable bodies that could be replaced by a flat bed lorry, thus enabling the vehicle to earn its keep for seven days a week. Derby Day at Epsom saw large numbers of charabancs congregate and over 90 are visible in this view of 1922. Charabancs had hoods which could be put up in the event of rain, although most here have their hoods down.

EPW007656

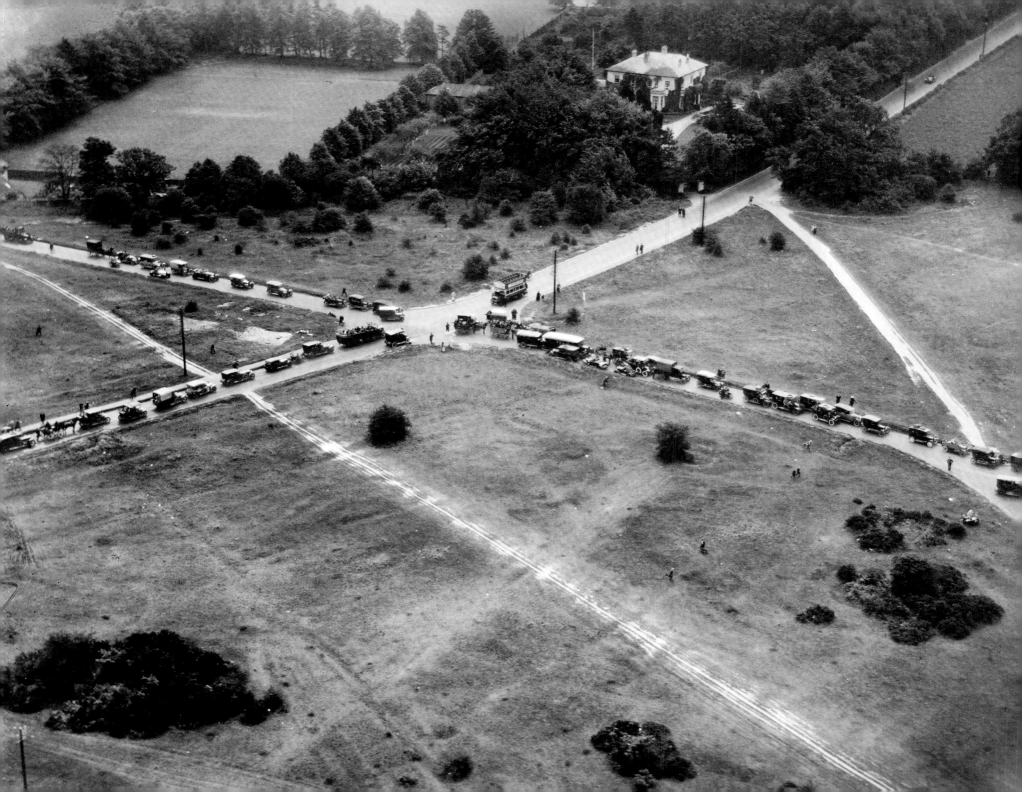

Banstead Road, near Epsom

1923

The Derby provided some of the first road congestion to be seen outside city centres. Although there were two railway stations within a short walk of the racecourse, Tattenham Corner and Epsom Downs, together with two in Epsom itself at this time, many well-to-do people preferred to drive so that they had all the essential trappings of a visit to the races with them: the picnic hamper and a generous supply of bottles of cooled wine. This view taken on Banstead Road shows a somewhat confused scene which a policeman is trying to control. Most of the cars are large and luxurious saloons and sedancas. Some well-laden horse-drawn carts, a number of charabancs and a double-deck bus of the S type, probably belonging to the East Surrey company, complete the picture.

EPW008678

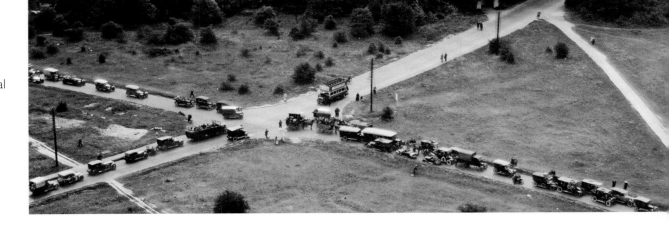

As well as the large numbers of private cars
heading for the Derby, many buses brought
race-goers from Epsom town. Here a line of the
buses, all London Transport double-deckers, are
parked awaiting the return journey. Most are
of the STL type, the standard LT design of the
period, but the third vehicle from the left is a
six-wheeled LT type while the seventh, eighth and
ninth are of the ST design introduced in 1930.
All were built by AEC at Southall (see pp 92–3).

Afl 03_r2897

Brighton Road, Horley, Surrey

4 October 1933

Facilities catering for the motorist grew steadily from the mid-1920s, especially along roads that led to popular seaside resorts. This is one such cluster on the Brighton Road at Horley, Surrey. In the centre of the view is the Chequers Hotel, typical of many older inns which were expanded to meet the new demand. Extensive new refreshment rooms have been added to enable large coach parties to eat or drink quickly during a short refreshment stop. Only coaches on long-distance routes had toilets so a stop during a two-hour run was essential. Even at this date, much of the land in front of the hotel has been laid out for car parking. Immediately to the left of the Chequers is a tea room, an idea that took off in the late 1920s to the point where it was described as a 'craze' in the motoring journals. A filling station and garage stands in the junction of the two roads at the bottom of the photograph, triangular sites like this being a popular arrangement for filling stations of the period. The pantiled buildings are quite substantial and an effort has been made at landscaping the forecourt with lawns and urns adjacent to the petrol pumps, which are spread out – layouts for filling stations were not at all standardised in the early 1930s. The RAC has a telephone box just below the signpost by the filling station. The Brighton Road, diverging to the left, is distinguished by its concrete surface. Because through traffic has been diverted to the M23, the location is

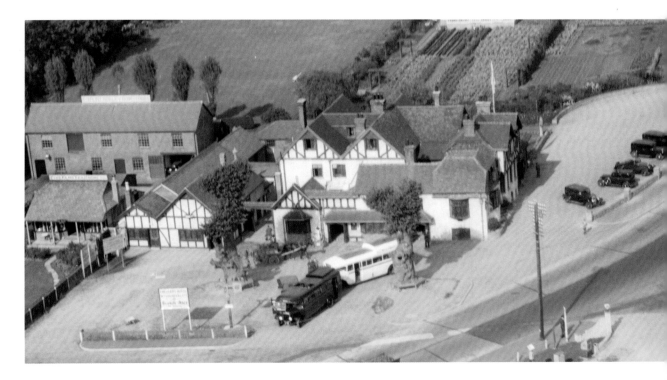

still recognisable today and both the hotel and the garage remain. The hotel has been greatly extended and surrounded by car parks, while the garage has been completely rebuilt. The tea room is no more and the fields in the background have been built over.

Afl 03_h712

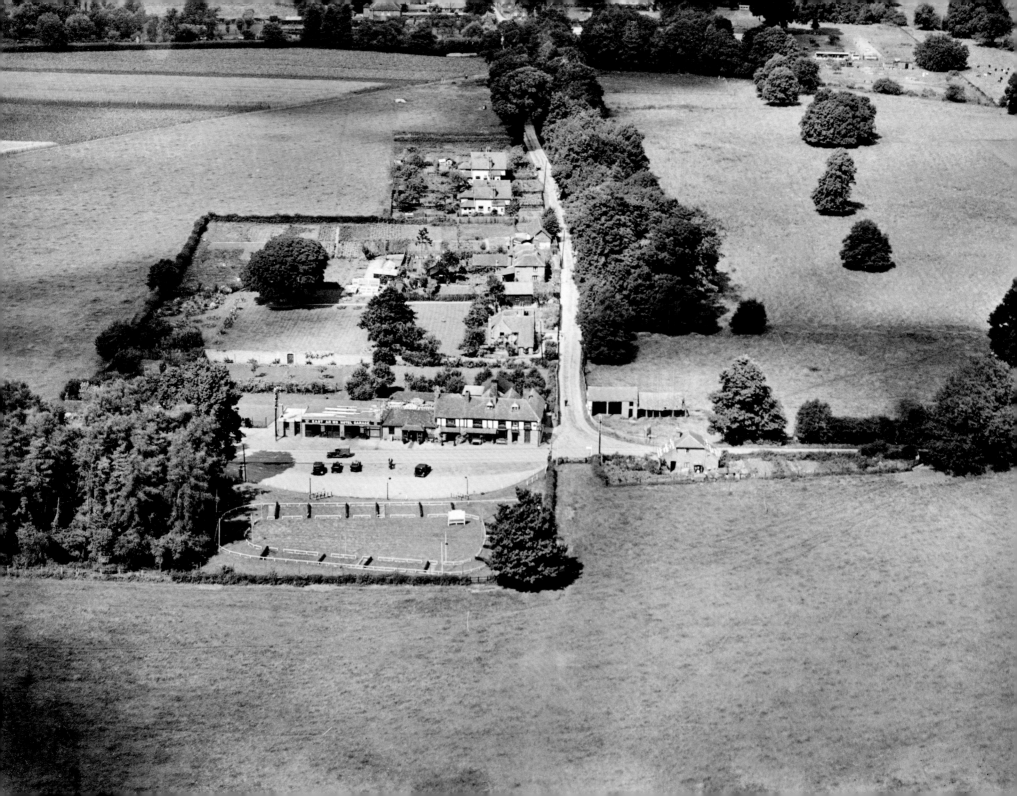

East Arms Hotel, Hurley, Berkshire

12 August 1931

The increasing numbers of motorists using the
roads gave a shot in the arm to many rural
inns, which were able to provide meals and
accommodation for them. The East Arms Hotel
at Hurley lay on the road from Maidenhead
to Henley and provided garaging for its clients'
cars, and it most probably operated as a general
roadside garage in addition. The area has seen
housing growth, being only four miles from
Maidenhead, and the inn has been replaced
by large detached houses.

EPW036191

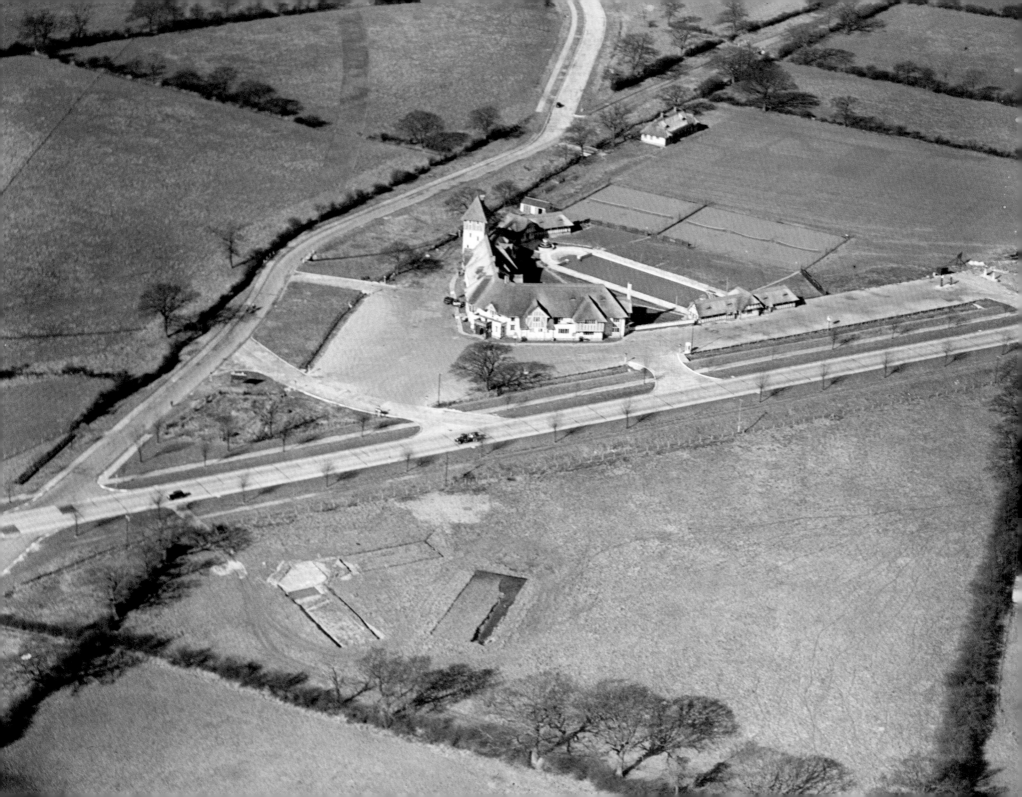

The Thatched Barn, Barnet bypass, Hertfordshire
March 1935

Roadhouses proved to be a short-lived craze in the early 1930s but one that achieved a currency in literature in excess of their actual numbers. Among the best-known was the Thatched Barn on the Barnet bypass, Hertfordshire. It satisfied all the requirements for a roadhouse, as may be seen in this photograph. It was located just half an hour's drive from town on one of the new arterial roads leading out of London; its concrete surface and cycle path stand out. It had a heated swimming pool measuring150ft by 50ft, floodlit and sublit, with single-storey changing rooms at each end. Inside the principal building, with its Norfolk reed roof and ornamental water tower, were a squash court, cocktail bar and lounge, a sprung dance floor and a restaurant. Beyond the pool are hard tennis courts, a baseball ground and a sports pavilion. The Thatched Barn was built in 1927, reputedly at a cost of £80,000, and became a roadhouse in 1932. It was occupied by the Special Operations Executive for developing secret weapons in the Second World War. Some of them, such as an exploding rat, were worthy of James Bond himself. It enjoyed a final period of fame in the 1960s as a location for *The Saint* and *The Prisoner*. After this somewhat chequered history, it was demolished in the late 1980s and replaced by a hotel.

EPW046584

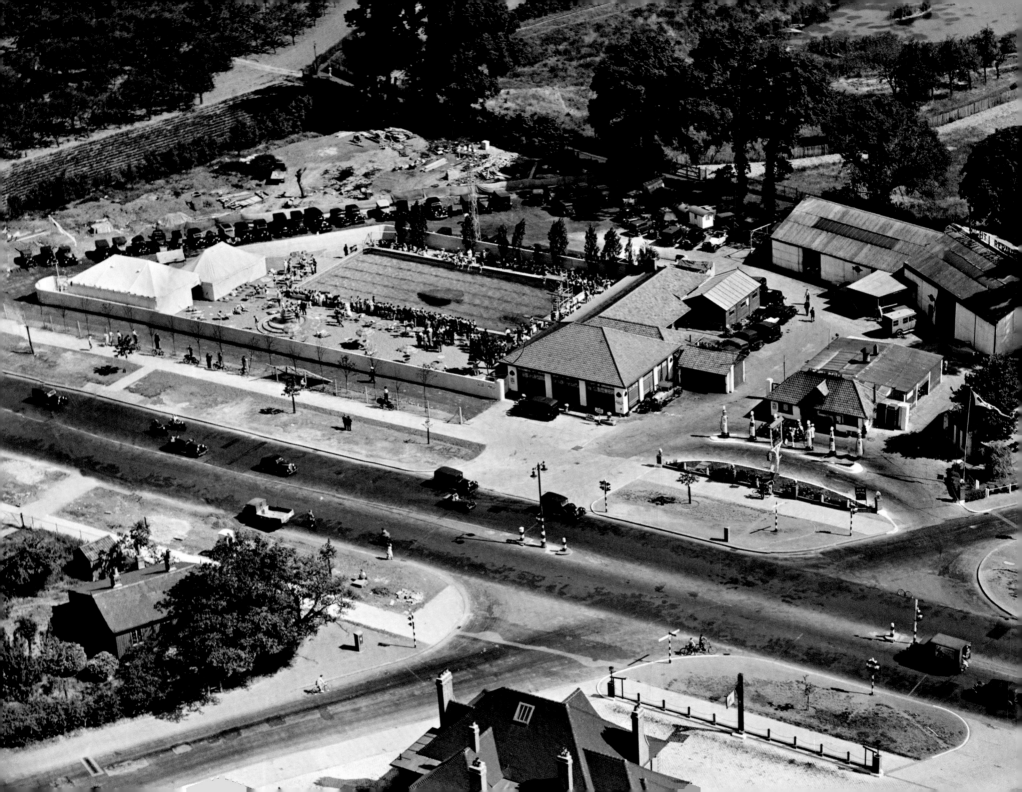

Ace of Spades, Great West Road, Heston

July 1934

The Ace of Spades on the Kingston bypass was probably the best known of all roadhouses. It had a smaller branch at Heston, well placed on the Great West Road, far enough to be a good drive from central London but not too far to visit for an evening. This view has been reconstructed from a glass plate on which the emulsion has begun to peel but it illustrates perfectly a roadhouse fully in use. The pool is packed, the car park is full and everyone appears to be having a whale of a time. The fairly rudimentary nature of many roadhouses is evident with the pool, café and filling station in close proximity, marquees being used as changing rooms. One criticism often made of roadhouses was that there was a pervading smell of petrol and a deafening roar from the passing traffic and one can certainly imagine this to be the case at the Ace of Spades. The site has a half-finished look with canvas screens at the back of the car park hiding building works beyond. The filling station building with the words 'Ace Petrol' on cut-out lettering on the roof ridge is neat enough, but the two large workshops behind are utilitarian corrugated iron structures. The reference to 'All Night Repairs' is a reminder that 24-hour service was common before the Second World War, while the café and restaurant in the single-storey building to the right of the pool was also open all night. Next to the café, the 'motor ambulance' or breakdown truck is a conversion from an early 1920s Rolls-Royce. Many large and powerful luxury cars ended their lives in this humble capacity. Outside the complex, a number of somewhat voyeuristic cyclists are standing on their machines to see over the high walls that enclosed the swimming pool. On the other side of the relatively quiet arterial road stands a newly built pub of the well-known Chiswick brewers, Fuller, Smith & Turner, 'The Master Robert' (which in the early 1960s became one of the first motels in London). The presence of this large pub opposite the Ace of Spades reflects the often forgotten point that many roadhouses were not in fact licensed and depended on swimming, dancing and meals for their income.

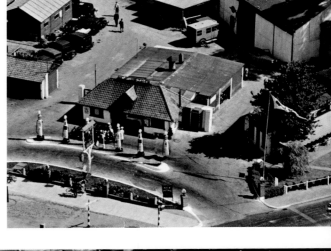

EPW045355

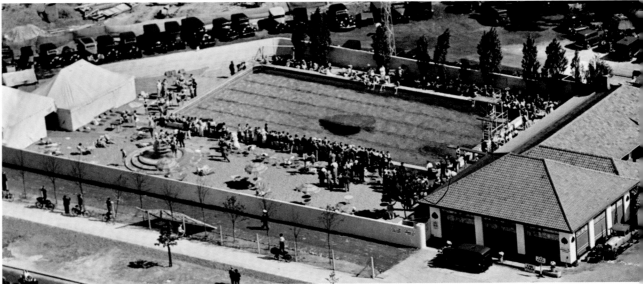

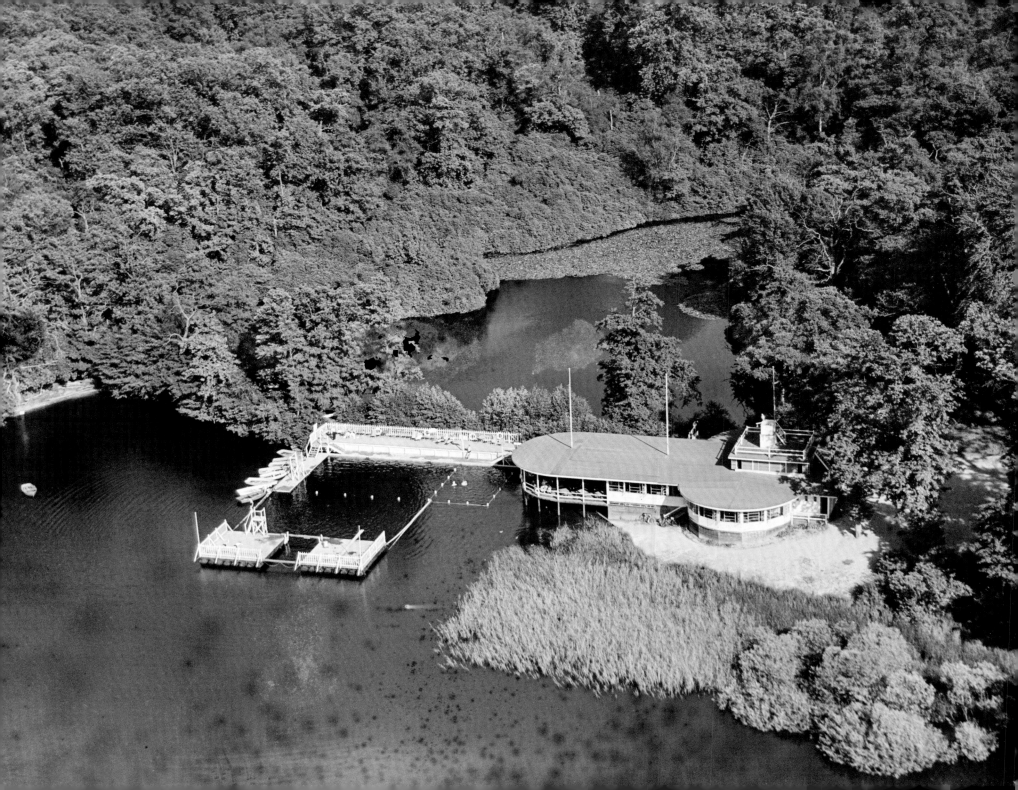

The Laughing Water, Cobham, Kent
20 July 1936

The Laughing Water roadhouse was built in 1933,
at the height of the roadhouse craze, for the Earl
of Darnley on the edge of a lake on his Cobham
Hall estate in Kent. It was just off the main Dover
road in an idyllic setting. The roadhouse was
built entirely of wood and had three balconies,
that to the north jutting out over the water.
Designed by Clough Williams-Ellis, the architect of
Portmeirion, who had a particular interest in this
type of building and wrote about it at length in
the architectural press, it has subsequently been
demolished.

EPW051613

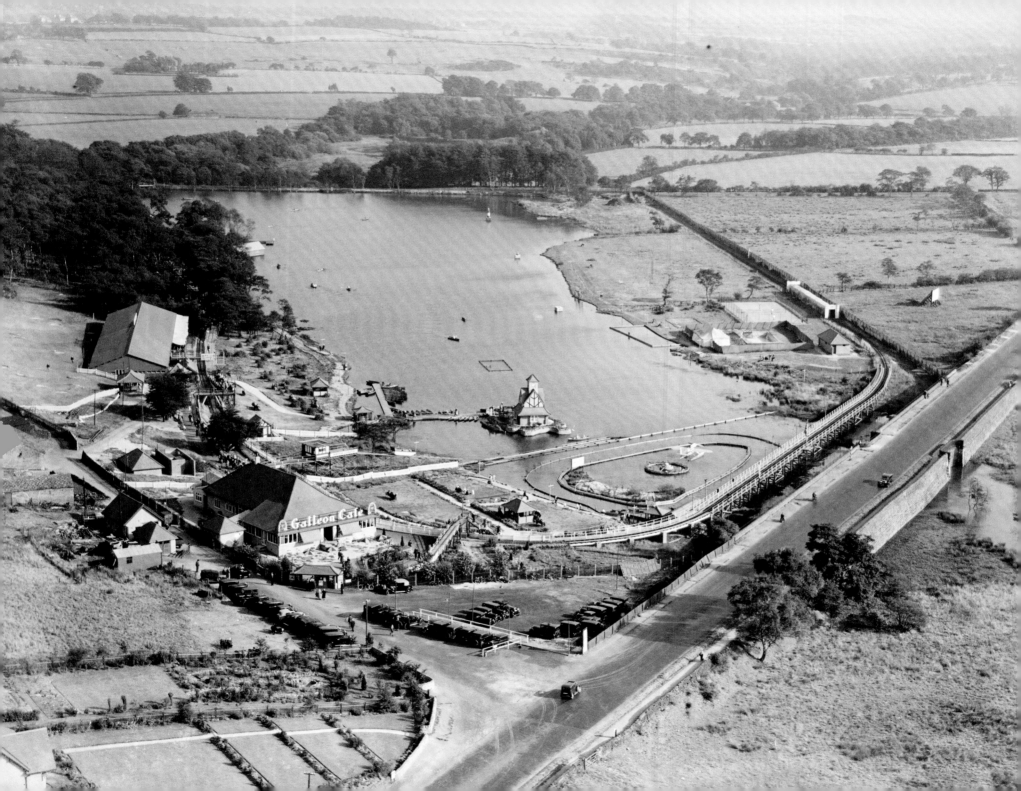

Golden Acre Park, Bramhope, Yorkshire

September 1933

The growth of motor transport encouraged entrepreneurs to open what would be described today as visitor attractions or theme parks in the country, within reach of larger centres. One such place was Golden Acre Park, centred around a lake formed from a dam, at Bramhope, north of Leeds. Frank Thompson opened the park on 29 March 1932. He was trying to create an American-style amusement park, inspired by Blackpool Pleasure Beach. Beyond the well-filled car park can be seen the Galleon Café, a miniature railway encircling the site, a water chute, and parts of the lake laid out for motor launches and rowing boats. Other attractions included a dance hall, tennis, pitch and putt, ponies and the Blue Lagoon swimming pool. The clock tower on an island in the lake was fitted with loudspeakers that blared out music and announcements. Although the park was served by buses, it is an example of something that would have been almost impossible to establish without a substantial car-owning public. In the event, it failed in 1938 and remained derelict until taken over by Leeds City Council in 1945. The emphasis was now on horticulture rather than entertainment, with an arboretum and ornamental gardens. The park remains open today and houses the National Collections of lilacs, hostas and hemerocallis.

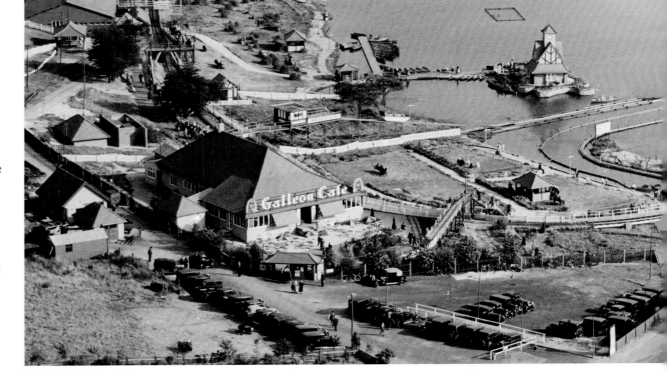

EPW043163

Out for the day

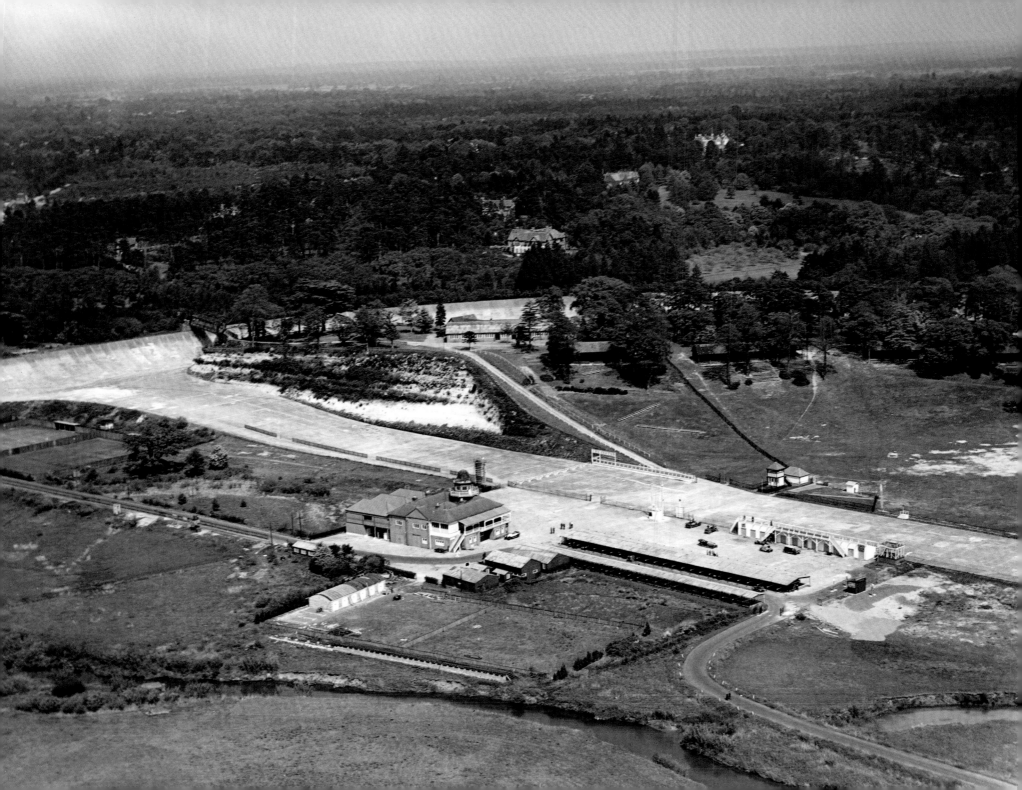

Brooklands, Surrey
1921

Brooklands was the first purpose-built motor racing track in England. It became the centre of motor sport until its closure in 1939 on the outbreak of war. Opened in 1907, it was a private venture by H F Locke-King who felt that such a venue was essential to test cars if the British motor industry was to remain competitive with that on the continent. By the time this photograph was taken in 1921, it had become established as an essential part of the social scene, something rather select: 'the right crowd and no crowding'. The photograph shows the clubhouse in the centre, adjacent to the paddock alongside the Finishing Straight. On the opposite side of the track, looking rather like a railway signal box, is the judges' box. Beyond it is the Members' Enclosure and the Test Hill, where members of the Brooklands Automobile Racing Club, which controlled racing at Brooklands, could practise hill climbing. In the foreground are some small sheds used by motor cyclists to prepare their machines and a couple of hard tennis courts, installed in 1911 for the Brooklands Lawn Tennis Club. The high concrete Members' banking, at this point with a 32ft super-elevation, which characterised the circuit more than anything else may be seen in the background

EPW006229

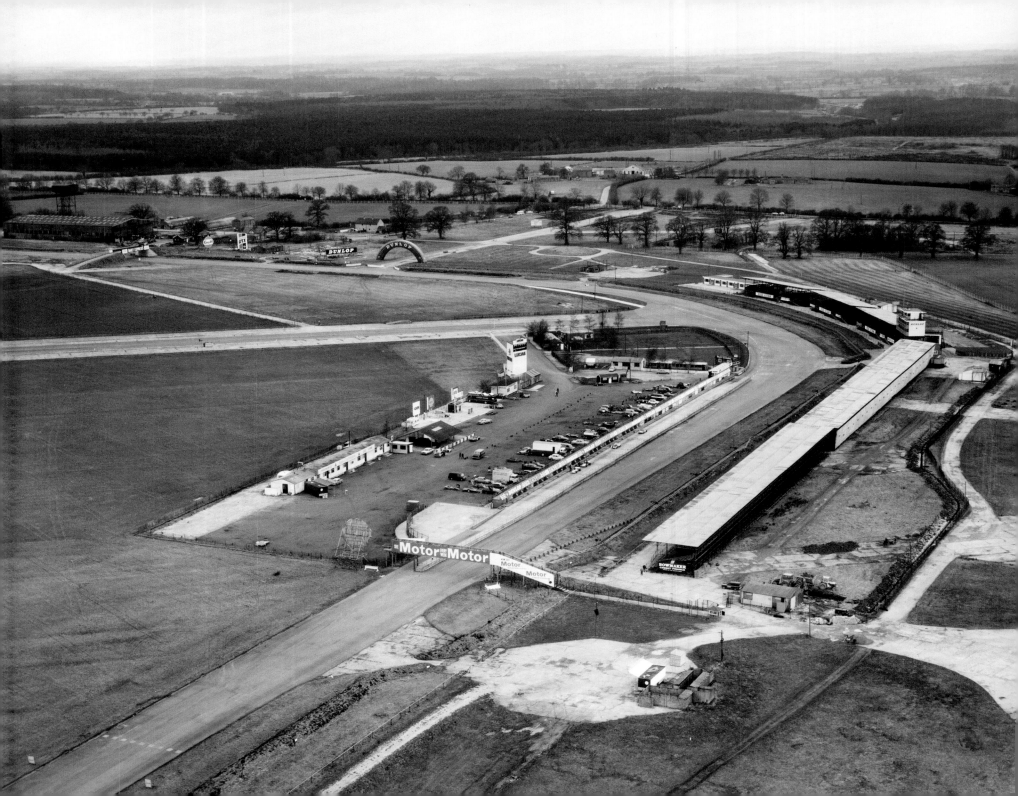

Silverstone, Northamptonshire
1 March 1971

Silverstone is by far the best known of British motor racing circuits and has been, for many years, the home of the British Grand Prix. The circuit's origins as a Second World War bomber station are evident in this view. It opened in 1948 and since 1951 has been operated by the British Racing Driver's Club, who bought the freehold of the circuit in 1971. Its facilities were rudimentary, reflecting the prevailing austerity of the years when it was established. The paddock is in the centre of the track and the buildings are, from left to right: the bar, a conversion from RAF huts, the scrutineer's bay and the newly installed filling station. Adjoining the track in the centre of the photograph are the row of pits with the timekeeper's box above them at the far end and,

on the opposite side, the grandstands, which were little more than a tubular steel framework covered by a corrugated iron roof. In wet and windy conditions, these became decidedly unpleasant for the spectators. Beyond the first two grandstands, the control office stands up above the roofs. At the time of its construction, in the late 1960s, this was by far the most modern and sophisticated building at the circuit. In the photograph it is evidently a practice day, single-seaters being visible in front of the pits and in the paddock but no spectators present. In the intervening 40 years, the circuit has been transformed with a new pit and paddock complex, commenced in 2009.

AfI 03_a210185

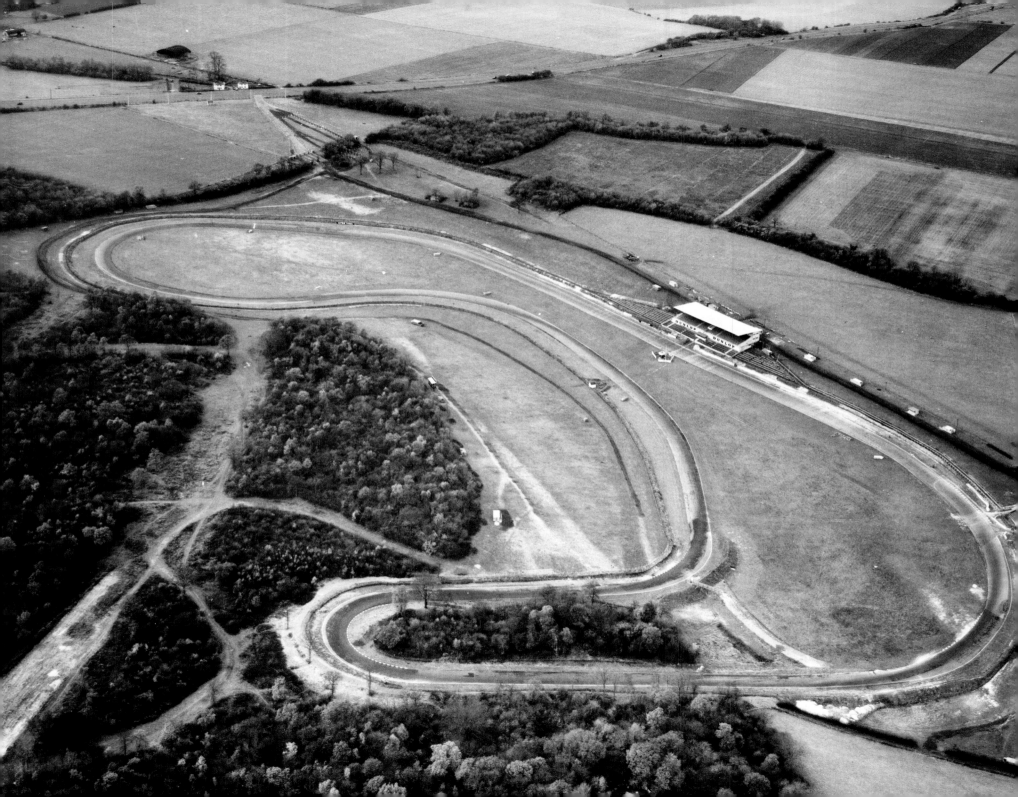

Brands Hatch, Kent

14 November 1955

Brands Hatch, seen soon after the circuit was extended by the loop up the hill to Druids bend, on the bottom left of the photograph. The circuit was originally a motor cycle grass track between the wars, and a surfaced track was home to many Formula Three events in the early 1950s. The original route of the track, in its kidney-shaped form, is apparent, with the short stretch of disused track at the bottom of Druids Hill. At this stage the track was largely used for club racing under the British Racing and Sports Car Club. In 1960 the track was turned into a form suitable for Formula One events by the addition of another loop leaving the existing circuit from the bend on the left to the rear of the photograph, extending the circuit from 1.24 miles to 2.65 miles. It hosted the British Grand Prix in 1964, 1966, 1968 and 1970, since when the race has returned permanently to Silverstone. Facilities for the spectator have expanded greatly, with the circuit now used for international meetings.

Afl 03_a61931

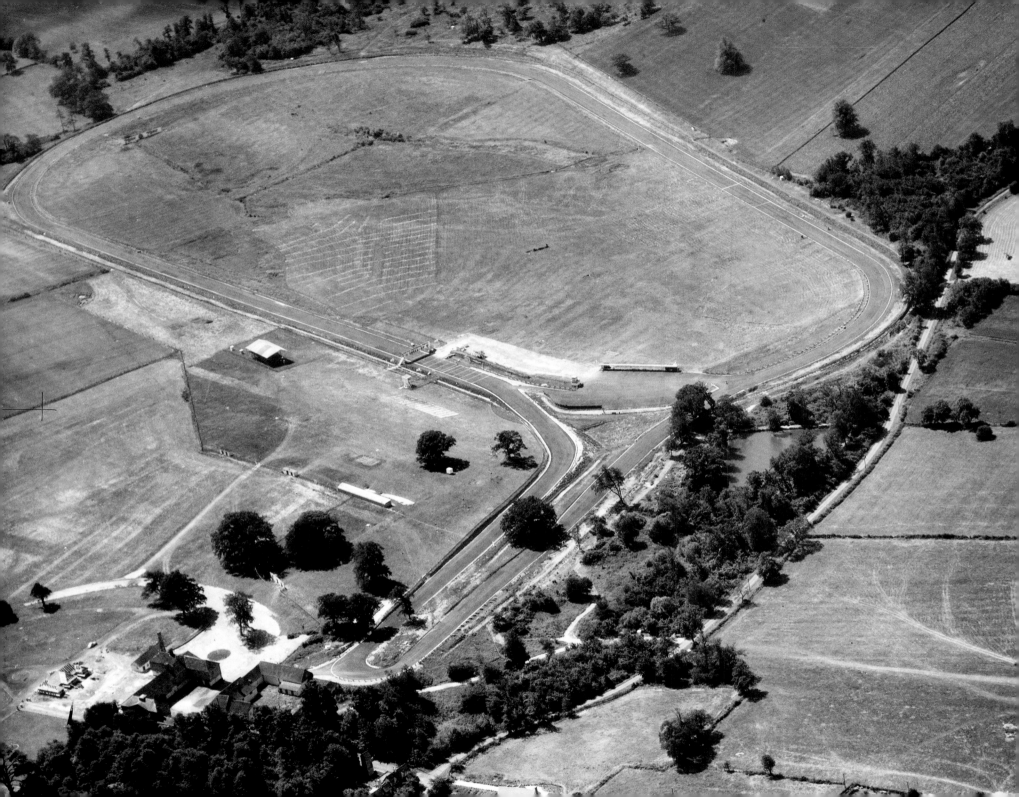

Mallory Park, Leicestershire
25 July 1956

Mallory Park is one of the less well-known
motor racing venues, used mainly for club events,
motorcycle racing and Formula Two. It had its
origins in a grass pony-trotting track laid out in the
grounds of Mallory Park. This proved unsuccessful
and the track was surfaced with a loop running
up to the stables of the Hall, the circuit being
opened on 25 April 1956. The circuit has not seen
large-scale development such as has occurred at
Brands Hatch and Silverstone, and the facilities
amount to little more than the single grandstand
on the left of the photograph.

Afl 03_ r27508

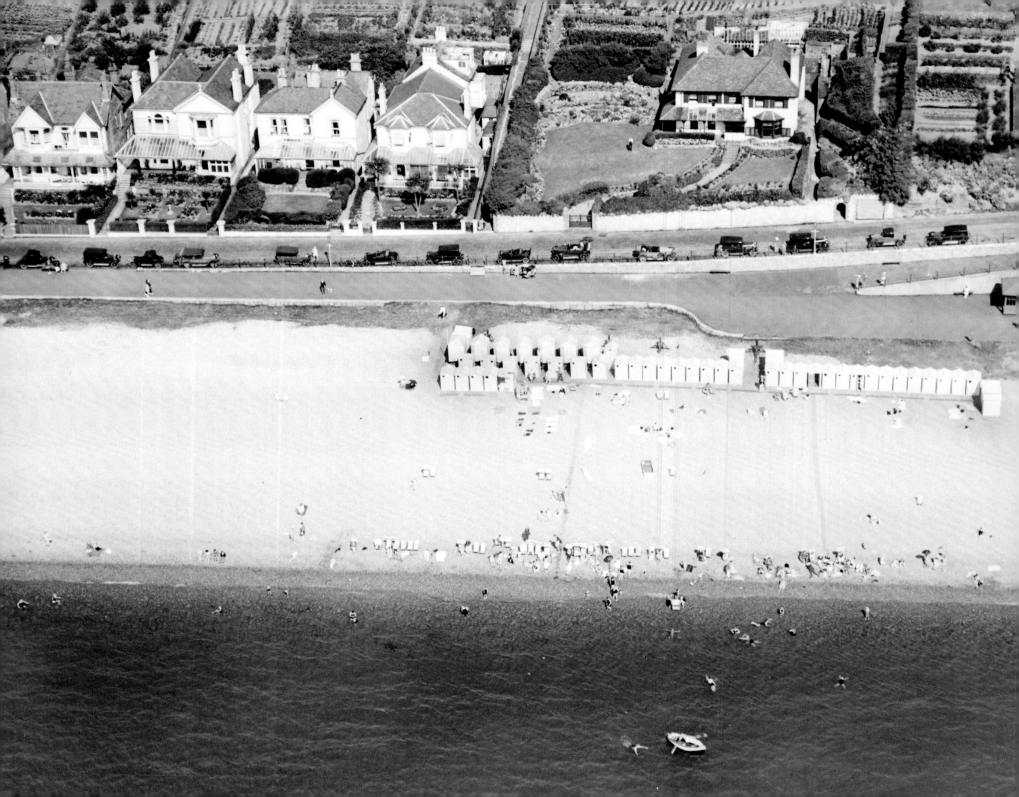

Budleigh Salterton, Devon
1928

The practice of parking cars along the promenade at seaside resorts became common in the early 1920s. It was an exception to the general reluctance to allow cars to park on the street and was initially uncontrolled, although by the end of the 1930s the numbers of visitors had grown to the point where, increasingly, car parks were being provided. This is the scene at the bottom of Coastguard Hill, Budleigh Salterton, in east Devon. By this time, closed saloon cars were beginning to account for a much higher proportion of vehicles: a similar view just four years earlier would have seen open cars in an overwhelming majority.

EPW023990

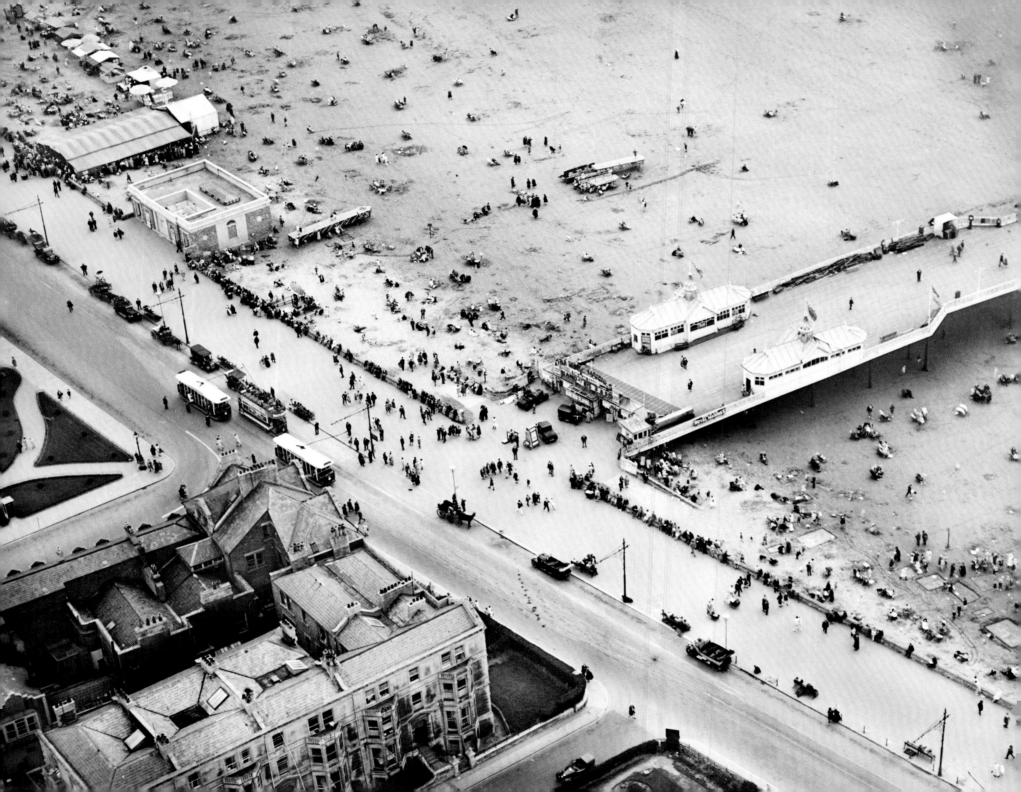

Weston-super-Mare

1928

Trams were still in the forefront of transporting visitors at Weston-super-Mare when this view of the entrance to the Pier was taken in 1928. The electric tramway system operated by the Weston-super-Mare & District Electricity Supply Co Ltd was opened in 1902. It was a small undertaking, just three and a half miles in length, and was finally abandoned in 1937. The cars in the view all date from 1902: a four-wheeled double-deck open-top car built by Brush and two open-sided single-deck cars of a type known as a 'toast rack' which was to be found on some lines running along the seafronts of resorts. Weston originally had only four of these toast rack cars, Nos 13–16. The image shows an equal mix of motor and horse-drawn vehicles parked at the kerb. The landau, although now largely obsolete in cities, was still popular at seaside resorts and, indeed, a few remain in use today as an attraction.

EPW023970

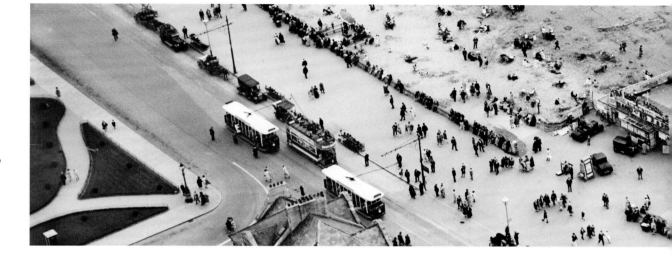

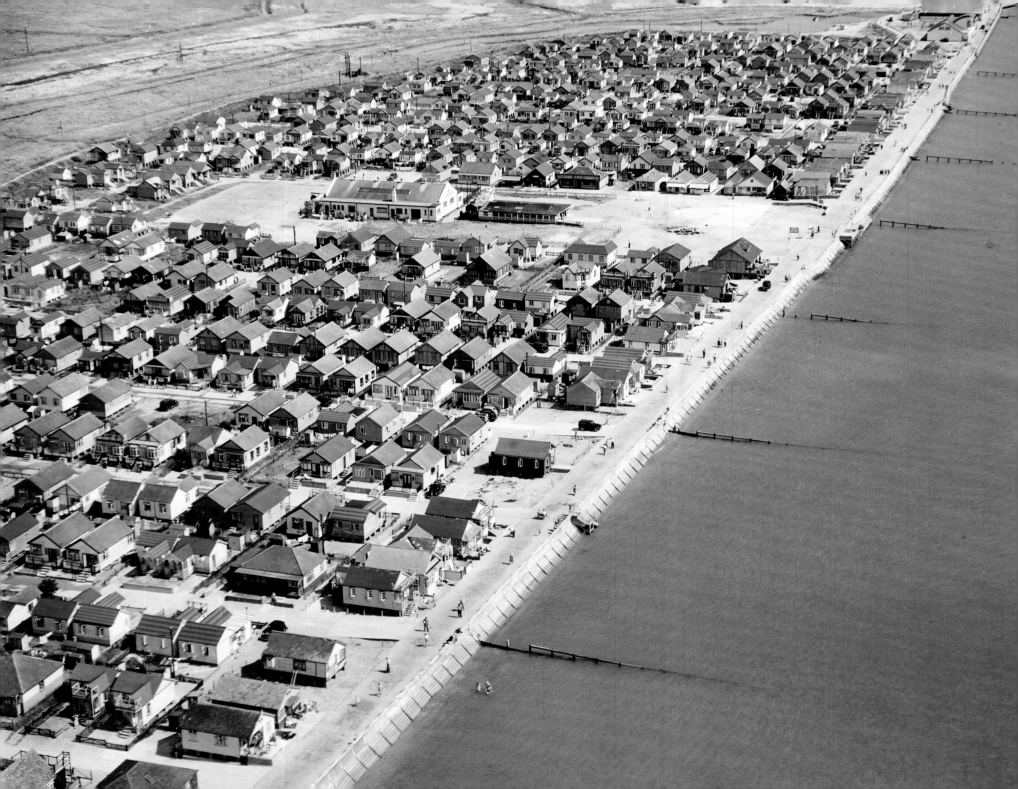

Jaywick Sands, Essex

16 August 1951

An inter-war development with motorists in mind was Jaywick Sands, near Clacton, Essex. Consisting almost entirely of small chalets, it was intended that these would be occupied as weekend cottages by motorists, and roads were named after makes of car to establish this link in the minds of drivers. However, most became permanent homes. Similar developments took place along the coasts of southern England. Often much more ramshackle than Jaywick and consisting of old railway carriages and bus bodies, they became known as 'plotland' developments. Jaywick is seen here on 16 August 1951, just 18 months before it was devastated by the great floods of 1953 in which over 30 people lost their lives. Many of the original houses remain but are falling into disrepair.

Afl 03_ r15353

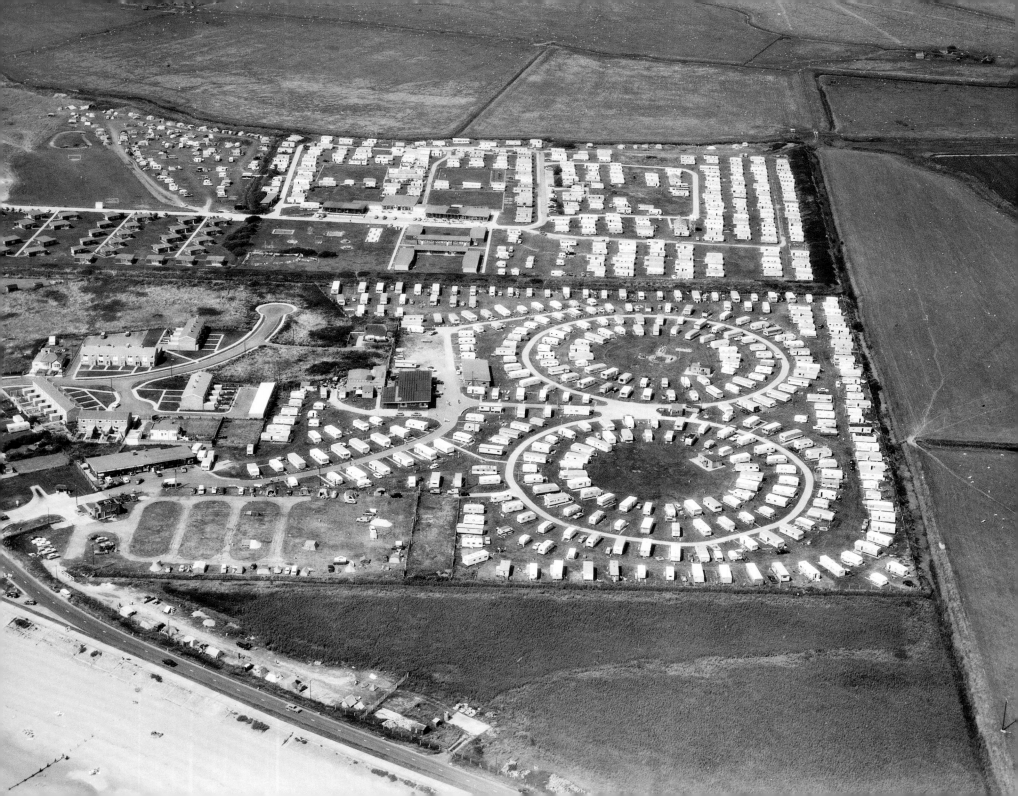

Caravans, Camber, Sussex

6 August 1969

The post-1945 years saw the ramshackle inter-war plotland developments replaced with something that was much more orderly and regimented, the caravan or mobile home park. Examples of this are the Maddisons and Silver Sands caravan parks at Camber, East Sussex, although the latter is perhaps a little extreme in the mathematical precision with which the vans are set out. Amenity blocks replaced the dubious or non-existent sanitation of pre-war days. Increasingly caravans became static and their numbers multiplied so that large areas of, for example, the Lincolnshire coast have been devoted to them.

Afl 03_a197163

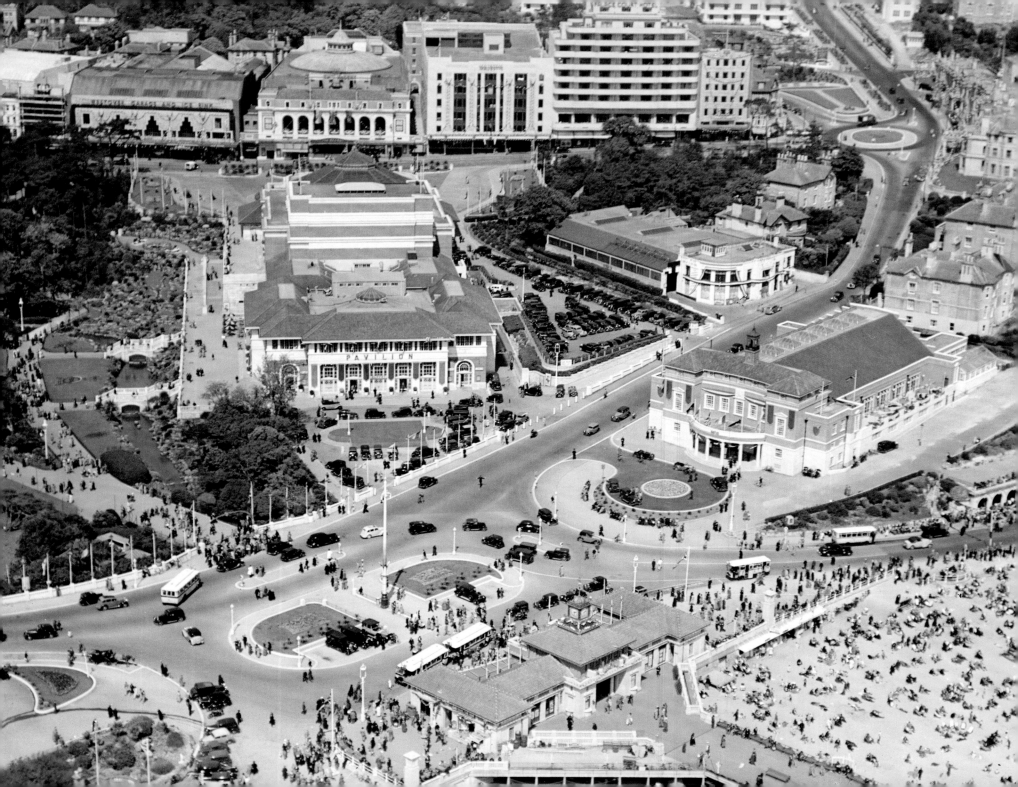

Bournemouth

17 May 1937

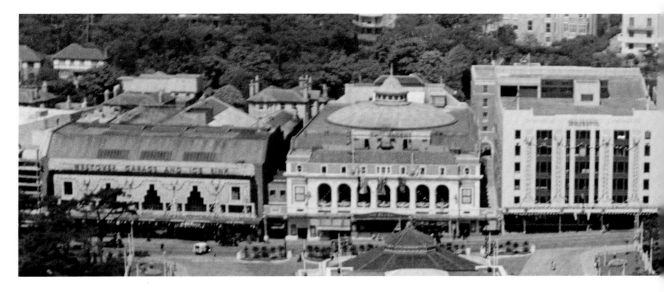

Seaside resorts were among the first towns to make efforts to cater for car parking on a large scale. In this view of Bournemouth on 17 May 1937, the building at the top of the photograph behind the Pavilion and to the right of the domed structure is Motor Mac's Ramp garage. Motor Mac's had been a leading garage in Bournemouth for many years and commissioned Seal & Hardy to design this, one of the first multi-storey garages to be built outside London. Opened in 1932, it held 900 cars on six floors and, like other car parks of the same period, it was fully enclosed, rather resembling a department store in appearance. Showrooms were located on the ground floor. By the time the photograph was taken ownership had passed to the Westover Garage whose premises, which were combined with an ice rink, can be seen on the left further along Westover Road. Below it, the building with the curved façade to the right of the Pavilion is the Pavilion Garage in Bath Road. It was built speculatively by a local builder and was leased by Elliott Brothers for their Royal Blue Coach Station and garage. Its style owed something to art deco with a neo-Egyptian moulding on the cornice, but the garage behind was of the usual utilitarian pattern. The portion of the building with large windows was the Corner House Café. The Pavilion Garage, which was retained by Hants & Dorset Motor Services for many years for bus storage, has been demolished. The extent of

motor traffic in seaside resorts is evident here, with an open car park next to the Pavilion Garage full and many cars on the roads. All the buses visible belonged to Bournemouth Corporation, which used a distinctive primrose colour. On the left are two Shelvoke & Drewry Tram-O-Car buses of a type used elsewhere in seaside resorts at Worthing and Llandudno. Bournemouth Corporation had seven delivered between 1924 and 1926, which were withdrawn the year after the photograph was taken. The other buses are Thornycroft single-deckers.

Afl 03_ r2730

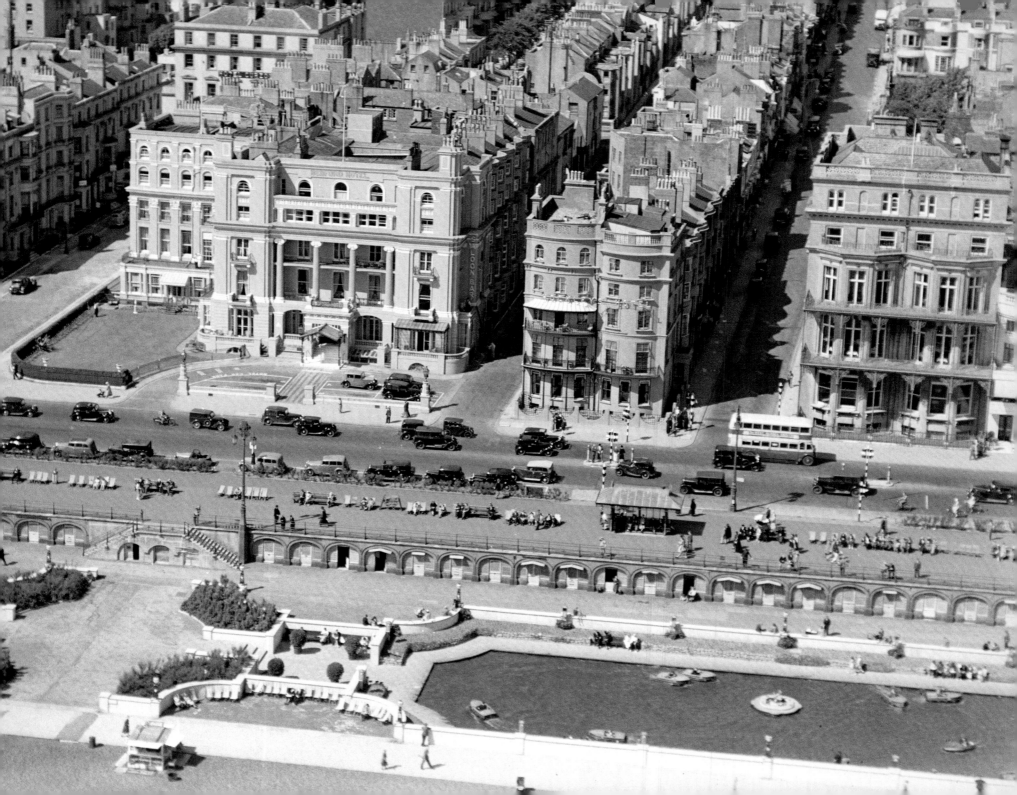

Brighton, Sussex

17 June 1936

By the late 1930s, congestion was growing along the sea fronts of major resorts. Like Bournemouth, Brighton has plenty of traffic and cars are parked by the side of Kings Road. But although there are cars parked in the side streets, these are by no means completely filled with vehicles. The Bedford Hotel (1829), which was demolished after a devastating fire in 1964, was one of Brighton's premier hotels and has not turned its small patch of lawn into a car park as yet. It still has some parking space left in its forecourt. Only two of the cars visible in the view are open topped, an indication of how things had changed since the 1920s. The bus is a Leyland Titan belonging to the Southdown company whose distinctive green and cream vehicles were synonymous with Sussex for many years.

Afl 03_ r1602

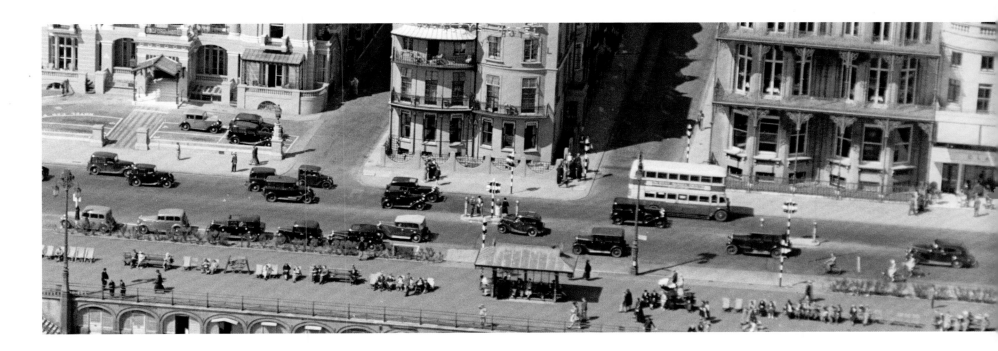

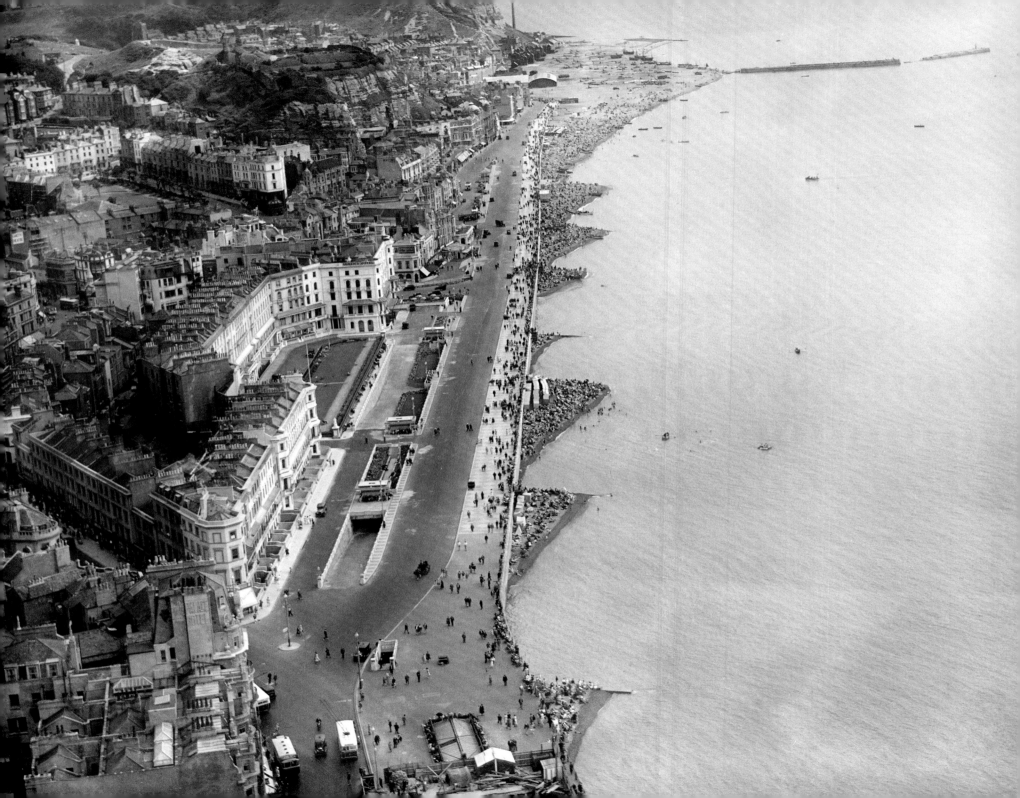

Hastings, Sussex

4 August 1932

The first public underground car park in England was built in Hastings in 1930–1 as part of a series of improvements to the seafront by the town's engineer, Sydney Little, a pioneer in the extensive use of concrete for shelters, lamp standards and subways. The car park was created as part of a new sea wall scheme, with a road and promenade built over it on land reclaimed from the sea. It is seen here soon after opening. The gently sloping ramps led to the car parking area underneath the roadway on the seaward side.

EPW_39369

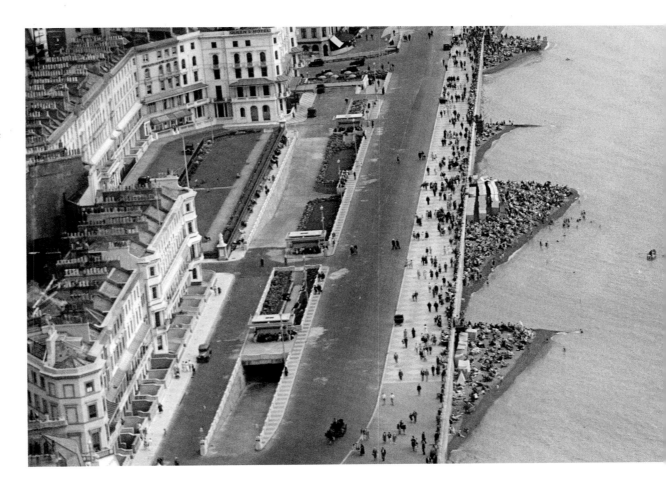

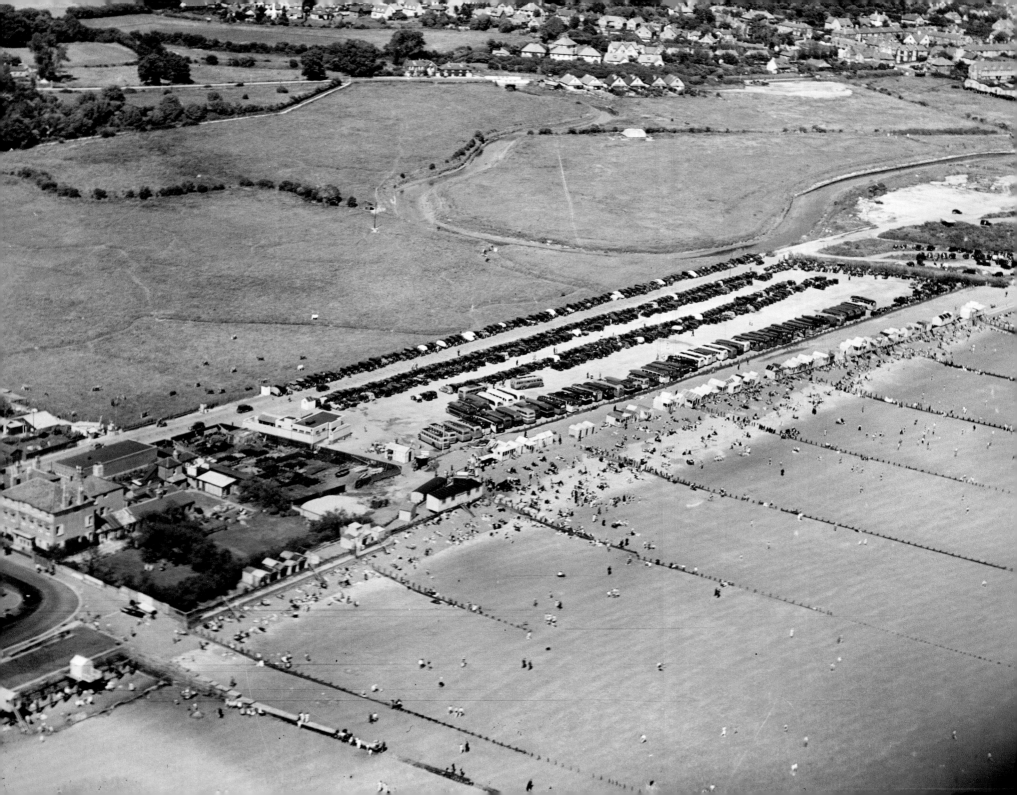

Bognor Regis, Sussex

5 June 1939

By the late 1930s, open surface car parks had become common in seaside resorts. This one by the beach at the east end of the promenade at Bognor Regis gives an idea of the quantity of cars that would come down to the sea at weekends. What is equally striking is how many visitors would arrive by coach – at least 55 are parked. Café and toilet facilities, in a modernist structure, have been provided at the west end of the car park for its users. The site later became part of a large Butlin's holiday camp.

Afl 03_ r2933

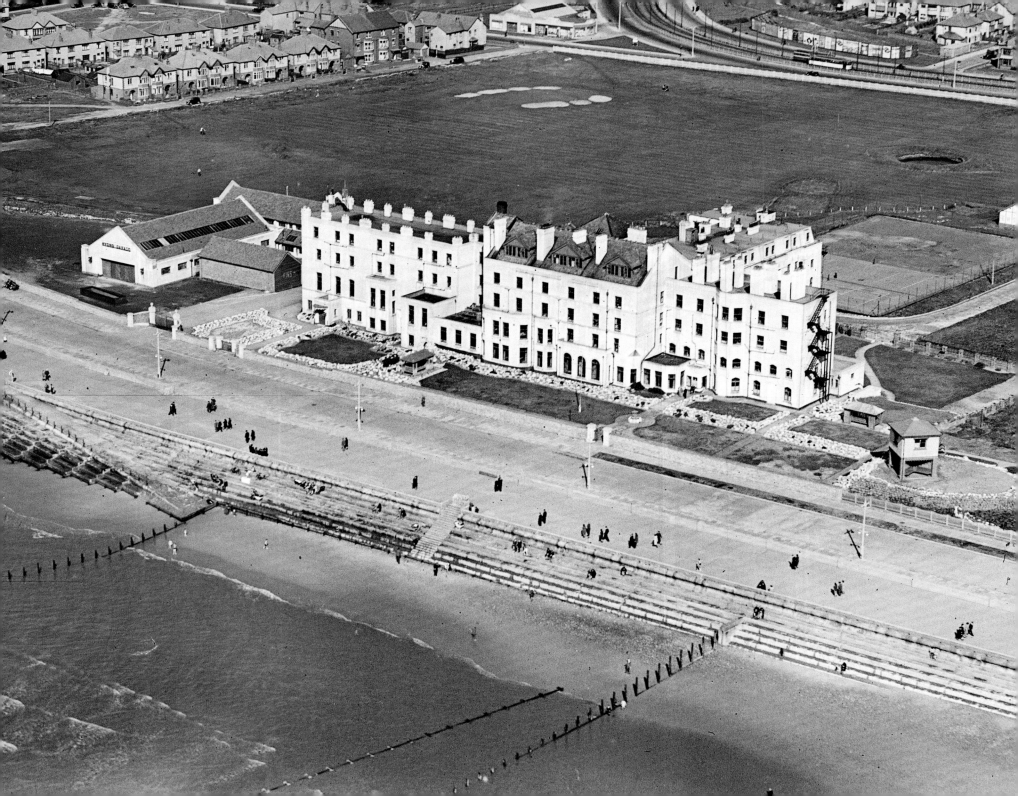

Cleveleys Hydro Hotel, Blackpool

19 April 1946

Covered accommodation for the cars of guests became almost *de rigueur* for hotels from the Edwardian period. The garage at the Cleveleys Hydro, Blackpool, shows that, although substantial structures, such hotel garages were only able to accommodate the cars of a proportion of hotel guests, many of whom, often the majority, still arrived by rail. Increasing car ownership since the 1950s across the social scale has led to the removal of many hotel garages and their replacement with open car parks capable of handling far more vehicles. In some cases, hotel garages offered a range of services besides parking, including the sale of petrol and servicing, and some of these have subsequently been separated from the hotels and become independent garage businesses.

Afl 03_ r7010

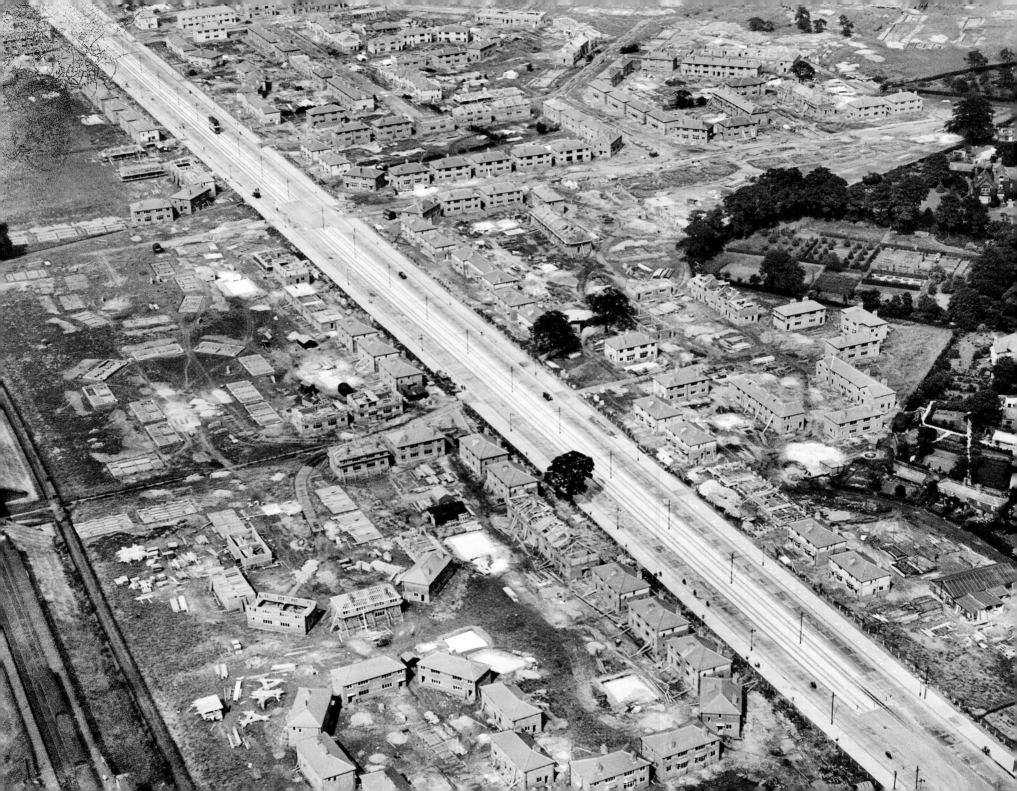

Kingsway, Manchester

8 July 1927

Throughout the twenties and into the thirties,
in some cities such as Manchester, Liverpool,
Leeds and Sheffield, trams were seen as having
a continued role as an integral part of suburban
transport, and as new municipal housing estates
were built on their rural fringe, wide boulevards
with trams running down their centres were
constructed. This is Kingsway, Manchester, on 8 July
1927, where twin tram tracks divided the road
into dual carriageways, flanked by wide pavements.
It is evident that some far-sighted cites saw a need
to provide up-to-date facilities for both private
and public transport, although in the case of these
new estates it is likely that this was prompted by
the expectation that working people would not
be able to afford motor cars. Just three cars are
using the road.

EPW018843

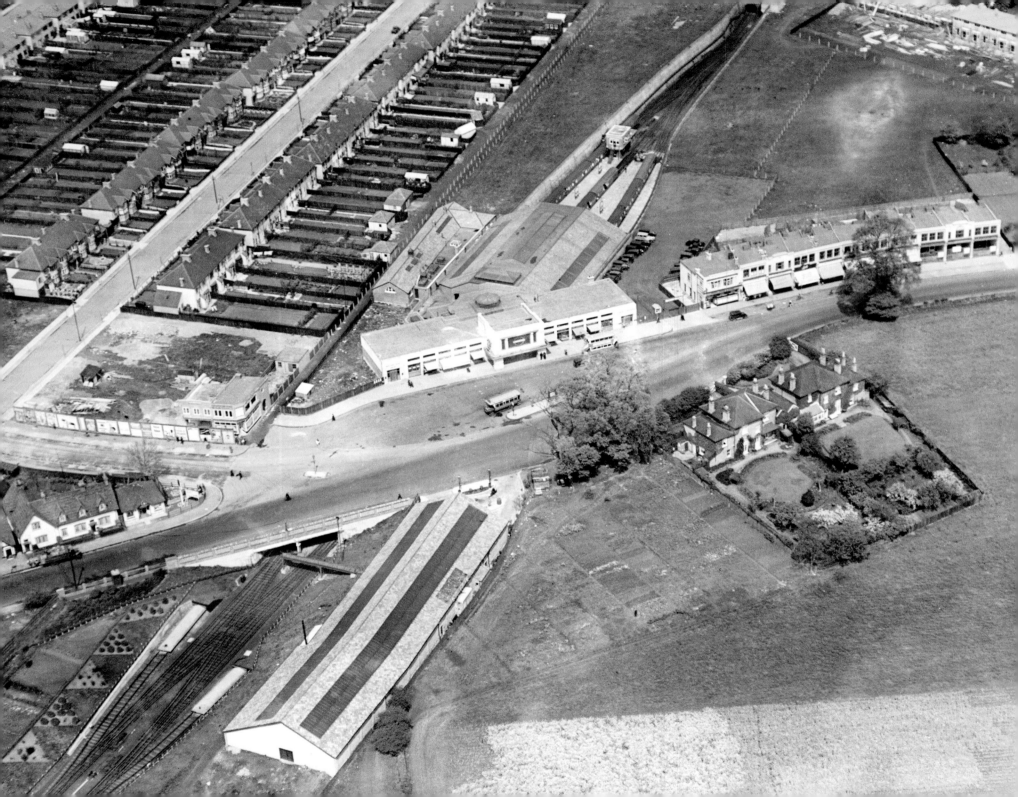

Morden
May 1930

Although the extension of the tube network was perhaps the key factor in the extraordinary growth of London's suburbia in the 1920s and 1930s, the car and bus also had a role to play. Here at Morden there was a clear attempt to integrate three forms of transport. The Northern line extension was opened in 1926 and the new station became the terminus of a number of bus routes, including those to Cheam, Worcester Park and Ewell, that fanned out from the forecourt, acting as a feeder to the tube. An S-type single-deck bus is seen in front of Charles Holden's striking station building. On its right is an NS-type double-decker. A large garage, seen at the bottom of the photograph, was built by the Underground and operated by its subsidiary, the Morden Station Garage Ltd, to enable its passengers to drive from their homes further

out and park all day in the garage and then collect their cars to return home. It also accommodated motor cycles and bicycles and could hold around 200 vehicles. Tube season ticket holders paid one shilling per day or five shillings per week, ordinary users one shilling and sixpence per day. The garage also sold petrol and carried out repairs. Steel-framed with corrugated iron cladding, its façade was rebuilt in 1936 and lasted many years. The newly built houses on the left of the photograph demonstrate some of the favoured positions for locating garages: at the end of the garden accessed by rear service lanes in the case of the terraced groups, and paired, sharing a common driveway, for the semi-detached houses on the upper left.

EPW031964

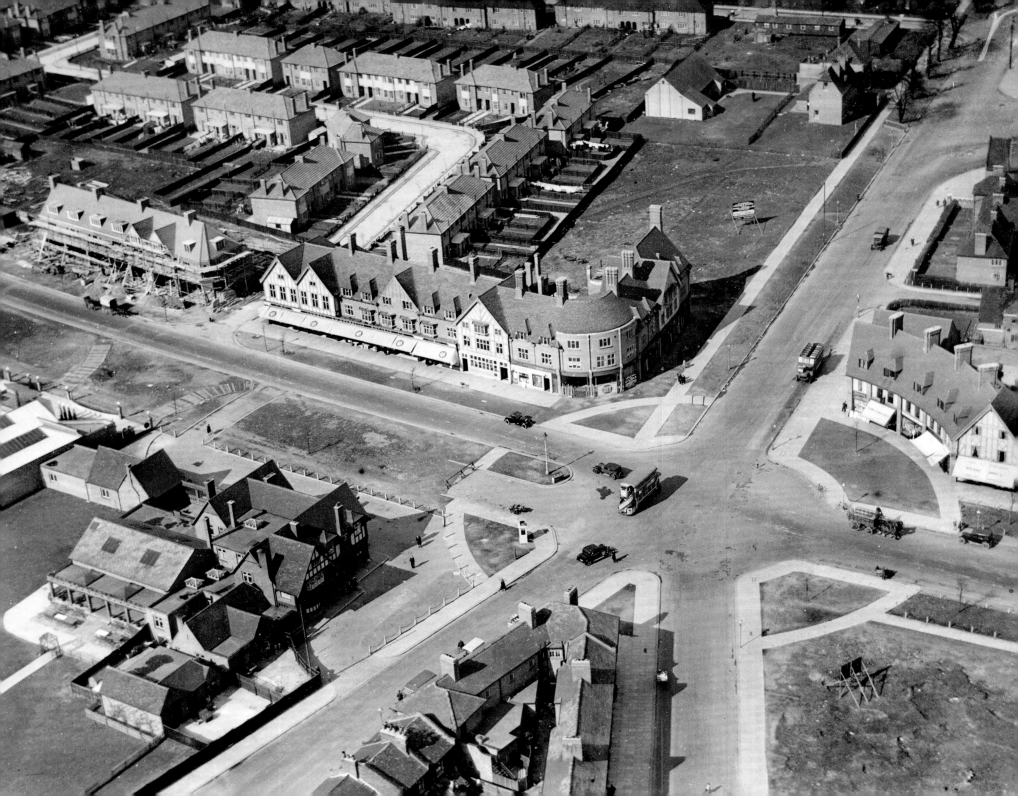

East Acton

1930

Arterial roads quickly attracted suburban development. This is the junction between Western Avenue and Old Oak Common Lane East at what was called Western Circus, East Acton, with shopping parades going up to serve the still raw-looking new development. Provision for the dualling of Western Avenue is evident on the left, with access to the filling station running across temporary timber boarding. The layout of the junction with its complete absence of any form of traffic controls looks hazardous to present-day eyes. Although forming a circus, the junction is not a roundabout and is primarily designed to act as a visual focus for the shopping parade rather than for practical traffic considerations. A large neo-Tudor pub, so typical of suburban main road locations, is on the left. A bus of the NS type is negotiating the junction and a few cars can be seen although horse-drawn traffic is still prominent. Today, the circus is where Westway meets Western Avenue. All the buildings on the north side of Western Avenue remain, while those on the south side have been demolished.

EPW031462

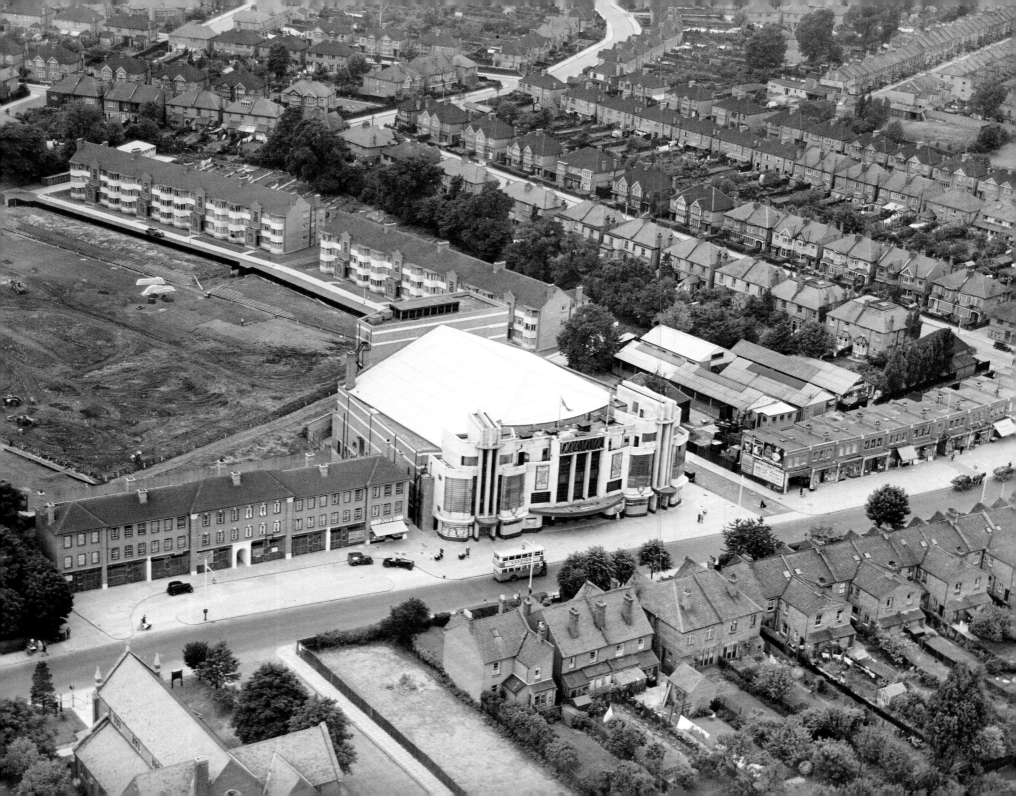

Harrow

1937

The new suburbs made provision for motorists from the start. At this shopping parade in Station Road, Harrow, seen soon after the construction of the Dominion cinema, a service road for shoppers to park in front of the shops was created – something very common in 1930s suburbs which avoided parked vehicles obstructing the traffic on the main through road. Only one of the shops is as yet occupied, which explains the lack of parked cars.

EPW053687

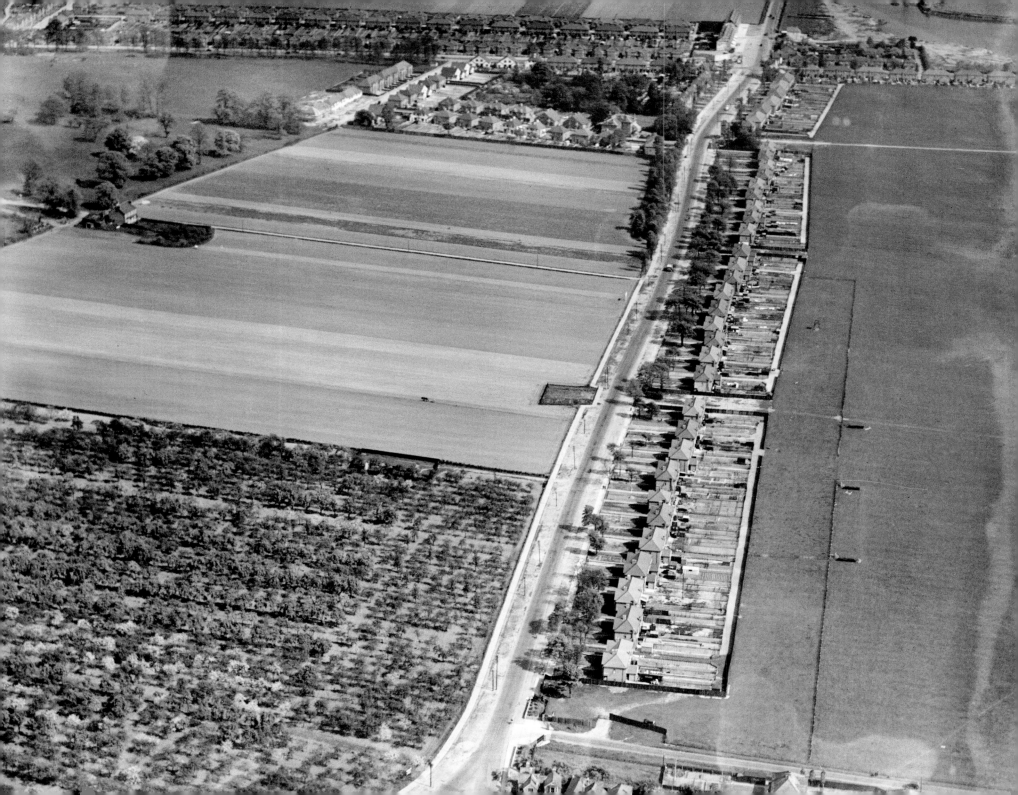

Uxbridge Road, Feltham, Middlesex

May 1934

Ribbon development was, for those living in the 1920s and 30s, perhaps hated more than any other change arising from the growth of popular motoring. Yet, attracted by low prices, easy access and large gardens, people were happy to buy the new houses that sprang up along major roads. The first recorded use of the term 'ribbon development' was by Sir Patrick Abercrombie in 1926 and it soon became a catch-all phrase used to excoriate all kinds of roadside development from groups of tatty shacks, cafés, filling stations, scrap yards and bungalows to orderly suburbia of the type shown here at Feltham in west London. The houses on the right backed on to Hanworth Park and so remain forming a ribbon along Uxbridge Road today. The fields on the left were mostly covered with housing within a few years of this photograph being taken.

EPW044344

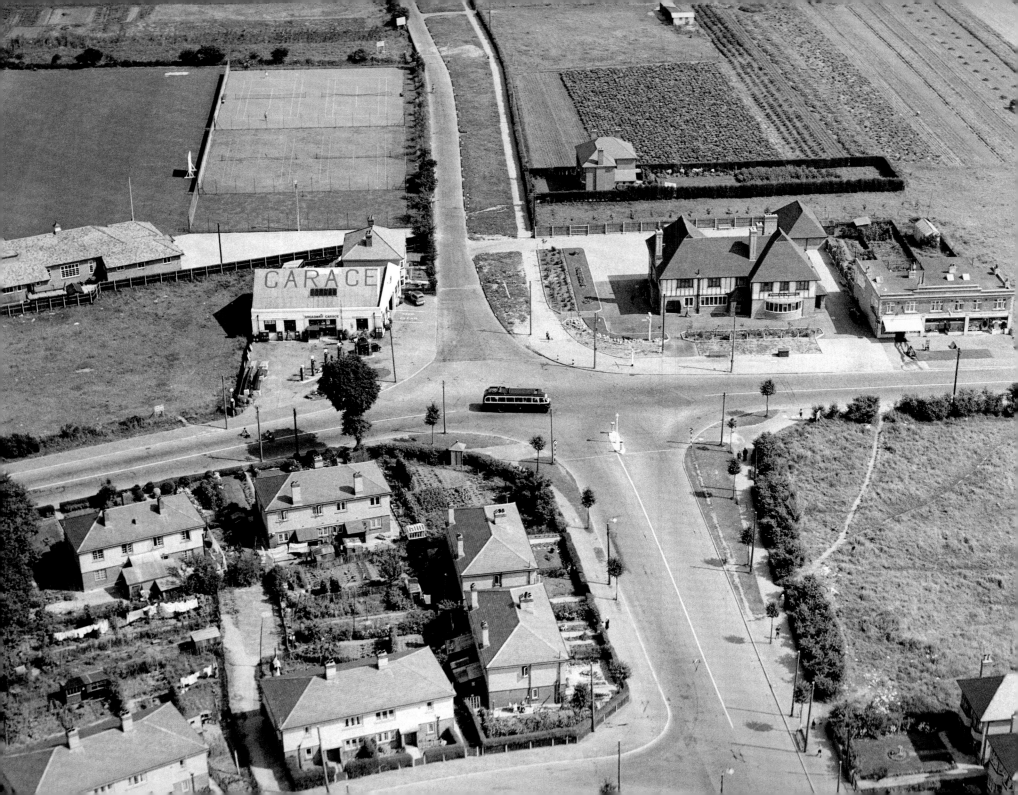

Castle Lane, Bournemouth

15 August 1939

The car helped bring about development of the edges of towns, far from traditional centres of population. For many years these areas remained a mixture of undeveloped, scrubby fields, market gardens and individual houses seemingly placed almost at random, and shops and pubs grouped around road junctions. This is Castle Lane, Bournemouth, with the Broadway Garage, the large Broadway Hotel, a Strong's pub and a block of three shops, with little but open country and playing fields beyond them. A Royal Blue coach turns into the side road. Today, Castle Lane is a major outer route around Bournemouth, much of it dual carriageway. The area is completely built up, with large retail parks and an out-of-town shopping centre just to the east.

Afl 03_ r6464

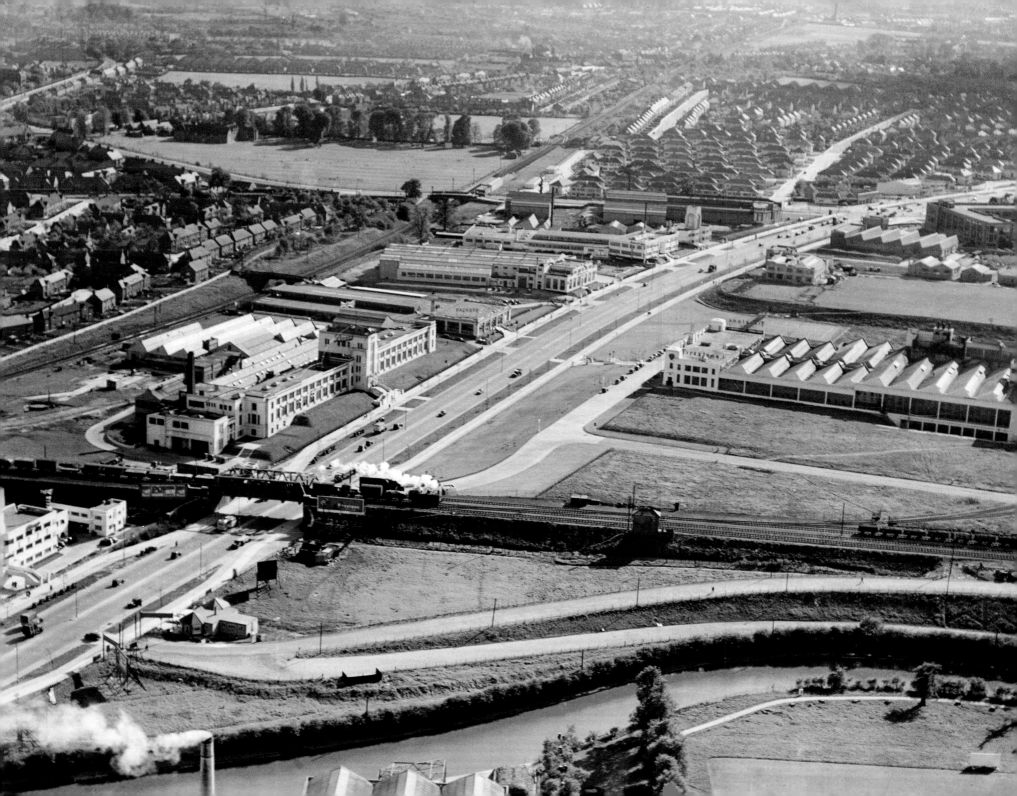

The Great West Road, near Brentford

19 May 1937

The Great West Road, an arterial road intended
to speed west-bound traffic out of London
avoiding the bottlenecks of Brentford and
Hounslow, was opened in 1925. Along much of
its length it was lined with ribbon development of
houses but one stretch of it became synonymous
with modernity, the white façades of the factories,
many of them linked to the motor industry, adding
an appropriate sense of scale to the broad new
highway. In this view looking west, on the right is
the Firestone building, the demolition of which in
1980 on the eve of its listing led to an increased
awareness of the importance of 1930s buildings.
In the foreground, the bridge carrying the Great
Western Railway Brentford Dock branch crosses
the road with the 1930 Pyrene factory (fire
extinguishers and bumpers) on the left. Then
there is the UK headquarters of the US motor
firm Packard (1931) and beyond it that of Lincoln
(mid-1930s) – a number of American companies
had their British bases along the Great West Road.
All of these buildings were designed by Wallis,
Gilbert & Partners.

Afl 03_ r2624

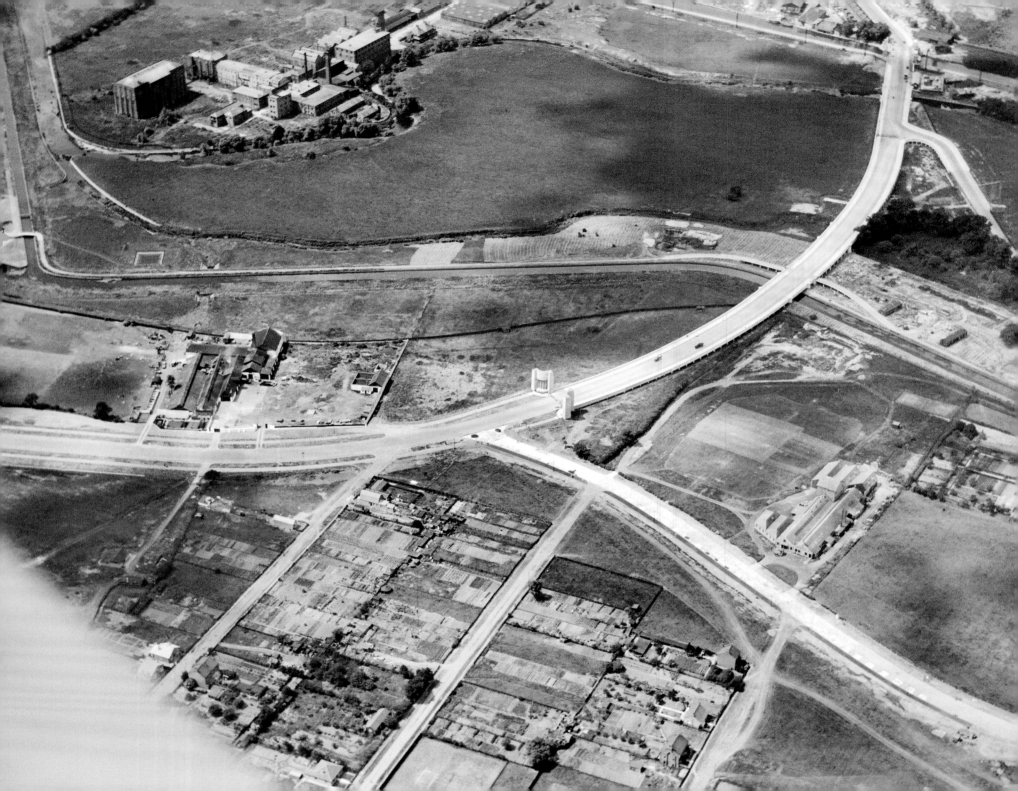

Lea Valley Viaduct

1927

The arterial roads programme seldom saw spectacular new construction, but the Lea Valley Viaduct carrying the North Circular Road in north-east London was an important exception. Designed by Sir John Simpson and Maxwell Ayrton with Sir Owen Williams as engineer, it was built of reinforced concrete and opened in 1927. The most striking feature was the marking of the eastern end with two massive pylons forming a gateway to open country. They were some of the very few examples of a grand gesture being made on an English road. The pylons, together with the viaduct itself, have disappeared with successive widenings of the North Circular Road.

EPW018564

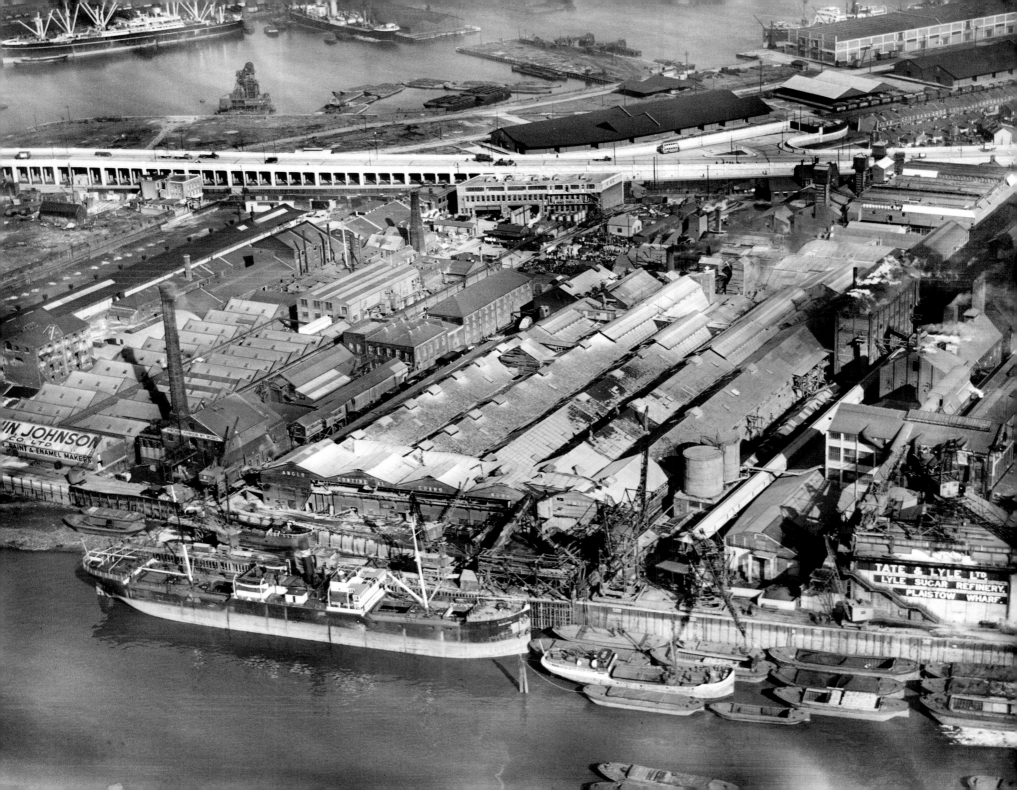

The Silvertown Flyover
February 1935

The precursor of the modern flyover, the 1,300-yard-long Silvertown Flyover, was designed by the civil engineers Rendel Palmer & Tritton in 1926–30 and built between 1930 and 1934. It was part of the Royal Docks Approaches Improvement scheme and led to North Woolwich and the Woolwich Free Ferry in east London's Isle of Dogs. Slip roads running each side of it served the Royal Albert and King George V Docks. It spanned roads, dock entrances and the North Woolwich railway branch, enabling a busy level crossing to be eliminated. The cost was high, both financially (the scheme cost about £2m in total) and socially (hundreds of houses had to be demolished). The reinforced concrete viaduct is still pristine in its appearance in this 1935 view, occupied principally by the heavy lorries it was designed to accommodate. The modernity of the structure stands in stark contrast to the jumbled buildings of the factories along the Thames – from left to right, the Pinchin Johnson Paint Works, the Anglo-Continental Guano Works and the Tate & Lyle Sugar Refinery – that formed the ostensible subjects of this photograph. The flyover remains in use today; the factories, like many of those in the East End, have gone.

EPW046559

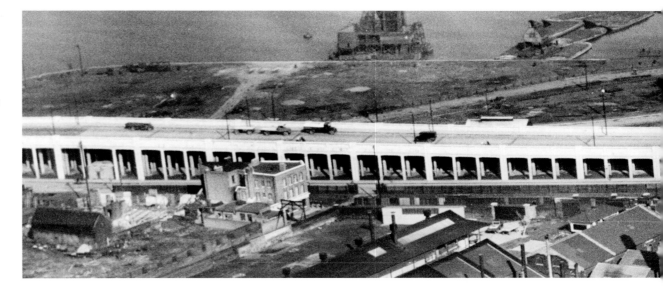

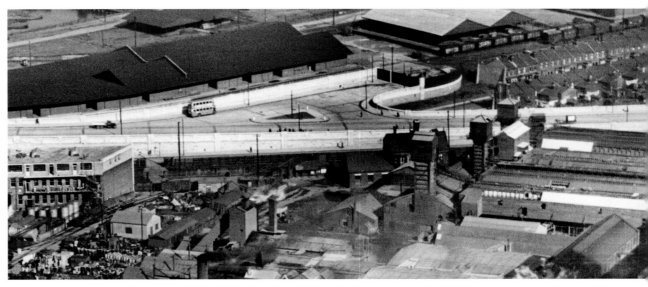

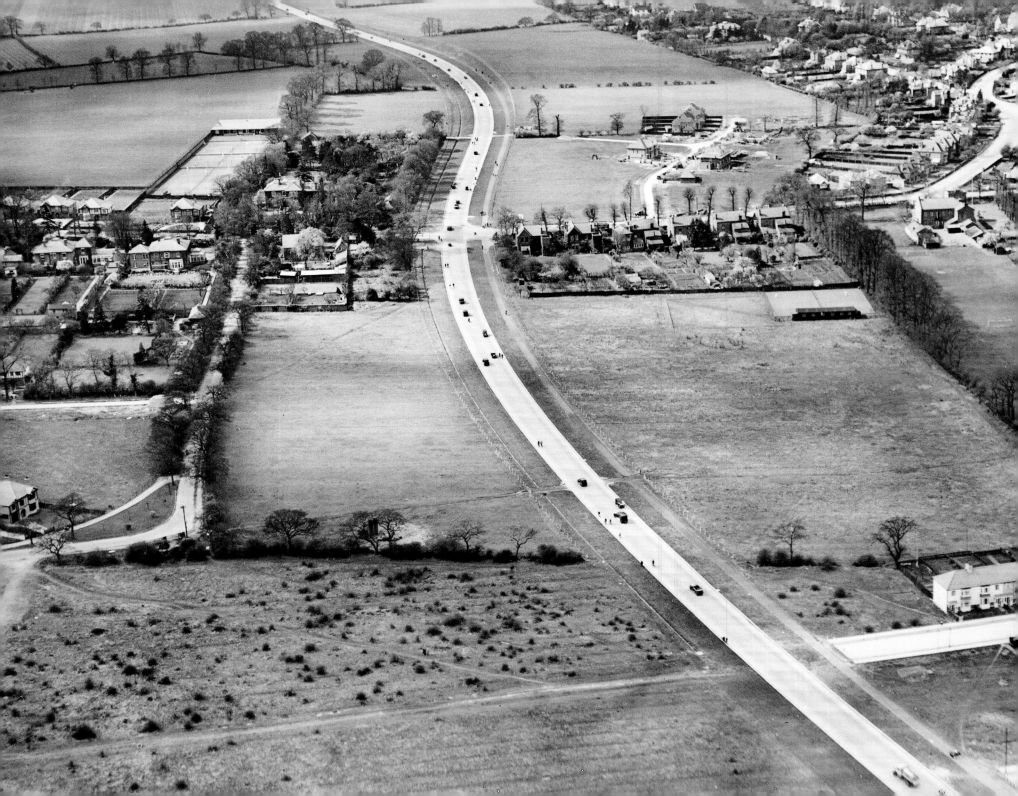

Kingston bypass

1928

One of the most famous of the new roads leading out of London was the Kingston bypass. It is seen here at Motspur Park soon after opening, with only one carriageway (it was not dualled until 1937) and no road markings. The number of cyclists using the road is noteworthy, as is the lack of separate cycle lanes for them. The new road cuts through existing field boundaries and road systems; the somewhat makeshift arrangement of the junction with the existing road may be observed in the middle distance. Also significant are the new concrete roads of the suburban housing in the foreground which terminate suddenly, making no connection to the bypass at this point, although within a few years all this land was built upon and the bypass lined with houses on both sides. This development, often given the title 'ribbon', slowed the new route down with frequent junctions and added traffic.

EPW020673

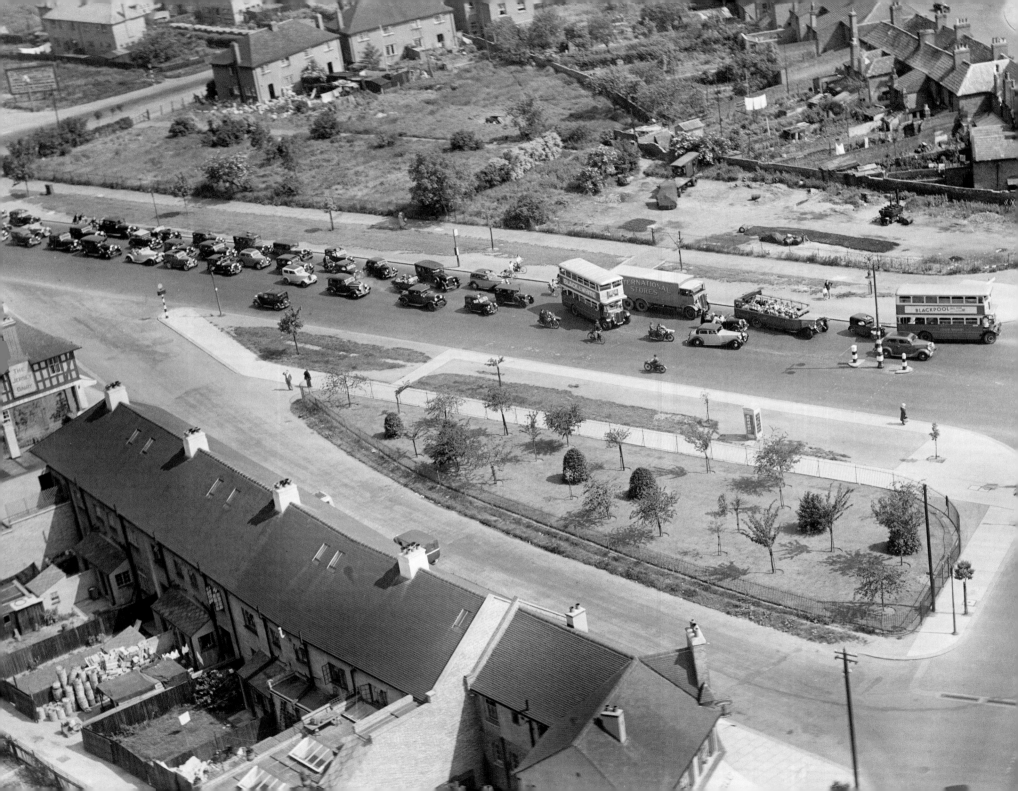

Lampton, Great West Road

22 June 1935

The new arterial roads, intended to speed long-distance traffic out of London, soon became clogged with traffic arising from the ribbon development of housing and industry that accompanied them. Roundabouts and traffic lights held up the traffic at major junctions, and vehicles slowing to turn into side roads or to let drivers in from them slowed progress still further. A typical queue is seen on the Great West Road at Lampton opposite one of the many shopping parades that grew up to serve the new suburbs. The road is single carriageway and the absence of road markings may be noted. Two London Transport ST-type AEC Regents are in the queue, the first being overtaken by a Ford. It is followed by an Austin 7 and a Derby Bentley. A Singer, a second Austin 7, a Ford and a Vauxhall are among the other cars visible.

Afl 03_ r683

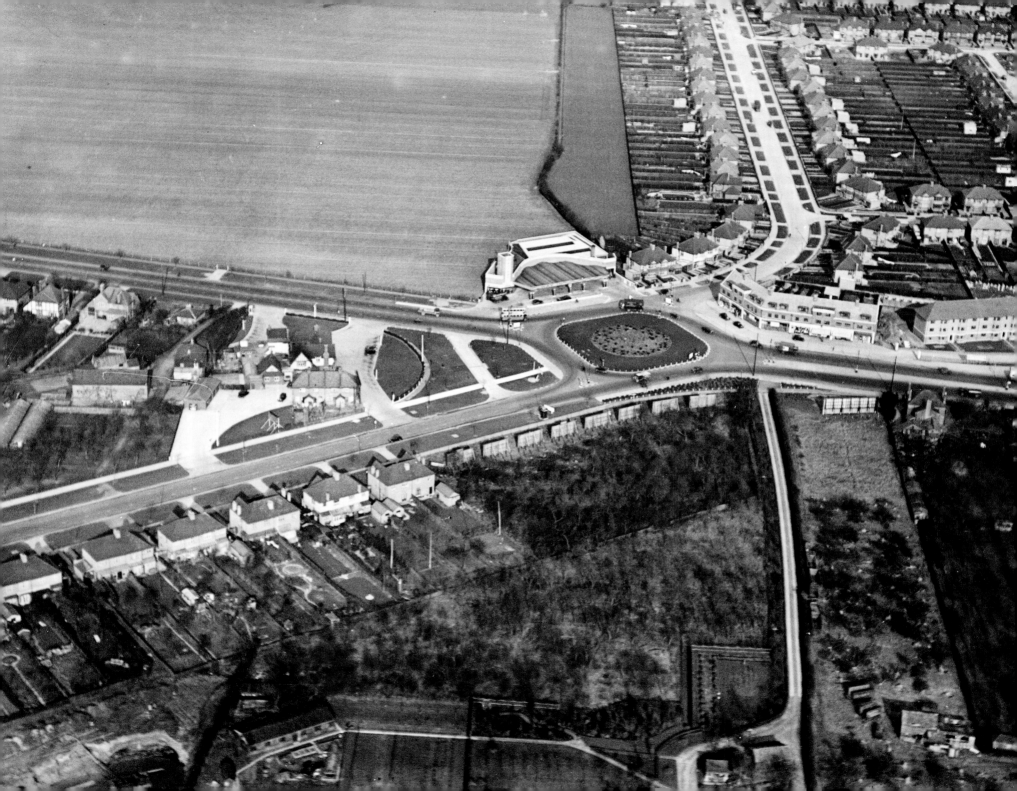

Henly's Corner, West Hounslow

14 February 1938

The junction of the Great West Road, Bath Road and Staines Road at West Hounslow formed a nodal point, like so many junctions in outer London. Around it grew houses, flats, a shopping centre and a large garage. The area still has an incomplete look to it in this view, with building plots hidden by advertisement hoardings. The roundabout itself is not actually round but square with rounded off corners, a common form where major roads met. The Airport Garage had been opened in 1937 and was designed by a local firm of architects, Roper, Son & Chapman. It was so named because of the proximity of Heston aerodrome and bookings could be taken from it for any flights from Heston, from five-shilling pleasure trips to long-distance journeys. The flying theme was continued in its decoration, the colour scheme being blue and silver – both colours associated with aviation. What was really an ordinary workshop building was hidden by a high parapet, with the front of the building marked by a concave façade and a neon-illuminated clock tower – something much favoured in 1930s garages. A very large canopy had 11 pumps underneath it. The Airport Garage had a short life under its original owners, the major chain Henly's taking it over by mid-1939 and, over time, giving the name 'Henly's Corner' to the roundabout. The road junction is little changed today: the roundabout is circular rather than square, but although there is still a filling station on the same site, the buildings of the Airport Garage disappeared many years ago.

Afl 03_ r3828

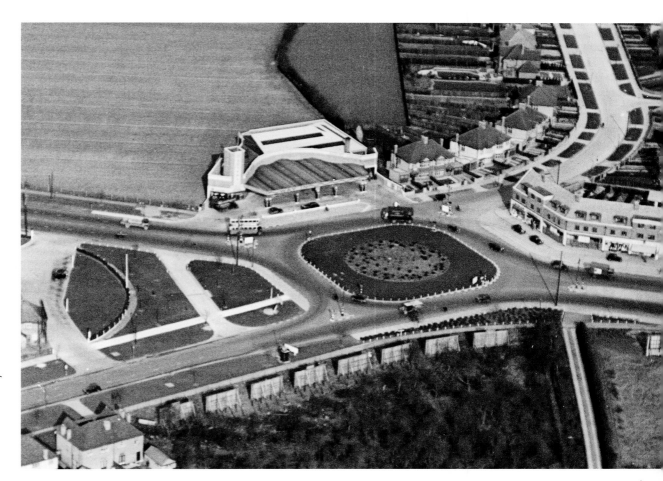

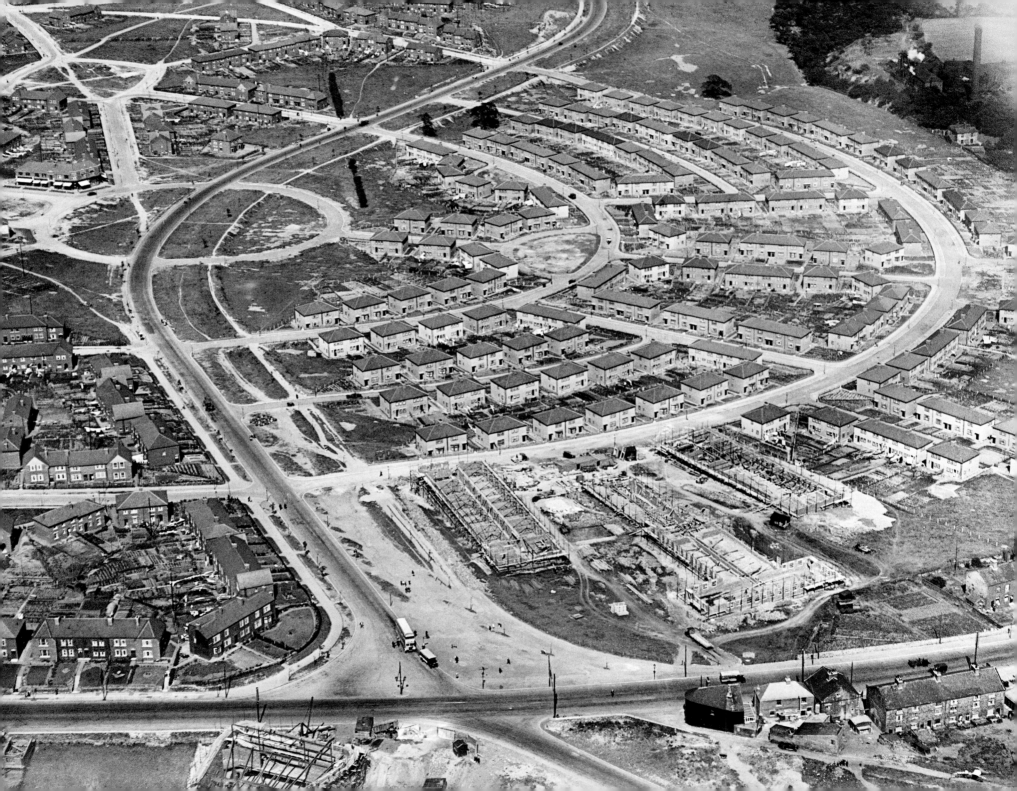

Prince of Wales Road, Sheffield

July 1927

New roads around Britain's cities became widespread in the 1920s. They were often intended to form the first phase of ring roads, which could take many decades to reach completion. One such was Prince of Wales Road, Sheffield, seen here when newly constructed. It was intended to provide a link between the city's east end, with its steel works, and the main roads to the south. It also acted as the spine of the Manor housing estate, which had a highly geometrical road pattern that cut across Prince of Wales Road. Initially just a single carriageway, it was later dualled with a tram track running along the central reservation – the space left for this additional carriageway is evident. As with many of these ring roads, shopping parades were later built at principal road junctions and additional houses were constructed facing the new road. While the remainder of the estate was council housing to rent, those houses facing the main road were larger and built by the council for sale – a continuation of the 19th-century practice of building the largest and most impressive houses along the main roads leading into the town with roads of smaller houses behind them.

EPW018976

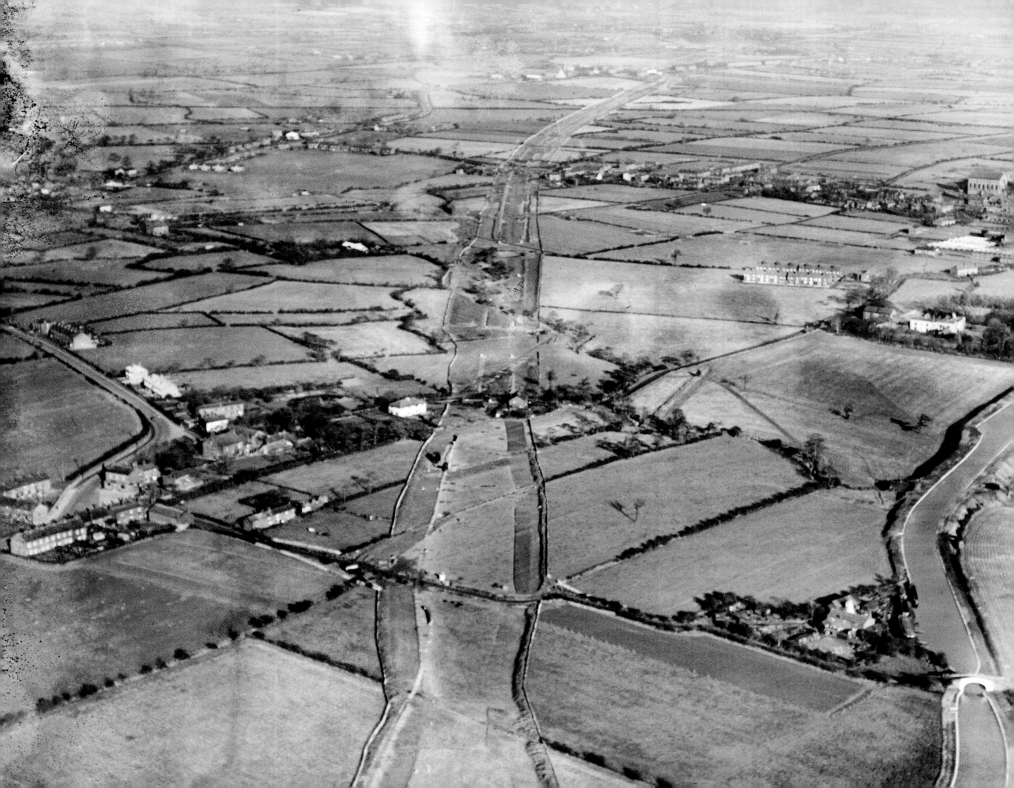

The East Lancashire Road

October 1929

The East Lancashire Road linking Liverpool and Manchester was the most extensive entirely new road to be constructed in the north in the inter-war years. It is seen in its early phases, with the route marked out and some preliminary clearance taking place as it cuts across the country: a scene to be repeated on a larger scale over much of the country a little over 30 years later as the motorway programme got under way. Work began in 1927 and the £3m road, which ran from the eastern suburbs of Liverpool to Irlams-O'-Th' Height to the north-west of Manchester, was opened by King George V in 1934. The new road, built to carry traffic to and from the Liverpool docks and industrial districts, eliminated the bottleneck formed by the narrow streets of Warrington.

EPW031135

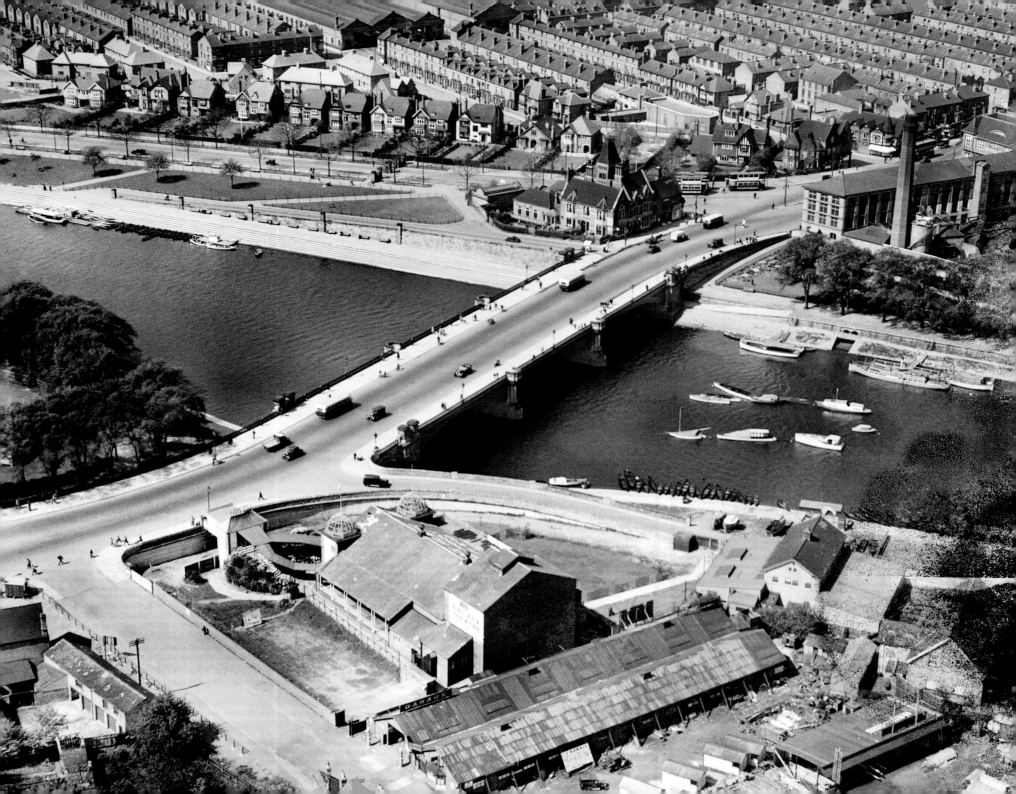

Trent Bridge, Nottingham

8 May 1928

The growing demands of motor traffic led local authorities to carry out major improvements such as the widening in 1926 of Trent Bridge, Nottingham, originally constructed in 1868–71. The widening, which was on the west side of the bridge, faithfully reproduced the detailing of Marriott Ogle Tarbotton, who had been commissioned to carry out the 19th-century work. It is seen here looking northwards, with a garage in the foreground. Many garages of this period were quite ramshackle affairs, as seen in the premises of C E Norris, used for servicing and repairs. A pair of pumps stand by the entrance to the building which is being supported by timber struts. At this time, many garage owners started to add lock-up garages in spare corners of their sites for customers to garage their cars. A row of asbestos examples are being constructed here, with four erected and the others having just the concrete slabs laid.

EPW021126

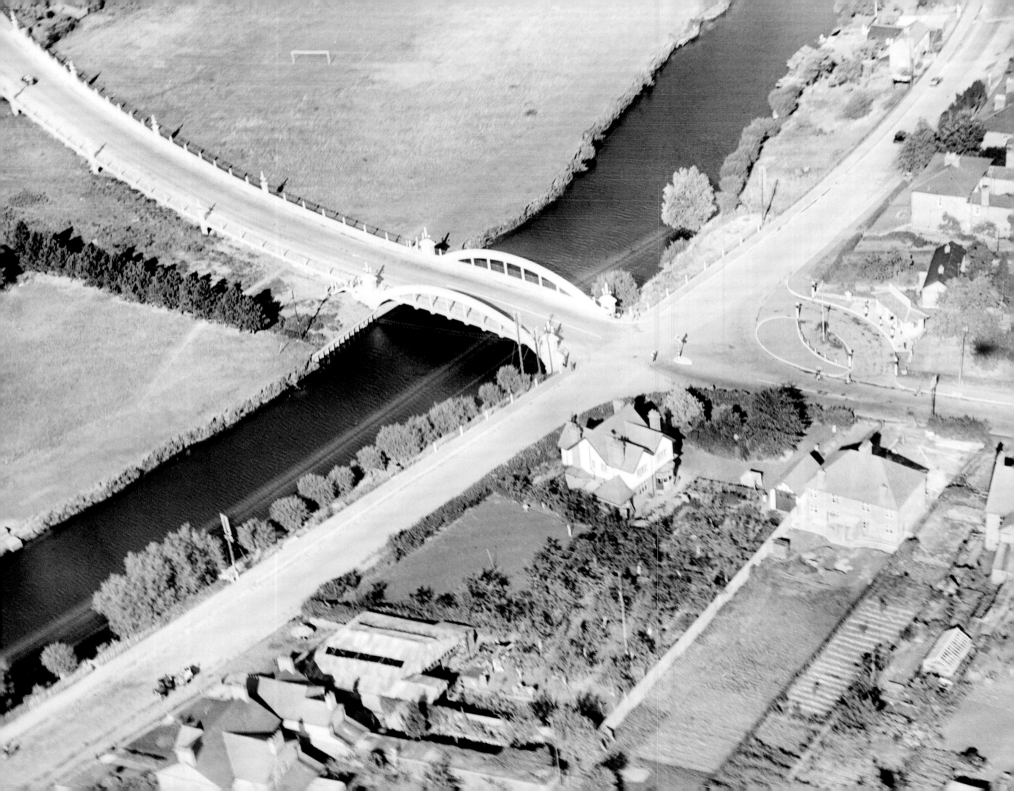

Abbey Bridge, Evesham, Worcestershire
1928

In some cases in the 1920s, new bridges were constructed to cater for increased motor traffic employing the latest constructional techniques. This is the Abbey Bridge over the River Avon at Evesham, completed in 1928, linking the town with the village of Bengeworth. It was a bowstring bridge constructed of ferro-concrete (Feathercrete) and was linked to a low viaduct of the same material. It was designed by the County Surveyor and like many of these early concrete bridges had some quite elaborate decorative elements such as light standards mounted on piers. The concrete is now failing and a new bridge is planned to replace the 1928 structure. Also visible on the right of the photograph is a filling station, typical in its simplicity of many from this period, and with its function limited to the supply of fuel. Its location on a corner site is again typical of many filling stations. There is still a garage on the site today.

EPW023910

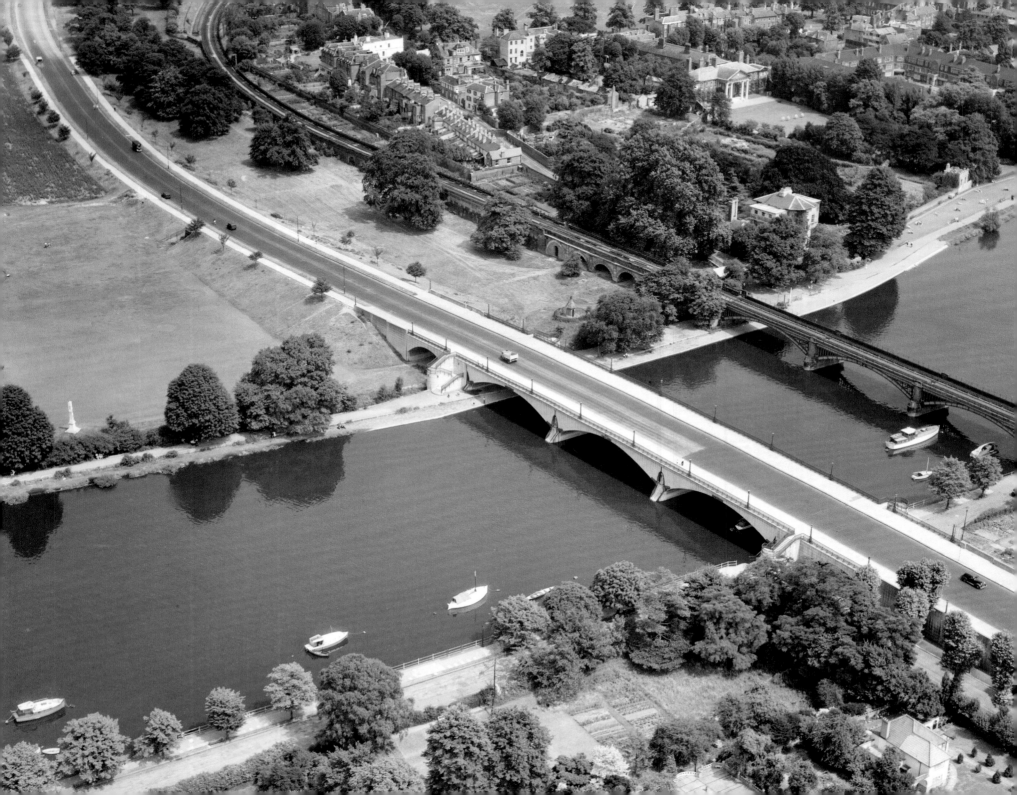

Twickenham Bridge

16 July 1947

Traffic bound for the south-west had a long slow journey out of London through the congested narrow streets of Richmond and Twickenham. The entire area was bypassed by the new A3 Great Chertsey Road, built in stages and involving new crossings of the Thames at Chiswick and Twickenham. Twickenham Bridge, with its approach roads, was constructed in 1928–33 and is seen from the Twickenham side, still looking very new in 1947. It was designed by Maxwell Ayrton (architect) and Alfred Dryland (engineer) and was the first large concrete bridge in the country to be built on the three-pin principle. This entailed hinging or pinning the three arches at the crown of each arch, which enabled the forces acting on each arch to be precisely calculated, thus reducing the possibility of failure. The joints, as can be seen here, were clearly expressed by means of art deco bronze cover plates. Post-war fuel rationing may account for the lack of vehicles. Other than an increase in traffic, the scene is remarkably little changed today, with only the redevelopment of some of the buildings in the foreground and the removal of later accretions to Sir Robert Taylor's Asgill House on the river front behind the railway bridge to note. Areas such as that surrounding Richmond Green, subject to the full gamut of listed building and conservation area controls and with high property values, are those least changed in aerial views and least impacted by motor vehicles.

EAW008241

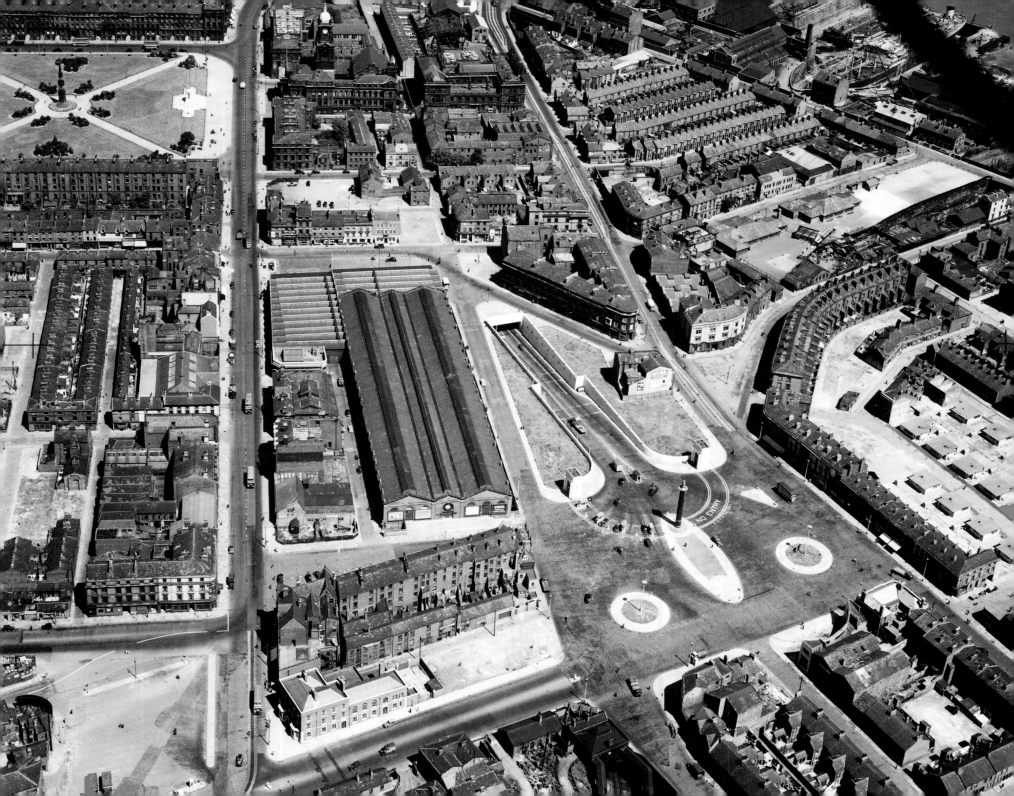

Mersey Tunnel, Birkenhead

1946

Perhaps the most spectacular piece of construction to deal with traffic problems during the 1930s (and certainly among the most publicised) was the Mersey Tunnel, opened in 1934. This is the more rarely photographed southern exit at Birkenhead, with seemingly few users: the surrounding streets are almost empty – possibly due to petrol rationing still being in force when the photograph was taken. Though lacking some of the decoration of the better-known northern exits in Liverpool, there was nonetheless an attempt in King's Square to create a wedge-shaped *grande place*, with axial planning linking the two lamp standards, the monument and two archways at the top of the tunnel approach ramp. The shape of the tunnel entrance is echoed in the concave façade of the filling station put up by W Watson & Co in 1939, immediately opposite it. The design, in a dignified classical style, was by D A Beveridge, who carried out much work for the Liverpool-based motor dealers in the 1930s. On the bottom left is Birkenhead Town station (closed in 1945), on the branch to Birkenhead Woodside.

Afl 03_a1722

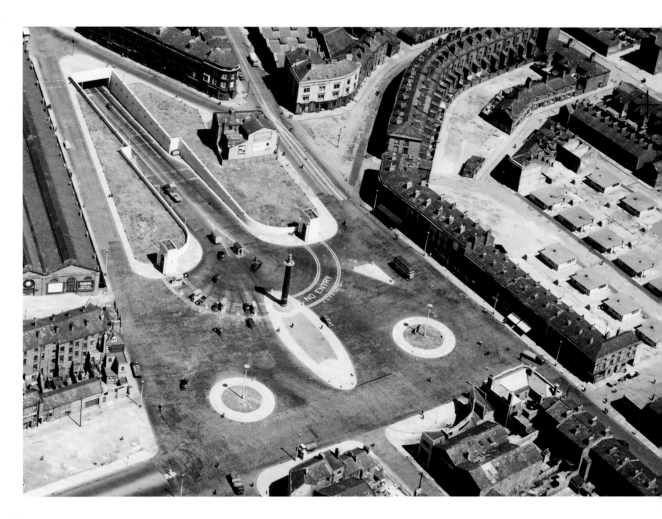

Charing, Kent

19 April 1929

Out in the country, from the 1920s villages on major through routes began to be bypassed. The effects were double edged. On the one hand, villagers regained peace and quiet from the lines of traffic that formerly sped through them, particularly at weekends in the case of those on roads to the coast. Against this must be set some financial harm for the pubs, inns and shops that had catered for passing motorists. One consequence of this was the establishment of new and large pubs to serve the traveller on the edge of or just outside the village, as seen here in this view of Charing. The bypass, whose concrete surface stands out clearly, draws off to the right, while just before the roads divide a large neo-Tudor pub has been erected with a sweeping entry and ample parking. What is significant here is that the Swan Hotel in the centre of

Charing had closed after some 300 years and its licence was transferred to the new premises, which opened in 1928. The new Swan was set in seven acres with tennis courts and lawns. Its predecessor became a private house. Meanwhile, in the junction of the roads to the left, a new and somewhat rudimentary filling station is nearing completion. The Charing bypass was part of a large-scale programme of works in 1925–6 to improve the London–Maidstone–Folkestone road, and a northern bypass was also put in for the Canterbury and Margate traffic. The photograph illustrates the way in which motoring tended to cause main road villages to expand and straggle even more than they had done in the past.

EPW026092

Staples Corner

26 June 1937

Staples Corner, where the North Circular Road meets the Edgware Road in the amorphous region between Neasden and Brent Cross, is one of those parts of the roadscape – like the Thelwall Viaduct or the Brampton Hut – that have a strange resonance for the motorist. This is the view, looking south. The road in the left foreground is Edgware Road which crosses the River Brent. The North Circular Road crosses Edgware Road at right angles before running under the Midland Railway main line. Cricklewood sidings are visible to the right of the bridge. The junction with the North Circular is controlled with traffic lights, and massive queues have arisen on both roads – an indication of how quickly the new arterial roads constructed only 10 years previously became clogged with cars. New construction of shops and flats is taking place around the junction of the two roads while the north-east quadrant of the crossroads is occupied by a filling station, a typical location of the period. The transitory nature of much of the roadscape around London is emphasised by the provision of many advertisement hoardings and the shacks behind some of the buildings. The vehicles visible in the photograph include a fine selection of London Transport buses, trolleybuses and coaches, among them Green Line coaches of the Q and T classes, trolleybuses of the distinctive LT six-wheeled type,

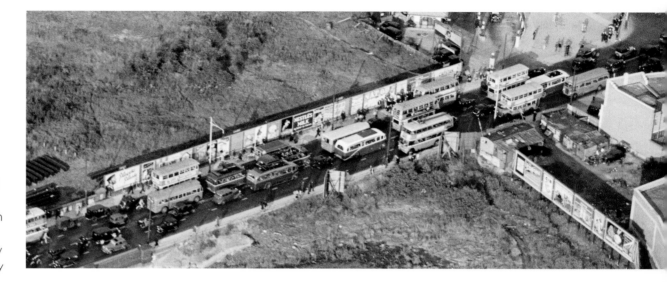

and STL and ST double-deck buses. Coaches from independent operators include several just in front of the Q with sun saloon bodies, where much of the roof could be opened on a fine day. Today the scene is almost unrecognisable, with only the river and railway bridges providing any continuity. The North Circular crosses both railway and Edgware Road on a flyover, the site of the crossroads is hidden beneath a roundabout and all the buildings in the 1937 photograph are long demolished.

Afl 03_53785

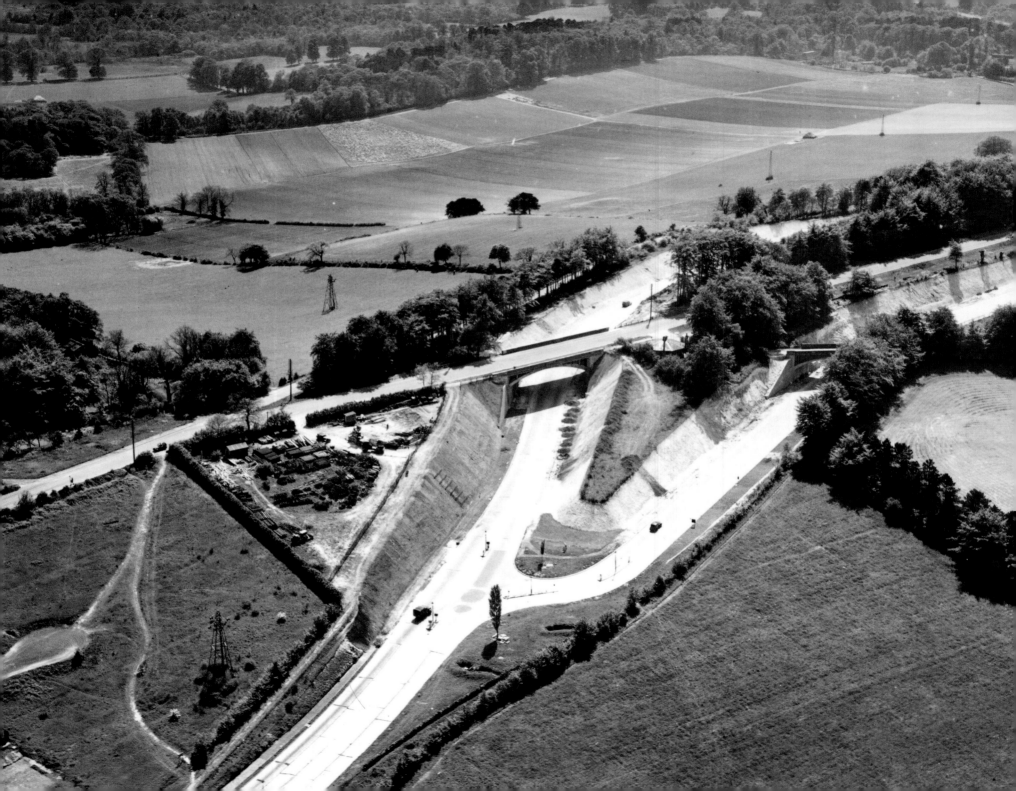

Godalming bypass

14 May 1948

One of the first two-level junctions to be constructed in England was where the new Godalming bypass went under the A31 Guildford–Farnham road across the Hog's Back. The bypass is the road within the cutting and is linked to the Farnham Road by slip roads. This photograph shows it still looking as though it has been recently constructed although it had been open since 1934. The junction survives, broadly in the same form, to the present day.

Afl 03_15533

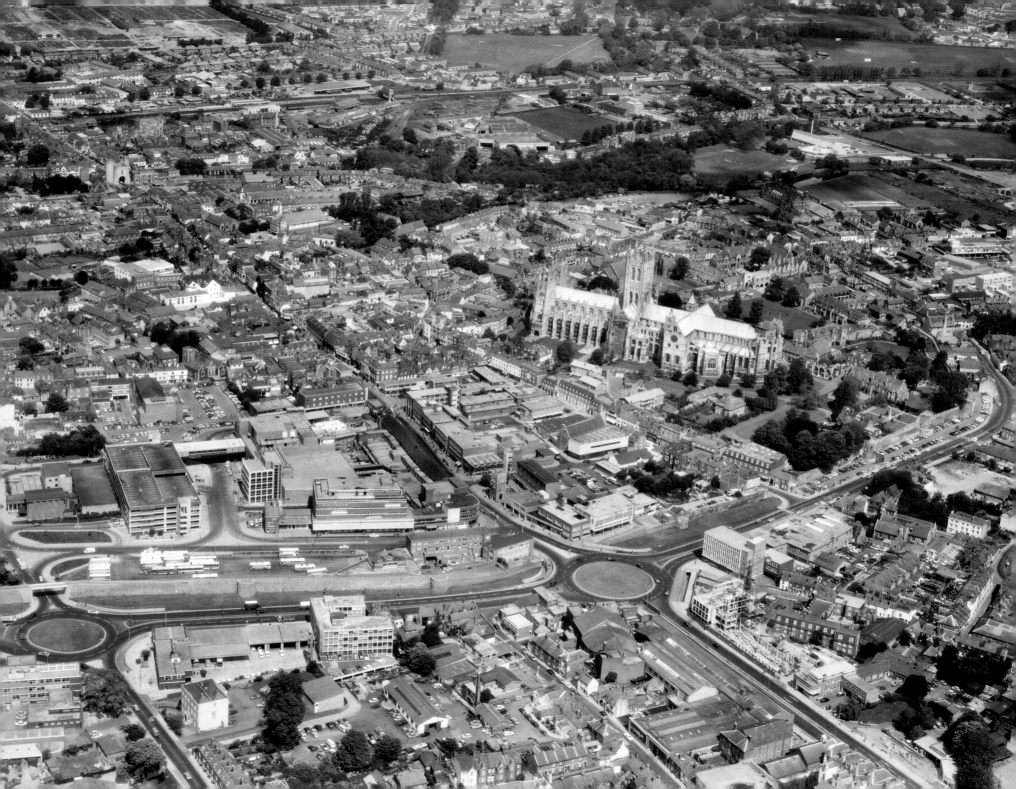

Canterbury
22 May 1973

The bombing of Canterbury in the so-called Baedeker raids of the Second World War gave planners an opportunity to reconstruct the south-eastern part of the city. An inner ring road was built, tightly enclosing the largely extant city walls with roundabouts at major junctions. The impact on the city's fabric was considerable, cutting off the centre from its suburbs with a ring of tarmac. On the right, it can be seen that the area immediately outside the walls was (and still is) used for surface car parking. Inside the walls, the rebuilt area enjoyed the benefits of a multi-storey car park, seen to the left of this view, looking north-east towards the cathedral. The car park, which vied with the cathedral in its dominance of the city, has now been demolished. Inserted between it and the city wall, the East Kent Road Car Co bus station was occupied mainly by AEC Regent Vs and Reliances with Park Royal bodies of the early 1960s.

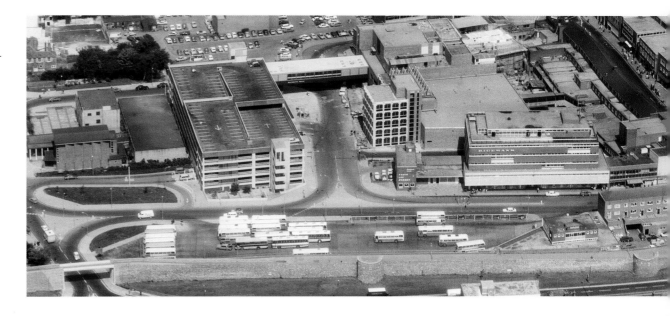

Afl 03_a256721

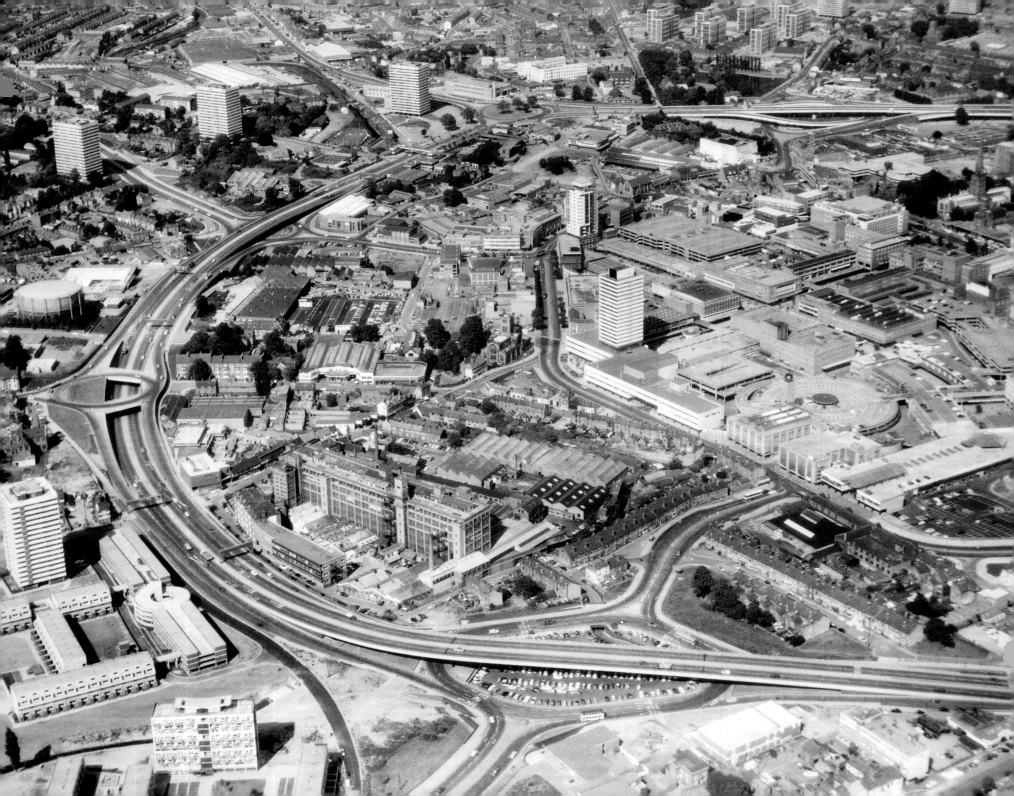

Coventry ring road

4 June 1970

Coventry has one of the most highly developed
and tightly drawn inner ring roads of any city
in England. Built in stages between 1962 and
1974, the western half is seen here. It is under
two miles in length and entirely grade-separated,
except for one roundabout. A key feature of it is
the nine junctions, which because of the road's
length are almost continuous — compared by
some to the road equivalent of a fairground ride.
Although the ring road has been highly successful
in speeding traffic around the city, this has been
achieved at considerable cost. The city centre has
been physically severed from its hinterland and is
now constrained by the road to the point where
expansion within the ring is difficult and those
areas immediately outside it are economically
deprived. Possibilities are being investigated to
try to re-integrate the centre with its suburbs.

Afl 03_a203599

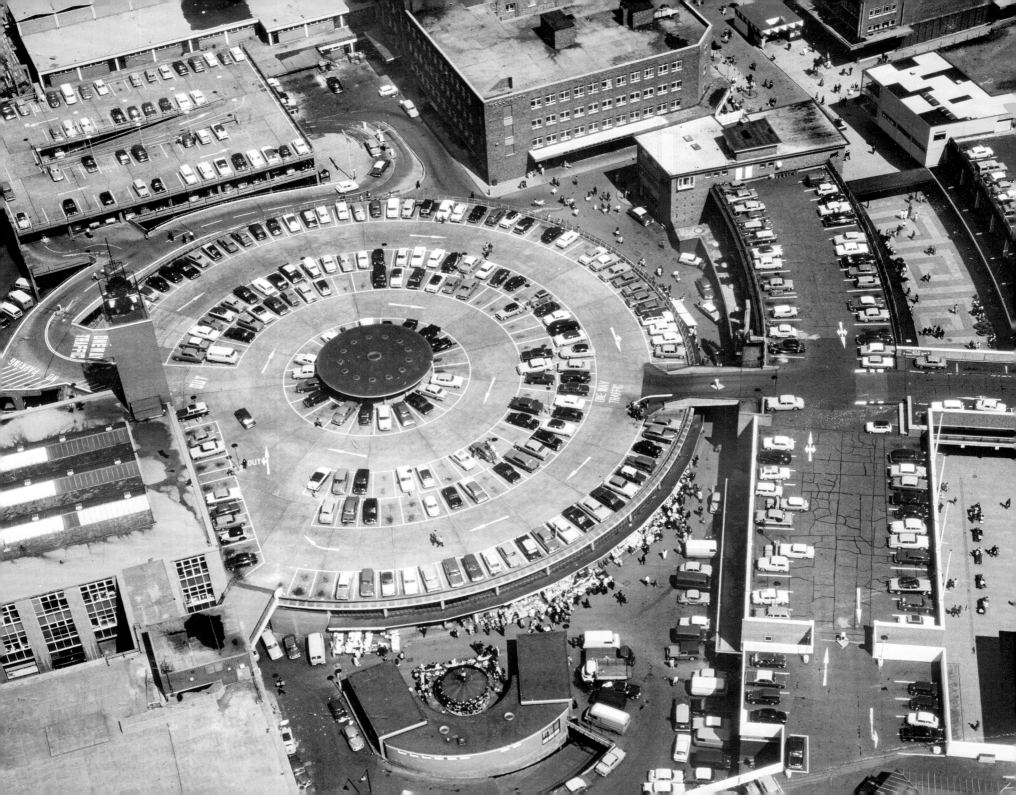

Coventry market

c 1961

Coventry's plan envisaged a complete ring of roof-top and multi-storey car parks interconnected with each other and directly linked to the ring road. When the city centre was completely rebuilt following wartime bombing, the use of concrete slab construction for the pedestrian precinct buildings allowed the use of their roofs for car parking, the most impressive example being the circular market building (1957). This building was entirely of reinforced concrete, and its complexity was increased by a branch off the ramp to the two-tier car park seen at the top of the photograph. Built in 1959–60, it is believed to be the first open-deck multi-storey car park in Britain but it was demolished, unrecognised, in about 2008. The market building has, by contrast, been listed. Parapets disguised the presence of the car parks when the buildings were viewed from the ground. The parking areas were linked at roof-top level by bridges, such as the one seen here, linking the market building to its neighbours.

Afl 03_c13908a

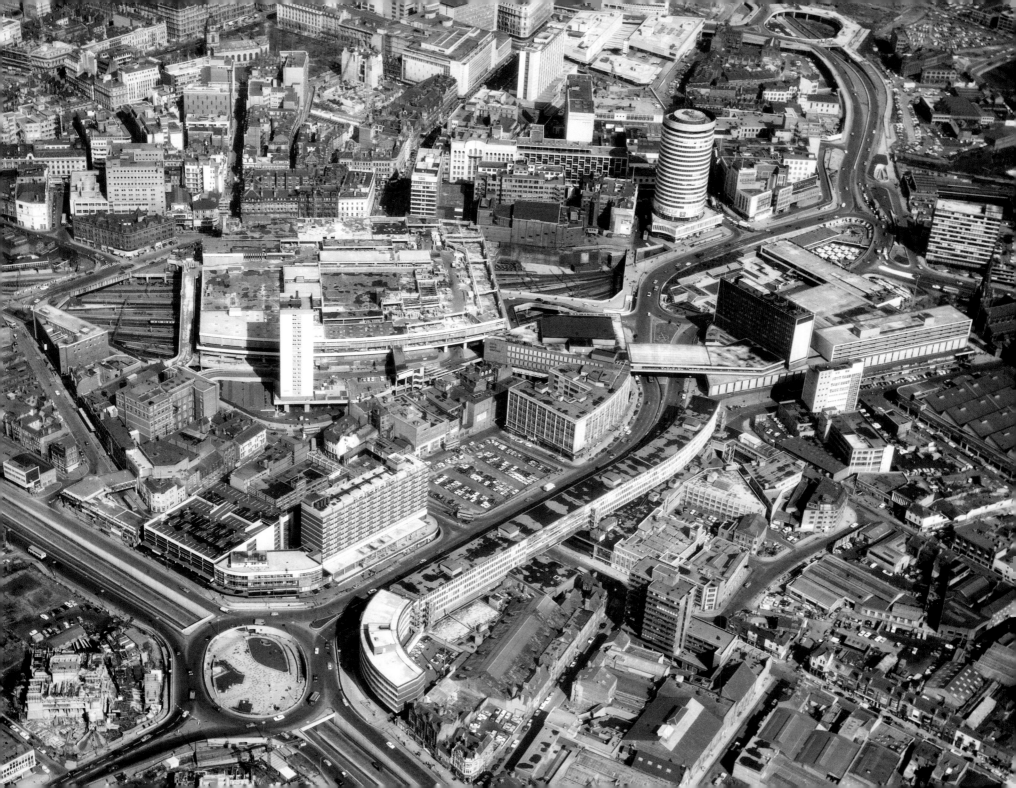

Birmingham

1 April 1969

Birmingham represents the high point of the dominance of the motor car in England. Its City Engineer, Sir Herbert Manzoni, famously declared that there was little worth preserving in it and set out to design a city for the motor age. His ideas had a coherence to them that attempts in other cities such as Nottingham lacked, and the Birmingham of the Bull Ring, the Rotunda and Smallbrook Ringway had a certain style to it, but the destructive effect of a tightly drawn inner ring road cutting off the centre from its hinterland became unbearable. So, steadily, Manzoni's schemes have been reversed. Surface pedestrian links between the Bull Ring area and the city centre have been restored, the ring road has been tamed and much of the 1960s development demolished. Here, we see the 1960s development at its zenith. Smallbrook Ringway is in the foreground and the Bull Ring off to the right. Some of it is still being completed – such as the shopping centre above New Street station – but here are all the elements of 'motopolis': the complete segregation of pedestrians and vehicles, with underpasses built below roundabouts, buildings straddling roads and all kinds of disjuncture.

Afl 03_a191916

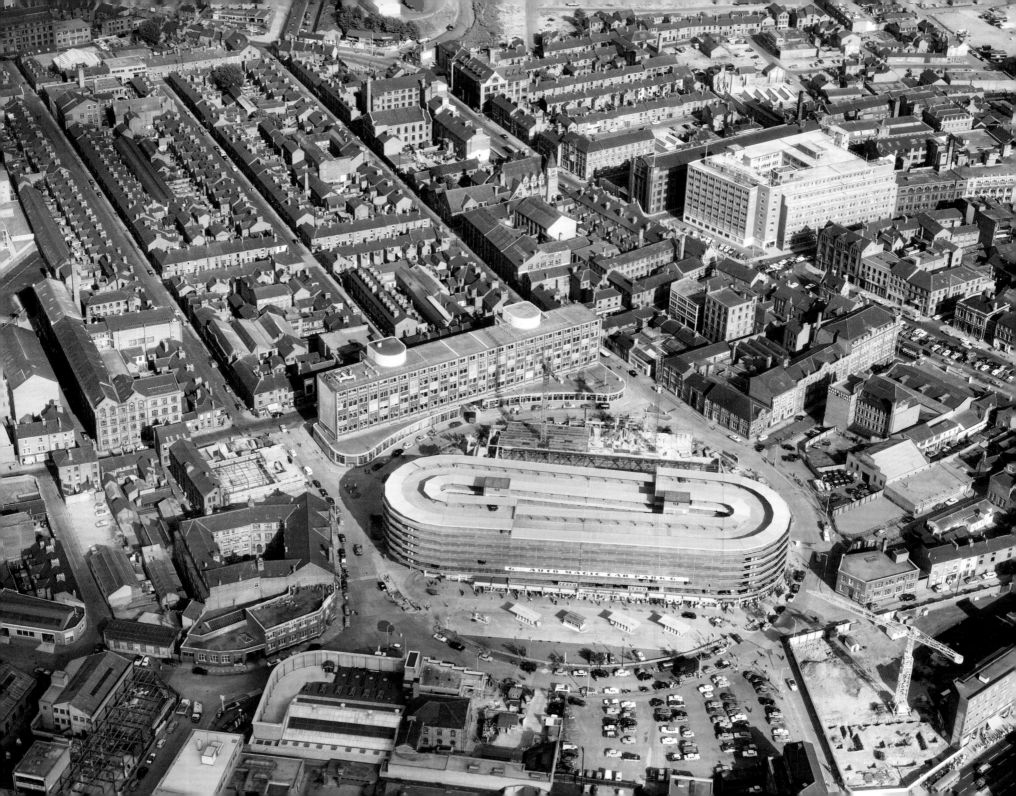

Auto Magic Car Park, Lee Circus, Leicester

22 June 1962

The Auto Magic Car Park at Lee Circus, Leicester, was designed on the continuous ramp principle and is of similar design to that at Lewins Mead, Bristol. It was the first multi-storey car park to be built in Leicester. Plans were submitted in March 1960 and it opened in December 1961, costing £750,000. The architects were Fitzroy Robinson & Partners. Construction was of beams and columns cast in situ with a reinforced concrete deck. The roadway, which is 24ft wide, gradually ascends six tiers, with the decks curving at each end to produce an elliptical shape for the car park. The decks are tilted towards an inner well for drainage and the tilt ensures a camber at the curved ends running in the appropriate direction. The structure is formed of a double ramp with entrances at each end. It incorporated at ground-floor level, beneath the car park, a bowling alley and a Tesco supermarket claimed at the time as the largest in England: goods purchased there could be delivered to customers' cars. The development was viewed as being more than just a car park, with a sign prominently declaring it to be the 'Auto Magic Shopping Park' displayed on the side of the building; an account in *The Motor* was headed 'Drive-in shopping in Leicester'. On the west elevation was a filling station with three stands and what was described as an 'automatic car laundry' – a car wash. Behind the car park is the central post office, itself the scene of a unique experiment. On the ground floor, there is a gap in the centre of the building: this was the site of Britain's first (and only) drive through post office.

Afl 03_a102088

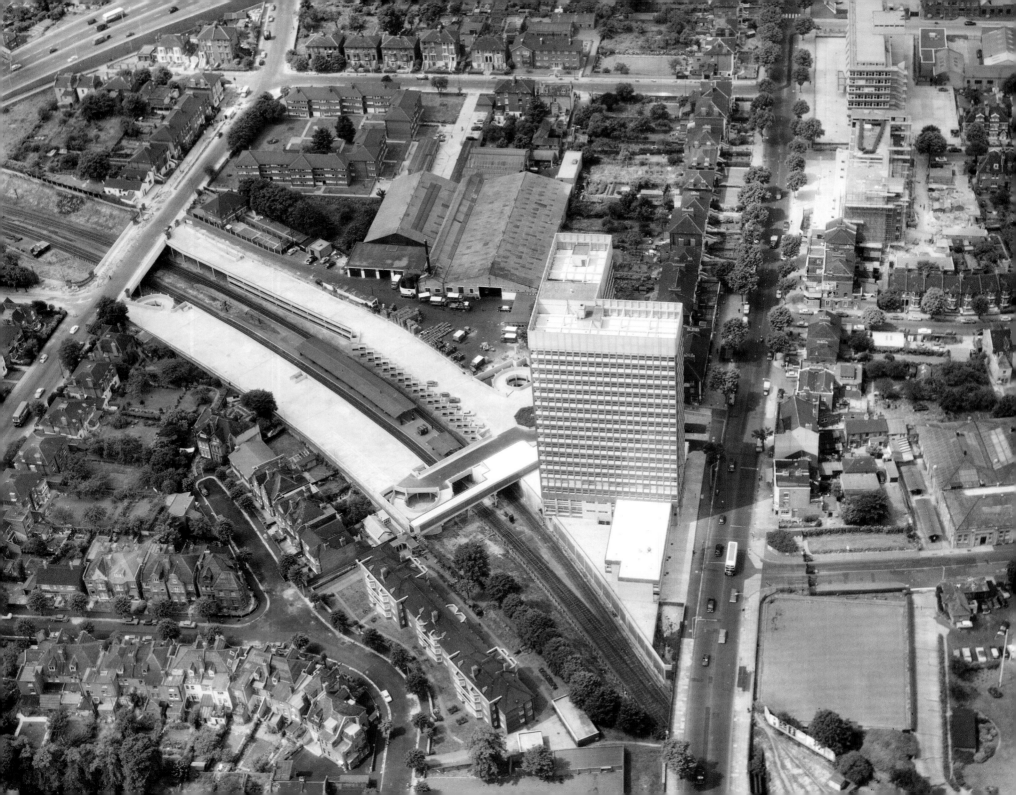

Gunnersbury

2 July 1966

As the demand for car parking grew and land values went up in the 1960s, some imaginative schemes for making use of otherwise unused space appeared. One of the most ingenious was at Gunnersbury station in Chiswick, west London, where as part of an office development that replaced the original station building a long, narrow multi-storey car park was constructed along the sides of a railway embankment, seen here immediately after completion.

Afl 03_a164332

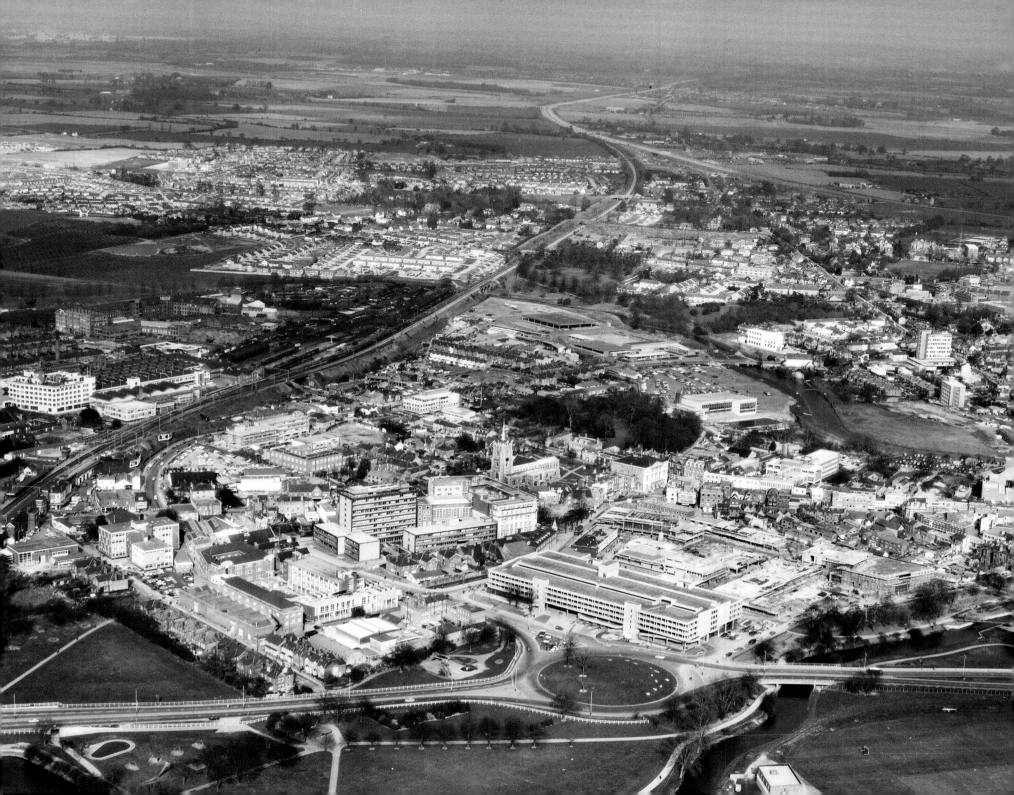

Chelmsford

23 March 1971

Chelmsford – a county town becoming engulfed by the motor car. When the photograph was taken, on 23 March 1971, the centre of the town had not yet been pedestrianised but the car's impact was already evident. The inner ring road, Parkway, constructed in 1965–8, cuts through the town, and the multi-storey car park, serving the High Chelmer Shopping Precinct which is nearing completion (later described in the Buildings of England volume for Essex as 'miserable'), is the most prominent building, dwarfing the town's cathedral and Shire Hall.

Afl 03_a212037

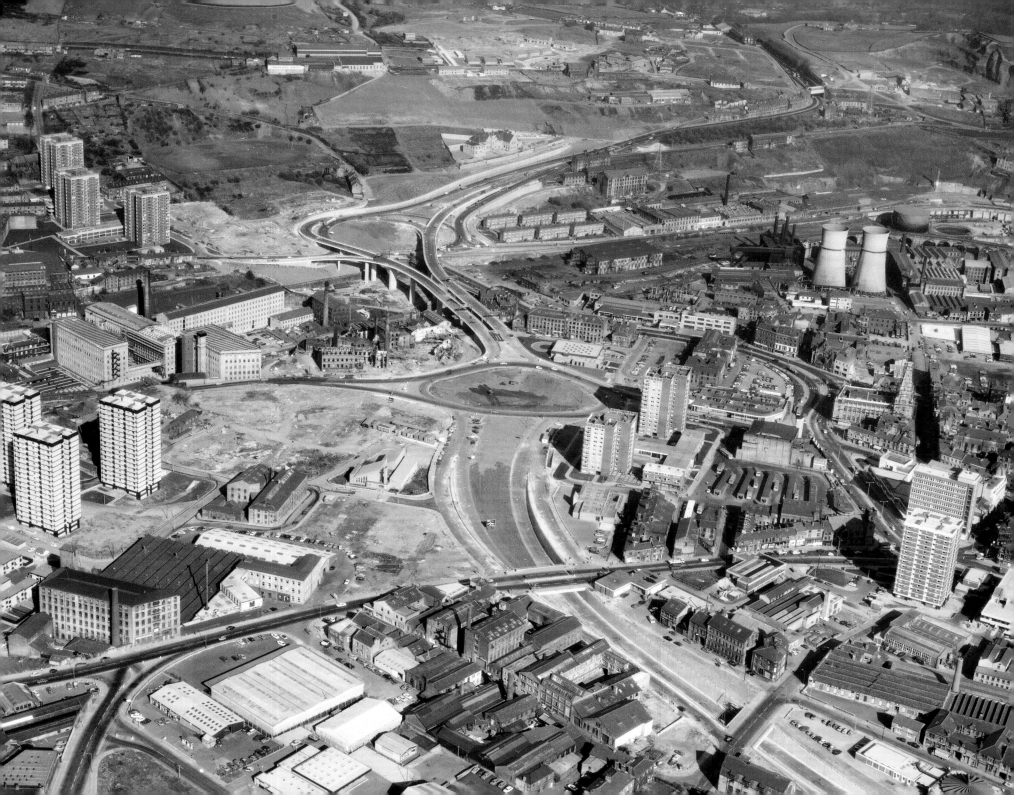

Halifax
23 March 1973

In many northern cities, the car's impact was even more pronounced. An entirely new landscape began to grow up, doing away with the close-knit urban fabric and replacing it with something much more open, fragmented by wide roads with few crossing places and interspersed with large buildings set away from them but having little relation to one another or to the earlier industrial town. These changes are graphically seen in this view of the North Bridge area of Halifax. The Town Hall (1859–62) by Sir Charles Barry and his son, E M Barry, with its tower, has lost its place in the architectural hierarchy of Halifax, being dwarfed by numerous residential tower blocks. The width of the new roads and the space taken up by their junctions and roundabouts introduce an entirely new element into the morphology of the town. However, the town centre of Halifax remains relatively intact, with the through traffic diverted to the edge: is the scale of destruction on the periphery a price worth paying for this? The overall scene has changed little since 1973, although the planting has now matured, enabling the work carried out in the 1960s and 1970s to mellow somewhat.

Afl 03_249530

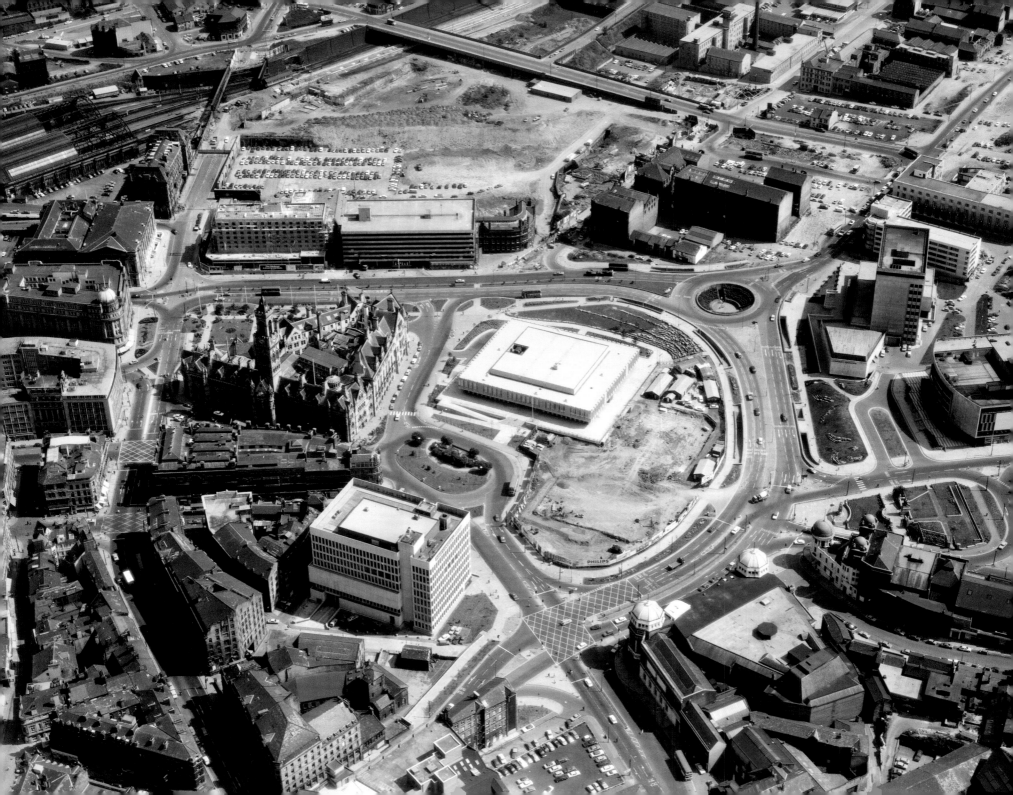

Bradford

12 July 1972

At Halifax the new roads were on the periphery of the town centre, but at Bradford they were brought right into the heart of the city, changing the setting of the Town Hall (1873, Lockwood & Mawson) almost beyond recognition. The free movement of motor traffic was at the heart of the redevelopment and pedestrians were forced underground through subways such as those around the roundabout to the right of the Town Hall. The new buildings no longer had any relation to the street line, the Magistrates' Court of 1969–72 sitting uncomfortably on its podium, surrounded by roads in every direction. Bradford underwent greater change than most other northern cities in the 1960s and 1970s, and much of it is likely to be revisited in the near future. In 2003 Alsop Architects proposed covering much of the area in this photograph with a lake, although the scheme was not implemented.

Afl 03_a238888

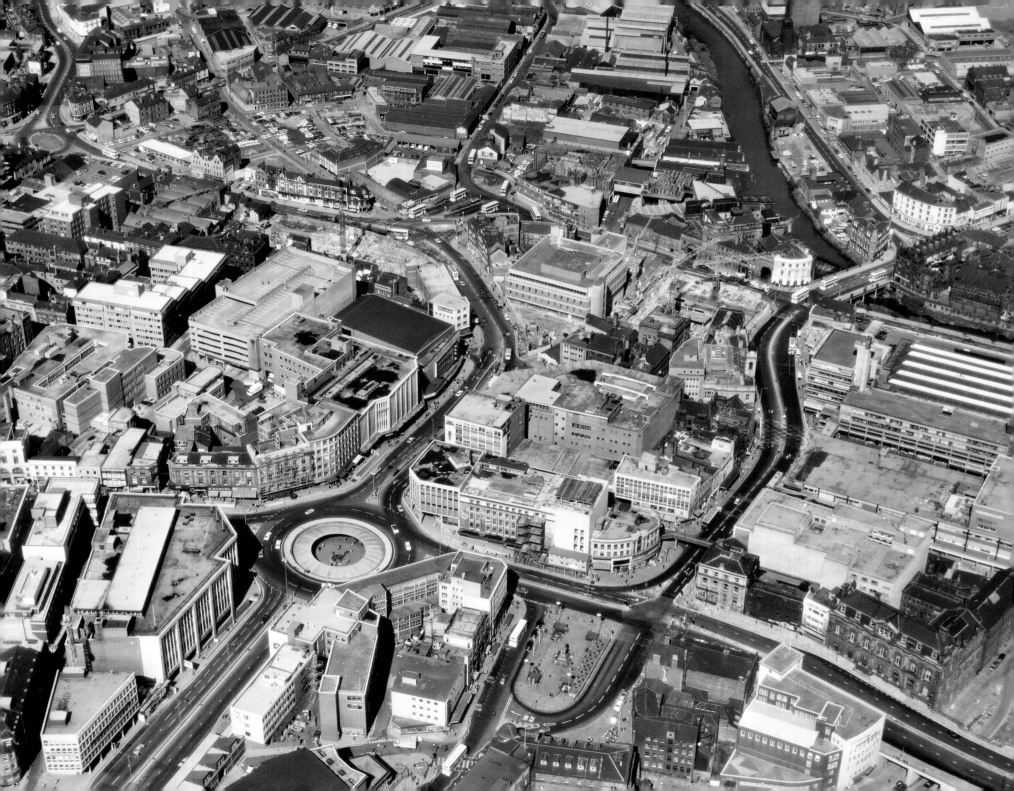

Castle Square, Sheffield

August 1974

Some of the sixties attempts to separate vehicles and pedestrians were more benign than was often the case. One that was well received was Sheffield's Castle Square or, as it was known to all Sheffielders, the 'hole in the road'. It was rather quirky, not least because of the oxymoron: it was a circular square. The work of the City Architect's department and opened in 1969, it was a paved area below a roundabout with a coved concrete roof extending over much of it and the central part left open to the sky. It was approached by subways coming in from many different directions and formed a hub for the city centre so that people heading for the market or the bus station would walk through it. It had kiosks and shops located within the subways while many of the major department stores had shop windows and entrances at subway level. This gave it the life that so many of these developments seemed to lack. It worked well, with traffic moving at high speed above it, and yet it occupied very little space and did not destroy the sense of enclosure essential to a city centre. The open space had seats and a fish tank in it, and the 'hole in the road' became a focal point where Sheffield people would meet. Its destruction in the early 1990s to make way for a new tramway network was regretted by many residents.

Afl 03_a 284073

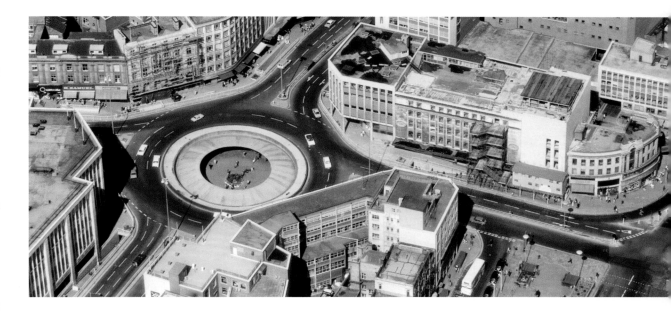

Nottingham

31 July 1969

One of the greatest criticisms that can be levelled at 1960s road schemes is that, besides destroying many fine buildings, they took no account of the history of a place. One of the most graphic examples of this is Maid Marian Way, Nottingham. The dual-carriageway road cut across the grain of the city, severing the castle, seen on the left, and many of its most ancient streets from the Market Square and the Council House, seen on the right-hand edge. Streets that had been in existence for over 500 years were suddenly cut in two and no longer directly accessible, and the photograph shows how a coherent city centre was transformed to meet the needs of traffic management.

Afl 03_a198096

Reading

6 September 1971

An inner ring road cuts a sharp, largely impermeable line around a town centre. This is Reading's, nearing completion in 1971. With its underpasses, surmounted by roundabouts connecting it with the principal roads leading out of the town, it dominates Reading, imposing a different aesthetic and scale, as do the massive Chatham Place multi-storey car parks newly constructed just outside it. These have recently been replaced, another indication of the short life of many car-related buildings. At the bottom of the photograph on Lower Thorn Street is the headquarters and garage of the Thames Valley (later Alder Valley) Traction bus company. The neo-Georgian headquarters building on the left was built in 1928 and had an extra storey added in 1933. Thames Valley first occupied the site in 1922 but most of the garage buildings – which had an uninterrupted 220ft roof span – date from a rebuilding of 1938–40. The headquarters closed in 1981, the garage followed in 1983 and the entire site has subsequently been redeveloped.

Afl 03 _a218617

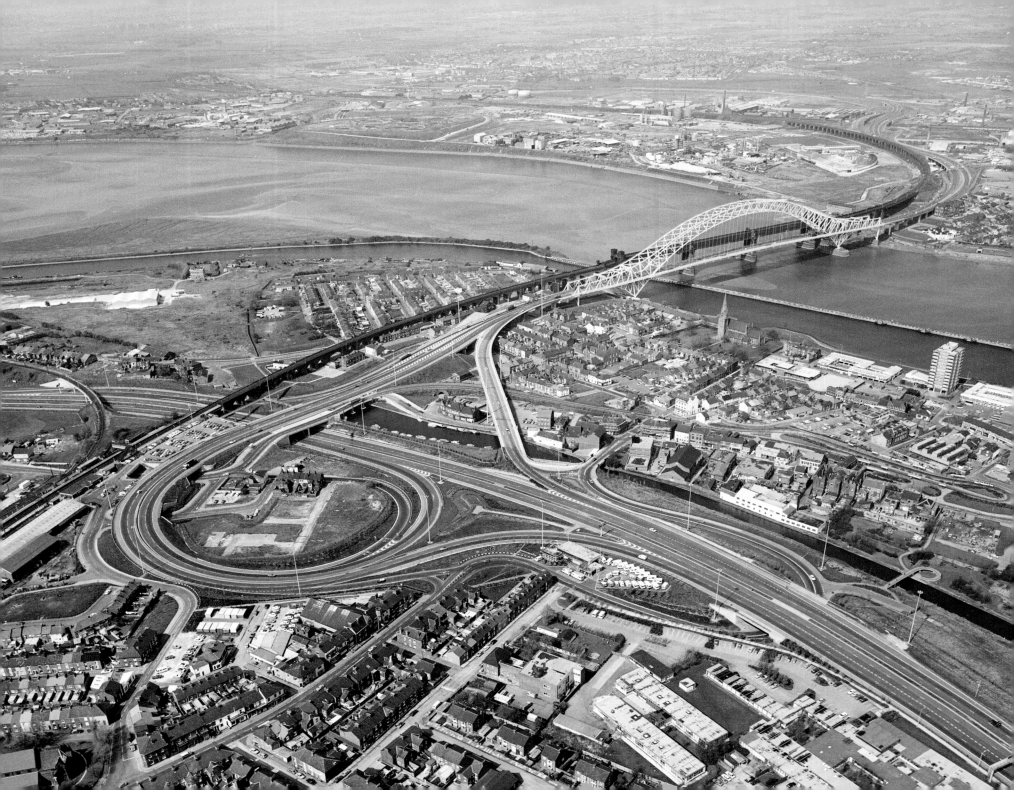

Runcorn

c 1972

The spatial impact of motor vehicles is evident in this view of Runcorn. The present road bridge over the River Mersey replaced a transporter bridge in 1961. The approach roads linking the A553 Queensway across the bridge with the A557 Bridgewater Expressway running east–west across the view emphasise how great the land grab of roads is by comparison with the West Coast main line railway that crosses the Mersey parallel to the road bridge.

Afl 03_415654

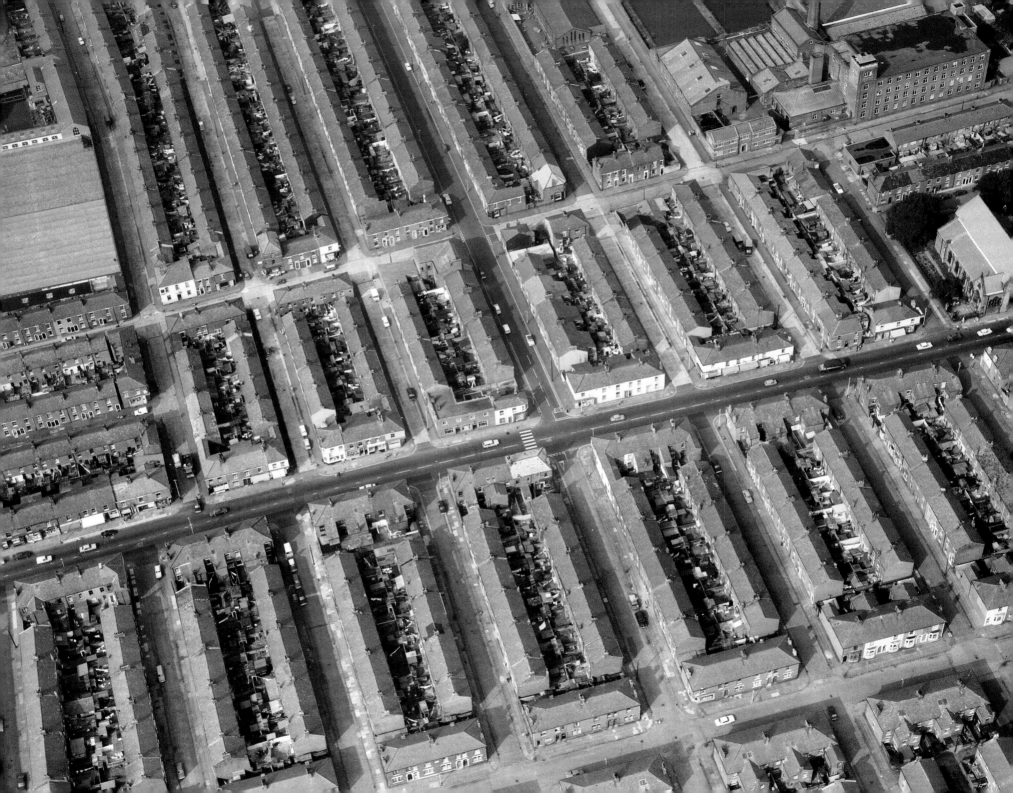

Preston

16 September 1971

In stark contrast to those places where so much was being done to accommodate the motor car, in the Victorian by-law streets of the north the car's impact was still modest as late as the early 1970s: in 1970 there were just under 10 million cars in Great Britain as compared with 27 million in 2013. This is Preston in 1971, where only a handful of cars are parked on the residential side streets. Today, the streets in such areas are choked with cars to the extent that many are now controlled by residents' parking schemes.

Afl 03_a216237

Harlow
24 March 1961

The separation of people and traffic was nowhere
more marked than in many of the New Towns.
Provision was also made for cyclists at Harlow,
and a comprehensive network of cycleways was
created. These were quite independent of the
road network, and when they met major roads
were channelled underneath them in underpasses,
as can be seen in this view taken a little to the
south of the town centre. Pedestrians had their
own pavements on the cycleways. The seclusion
of these routes has, however, put some people off
using them as they are felt to be potentially unsafe,
particularly at night.

Afl 03_a86050

Bracknell

5 April 1968

A common way of separating cars and pedestrians in the New Towns was by the use of Radburn layouts (named after the town in New Jersey where the idea first took hold in 1928). These took the form of spine roads, with pedestrian paths giving access to houses. Car parking was in garage courts within each block of houses. In the example here at Bracknell, the pedestrian path runs in the centre of the photograph from left to right. The garage court is accessed from the spine road at the bottom of the photograph. In fact, as in many of the schemes that were actually built in Britain, the Radburn principle is only partly adhered to, as the majority of the houses are located on the spine road itself and there is not the total separation of cars and traffic that one would find in a true Radburn layout.

Afl 03_gf925

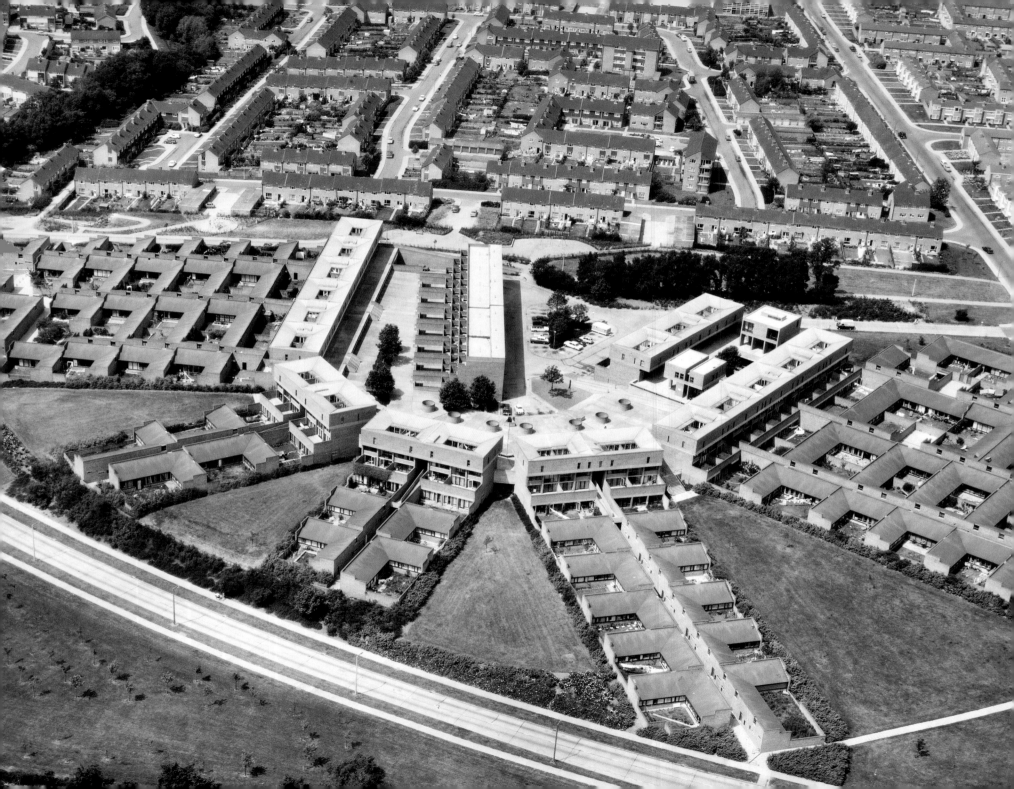

Bishopsfield, Harlow

13 July 1972

Harlow saw one of the most striking attempts at separating cars and pedestrians in Bishopsfield (Neylan & Ungless, 1963–6). Here cars were hidden beneath a piazza formed by the U-shaped area at the top of the photograph. From there alleys radiated down the slope of a hill flanked by the high walls of houses, each of which was built around a walled patio and enjoyed views out over the surrounding country. It was one of the most adventurous housing schemes of the 1960s. But the problem here is that cars are garaged some distance from peoples' houses in a rather depressing underground location. It all looked pristine in 1972 but the public areas, especially around the garages, have deteriorated since then.

Afl 03_a237849

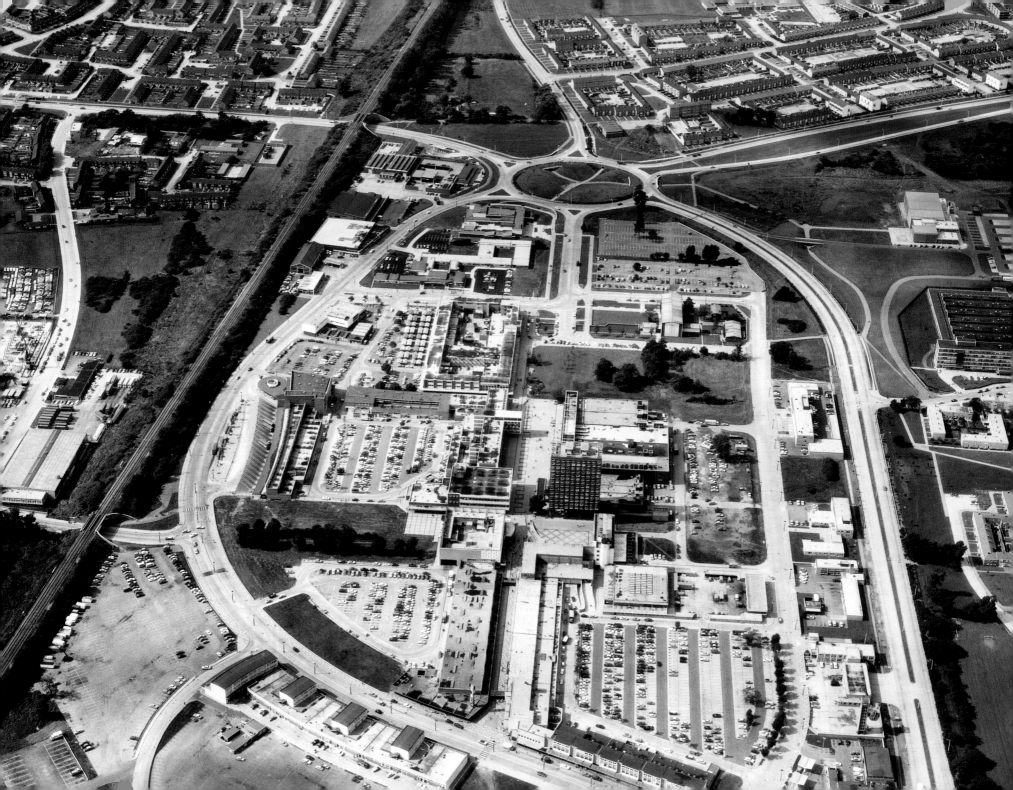

Basildon

5 September 1968

Basildon was one of the second generation of New Towns to be designated, and in this view it is clear how its design was focused on the motor car. Pedestrianised shopping streets are entirely encircled by an inner ring road and the shops are almost a foil for the large areas of surface car parking. Pedestrian access to the town centre, which is entirely zoned for commercial purposes, is controlled by having a limited number of entry points across the dual-carriageway ring road while there is no gradual transition from town centre to outlying areas or countryside: everything is circumscribed by hard edges. The paths giving pedestrians access to the centre through subways can be seen in the roundabout at the top of the town centre

Afl 03_a190438

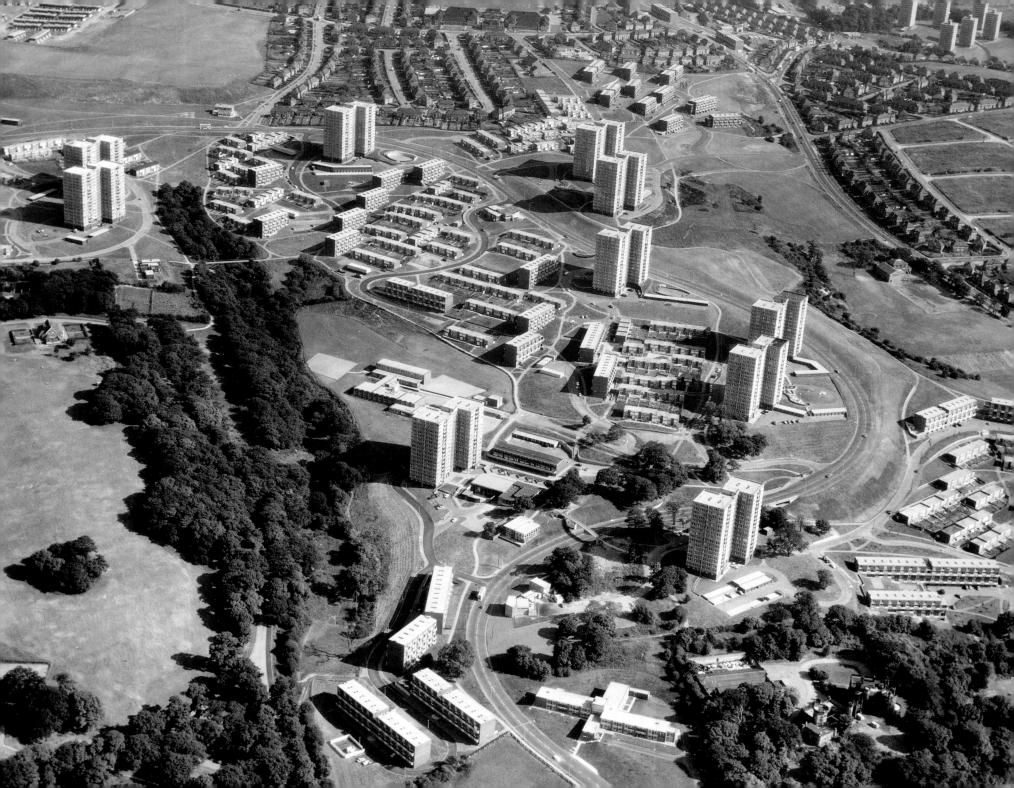

Norfolk Park, Sheffield

1969

Sheffield was renowned in the 1950s and 1960s for its public housing. It used innovative designs to enable maximum use to be made of the dramatic topography of the city. One such estate was Norfolk Park, built on the last piece of undeveloped land close to the city centre. It was complete by 1969, the date of this photograph, and was on a steeply sloping hillside. A sinuously curving spine road ran through the estate and can be seen emerging at the bottom of the photograph. Houses, maisonettes and tower blocks were grouped picturesquely in parkland, with none being approached directly by road. Footpaths were all located away from roads. Separation of traffic and pedestrians was almost total, with elegant arched concrete footbridges crossing the spine road, using the topography to avoid steps up to them. It was one of the most exciting attempts to create a place to cope with both cars and people but it has now been rebuilt on much more conventional lines, the tower blocks being ceremoniously blown up in the early 21st century. In its original form, it lasted no more than 30 years – a sad end to a brave experiment.

Afl 03_1962902

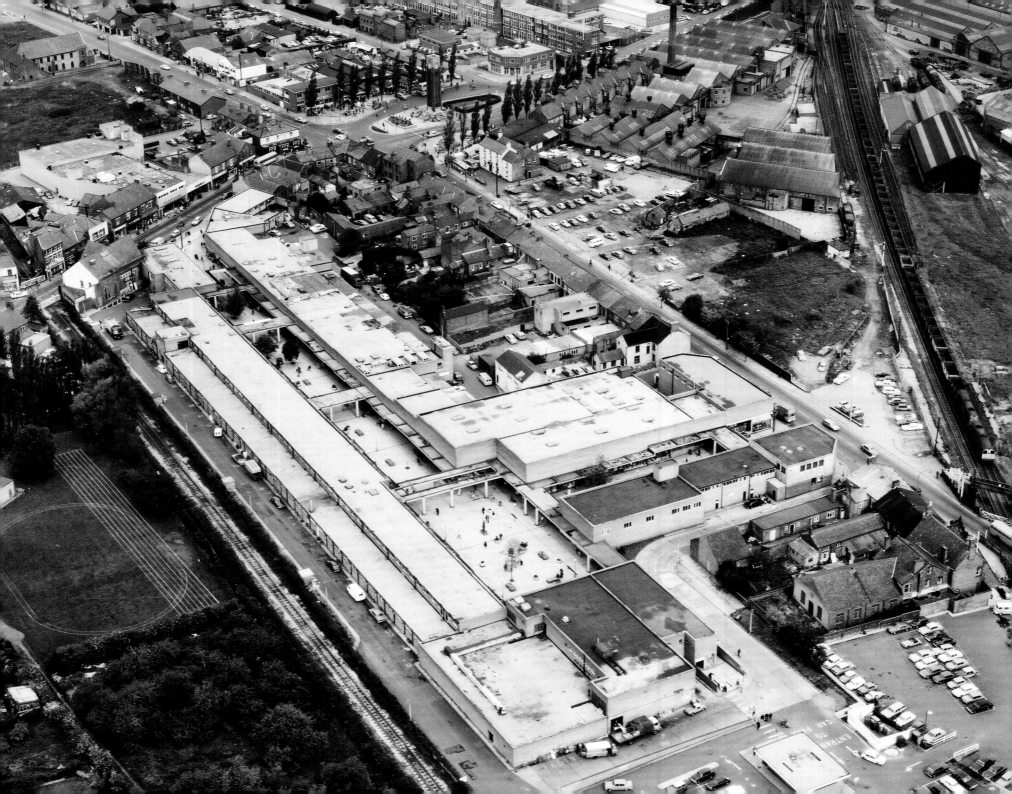

Coalville, Leicestershire

2 June 1972

The separation of cars and people was by no means confined to New Towns. By the late 1960s and early 1970s, it became almost obligatory for every town to have a small pedestrianised shopping area. This is Coalville's Broadway Shopping Precinct. Comparing this view to those of towns in the 1920s, the impact of the car on communities becomes apparent. What was once a tightly built-up urban area becomes fragmented with the extensive surface car parking required for such developments. The shoppers are enclosed within a complex, with few views of a world outside. The development has forms of a scale totally different from those of the surrounding streets, and the corollary of the pedestrianised spaces are the service roads that run behind the development providing a hard edge in place of the gardens that ran gently into countryside or market gardens.

Afl 03_a231906

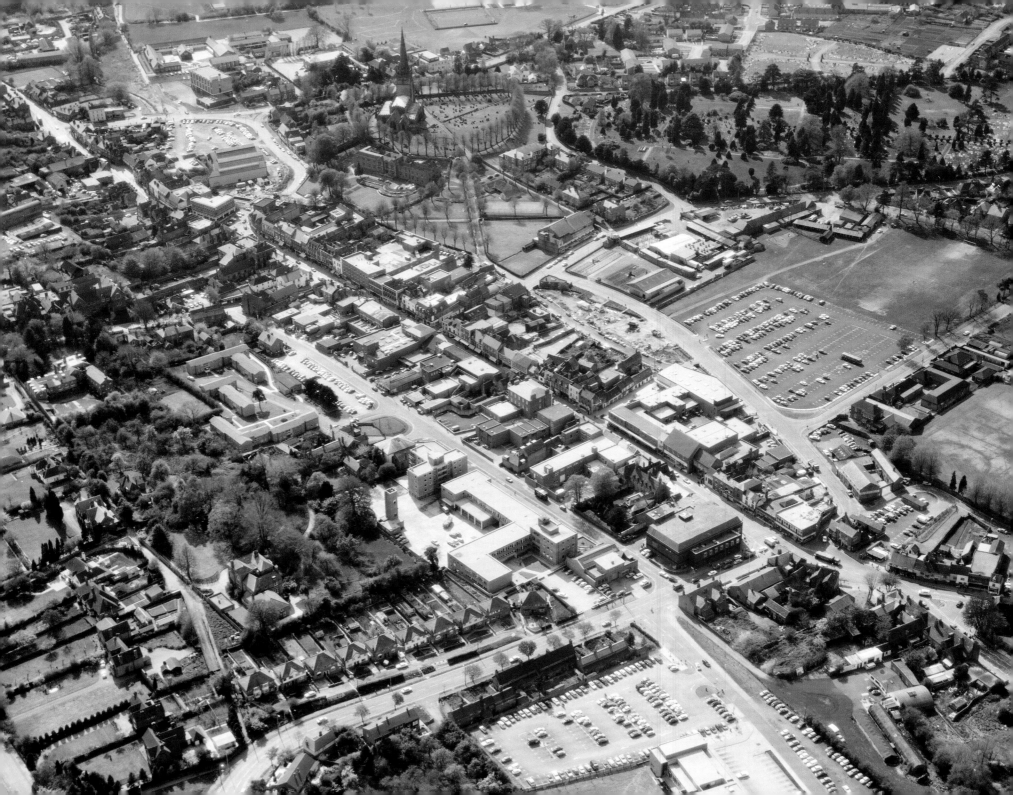

Bromsgrove, Worcestershire

1 May 1972

Even relatively small towns experienced far-reaching changes by the end of the 1960s. Bromsgrove, Worcestershire, is typical of many that saw their traditional high streets and shops paralleled on each side by a relief road. In place of the gardens, market gardens, cottages and small-scale workshops that were so evident in the aerial photographs of the 1920s we have straight, sharp-edged roads, the backs of the shops in the high street exposed and tarmacked service yards. Large surface car parks are beginning to appear, approached from the relief roads of Market Street and Windsor Street. The medieval St John's church on its hill is separated from the town by Market Street and now looks out onto a large car park. Forty years later, there is little change other than the pedestrianisation of much of the High Street.

Afl 03_a230453

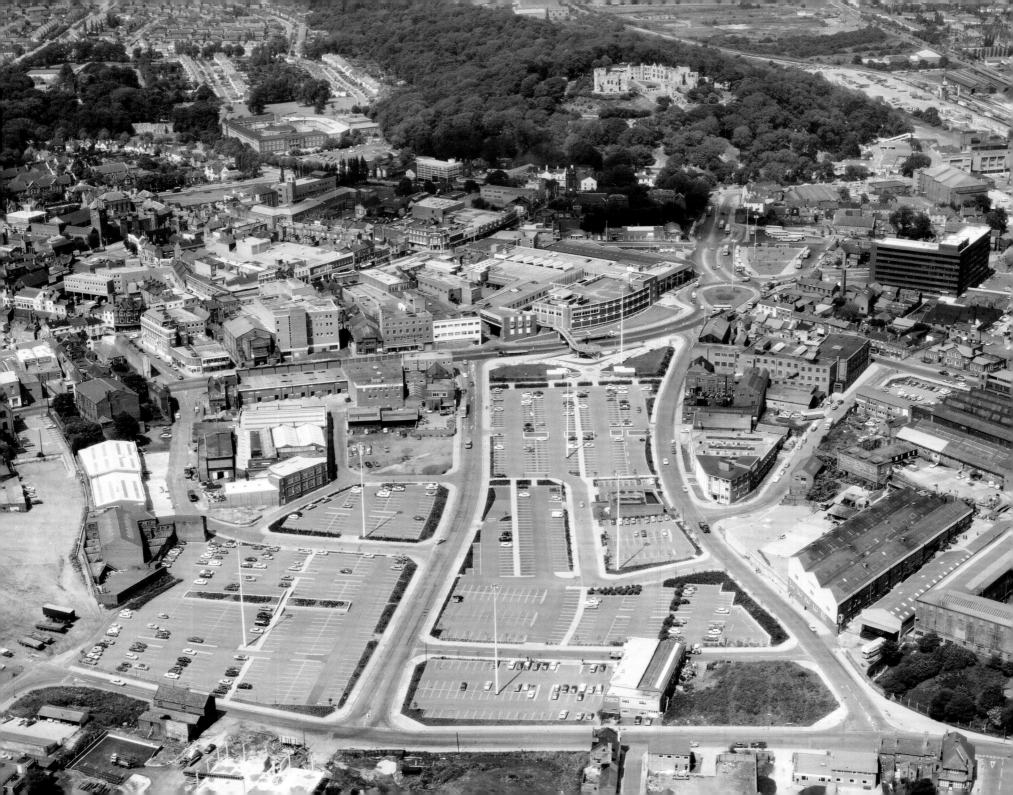

Dudley
26 June 1972

Surface car parking could reach extreme levels.
This is Dudley, where the area laid out for parking
has ripped apart this area of the town, taking away
any feeling of urbanity and producing a place more
akin to American cities such as Houston where
urbanism has been subordinated to the car. The
surface parking is on the edge of the town centre
(Dudley castle is top right) and occupies almost
as much space. Most of it remains today.

Afl 03_a236906

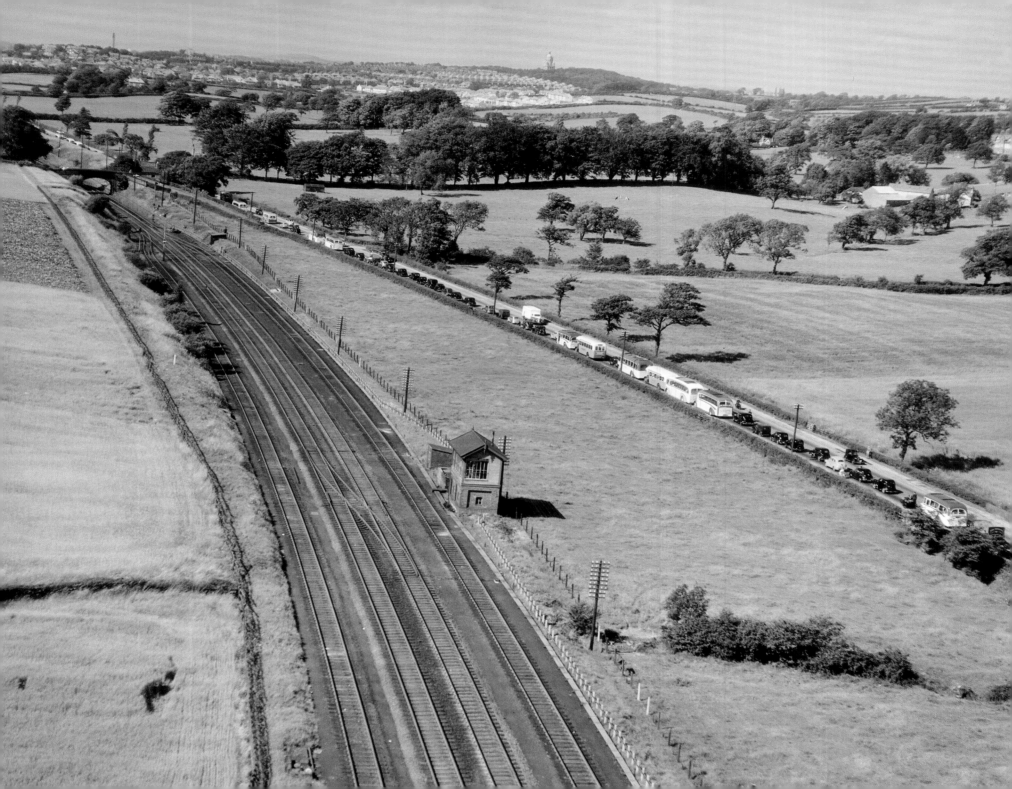

A6 south of Lancaster

28 July 1951

The Preston bypass, now part of the M6, was the first motorway in England, opened in 1958. It was followed in 1960 by the Lancaster bypass. One of the reasons why both bypasses were so urgently needed is seen in this view of the A6 south of Lancaster. A continuous line of cars and coaches crawls northwards towards Scotland and the Lake District on a summer day. Alongside, the West Coast main line of the London Midland Region stands empty as if to epitomise the capacity of the railways to handle such exceptional traffic. Lancaster is just beyond the range of hills in the distance, with the Ashton Memorial on the skyline.

Afl 03_ r15159

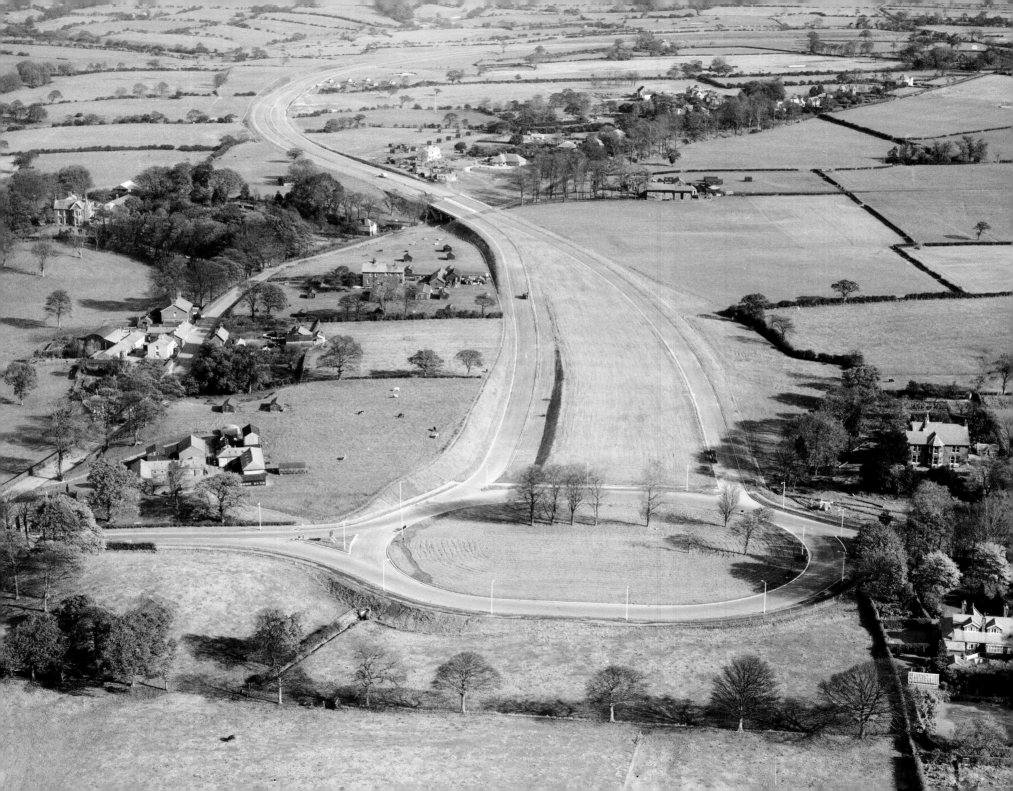

Preston bypass

5 November 1958

The end of the British motorway system for the time being, the north end of the Preston bypass photographed prior to its formal opening to traffic on 5 December. The largely complete and deserted motorway simply ends at a roundabout with the A6. Provision for its extension has been made and can be seen in the way in which the twin carriageways splay out to enable an overpass/underpass to be constructed in the future.

Afl 03_a739744

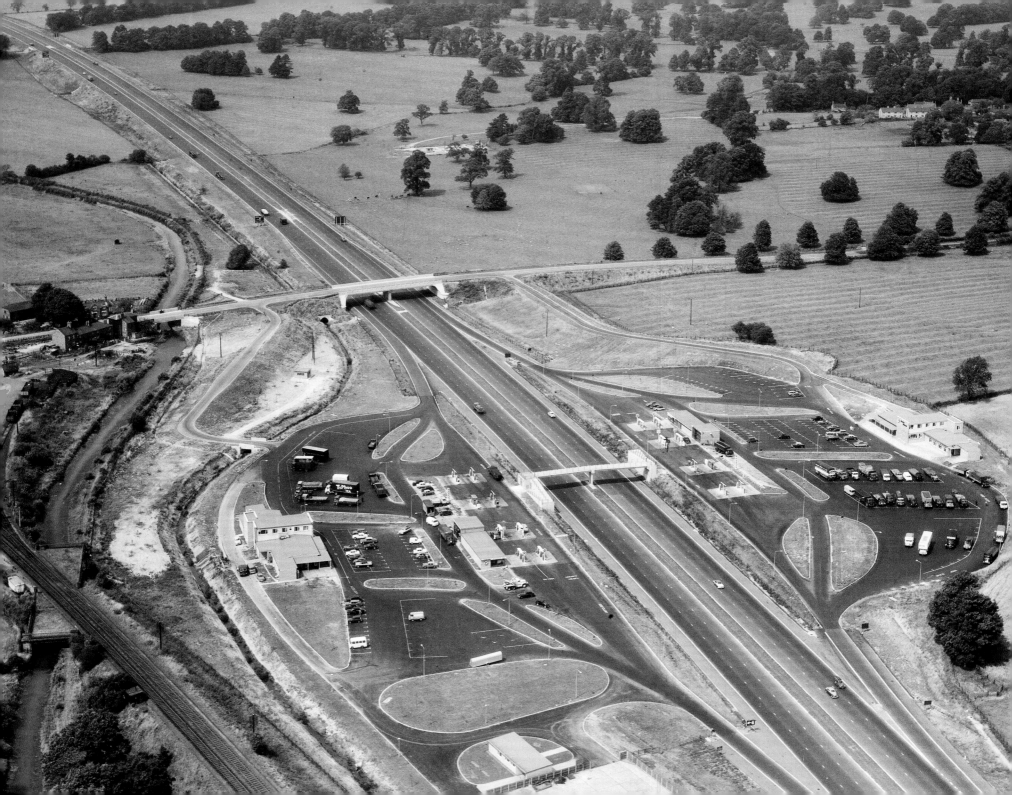

Watford Gap services

1959

The first of the motorway service areas on the M1 to be opened, Watford Gap has almost become part of English folklore. It is seen here soon after opening in 1959. What stands out so clearly is how limited the facilities are by comparison with a present-day motorway service area. There is no attempt to create anything architecturally striking or innovative to accompany the new road. Both east and west service areas are completely separate, linked only by an exposed footbridge. The small size of the car parks and the limited number of cars using them are again extraordinary to modern eyes. Unfamiliar, too, is what now seems the small size of the heavy goods vehicles in comparison with those of today. All are of British origin and include Ford Thames Traders, Bedfords, a Commer, an AEC and – a rarity – a Jenson pantechnicon. One of Sir Owen Williams's distinctive concrete bridges lies just beyond the limits of the service area.

Afl 03_a94297

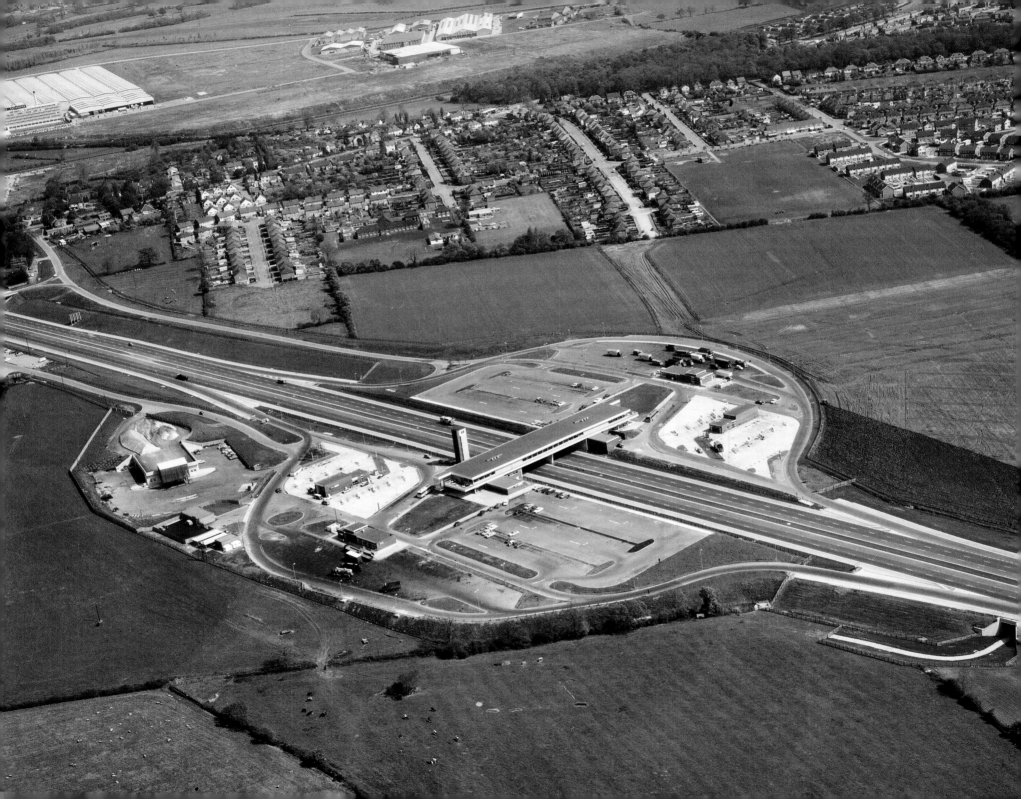

Leicester Forest East services
13 May 1966

By the time Leicester Forest East opened in 1966, things had moved on considerably from Watford Gap. While the latter had facilities on each side of the motorway linked by a footbridge – what the historian of motorway service areas, David Lawrence, has termed the 'railway station' arrangement – Leicester Forest dramatically spans the motorway: in Lawrence's typology, the 'bridge' type. It's a building much more in keeping with the excitement that motorways engendered in the 1960s and uses its impressive location to draw motorists off the road for a break. The flag of the fishing fleet of the owners, Ross, is just visible on the tower of the motorway service area. There is very little traffic, either in the car parks or using the filling station. Indeed, the motorway itself has only four vehicles on it. Ross tried to promote Leicester Forest East as a high-quality dining experience, with its Terence Conran-designed Captain's Table restaurant, but not enough customers were prepared to pay the prices commensurate with such fine dining. Unlike the restaurant, the service area is still there today, albeit disguised behind many later additions.

Afl 03_a161610

Chiswick flyover

29 April 1959

The Chiswick flyover seen under construction. Opened in September 1959 by the actress Jayne Mansfield, this was one of the first major road schemes to be carried out in London since the Second World War and marked the first phase in the construction of the M4 motorway, which ran westwards from this point. The new road, supported on concrete piers as it crosses the roundabout, cuts across the established suburban area at high level. Existing roads are in some instances simply cut off and neighbourhoods fragmented – something that would increasingly happen as the 1960s saw the creation of tightly drawn inner ring roads and urban motorways. Chiswick and Hammersmith were among the first places to experience it. Relics of the inter-war arterial road era surround the roundabout: a large pub, a garage and a filling station, all of which tended to congregate around these road hubs.

Afl 03_a74922

Boston Manor

27 August 1963

The course of the elevated M4 motorway sweeps right across the park of Boston Manor, the 17th-century house visible just below the lake on the right of the photograph, cutting through a planned landscape with its vistas towards the River Brent and its groves of trees. The view clearly shows the devastating effect that the building of urban motorways could have on both the setting of a historic building and the designed landscape created around it.

Afl 03_a119636

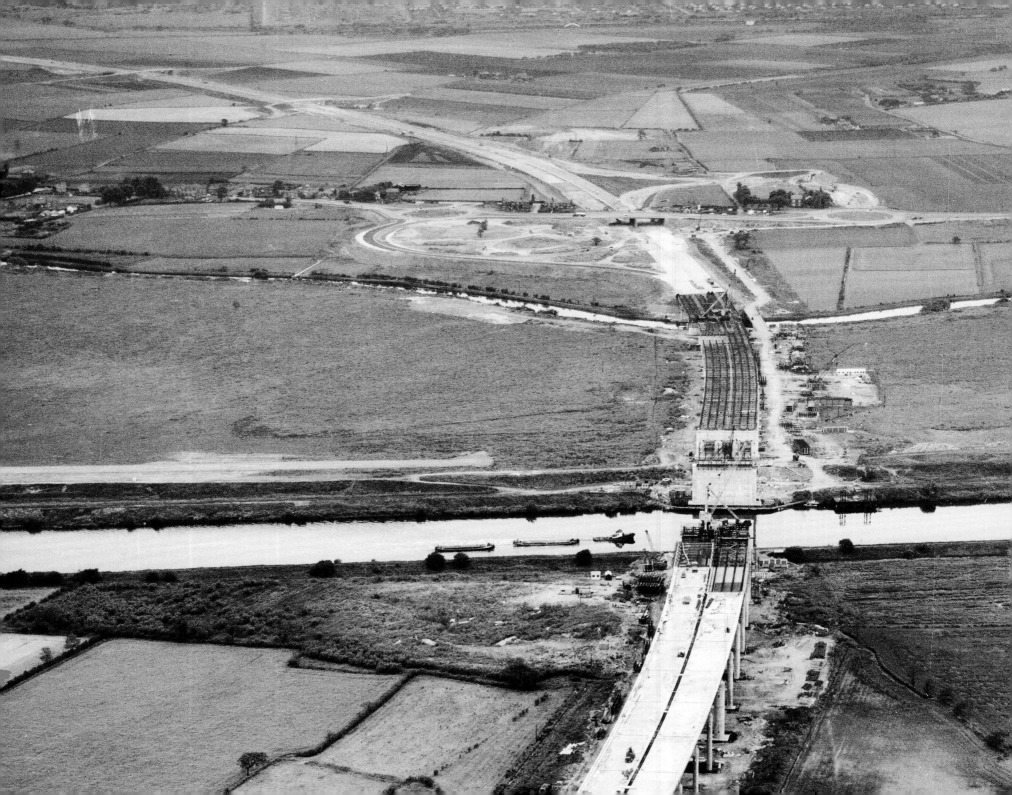

Thelwall Viaduct, M6, Cheshire

26 June 1962

A landmark on the M6, the Thelwall Viaduct, Cheshire, under construction. The viaduct carries the motorway over the Manchester Ship Canal and the River Mersey and rises to a maximum height of 93ft where it crosses them. In order to reduce costs, no hard shoulders were provided and this led to the structure's name becoming synonymous with delays when it was necessary to close lanes for maintenance or following accidents. To deal with the problem, an additional viaduct on the east side of the existing one was built between 1993 and 1995. This was followed by extensive renovation of the existing structure, which when the work was completed in 1996 enabled the provision of hard shoulders and greatly increased capacity to handle the 140,000 cars using the viaduct each day.

Afl 03_a102424

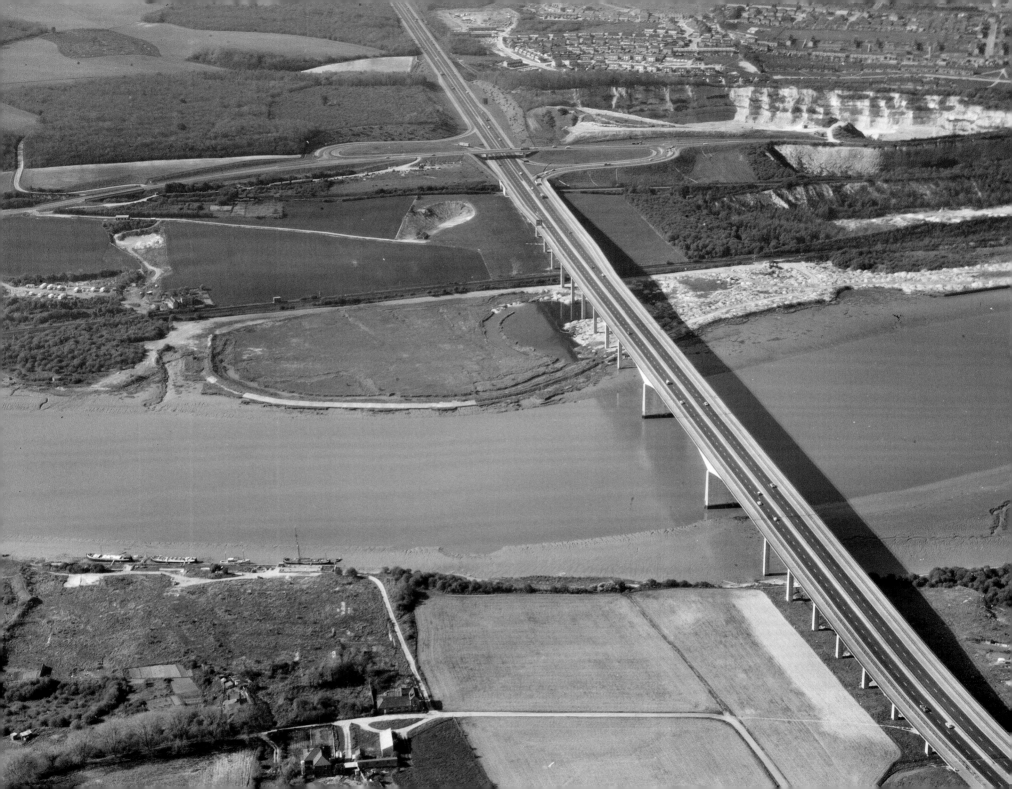

Medway bridge, M2, near Maidstone

26 April 1968

One of the most spectacular structures on the motorway system in the south-east is the Medway bridge on the M2, opened in May 1963. It was designed by Oleg Kerensky (1905–84), son of Alexander Kerensky, Prime Minister of the Provisional Government of Russia prior to the October 1917 revolution. Kerensky was a partner in Francis Fox & Partners and one of the greatest bridge engineers of his generation. The reinforced concrete viaduct is almost two-thirds of a mile in length, with a central span of 500ft. A second bridge was built to the south in 2003 to give two additional lanes, at the same time that the new viaduct for the Channel Tunnel Rail Link was constructed.

Afl 03_a182907

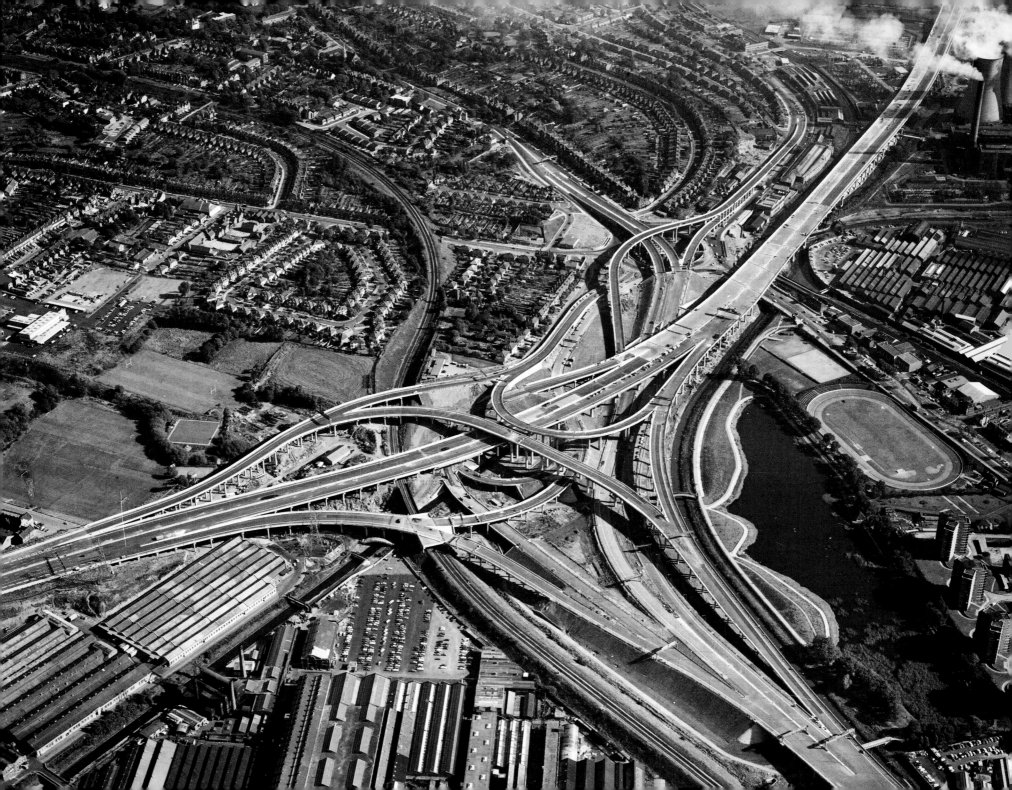

Gravelly Hill interchange

6 October 1971

Gravelly Hill interchange – or, as it is popularly known, 'Spaghetti Junction' – nearing completion. The road surfaces are still pristine, yet to take the battering they will receive over the next 40 years from nearly 2 billion vehicles. Work started on the viaduct in 1968 and it was opened to traffic on 24 May 1972. It occupies some 12 hectares and followed, where possible, the line of canals and rivers to avoid extensive demolition of property. Usage has gone up from 40,000 vehicles per day when it opened to over 210,000 today.

Afl 03_ac220279

Index of places